Single-Camera Video Production

SIXTH EDITION

Single-Camera Video Production

SIXTH EDITION

Robert B. Musburger
Michael R. Ogden

Focal Press
Taylor & Francis Group

NEW YORK AND LONDON

First published 1992 by Focal Press

This edition published 2014
by Focal Press
70 Blanchard Road, Suite 402, Burlington, MA 01803

and by Focal Press
2 Park Square, Milton Park, Abingdon, Oxon OX14 4RN

Focal Press is an imprint of the Taylor & Francis Group, an informa business

© 2014 Taylor & Francis

Library of Congress Cataloging-in-Publication Data
Musburger, Robert B.
 Single-camera video production / Robert B. Musburger, Dr. Michael R. Ogden.—Sixth edition.
 pages cm
 1. Video tape recorders. 2. Video recordings—Production and direction. 3. Camcorders. I. Ogden,
Michael R. II. Title.
 TK6655.V5M88 2014
 777'.34—dc23
 2013050384

ISBN: 978-0-415-82258-9 (pbk)
ISBN: 978-0-203-37152-7 (ebk)

Typeset in Univers
by Apex CoVantage, LLC

DEDICATION

To my mother, Mary Tomazine Wemple Musburger Houska, for teaching me the value of integrating art and technology.

R. Musburger

To my maternal grandmother, Nadine Hamilton, who encouraged my love of art and gave me her Kodak Brownie camera when I was 10-years old . . . I have been in love with the image ever since.

M. Ogden

Contents

Chapter Four

Chapter Six

Introduction

This text has been written to provide three groups of video enthusiasts with enough information to produce acceptable single-camera video productions: the media production student, the professional who needs a refresher in the basics, and the first-time video camera owner. It is a basic, introductory book designed to point the beginner in the right direction.

This is not an advanced book in preproduction research and writing, nor is it an inventory of the latest production equipment or a book on advanced techniques in electronic editing. The former and latter subjects deserve their own titles; the technology changes so fast that a production equipment inventory would be useless soon after publication.

The book has been prepared from three points of view; first, from that of instructors introducing the techniques that lead to quality video productions utilizing a single video camera. Second, from that of practitioners who have spent, collectively, over 80 years working in professional media and learning the contents of this book the hard way—by making mistakes until we finally got it right. Third, from that of academics who field innumerable phone calls and emails each week from people new to electronic production who desperately want information about single-camera video production.

This book outlines the process of working with a single video camera from beginning to end, with an emphasis on the actual production process. First, though, you must lay some groundwork before you pick up your camera. Today's digital video cameras and whichever recording media you choose to use remain two complex pieces of technology, despite industry efforts to simplify them. The processes by which a video image is created, stored, and shared are also complex, and you must understand them in order to properly utilize the benefits and master the restrictions of the medium.

The first chapter of the book outlines the production process, importance of goals and audience analysis, an explanation of the production workflow process, and the importance of technology.

The second chapter is new to this edition. The authors felt the basic principles and significance of aesthetics and their impact on the mediated image as well as the important role aesthetics play in engaging and appealing to an audience needed explanation.

The third chapter of this book contains a simplified explanation of how and why the video and audio signals are created. It also describes the technical restrictions in a digital system. The fourth chapter describes the equipment: cameras, recorders, and audio, lighting, and stabilization equipment. With these earlier chapters providing a firm base, the fifth chapter carries you through the production process from preproduction planning (much more important than most beginners realize) to setting up, rehearsing, shooting, and striking. The sixth chapter details the digital production process including lighting and audio techniques. The next chapter concentrates on digital nonlinear editing process, techniques, aesthetics, and the importance of shooting for the editing process. The final chapter outlines methods to move your career beyond the classroom, to finding and earning an internship, preparing for the interviewing and job search process and approaching your first or next job.

The media production world today is a fast-moving, nearly all-digital, environment. As such, we have included those changes that are critical for single-camera production. From experience, we are well aware that rapid changes in technology will require new information on virtually a weekly basis. We have attempted to anticipate and discuss some of those changes, but at the same time we have avoided making any wild guesses as to the next level of production changes. There are too many new concepts and proposals in the works—some of them will be operatng years from now, others will be gone within six months. As practitioners of mediated communication, all we can do is watch and take advantage of what the field has to offer and keep in mind it isn't the paintbrush that makes the difference, but the mind and the hands of the artist.

To compensate for the rapid changes in media production technology, a new website has been created to provide information on the latest changes in the industry on a regular basis. The site address is: www.focalpress.com/cw/singlecam

Acknowledgments

One cannot work in the video business without relying on many other people. This is not a solitary business, and throughout the years many people have made major contributions to our respective knowledge and careers. For Robert, here are a few of many: Parks Whitmer and Sam Scott, who started me in media production and kept me going; Art Mosby, who paid my first television paycheck; and Bob Wormington, who let me develop my directing skills. For Michael, those among many deserving special mention include: Mel Schroeder and Alan Hueth for my first job in corporate video; Oregon Education and Public Broadcasting for trusting in a young cameraman; Dan Wedemeyer and Stan Harms for encouraging my interest in technology; and my colleagues on countless film and video productions for never letting me give up my dream—you know who you are!

Also, we would like to thank the thousands of students at Avila College, University of Missouri at Kansas City, Kansas University, Florida State University, the University of Houston, the University of the South Pacific, University of Hawai'i at Mānoa, and Central Washington University who constantly reminded us that we don't know everything there is to know about media production.

Credit for the illustrations for this book we share with over 30 manufacturers of equipment who provided photographs, ideas, and illustrations for this text. Thanks also to all of the helpful people at Focal Press who have guided and prodded us through our publishing efforts: Karen, Philip, Mary, Trish, Marie, Maura, Tammy, Tricia, Lilly, Jennifer, Amy, Elinor, Michele, and for this edition, Dennis McGonagle and Peter Linsley of the Taylor and Francis Group.

Robert B. Musburger, Ph.D.
Michael R. Ogden, Ph.D.

Chapter One
Production Philosophy

The Production Process

Despite the general public's attitude toward digital media production as a simple activity, in reality you will find that although digitizing has made the equipment lighter, smaller, more powerful, and full of technology that offers greater creativity to you as a producer, director, camera operator, or editor, the process actually has gotten more complex. When you replace controls and functions necessary to operate analog video and audio equipment with digital equipment, it appears to make operations simpler, and in some ways that has occurred. But the nature of digital technology and equipment provides you with a greater opportunity for more choices in operations. Those opportunities require you to meet a broader range of decisions, setting specific operational criteria for each shot or setup. You may point and shoot, but that alone is not professional. The increase of distribution systems available to your production include smart phones, tablets, streaming, and newer technologies that require care and consideration while planning, producing, and especially editing your final production.

To give you the best means to take advantage of all that digital equipment offers, this text is organized to lead you through the entire production process from beginning to end. The first step is to understand that production is actually a three-stage process: preproduction, production, and postproduction. The three stages are unique and separate to a point, but they are also dependent on each other for the success of the complete project—what you fail to account for in preproduction will impact what can be accomplished in production which will, in turn, effect what you can do in post-production which may result in a different product than was originally planned. Also, each of these stages of production is dependent on the final plans for distribution of the project. The three steps are equally important—without all three you will not be able to complete a professional production. Each step requires your thoughtful consideration of the aesthetic values of the entire production as well as each individual production choice (see Table. 1.1).

You will use the preproduction stage to prepare the production, organize and research your thoughts on what you want to do, and complete the many sets of written materials from proposals through completed scripts as well as a budget and production schedule.

TABLE 1.1 – Depending on the requirements of the individual production, the size of the crew, and the length of the production, some of the functions and operations of each of the three steps may be combined simultaneously.

SINGLE-CAMERA VIDEO PRODUCTION
THREE-STEP PRODUCTION PROCESS

PREPRODUCTION	PRODUCTION	POSTPRODUCTION
Concept Research Planning	Organizing Crew Cast Equipment	Acquisition Organizing
Proposal Treatment Budget Storyboard	Constructing Sets Props Communication Prompting	Ingesting Logging Formatting
Draft Script Scene Script Shot Script	Setting Up Lights Audio Camera(s)	Rough Cut Final Cut Audio Mix
Location Scouting Site Survey Plot Drafting	Rehearsal Rough Cast Camera Final	Effects Color Correction Audio Correction Rendering
Hiring Crew Cast Equipment	Recording Logging Effects Striking	Master Release Output

During the production stage, before you actually start shooting, you still must perform some preparation steps before you remove the lens cap, turn on the microphone and record images and sounds. You must take as much care with logging and striking equipment as you did with setting up and shooting.

Once the images and sounds are recorded on tape, disc, or solid-state media, you then are faced with organizing the material again in the postproduction stage. Recorded images and sounds must be encoded into an editing system (usually computer-based

and nonlinear), and you must choose the shots you want and trim them into a final form before adding music, visual or sound effects, color correction, and completing your final project. At this stage of your production, knowledge and planning for distribution (undertaken in preproduction) becomes critical since technical choices (in production and postproduction) must be made before your project is ready for distribution.

Importance of Goals and Objectives, and Audience Analysis

Goals and objectives are often confused with each other. This is understandable: They both describe things that you may want to achieve or attain but, in relative terms, they may mean different things. Obviously, both are desired outcomes of the work you do as a media producer, but what sets "goals" apart from "objectives" is their time frame, the attributes they are set for and the effect they have on your project, career or even your life. For example, your goal may be to become a successful media producer with a reputation for innovative storytelling. This is a long-term, ongoing process that will encompass your entire career. Along the way, you may set short- to medium-term objectives like successfully completing a course in video production, or taking on a succession of increasingly more challenging media projects—each one completed on time and on budget. In other words, a goal is an idea that you wish to accomplish; objectives represent a plan of action to achieve your goals.

Before you commit yourself to a project, you ought to seriously consider what you have decided your goals are and what objectives you want to attain. You must work toward illustrating your concept accurately and as you have envisioned it in your own mind. Your project has little chance of success unless you have developed a story that will attract and hold an audience. As much as you may want to produce a project for your own enjoyment, there is no value in such a project unless someone else is interested in viewing it, in understanding your message, and unless it stands as an example of your ability to create a professional and aesthetically acceptable quality production (see Table.1.2).

You may be able to produce a short video using the equipment made available to you by your employer or school, but as a professional you must learn to create concepts that organizations or individuals will believe in enough to provide the funds that will allow you to complete the project. One aspect of what determines a funding source's decision is your convincing the organization that a large enough audience would be interested in

TABLE 1.2 – Among the six key characteristics of a professional production are fulfilling a vision and telling a story that will establish your professional qualifications by attracting funding and an audience.

PRODUCTION GOALS-OBJECTIVES

GOALS	OBJECTIVES
Fulfill Personal Vision	Attract a Funding Source
Tell a Compelling Story	Attract an Audience
Create a Professional Production	Establish Professional Qualifications

the project to make the investment worthwhile. As a media producer, you must understand how to analyze audiences and how to create productions that will maximize the size of that audience.

Importance of Work Flow

The process of moving video and audio signals in digital formats from one stage to another is called workflow. As your production moves away from tape and disc recording systems, solid-state devices allow digital audio and video signals to be managed as data-files, discrete documents of ones and zeros that represent the encoded audio or video signals you actually recorded. These digital signals may also contain metadata (data about data). Metadata may occur in a variety of forms depending on the needs and functions of the operation. In media production "operational" metadata is a set of information about the content you produce and is usually encoded by your camera when shooting. This type of metadata may describe each individual shot by its color depth, resolution, how the image was created, even GPS coordinates of shooting locations, among other critical characteristics. Human authored metadata may contain manually entered judgments on the quality of the image or audio, the type of framing, scene and take numbers or any other information that would facilitate searching, sorting, and arranging the media files, or "assets." Because these media assets are in the form of digital data, you can more easily move, manipulate, store, and transfer the data quickly and without loss of quality from one location to another and you can do it simultaneously while using less bandwidth to store and distribute. Several different systems define different means of manipulating metadata. This allows you and others to edit, review, and

WORKFLOW SYSTEMS

LINEAR

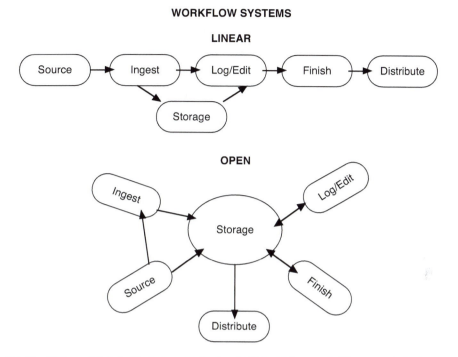

OPEN

FIG. 1.1 – Since workflow had become a practical and widespread concept, different methods of using the systems have developed. The two most common are the original linear, straight-through systems and the more flexible system used in news operations, the open system.

manage a production at the same time. Such a workflow process makes broadcast news and multi-editor postproduction facilities highly efficient operations (see Figure 1.1).

The migration to a digital workflow requires careful tracking of your media assets as well as the need to process the original media (encode and/or transcode, error correction and quality control, etc.) and make it available for use in postproduction. You may use a workflow management system in a linear manner enabling you or your crew to record the video, audio, and associated metadata onto a flexible medium for both storage and access for processing. After the media assets are encoded and editing is completed, you or your crew may again access the media assets for additional processing such as special effects or you can prepare the final project for distribution. Alternatively, you could use the more common multi-simultaneous system used in broadcast news, cable production, and motion picture production which provides the flexibility for more than one person or team of people to work on the project at the

Importance of Work Flow

same time. You encode the original audio and video (including all metadata) and store it in a shared server (or even in "the cloud;" Internet-based, network storage) that allows access from a variety of different personnel simultaneously. You, your writers, producers, directors, and editors may access the media assets on their computers, study the footage, communicate between one another, manipulate files, and complete whatever production decisions are needed for final editing, adding effects, music, and finalizing the project all using the same media assets at the same time without interfering with each other's work.

Difference between Studio and Field Production

One of the first choices you will need to make once you have developed, researched, and found funding for your project is to decide whether to produce it in a studio or in the field. You will face advantages and disadvantages in either location (see Table 1.3). A studio production offers you the protection and control over all aspects of sound, lighting, personnel, and equipment. Once you design and construct the set, it is a known factor

TABLE 1.3 – In many cases, the advantage of working in a small studio may be the disadvantage of working in the field: controlled sound in the studio, less control of sound in the field. But advantages in one location may be offset by advantages in another location.

LOCATION CHOICES

STUDIO	FIELD
Control Light	Realistic Environment
Control Sound	Unrestricted Movement
Control Environment	Subjects Unavailable in Studio
Single Location	Flexibility of Movement
Secure Equipment	Difficult to Reproduce Environment
Protected Cast and Crew	Impossible to Reproduce Environment

for which lighting can be designed to work for you. A soundproof studio guarantees you the best possible sound environment while shooting. The entire production, cast, you, and crew will have a known location and a shooting set physically constructed, in place and ready to begin each day's shooting under a climate controlled environment, clean, and ready for action. All equipment and other facilities will be present when you need them and in place properly secured and operable on schedule. One of the major positive factors in studio production is the isolation from external annoyances like crowds, weather changes, unwanted sounds like aircraft or automobiles. A studio may restrict your actions and scenes to what can be constructed or is available between the studio walls and facilities. This may be a limiting creative factor within your production concept and will require changes in your plan of action to complete the project. Your budget must include the daily cost of the studio and facilities that may be more or less than the cost of producing the same project in the field.

On the other hand, shooting in the field offers you creative flexibility in choosing a precise, realistic setting that cannot be reproduced easily in the studio, such as shooting on the side of the Grand Canyon. You may not be able to move some subjects or objects to a studio setting, and these are best shot in their natural environments. Despite the wide-ranging ability of digital postproduction techniques to allow you to duplicate settings and situations not available in the studio, shooting on location adds a touch of empathy that cannot be created digitally. In other words, location shoots afford greater "realism" in your productions. Obviously, news and many documentary subjects can only be shot in the field. Shooting in the field allows an unlimited range of locations, settings, and, many times, access to people and situations that cannot be duplicated in the studio. But, the disadvantages of field shooting must be overcome by your careful and creative production planning. Advanced location scouting, detailed planning of equipment, personnel requirements, security, and transportation concerns for both people and equipment must be thoughtfully and professionally considered before making the decision to shoot in the field.

The Importance of Technology

If you were to suddenly pick up a brush and start to dab paint on a canvas or any other handy surface, the chances of achieving an immediate masterpiece would be minimal. The same holds true if you tried to be a sculptor. You cannot attack a piece of marble with a chisel without first learning the skills necessary to properly mold the form without

Unplanned Planned

FIG. 1.2 – Art or creativity in digital formats can occur in both planned and unplanned situations. But unplanned productions rely on happenstance of the desired creativity surfacing without control or a goal. Planned productions create an environment to carry out the vision of the creator in a logical, controlled, and professional manner. © Robert Musburger.

damaging the original material or exceeding the capabilities of the medium (see Figure 1.2). Likewise, running through the woods with an out-of-focus camera may seem creative, but it is neither good art nor good video. You must understand the basic technology of any art form in order to utilize properly the artistic characteristics of that medium and to avoid the pitfalls of its technical limitations. Audio and video are highly technical; the media require some basic knowledge of sound, optics, electronics, electricity, physics, and mathematics. Of course, you could complete a media production without any knowledge of the subjects just listed, but the possibility of it being a top-quality production is limited. Trial and error is not a realistic means of achieving the goals of a professional production.

With the development of lighter, smaller, and more powerful equipment that operates using digital technology, you can create higher-quality video productions at lower cost than was possible a few years ago. But the advances in digital technology that facilitate production also require you to acquire some knowledge of the digital domain and how it can and should be used in video production. You may be able to operate digital equipment easily and with a minimum of knowledge of the media production process, but the ease of operation does not replace your thinking and your creativity, which are necessary for a quality production. Placing a microphone, pointing a camera, and recording abstractly without a plan will more than likely produce nothing more than a recording of useless digital signals.

Chapter Two
Aesthetics in Media Production

Importance of Aesthetics

Why is there a chapter on aesthetics in this book?

In all communication fields, a set of standards for both the production creator and the audience is needed to reach a level of judgment on the creative value of that production. Media productions are no different than art works, theatre productions, motion pictures, photography, musical composition, or other creative endeavors. How do you, a creative media person, determine what meets aesthetic standards? The philosophical field of aesthetics has served as a benchmark for judging all creative works. The problem with the field of aesthetics is a lack of agreement on exactly what specific aesthetic values may be used to judge a creative work. Throughout history, governments, churches, even social classes have tried to set standards to fit the attitude of society at the time. None of those standards held fast for long because views on politics, religion, and society itself are constantly changing.

The term *aesthetics* comes from the Greek *aisthētikos*—perceptible by the senses, from *aisthesthai*—to perceive. Aesthetics was considered the philosophy of art and of beauty and on a second-order level, the philosophy of criticism, because not only does it attempt to define "what is art," but also "what is good art."

A painting, play, or motion picture judged as beautiful or outstanding in one decade could be thought valueless in the next. Conversely, a movie originally deemed inferior can be accepted years later as a world-class example of excellence because the standards to determine the aesthetic quality of film constantly change. For example, only silent, black and white films could be considered aesthetically acceptable before the 1920s, but, of course, with the arrival of sound and later of color, all of those standards changed. But standards also may revert unexpectedly. Silent, black and white films in the late 20th and early 21st centuries seemed unacceptable, but in 1993, for example, *Schindler's List* (a black and white film) won seven Academy Awards and in 2011 *The Artist* (silent as well as black and white film) won the Academy Award for Best Picture (see Figure 2.1). Now, with the arrival of digital technology, the standard of media aesthetics is once again changing as the new technology opens different means of communicating with an audience.

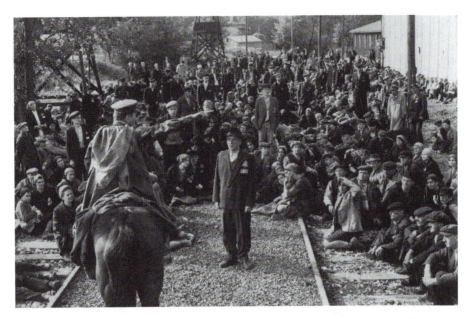

FIG. 2.1 – Despite the popularity of full color motion pictures, 33 years after the last black-and-white Hollywood film (*The Apartment*) Steven Spielberg produced and directed the Academy Award winning film, *Schindler's List* in monochrome. Following 18 years of full color films another Academy Award winning film, *The Artist* was released in 2011. (Courtesy Universal Studios.)

As a media producer, you will face aesthetic judgments along every step of the production process. The series of decisions you make based on your experience and education, from the original concept through the writing, preproduction, production, and postproduction processes, will result in the aesthetics of the final product.

Criticism and Critics

The traditional function of making aesthetic judgments belongs to critics. Again, a critic's opinion may change as fashion, demographics, and the economy change the attitudes and perceived likes and dislikes of the public. Critics may claim that they apply their own criteria to determine the values they use as a basis for judgment. However, over time, even the most unbiased critics can find their values change along with the values of the society within which they work and live.

Valued criticism, whether offered by a paid critic, the public, or a creator must depend on more than a personal judgment. It must offer a valid evaluation based on description and analysis of production values derived from experience, knowledge, history, description,

and theories of the nature of art. In addition, a philosophy of art from social, political, economic, and ethnic points of view is applied to media production. As a producer of media for public consumption, your work will be scrutinized, your judgments challenged, and the final product criticized. But you must maintain confidence in your work regardless of criticism while paying attention to the details that may help you correct errors you did not notice at the time of the production.

The meaning of your work is in the production's structural or formal qualities, rather than in its content, examples include: syntax in writing; line, color, and design in art; material and function in architecture; and composition in music. The technology of media allows you, the creator, to use the medium to structure the story as you would a sentence. The subject of the production is the noun, the action of the scene is the verb, and everything the camera operator, lighting director, and editor completes functions like adjectives and adverbs. Each script, lighting design, camera framing and movement, shot sequence, sound recording, acting performance, and edit encompasses the media production's formal qualities—what, in media criticism terms, is referred to as *mise-en-scène* (literally "placing on stage") and has come to encompass all of the various elements of visual design that help you to express the "vision" and even emotional tone of your production.

You may consider your media production an original physical object extended into space and time. But you need to recognize that it's a reflection, duplication, or reproduction of elements of your experience. As a media producer, you duplicate what you see in the real world, then, through your understanding and knowledge of the medium, you translate your perception of the world into the defined codes of the medium.

You should understand the relationships of the incidents you observe to other incidents in order to perceive them accurately. An airplane appears to fly fast only because a helicopter near it moves more slowly. Your sense of fear or happiness may come as a result of what is happening at that moment in your environment, not necessarily an overall sense of fright or well-being. A scene you envision may have value only because of its relationship to the shot or scene immediately before or after it. You also may visualize a shot only to find that what you had designed looked different to the audience depending on their context during the presentation.

Often the general public tends to judge what it sees and hears depending on individual experience. This is called *selective perception*. Once one determines through experience

<div style="text-align: right">**Criticism and Critics**</div>

that a view or belief has value, then each time the same experience arrives the value will not be questioned or an alternative considered. This tends to develop stereotypes in your values rather than making careful, well-developed judgments. You tend to jump to past experience in your mind by automatically excluding important details, leaving a distorted view of the world.

Cultural Differences

The traditional arts, music, theatre, storytelling and other primitive media developed over thousands of years usually within specific, isolated cultures leading to distinctive and widely diversified aesthetic forms. On the other hand, modern media, photography, motion pictures, and television developed within one major culture: Western European. These new media evolved without including the diversity of the many other cultures that flourished pre-18th century. But when any of those cultures start to use modern media, no reason exists for them not to adapt their traditional philosophies, beliefs, and aesthetic patterns. The end result may be a new media form different from the traditional Western-European one.

The Northwest aboriginals of Australia in the desert areas create paintings illustrating what is most essential to their lives—large maps of deserts and the location of springs and other water sources. The First Nation Salish artists of the Pacific Northwest sculpt totems and weave baskets representative of species important to their livelihood—the birds, fishes, and animals needed for survival. In both cases, the beliefs and rituals determine the form and direction of their aesthetic choices as much as the form of the artistic expression they choose (see Figure 2.2).

Islamic religious art concentrates on the glorification of passages from the Koran by writing it beautifully accompanied with geometric and floral designs (or *arabesques*) in which plants grow according to the laws of geometry rather than nature. Thus, calligraphers in Islamic countries have the fame accorded to painters or sculptors in the West. Islamic secular art, on the other hand, might or might not have representations of living beings, depending on local cultural traditions and the preferences of the artist or their patron. Hindu art in India evolved with an emphasis on inducing special spiritual or philosophical states in the audience. Also much of Hindu art is based on their Gods and historical figures. Different forms of art in Asia are based on a long history of varied styles. Some, especially music and poetry, emphasized the role of the arts and humanities in

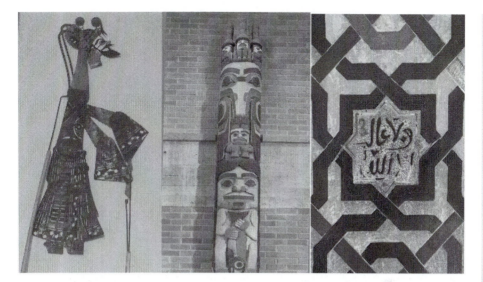

FIG. 2.2 – Cultures determine art, not taste or fashion. Each ethnic culture during the years of develop-ment of that culture provided the basis of the artistic creation of that culture. All such artistic events need to be accepted and considered for their own value, not the value of other cultures or traditions. (Courtesy The Art Archives. Totem pole image courtesy Central Washington University.)

broadening human nature and aiding ceremonial rites in bringing them back to what is essential about humanity. Most African art followed traditional forms and aesthetic norms handed down orally as well as in written form. Sculpture and performance art were prominent, with abstract and partially abstracted forms highly valued, long before influence from the Western tradition.

Today, many of these cultures use modern media aesthetics to present their artistic traditions in a new form using a combination of traditional and new media techniques. For example, the same ancient Indian epic stories and Sanskrit dramas that influenced Hindu art have exerted a profound influence on popular Hindi films in India. Such tradi-tional narrative techniques as side story, back-story, and story within a story can clearly be seen in many popular "Bollywood" films. This means you must learn as much as pos-sible about other cultures, not only for the aesthetic values of those cultures, but also because some of your audience may relate to those cultures. If you are not careful, you may judge others and the aesthetic value of their work from the perspective of what you have seen before or borrowed from other judgments. This can lead to a reliance

Cultural Differences

on stereotypes as a means to judge other people and the aesthetic value of others. If you can't match what you see from prior experience, then you may think of them as out of step or not aesthetically acceptable. Some objects may be unfamiliar or strange to you, but experience and education may help you understand the difference. The almost familiar may become familiar, but be careful of branding the slightly alien or strange as unacceptable to you.

Unless education has made you acutely aware, stereotypes govern deeply the whole process of your perception. It is important to guard against allowing stereotypes to cloud your aesthetic judgments. Instead your judgments must be based on sound study, experience, education, and the reality of the moment.

Reality

Media production provides a method of approaching realism and a way of looking at life. As a media producer, you need to deal with reality accurately within the context of the production. You constantly face the conflict between realism and drama. Reality depicts what actually happened or is happening at the moment. Drama stages relationships and experiences of characters in a story designed to entertain the audience. The story may be based on a real situation, but the dramatic presentation is not reality. The *mise-en-scène* of your production, along with the cinematography and editing, influences the verisimilitude (the appearance of being "true" or "real") of your production in the eyes of viewers. Truth and realism may not serve the needs of the dramatic moment of the production. You will learn to make the aesthetic judgment as to whether reality is more important than the dramatic point of that moment, or vice versa.

Keep in mind that realism helps you develop the aesthetic quality of the media you are using by laying bare the essentials of the subject and environment. Even though all recorded images and sounds are mediated, they are representations of what actually took place in front of the camera, but are not necessarily reality. The camera can be a passive observer of reality or an active participant in shaping reality. Either way, your use of the camera may reveal what cannot be readily seen or obviously understood within the value of the entire production. Reality may appear simultaneously with reproduction—reality and reflection are juxtaposed. Any reproduction cannot be reality, only a copy of reality. Can you offer a representation of reality using media production or are you merely creating replicas or derivatives of what transpired in front of your

camera? Can such work be truly unique? Is a media production a product of you as an individual or rather a group of individuals?

Cinéma vérité (literally, "film truth," a style of documentary filmmaking) and television news coverage may represent events with verisimilitude depending on the aesthetic of the final production. But, both genres may manipulate the truth to build the purpose of the production. Be especially carefully using these genres to maintain the truth of your production.

Taste

Taste, your personal pattern of choices and preferences, results from an education process and awareness of elite cultural values learned through exposure to mass culture. Philosophers and sociologists examine how the elite in society define aesthetic values like taste and how varying levels of exposure to these values can result in variations by class, cultural background, and education. However, as definitions of the elite are altered and as social standards change along with acceptable public activities, taste becomes a variable. Taste tends to be a more direct interpersonal means of explaining if an action or an object will be accepted by an individual or by a segment of a population as "beautiful," "good," or "proper."

But does taste affect the aesthetic value? Or is the audience's enjoyment and reflection irrelevant as taste is even more affected by fashion and impulses than traditional aesthetic judgments? Taste offers little value in making valid aesthetic judgments on your production decisions.

Summary

Aesthetics has been a traditional method of judging artistic beauty since the earliest periods of creative endeavors. The problem with making accurate aesthetic value judgments over the years is the lack of consistency due to the changing social, political, and philosophical attitude toward art and beauty. Without set, specific standards, making aesthetic judgments on any creative work has historically been difficult, if not impossible. Making such judgments on modern media creations is not possible using antiquated or inconsistent standards.

Instead, making aesthetic value judgments on modern media productions must depend on making judgments based on the sensitive response of your audience rather than

that of external critical judgments. Each aspect of the production from preproduction to postproduction produces an aesthetic response in your audience. It is therefore your responsibility to make the appropriate decisions to fulfill the aesthetic needs of that audience.

This text will lead you through each stage of the production process, from technical decisions, preproduction, production, and finally through the postproduction process and the varieties of distribution to assist you in making these decisions. The decisions still must be yours based on your education, experience, and willingness to open your mind to making the best choices for your production.

Chapter Three
The Technology

Connecting the Real World to the Digital World

The realization of a complex video production requires several things: a thorough knowl-
edge of the creative story you are trying to tell, the ability to collaborate with other cre-
ative people, the willingness to suspend your personal ego in service to a shared common
cause (i.e., "the story"), and an understanding of the technology you will need to use to
produce your project. Therefore, to utilize video cameras and associated audio equipment
effectively, you must be aware of the capabilities and limitations of each piece of equip-
ment. In addition, you must know how each piece of equipment operates in relation to
other equipment used in the production. This awareness does not necessarily mean you
must have an expert range of knowledge in all of the technology involved in media pro-
duction, but rather that you appreciate and understand why the equipment is designed to
operate as it does and what it can accomplish. Rest assured, when audiences are engaged
in your story, they don't care if you shot your video using a 4K digital cinema camera and a
large crew or you managed single-handedly using your AVCHD palmcorder or DSLR. How-
ever, it is your ability to tell a compelling visual story that matters more than your cam-
era's imager, pixel density, dynamic range, or signal-to-noise ratio, although the technical
issues that impact the quality of the images and audio you record can also influence the
effectiveness of your storytelling. As a practical media producer, you should understand
that your viewers have a breaking point when it comes to technical shortcomings.

Knowing what the equipment can do is important. Most professional videographers and
producers believe the camera to be one of the most important of all inventions; it has
the ability to stop time, record history, generate art, tell stories, and communicate mes-
sages that transcend language and cultures like nothing else ever conceived. Still, it is
equally important that you also understand what the equipment cannot be expected to
accomplish. Digital equipment does not replace your knowledge of composition, shot
sequencing, or the construction of characters and storylines necessary to assemble a
professional production. In fact, the basics of production are even more important in your
digital production because of the high level of resolution and clarity made possible in the
digital formats. This clarity reveals poor lighting, bad framing, incorrect exposure, and all
other gaffes that would barely show in analog production.

Limitations of Equipment

During the late 19th and early 20th centuries, photographs and movies were shot on film—a light-sensitive chemical emulsion on celluloid strips that could record lasting images—and it did a pretty good job of recording time-honored classics from Ansel Adams' black-and-white landscape images to Orson Welles' *Citizen Kane* (1941), Francis Ford Coppola's *The Godfather* (1972), and even Quentin Tarantino's *Django Unchained* (2012). The television that we watch today is not a recent invention either; it was conceived in the 1940s and slowly improved over time. Originally, the quality of the video image was no comparison to that of film but, as technology advanced, digital video began to compete with film as the preferred medium of image capture. In fact, since 2011, *ARRI, Panavision,* and *Aaton* have all quietly ceased production of film cameras in order to focus exclusively on the design and manufacture of digital cinema cameras. However, despite over 100 years of advances in sound and image capture technology, it is easy to forget how limited the electronic aural and visual equipment are until you compare them to your human counterparts (see Table 3.1).

TABLE 3.1 – No electronic equipment—analog or digital—can sense or reproduce the equivalent of human senses of hearing and seeing.

COMPARISON OF HUMAN TO EQUIPMENT LIMITATIONS

HUMAN			EQUIPMENT	
EYE	Focus	0–∞	10–30x	LENS
EYE	Field of View	Up to 140°	Up to 100°	LENS
EYE	Sensitivity	1:10,000	1:500	CHIP
EAR	Range	0 dB–+160 dB	10 dB–80 dB	MICROPHONE
EAR	Sensitivity	15 Hz–20 kHz	30–15 kHz	PROCESSOR

Many scientists acknowledge that the sample rate of the human eye is equivalent to about 15 frames-per-second (fps). Your brain takes this visual information that is flashing upside-down on the back of your retina, flips it, and smooths out the motion by filling in the "missing" information. We call this process *persistence of vision* (in video, it's called *error correction*), and movies, television, and even computer displays rely on this phenomenon to present smooth movement from a rapidly presented series of still images (typically 24fps for film, 30fps for video). Without persistence of vision neither film nor video could present smooth, seamless motion to the human eye.

In debates over the preferred superiority of film versus video, two points dominated the argument: depth of field and exposure latitude. But, how does this compare to your eyes? *Depth of field* is the distance between the closest and farthest objects in a scene that appear to be in focus and is a function of the distance of the subject from the camera, the focal length of the lens (wide-angle or telephoto), and the amount of light present. The closer the subject is to your camera, the less depth of field you will have in your image. The longer the focal length of your lens, the less depth of field you will have in your image. And, the dimmer the light you are working in, the less depth of field you will have in your image. In some cases, you may want to have the entire image in sharp focus, so a large depth of field is appropriate. In other cases, you may want a small depth of field, emphasizing the subject while de-emphasizing the foreground and background. In cinematography terms, a large depth of field is called *deep focus,* and a small depth of field is called *shallow focus.* Manipulating distance from camera, lens focal length, and the amount of light allows you to adjust your depth of field. Typically, 35mm film held the advantage here over small-format video cameras (this advantage is now being seriously challenged). However, your eye can autofocus from nearly the end of your nose to infinity instantaneously and can selectively focus on any point in between regardless of subject proximity or lighting conditions (sorry, you cannot change the focal length of your eye!).

Exposure latitude, the extent to which a light-sensitive material (like a film's emulsion or a video camera's imaging sensor) can be overexposed or underexposed and still achieve an acceptable result, is somewhat subjective dependent as it is on both your personal aesthetics and artistic intentions. It may be more accurate to compare *dynamic range*—the ratio between the largest and smallest intensities a medium can capture simultaneously. A recording medium with greater dynamic range will be able to capture more details in the dark and light areas of a picture (or the highs and lows of

Limitations of Equipment

both frequency and volume of a sound). Professional critique of digital video cameras often centers on the extent to which their dynamic range—and by extension, exposure latitude—falls short of that of film (again, technological advances are challenging this). On the other hand, your sense of sight and hearing have a very high dynamic range. Your eyes allow you to adjust to light variations quickly and allow you to see objects in starlight (although your color perception is reduced at such low light levels) or in bright sunlight, even though on a moonless night objects receive 1/1,000,000,000th of the illumination they would on a bright sunny day—that's a dynamic range of nearly 10,000,000:1, or 30 *f*-stops! You are also capable of hearing (and usefully discerning) anything from a soft whisper (20 decibels) to the sound of the loudest heavy metal concert (160 decibels) and can respond to frequency changes from 15 hertz to more than 20,000 hertz. Of course, you cannot perform these feats of perception at both extremes of the scale at the same time. The static dynamic range of your retina is about 100:1 (6.5 *f*-stops). However, your eyes are dynamic organs that take time to adjust to different light levels (both with your iris and chemically), so the functional dynamic range of your eyes is actually somewhere between 400:1 and 10,000:1. The dynamic range of human hearing is similarly limited; for example, you cannot hear someone whisper during a loud rock concert.

In practice, it is difficult for digital electronic equipment to achieve the full dynamic range that you experience. Electronically reproduced audio and video often uses signal processing techniques to fit original visual and aural experiences with a relatively wide dynamic range into a narrower recordable dynamic range that can more easily be stored and reproduced. These techniques are called *dynamic range compression.* For example, a good quality LCD display that you may have in your home has a dynamic range of around 1,000:1 (often referred to as *contrast ratio,* the full-on/full-off luminance ratio), and some of the latest Super-35mm equivalent digital cinema image sensors now have measured dynamic ranges of about 10,000:1 (typically reported as 13 *f*-stops). Practically speaking though, the best microphone is limited to less than 60 decibels in loudness range, most audio equipment cannot reproduce frequencies without inconsistent variations beyond a range of 15,000 hertz, and most professional digital video cameras cannot reveal detail in light variations greater than 300:1. Whereas, digital equipment allows repeated duplication of signals without degradation, it does little to extend the dynamic range of either sound or video to match the capabilities of your own eyes and ears.

TABLE 3.2 – The energy spectrum ranges from 0 Hz to above a yottahertz—a septillion hertz (a billion, billion, million hertz). The frequency range most humans can hear falls between 15 Hz and 20 kHz. Frequencies above the audible human range include radio frequencies (RFs) used as broadcast carrier waves, microwaves, X-rays, and light, or the visible spectrum.

THE FREQUENCY SPECTRUM

Frequency	Frequency Uses	Type of Wave
0-10kH	Audio	Sound
10kH-100kH	Experimental, Maritime Navigation & Comm.	Very Low Freq.
100kH-1MH	Maritime & Aviation Navigation & Comm. & Ham	Low Freq.
1 MH-10MH	AM B-cast, Ham, Radio Navigation, Industrial	Medium Freq.
10MH-100MH	Int'l Shortwave, Ham, Citizens, Medical, LORAN	High Freq.
100MH-1GH	Aviation, TV B-cast, FM B-cast, FAX, Ham, Wx	Very High Freq.
1GH-10GH	Aviation, STL Microwave, Gov., TV B-cast, Ham	Ultra High Freq.
10GH-100GH	Gov., Radio Nav., Ham, Fixed & Mobile	Super High Freq.
100GH-1TH	Experimental, Government, Ham	Extremely Hi. Freq.
1TH-10TH	Industrial Photo, Research	Infrared
10TH-100TH	Heat Waves	Infrared
100TH-1PH	Heat Waves	Infrared
1PH-10PH	Light-Heat Waves	Light-Ultraviolet
10PH-100PH	Ionizing Radiation, Medical Research	Ultraviolet
100PH-1EH	Ionizing Radiation, Medical Research	Soft X-rays
1EH-10EH	Ionizing Radiation, Scientific Research	X-rays
10EH-100EH	Gamma Rays	Hard X-rays
100EH-1 ZH	Gamma Rays	Hard X-rays

The Higher Metric Classifications

KILO	1,000	Thousand
MEGA	1,000,000	Million
GIGA	1,000,000,000	Billion
TERA	1,000,000,000,000	Trillion
PETA	1,000,000,000,000,000	Quadrillion
EXA	1,000,000,000,000,000,000	Quintillion
ZETTA	1,000,000,000,000,000,000,000	Sextillion
YOTTA	1,000,000,000,000,000,000,000,000	Septillion

Digital recorders are capable of recording audio frequencies from 15 Hz to 20 kHz, but because your hearing is limited, so is digital recording. You do not generally miss the frequencies excluded in recordings unless the production requires a wide range of frequency response, such as a music session.

Audio Signals

All sounds start as an analog signal because the vibration in the air that creates sound is an analog motion. The process by which the sounds you hear are converted into electrical energy that can then be recorded and eventually played back as audio is called *transducing*. A microphone's pickup element (e.g., a diaphragm or a capacitor) will generate an electrical *waveform* in response to the sound waves in air. This electrical waveform varies depending on whether the sounds are high- or low-pitched, loud or quiet. In analog systems, the audio signal recorded is a continuous fluctuation that exactly mirrors the original sound. Digital recordings, on the other hand, sample the incoming analog signal at fixed intervals, ignoring any information between intervals, and then assigns a fixed binary value to each sampled interval (you will learn more about this process later in the chapter). Whereas, analog audio can be transduced back into sounds you can hear, digital audio is created only within the equipment and must be converted back to an analog waveform before you can hear it. Of course, the advantage of digital over analog is that it has a much greater resistance to error (in terms of both signal quality and transport), it is computer readable and editable, and it can be compressed and duplicated without a great loss of quality.

Frequency

An audio signal has two basic characteristics: frequency (tone) and amplitude (loudness). In order to create with and record audio, you must understand these two characteristics. *Frequency* is measured in hertz or cycles per second and is abbreviated Hz. Because most of the sounds you can hear are above 1,000 hertz, the abbreviation kHz, or kilohertz, is often used (k is the abbreviation for kilo, the metric equivalent of 1,000) (see Table 3.2).

A cycle is the time or distance between peaks of a single sound vibration. A single continuous frequency is called a tone and is often used for testing. Humans perceive frequency as pitch, the highness and lowness of tones. *Timbre* is a musical term often used in media production; it refers to the special feeling a sound may have as a result of its source. For example, a note struck on the piano may be the same frequency as that of the same note played on a trumpet, but the timbre is very different and will sound different to your ear. Timbre is sometimes described using such terms as *bright, dark, warm,* or *harsh* as well as using characteristics such as *decay, sustain, release,* and *transients* (these terms also represent common controls on synthesizers).

Altering of the frequency response is called *equalization.* When you adjust the tone controls, treble or bass, on a stereo, you are equalizing the signal by modifying the frequency response. Sometimes, you may use audio equipment that will have a switch labeled "low cut" or "high cut." Low cut allows you to filter out low frequency noise like the low rumble of a building's air handling system, while a "high cut" filter helps eliminate "hiss" (hiss being an unwanted, high frequency noise). Although most video recorders do not have equalization controls, many audio mixers and microphones do.

Amplitude

Amplitude is the energy level of the audio signal. You perceive amplitude as loudness. Relative amplitude is referred to as *level* and is measured in decibels, abbreviated as dB. Deci is one-tenth on the metric scale, and the bel is the measure of audio amplitude created by Alexander Graham Bell. Because the bel is a very large unit of measure, dB is more commonly used. The decibel may seem to be a confusing unit of measurement because it is a reference measurement of the change of the power of the signal. It is not an absolute measurement and is logarithmic, not linear; it can be expressed in either volts or watts. A change of at least 3 dB is necessary in order for your ear to perceive a change in level.

Volume is the term used when referring to the measurable energy that translates into loudness and may be measured in either volume units (VUs) or dBs. You are sensitive to a change in volume, but your hearing is not linear. At some frequencies and at some volume levels, your ear senses a change but the actual measure of change is not registered accurately within your brain. Because digital recording equipment can handle a dynamic range of approximately 80 dB, accurate level readings must be available during recording to avoid distorted sound in digital systems (see Figure 3.1).

There are two aberrations of audio you must watch for: distortion and noise. *Distortion* is an unwanted change in the audio signal. The most common type of distortion, over modulation, is caused by your attempting to record the audio at a level that is too high for the equipment. In analog audio systems, over modulation results in the audio being over-powered causing it to sound like people are speaking through static on a kazoo—all "buzzy" and "crunchy." In digital audio systems over-modulation causes *clipping* and results in your audio skipping or even ceasing entirely. *Noise,* on the other hand, is any unwanted sound added to the audio. Digital systems are very sensitive to all sounds, so

Amplitude

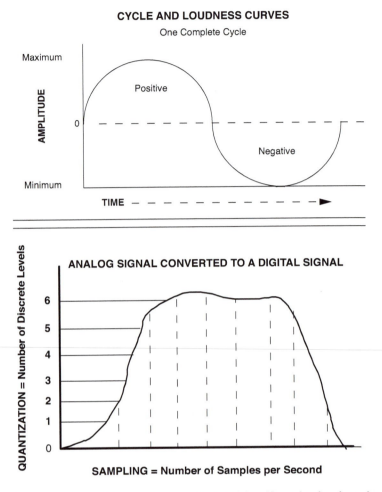

FIG. 3.1 – Sound and video are both measured in amplitude and time. Measuring time determines frequency, and amplitude determines loudness or level. Converting an original analog signal to a recorded digital signal requires both quantization and sampling.

noise may be added to a recording if you do not adequately monitor your audio using good headphones.

As previously mentioned, your audio's dynamic range (dynamics for short) refers to the difference between the loudest and the quietest passage you can perceive. Most analog equipment is limited to a range of approximately 60 dB; newer digital equipment features dynamic ranges greater than 100 dB. Crickets at night might be heard at 3 dB, a

normal conversation at 100 dB, and a rock concert at 160 dB or greater (the latter being over the threshold of pain and likely to damage your hearing).

To achieve the highest possible audio quality, you should record and reproduce sound as close to the original as possible. Even though it is not possible to record all frequencies at the exact same level as the original sound, you should make the effort to exclude as much noise as possible and avoid distorting the audio signal. As a rule of thumb, it is better for you to record digital audio at a slightly lower level than at too high a level. This is because lower-level digital audio can be boosted with minimal distortion or added noise, but over-modulated digital audio may be clipped and the audio lost completely (see Figure 3.1).

Two additional measurements are required for the recording of digital audio: sampling and quantization. *Sampling* is the number of times per second analog sound is measured as it is converted to digital. To transfer the maximum quality, sampling needs to be done at twice the highest expected frequency to be converted. The most common audio sampling rates range from 44.1 kHz (44,100 times per second, approximately twice the highest frequency of human hearing at 20,000 Hz) to as high as 192 kHz; however, 48 kHz is considered the standard professional sampling rate. *Quantization* is the number of discrete levels at which analog sound is measured as it is converted into binary digits or "bits" ("0s" & "1s"). The bit rate or "depth" of quantization directly corresponds to the resolution of each sample. Your typical audio CD has a sample rate of 44.1 kHz and a bit depth of 16-bits while DVDs and Blu-ray discs can support up to 24-bit audio. The greater the bit rate of quantization, the higher the dynamic range, the higher the quality of the conversion—32- to 64-bit quantization presently is considered the professional rate. However, increasing both the sampling and quantization rates will greatly increase the demand for memory and bandwidth for storing and moving the digital audio files.

Measuring Audio Signals

You can measure the audio level as it is being recorded using a VU meter, a peak meter (which indicates the highest output level at any moment, while simultaneously showing the sustained audio level), or a linear pulse code modulation meter (typically abbreviated as simply PCM, a digital representation of an analog signal)—the latter two typically represent their readings through light-emitting diodes (LEDs) while the former traditionally uses a continuously fluctuating needle. Each of these meters will give you a

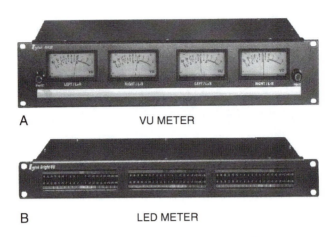

A VU METER

B LED METER

FIG. 3.2 – Audio level may be monitored by using one of three systems: VU meters, peak meters, or PCM meters. VU meters (top) indicate average voltage, PCM (/LED, bottom) meters indicate peak voltage while peak meters indicate the sustained level while simultaneously showing the loudest audio encountered (peak) during monitoring. Each one indicates potential under- and overmodulation levels as well as acceptable levels. (Courtesy Logitech.)

comparable indication of the level of your audio. When the level is too high, the meters read in the red above the 0 dB indicator, and with a peak or PCM meter, the changing color of the flashing LEDs indicates the audio level (from green to yellow to red). When the level is too low, the VU meter needle barely moves, and few, if any, LEDs flash on the peak or PCM meters (see Figure 3.2)

You need to keep dynamic levels within the specified range of the equipment, whether digital or analog, by attenuating the level (bringing it down) when the audio source is too loud and boosting the level (bringing it up) when the audio source level is too low. This is called *riding gain* and may be done either manually or automatically via circuits built into the equipment called automatic gain controls (AGCs) or automatic level controls (ALCs). AGCs and ALCs will maintain certain maximum and minimum levels, but they may add noise by boosting levels during a soft or quiet passage or by overdriving (causing distortion or clipping) if there is a sudden, very loud increase in the input.

Compression

The term *compression* in audio refers to two different manipulations of the audio signal. (1) Traditionally, in both analog and digital audio, compression is a process of decreasing

the dynamic range (loudest to quietest) of a signal. This allows you to record both the loudest and the softest sound to be heard within one recording. However, specific to digital audio, (2) compression can also refer to a reduction in the amount of either data storage space or bandwidth required to record or transmit a digital signal. In the later compression system, it omits certain sounds unimportant or redundant in the overall signal so that the human ear does not recognize the loss. The amount of compression is stated as a ratio such as 2:1, which means the bandwidth has been cut in half. The higher the compression ratio, the greater the possibility that so much of the signal will be lost that you will detect a loss in quality. But all compression systems are based on duplicating a digital signal so that you are not aware of the compression. MP3 recordings are compressed to reproduce a signal lower in quality than a CD, which is also compressed, but not at as high a ratio.

The term *codec* (COmpression-DECompression) refers to a process as well as the equipment that encodes or decodes data. To save storage space and time in moving files with high bytes of data, you want to reduce the amount of data but retain enough information for the file to still be useful. To do this, codecs look for redundant information in the digital files that can be eliminated. There are two basic systems of encoding and decoding data that you must choose between: lossy and lossless. A *lossy* codec identifies and deletes redundant information to make the file smaller (90 percent smaller in most cases!). This process results in the file also being permanently altered. Tests indicate you do not actually miss the deleted data. The advantage of lossy compression is that your audio file needs much less storage space. MP3 and AAC are two examples of audio formats that use a lossy compression system. *Lossless* means that, digitally, there is no loss of data during the compression process; all of the original data is retained because a mathematical expression is used to replace any redundant information. You use lossless compression when the quality of the compressed audio file is critical. Common lossless audio formats are AIFF and WAV. On average, a lossless compressed file will be about 50 to 70 percent of its original size. Lossy systems use far less space than lossless systems (typically, one-tenth to one-third the original size) but, because the removed data is lost, offer a lower-quality signal on reproduction. You must carefully weigh the trade-offs when making a decision between lossless (highest quality) and lossy (smallest file size) codecs; as always, communicative purpose and the anticipated medium of delivery (broadcast, computer, mobile device) should guide your decision-making (see Table 3.3).

TABLE 3.3 – Codec compression types are designed to serve specific audio purposes as well as to serve specific audio systems and markets.

Some Examples of Audio Codecs Now in Use

Lossless	
AIFF	Audio Interchange File Format developed by *Apple* in 1988 and is most commonly used on *Macintosh* computers. AIFF is a leading lossless format (along with WAV) used in professional-level audio and video applications.
ALAC	Apple Lossless Audio Codec. ALAC compresses files by 40-60 percent the size of the originals. Available in *iTunes* since version 4.5 and above, all current iDevices can play ALAC–encoded files.
FLAC	Free Lossless Audio Codec is an open source digital audio format that can typically reduce an audio file to 50–60 percent of its original size and decompresses into an identical copy of the original.
WAV	Waveform Audio File Format, is the standard audio file format used mainly in *Windows* PCs. Though a WAV file can store compressed files, it is more commonly used for storing uncompressed, CD-quality sound files. WAV audio can also be edited and manipulated with relative ease.
Lossy	
AAC	Advanced Audio Coding is a standardized, lossy digital audio codec. AAC generally achieves better sound quality than MP3 at similar bit rates. AAC is also the default or standard audio format for *YouTube*.
AC-3	Audio Compression 3 (also called "Dolby Digital"), by *Dolby Laboratories*, is a lossy codec designed to efficiently encode surround sound audio for movies and home theater. AC3 files are also used in authoring DVDs, at which point they are multiplexed ("muxed") with the video stream.
M4A	An audio-only MPEG-4 file, used by *Apple* for unprotected music downloaded from their *iTunes Music Store*.
M4P	A version of AAC with proprietary Digital Rights Management developed by *Apple* for use in music downloaded from their *iTunes Music Store*.
MP3	MPEG Layer III Audio, is an audio-specific format designed by the Moving Picture Experts Group (MPEG) to greatly reduce the amount of data required to represent audio recordings and still sound like a faithful reproduction of the uncompressed original for most listeners. MP3 is the most common lossy sound file format used today.
RA & RM	Developed by *RealNetworks*, the *RealAudio* format was designed to use variable bit rates depending on application. Used mostly for streaming audio over the Internet.

Video Signals

The technology of video image capture has, since its inception, been in a perpetual state of rapid evolution. If there is any truth to the statement that "any sufficiently advanced technology should, to the uninitiated, appear as if it were magic," then today's video imaging technology is truly "magical." Fortunately, although the electronics of digital video cameras have become increasingly complex, you may have noticed that they have

also become increasingly more user-friendly and available at all budget levels. With each technological generation, the trend has been toward an electronic image that is sharper, richer in color and increasingly more responsive to the subtleties of light and shadow. Unfortunately, in the fast-paced world of digital video innovation, engineers, corporations and national standards committees have been unable (or unwilling?) to establish a single standard—perhaps because of the enormous profits at stake! At present, there are over two dozen digital video formats, many of them in high definition and each offering multiple frame rates and varying aspect ratios. It can quickly become quite confusing.

Fortunately, the process of converting what you see into an electronic signal is rooted in similar techniques used to convert what you hear into an audio signal. Even though the electronic video signal is more complex than an audio signal, it is essentially made up of voltages varying in frequency and level that correspond to varying intensities in light and color that are then sampled and quantized into digital files. As such, you can think of the video signal in much the same manner as the audio signal previously discussed. And, just as audio equipment has its limitations, a video camera cannot record all that your eye can see, nor can it process all the information fed into it. Therefore, you must avoid both video distortion and noise as vehemently as you avoid audio distortion and noise.

Video distortion and noise are defined in much the same way as audio distortion and noise, except that you can see video distortion as flare in brightly lit areas (also called *bloom*), *crushing* in the darkest areas, or as image tearing, *combing*, skew, smear, wobble (also called the *jello effect*), or color shifts in the picture. Digital video can also suffer distortions (sometimes called *artifacts*) that result from compression errors or image *skipping* or *freezing* as a result of bandwidth or buffer restrictions. Video noise can be seen as a grainy or "crawly" texture to the picture or as color "vibrations" (*moiré effect*) in interlaced images.

Changing Light into Electrons

All video cameras change light into electrical signals in a two-part transducing process. The first change is the collection and concentration of light reflected from the subject by the camera's lens onto the surface of a photosensitive pickup element (or transducer) that changes the light to electrons. The video camera lens has three primary functions:

- To collect as much light reflected from the subject as possible;
- To control how much light passes through the lens;
- To focus the image on the camera's photosensitive pickup element.

The second change in energy is the transformation of that light by the camera's transducer into an electronic signal that is amplified and processed into a video signal that can be viewed, recorded, or transmitted. From the very inception of analog video in the 1930s, photosensitive camera vacuum tubes (e.g., Iconoscope, Orthicon, Vidicon, or Plumbicon) were used as the camera's pickup elements. As light strikes the photocathode mounted inside the camera vacuum tube, electrons are emitted in proportion to the intensity of the light to be captured by a detector. The output from the detector is an electric current whose magnitude is a measure of the brightness of the corresponding area of the image. Even though the quality and size of the smaller tube cameras made them applicable to both news operations and consumer use, the fact that they used tubes as light conversion transducers presented problems. Camera vacuum tubes were eventually replaced by the light-sensitive solid-state image sensors (or chips) invented in the late 1960s and introduced in broadcast cameras in 1987. In fact, by the early 1990s, the camera vacuum tube was rendered technologically obsolete by rapid improvements in chip technology (see Figure 3.3). Chips produce a superior picture quality and a much better signal-to-noise ratio. As the light strikes the surfaces of these chips, the voltages are altered in proportion to the intensity of the light falling on the light-sensitive

FIG. 3.3 – The evolution of the camera signal light source from tubes to chips was key to the ability of designers to create smaller, lighter, and more efficient cameras. © Robert Musburger.

surface; the brighter the light, the greater the reaction, the lower the light, the lesser the reaction. These changes become the electronic equivalent of the picture. Today, chips may vary in size from 1/4 inch to 35-mm square and less than 1/8th of an inch thick and can be mounted directly to a fixed focal plane behind the lens or to the surface of a light-splitting prism inside a camera (depending on the design of the camera), allowing for the development of smaller and lighter cameras. Likewise, chips operate at much lower voltages (prolonging battery life), have greater light sensitivity, last longer and do not burn, streak, or suffer from image lag or the tendency to lose registration as camera vacuum tubes did.

There are two types of camera chips in use today: selenium-based charge-coupled device (CCD) and silicon-based complementary metal-oxide semiconductor (CMOS) and each have unique strengths and weaknesses. Technically, they are quite different from each other, but they both perform the same function. CCD and CMOS chips contain hundreds of thousands and even tens of millions of light sensitive elements called *pixels* (picture elements) arranged in a grid on the chip's surface. Each pixel individually transforms color and luminance information into a corresponding electric charge that, taken together, make up the video signal. Generally speaking, chips with larger surface areas contain more pixels and can, therefore, produce a better quality image than smaller chips. This is, of course, where the similarity ends.

For many years, the CCD image sensor was the only chip used in both late analog and early digital video cameras. Today, many professional-quality consumer ("*prosumer,*" sometimes also called *industrial-grade* or just *industrial*) video cameras and most professional broadcast cameras employ three CCD imagers (sizes vary, but typically 2/3 inch in professional broadcast cameras) combined with prism beam-splitter technology behind the lens to divert the red, green, and blue (RGB) image components to their respective chip where the light is converted to a charge, buffered and sent as an analog signal to a separate image processor that converts the charge to voltage and combines the three signals into an analog video signal (or sends the analog signal to a digital codec for sampling and quantizing into a digital signal). For years, three chip cameras were a virtual imperative for the serious video shooter.

In the 1990s, with improvements in imaging quality and the promise of lower power consumption and higher integration for smaller components, CMOS designers focused efforts on cameras for consumer applications—especially for mobile devices, the

Changing Light into Electrons

highest volume image sensor application in the world. Because CMOS chips bundle both an image sensor and image processor into a single chip (separate functions in CCD chips) and transduce light directly into digital data, they can simultaneously deliver high image quality at a tenth of the power consumption of CCDs. Single chip CMOS cameras employ a color filter array arranged on the chips surface to separate red, green, and blue for processing. The most widespread and successful is the Bayer pattern comprised of alternating rows of red-green and green-blue filters (RGGB). The Bayer color filter array uses twice as many green pixels as red or blue in order to more closely mimic the physiology of the human eye (since green carries most of the luminance information). Today, CMOS chips are being incorporated into video-capable DSLRs, high-definition prosumer or industrial video cameras and even ultra-high resolution digital cinema cameras (e.g., Arri Alexa, RED One, Scarlet and Epic, or Sony PMW-F55 CineAlta). State-of-the-art CMOS chips with "active pixel array" (sometimes called "camera on a chip") offer greater dynamic range and higher quality images compared with CCDs as well as better signal-to-noise ratios, greater anti-blooming and vertical smear resistance, faster frame rates, selective "region of interest" capabilities and a reduced depth of field (favored by cinematographers but not so much by broadcasters). As demand for 1080p and 4K progressive formats increase, the interlaced formats that favored CCD technology, are giving way to CMOS technology in all video applications other than broadcast television. CMOS imagers have now joined CCDs as a mainstream, mature technology.

However, there are trade-offs. Because of the different way CCDs and CMOS chips *read out* (or output) an image; they also employ different means of exposure that can impact the final image. CCDs employ a *global shutter,* meaning all of the pixels are exposed to light at the same moment and register a complete image at your chosen frame rate then outputs that frame line by line to be processed. Cameras that use CMOS chips have active pixels that process their own electron charge and directly output a digital signal. Therefore, most CMOS chips have a *rolling shutter* that exposes and reads out one line of pixels at a time (from top to bottom) eventually creating a complete frame (and, it does this very, very quickly!). The advantage is that a rolling shutter increases chip sensitivity. However, even though this process happens very fast, not all parts of the image are recorded at exactly the same time. This produces predictable distortions of fast-moving objects or during quick panning of horizontal movement. These aberrations or artifacts of a rolling shutter are unique to CMOS chips and include such distortions as:

- *Skew* is probably the least objectionable image distortion in that vertical objects (e.g., tall buildings, trees, light, or utility poles) appear to lean one way or the other depending on which way the camera is moving.
- *Wobble* (jello effect) a type of skew artifact, is an unnatural undulation of vertical lines that should be stationary during horizontal movement (panning) of the camera.
- *Partial Exposure* usually occurs when there is a bright flash of light (e.g., lightening or emergency vehicle flasher) that significantly alters the exposure resulting in dark banding in the final image.

Although CCDs are immune to the artifacts caused by a rolling shutter, they are susceptible to *vertical smear* where bright points of light flare and then smear vertically across the image. Likewise, CCDs can suffer pixel damage caused by cosmic rays resulting in immovable white or violet dots on the screen which CMOS sensors are impervious to (of course, this kind of damage can be partially masked by black balancing a CCD camera). While the sensor isn't the only thing to consider when choosing which video camera you will use in your production, knowing more about what the technology is and is not capable of can really help you to distinguish the right camera and workflow for the job; which is, after all, the name of the game!

Scanning Systems, Formats, and Frame Rates

The image encoding system of your video camera must match that of the receiver and operate in the same manner so that the picture can be duplicated exactly as you originally shot it in the camera. Three different and mutually incompatible encoding system standards for analog television have existed practically since the beginning of commercial television in the early 1940s: the National Television Standards Committee (NTSC: North America, Japan and parts of Central and South America), Phase Alternative Line (PAL: British Commonwealth and parts of Europe, Central and South America, Africa, Middle East, Asia, and the Pacific), and Sequential Color with Memory (SECAM: France, Russia and parts of Eastern Europe, Africa, and Middle East). Each standard was developed to address various technical specifications for image reproduction, transmission, and reception and ensuring compatibility between every video camera and television set within countries that shared any of these respective systems. Each analog television signal (whether NTSC, PAL, or SECAM) contains encoded timing and synchronization information so that the television receiver can reconstruct a two-dimensional moving image from a one-dimensional time-varying signal.

Knowledge about the scanning system is not crucial to video production except that you, as the camera operator or video producer, must be aware that the reproduction system is not based on complete coverage of the frame (like a single frame of film). Instead, the reproduction system is based on a series of constantly refreshing horizontal lines that make reproducing fine horizontal or curved lines in a picture difficult. The scan system also limits the vertical resolution power of the video system. There are presently only two ways of creating and transmitting a video image: interlaced scanning and progressive scanning.

The display format of most standard definition (SD) analog television conforms to the early Academy of Motion Picture Arts and Sciences format with an aspect ratio of 4 × 3 (used by the motion picture industry into the 1950s). Completely scanning the frame, called a *raster*, in the original NTSC system requires 525 lines, to be scanned twice, 262.5 at a time, in a pattern called a *field*. The second field of 262.5 lines is scanned offset by one line from the first field in a pattern called *interlaced scanning*. The two fields are then combined—or interlaced—to complete the frame. The total scanning of the two 262.5-line fields comprising one 525-line frame occurs once every 1/30th of a second, therefore, the frame rate of SD analog television is 30 frames per second (fps). For this complex system to stay in synchronization, pulses are added between the fields and between the lines. These are called *sync pulses*, and they must be created either in the camera or by a sync generator. The sync pulses are part of the recorded signal, and the television receiver or video recorder locks onto those pulses when the signal is broadcast or the video is played back. Although the specifics vary, the electronic process of interlaced scanning is virtually the same in the other two SD analog encoding systems. However, it is important for you to remember that a PAL receiver or tape deck will not synchronize with an NTSC signal, or vice versa. The same is true of the SECAM system. The three systems are not compatible and if you are producing video for international audiences this incompatibility can greatly complicate your distribution plans beyond much more than uploading your video to YouTube.

In the 1990s, the Advanced Television Systems Committee (ATSC) developed a set of standards for U.S. digital high-definition television (HDTV) transmission through a "Grand Alliance" of electronics and telecommunications companies. It was hoped that, by developing an international HDTV standard, the international television transmission chaos that defined the earlier analog standards could be avoided. Alas, this did not happen, partially because of different power line rates in each country. U.S. power is on

a 60-cycle system, whereas power in much of the rest of the world is on a variation of a 50-cycle system. As a result, there are now two additional international digital television transmission systems in existence as well as ATSC: the Terrestrial Integrated Digital Broadcasting (ISDB-T) system developed in Japan, and the Digital Video Broadcast-TV (DVB-T) system developed in Europe. Because the Federal Communications Commission (FCC) refused to set specific technical standards—intending for the television industry to decide among the available formats for themselves (in hopes a standard would emerge)—the U.S. ATSC presently define 18 different formats (including SD formats) for digital television. On June 12, 2009, by FCC decree, all broadcasts in the United States switched over to digital formats and all analog television transmitters switched to digital or were shut off (see Table 3.4).

TABLE 3.4 – The FCC-recommended standards include 18 different combinations of line rates, frame rates, and aspect ratios.

DIGITAL VIDEO STANDARDS

INTERNATIONAL STANDARDS

SYSTEM/ COUNTRY	FRAME RATE	ASPECT RATIO	SCAN LINES	SCANNING
ISDB-T Japan	30, 60 fps	4:3, 16:9	480, 720, 1080	Progressive/ Interlace
DVB-T Europe	24, 30, 50 fps	4:3, 16:9, 9:4	480, 576, 720, 1080, 1152	Progressive/ Interlace
ATSC-DT No. Amer.	24, 39, 60 fps	4:3, 16:9	480, 720, 1080	Progressive/ Interlace

US ADVANCED TELEVISION SYSTEMS COMMITTEE (ATSC) DTV FORMATS

FORMAT	SCAN LINES	ASPECT RATIO	FRAME RATE	US ADAPTER
HDTV	1080	16:9	24P, 30P, 60I	CBS & NBC (60I)
HDTV	720	16:9	24P, 30P, 60P	ABC (30P)
SDTV	480	16:9 or 4:3	24P, 30P, 60P, 60I	Fox (30P)
SDTV	480	4:3	24P, 30P, 60P, 60I	None
LDTV	480	4:3	60I	None

DIGITAL MEASUREMENTS

1 Bit = 1/8 Byte
1 Byte = 1/1000 Kilobyte (KB)
1 KB = 1/1000 Megabyte (MB)
1 MB = 1/1000 Gigabyte (GB)

Pixel = smallest element of a picture
1 Video frame = 640 horizontal pixels x 480 vertical pixels = 307,2000 pixels
1 Color video frame = 307,200 pixels x 24 bits of color = 7,372,800 bits of 921 KB
1 Second of video = 30 frames = 28 MB of memory
1 Minute of video = 1680 MB of 1.68 GB of memory
60 Minutes of video = 100 GB of memory
Most consumer computer hard drives are limit to 1 GB or less of memory
Professional nonlinear editing systems require increased amounts of memory and use some form of compression to reduce the amount of memory required for processing and editing.

Scanning Systems, Formats, and Frame Rates

The goal of the "Grand Alliance" was to deliver high-quality visual images comparable to that of film (16:9 aspect ratio) with CD-quality audio via digital television transmission. Because of the different ATSC formats, the horizontal line rate varies from 360 to 1080 and the aspect ratio of the frame may be either 4:3 or 16:9. The scan system may be interlace (that is, two fields making up one frame) or progressive scan, meaning the entire frame is scanned one line at a time from top to bottom with a single scan producing a complete frame. The frame rate may vary from 24 frames per second (fps) to 60 fps. In between, one can find 23.976, 30, 29.97, 50, and 59.94 fps. Today's 1920 × 1080 resolution full-HD television presents us with an image of around 2 megapixels, but a new generation of television screens promise to deliver 4K image resolution at 4096 × 2160 (8 megapixels) and frame rates up to 120 fps to match that of high-end digital cinema cameras. Technically speaking, 4K denotes a very specific display resolution of 4096 × 2160 and most digital cinema cameras already record images at or above 4K. However, many people use 4K to refer to any display resolution that has roughly 4000 horizontal pixels. Pioneered by Japan's NHK Science & Technology Research Laboratories in 2003, ultra high-definition television (UHDTV) uses the standard HD aspect ratio of 16:9 but is capable of carrying and presenting native video at a minimum resolution of 3840 × 2160—that's exactly four times the resolution of present-day HDTV. The idea behind UHDTV is that the more pixels you use to make up an image, the more detail you see and the smoother the appearance of curved and diagonal lines. A high pixel count also enables images to be much larger before they break up, which suits the consumer trend toward bigger TVs. In 2012, the International Telecommunication Union (ITU), standardizing both 4K and 8K resolutions for the format, officially approved UHDTV as a broadcast standard. It wasn't long before the world's largest broadcaster, the BBC, publicly showcased UHDTV during the 2012 Summer Olympics in Great Britain. Eutelsat Communications launched the first Ultra HD demo channel in Europe in January 2013, and South Korea currently leads the way in UHDTV broadcasting. Likewise, the 2014 World Cup Final from Brazil will be shown in 8K Ultra HD to satellite viewers in Japan.

There is no doubt that technology is pushing the frontier of video image capture and transmission. Likewise, formats and standards seem as if they are in a constant state of flux. Therefore, it is critically important that each person on your team involved in the production process is aware of which system they are expected to use in order to shoot, edit, and distribute the final video to the intended audience in the best possible format.

Even though the video signal is digital, and can be converted (transcoded) into different formats, you will produce the highest quality and suffer the fewest problems when your team agrees on the standard from the beginning before the first frame is shot.

Measuring Video Signals

As stated earlier, video signals are complex, and the measurement and adjustment of the video signal is much more complex and requires testing equipment that is beyond the scope of this text. Still, to determine exactly how your camera is reacting to the light reflected from the subject, you need a precise means of looking at the electronic signal. The equivalent of an audio VU meter, a test instrument called a waveform monitor, is used to monitor the luminance level of the video signal. It converts the electronic signal into a visual equivalent that is calibrated for precise measurement.

The most important graphics on a waveform monitor reticule are the horizontal lines that go from 100 at the top to −40 at the bottom with a heavy subdivided line about a third of the way up from the bottom at 0. These are the primary measuring lines that you will be using to read the waveform. The units are in IRE (Institute of Radio Engineers, the organization that created the standard and later became the IEEE, the Institute of Electrical and Electronics Engineers). The video portion of the scale is from zero to 100, while the area below zero is for synchronizing signals. Between the zero and the 10 IRE line is a dashed line at 7.5 IRE, this level is called setup, or pedestal and represents NTSC black. One of the wonderful things about digital HD video is that black levels do indeed go to zero IRE as was originally intended. Although you would anticipate that 100 IRE represents white, the area between 100 and 120 IRE should be considered as highlights and not a normal part of the picture—what you perceive as white is actually 75 to 85 IRE, depending on the visual content of the video image. If you are looking at the standard Society of Motion Picture and Television Engineers (SMPTE) colorbars, white should sit at the 100 IRE line and the black on the 7.5 IRE dashed line. This represents a correctly adjusted video signal. If you are looking at an image through the lens of your camera, it shows the strength or level of the signal indicating if the signal is too high (too much video amplifier gain or too much light coming through the lens) or too low (too little gain or not enough light). It also shows the relationship between the two major components of the signal: gain (white level) and setup (black level). You must keep these two signals in the proper relative strength to each other to provide an acceptable picture (see Figure 3.4).

Measuring Video Signals

In a Multi-format Waveform monitor the view in the window on the top left is the waveform, Vector Scope is on the top right and SMPTE color bars in the lower left window. (Courtesy Tektronix.)

An image & its histogram: The white graph represents the tones in the photo, dark tones are on the left in the graph while light tones are to the right and mid-tones in between. (Courtesy Nikon U.S.A.)

FIG. 3.4 – Waveform monitors. The FCC-recommended standards include 18 different combinations of line rates, frame rates, and aspect ratios and vectorscopes are the two primary tools used to measure analog video signals. Introduced in many professional and "prosumer" or "industrial" digital video cameras (and DSLRs), the image histogram provides a graphical representation of the tonal distribution in the digital image. (Courtesy Tektronix and Nikon, USA.)

In most cases, many professional and prosumer or industrial video cameras allow you to manually set your white balance (and in some cases, black balance) for the lighting environment you will be shooting in. Some video cameras have factory preset white balance settings for the most common lighting environments (daylight or tungsten) or the ability to automatically adjust white balance as lighting conditions change (called *auto trace white*). Beyond this, however, white and black levels would need to be adjusted by

a technician. The iris setting in the lens also controls white level by controlling exposure. Your ability to read and understand a waveform monitor is crucial for determining proper levels in a single-camera production, ensuring uniformity of exposure levels during a multiple-camera shoot or in normalizing video exposure in the editing room.

With the advent of color television in the 1950s, a second type of video-signal monitor, a vectorscope, had to be developed to adjust and verify the color portion of the video signal. It shows the relationship of the three primary color signals—red, green, and blue—and just how saturated your image is and where the color signals in the image land on the color spectrum. These three signals are deliberately set out of phase with each other—that is, each of the three starts at slightly different times (in fractions of microseconds). This out-of-phase condition is critical in converting the three separate color signals into one acceptable color signal that accurately represents all colors in the video image. During shooting, a vectorscope is not nearly as useful as a waveform monitor except for achieving a precise color or color match. However, to understand how color is being represented in the video image, it is necessary to read a vectorscope, which provides a visual display of the phase relationships of the three signals. In the vectorscope's overlay, you will see several boxes just inside the circle marked R, Mg, B, Cy, G, and Yl. These represent the colors in the traditional color bar test pattern (red, magenta, blue, cyan, green, and yellow, respectively). The more saturated a signal is, the further toward the edge of the circle it will be. The proximity to one of the overlay boxes tells you what color it is. Outside of the editing room, the vectorscope is seldom used except to calibrate cameras in a multi-camera studio. In single-camera video production, a vectorscope is useful if you need to confirm white balance. If the signal is clustered in the exact center of the circle, you are properly white balanced. On the other hand, if the signal is off center (skewed noticeable in one or more directions), then you will need to re-white balance.

For CMOS equipped cameras, given their greater dynamic range, the most useful tool for monitoring your video image is the histogram. The histogram functions in much the same way as the waveform monitor in that it provides you visual representation of the video image's luminance. Therefore, a histogram is a simple graph that displays where all of the brightness levels contained in the video image are found, from the darkest to the brightest across the camera's full dynamic range. These values are arrayed across the bottom of the graph from left (darkest) to right (brightest). The vertical axis (the height of points on the graph) shows how much of the image is found at any particular brightness

Measuring Video Signals

level. To understand how to read your histogram, watch the graph as you open up your camera's iris—the entire graph should shift toward the right. As you close down your iris, it should drift towards the left. Depending on your artistic intent, you usually want to avoid build up at the two extremes (called *goal posts*). However, although the rule of thumb when shooting video with CMOS chip cameras is, "expose to the right," you need to avoid overexposing your video as well—in digital video, once your highlights are blown-out (overexposed or clipped, past the right-hand side of your histogram), the data is lost. You must bias your exposures so that the histogram is snugged up to the right, but not to the point that the highlights are blown-out. Underexposing your video image can also lead to problems (i.e., crushing the blacks past the left-hand side of your histogram) but not as dramatic as those caused by overexposure. Although it lacks the precision of a waveform monitor, a histogram can tell you whether or not your image has been properly exposed, whether the lighting is harsh or flat, and what adjustments will work best.

Video Compression

The compression of digital video is the same as for digital audio, except that much higher ratios are necessary to handle the greater quantity of recorded material. Your original analog video signal is sampled and quantized, requiring up to 300 MB per second of recorded program, as compared with less than 100 K per second for digital audio. Information from the camera is compressed to reduce the data rate and fit it onto the recording medium—in the world of digital video the trade-off is speed, size, quality: choose two! The juggling act of all digital video encoding formats is how to reduce the size of the image data while simultaneously maintaining as much quality as possible. If you compress too much, image quality suffers. If you don't compress enough, the files are too big and slow to work with. These are hard choices to make and depend, in large measure, on the intended means of distribution you anticipate for your video.

The compression process removes redundant or repeated portions of the picture, such as the blue sky or white clouds. As long as there is no change in the hue, saturation, or luminance value, the digital program will remember the removed portions, and then it will decompress and restore them when the recording is played back. This process saves space on digital videotape, computer hard disks, or solid-state memory, depending on the recording method. Compression allows you to record a reasonable amount of programming material, but the price is a slight degradation of picture quality. If you compare the quality of a signal carried on an HDTV broadcast at a low compression ratio to the

TABLE 3.5 – To record and manipulate high-frequency video signals within a digital format, some method of compressing the signals was developed to avoid the need for tremendous amounts of computer memory. Two basic systems and variations on those systems have been established, JPEG and MPEG. Researchers constantly work at developing newer systems that require less memory yet maintain the highest quality possible.

VIDEO COMPRESSION STANDARDS

LABEL	FUNCTION	ORIGINATING ORGANIZATION
H.261 or P64	Compressed video over telephone wires	ITU/Tele Consultative Commission
H.264	Compressed Internet video	ITU/Tele Consultative Commission
JPEG	Compressed still images	Joint Photo Experts Group & ISO
Motion-JPEG	Edited moving video	Joint Photo Experts Group & ISO
MPEG-1	Compressed moving images-CD video	Moving Picture Experts Group & ISO
MPEG-2	Compressed moving images-DVD video	Moving Picture Experts Group & ISO
MPEG-3	Compressed audio for MP3 files	Moving Picture Experts Group & ISO
MPEG-4	Compressed Internet video	Moving Picture Experts Group & ISO

same signal on a mobile device that must be highly compressed, the quality difference is obvious (see Table 3.5).

You should be aware of two basic video compression systems now in use: JPEG (specifically, motion-JPEG), developed by the Joint Photographic Experts Group and originally intended for compression of still images, and MPEG, developed by the Moving Picture Experts Group and intended for compression of moving images. Each system offers you advantages and disadvantages, and, or course, the possibility exists that new and better systems will be developed. Currently there are three MPEG systems for video compression: MPEG-1, MPEG-2, and MPEG-4. MPEG-4 was originally written for interactive media and intended primarily for consumer use. However, with the development of the H.264 MPEG-4 Advanced Video Coding (AVC) standard by the ITU Telecommunication Standardization Sector's (ITU-T) Video Coding Experts Group (VCEG) together with the International Organization for Standardization (ISO) and International Electrotechnical Commission's (IEC) joint Moving Picture Experts Group, H.264/MPEG-4 AVC quickly

Video Compression

became one of the most commonly used codecs for recording, compressing, and distributing HD video. H.264/MPEG-4 AVC is perhaps best known as being one of the codec standards for Blu-ray Discs (the other being AVCHD) while being flexible enough to also be used for streaming video over the Internet by such service providers as Hulu, NetFlix, Vimeo, YouTube, and Apple's iTunes Store. It is worth noting that individual companies have also developed additional, proprietary MPEG standards for their own equipment. One that is beginning to dominate the consumer and industrial markets is the Advanced Video Coding High Definition (AVCHD) codec developed and owned jointly by Sony and Panasonic. The AVCHD format was introduced in 2006 primarily for use in high-definition consumer-oriented cameras. A highly compressed variant of the MPEG-4 AVC/H.264 standard, AVCHD supports a variety of SD, HD, and stereoscopic (3D) video resolutions as well as stereo and multichannel audio. In 2008, Panasonic released the first professional AVCHD camcorder (followed by Sony two years later) and, in 2011, the AVCHD specification was amended to include both 720- and 1080-line resolutions in both interlaced and progressive scans and frame rates of 24, 25, 30, 50, and 60 and stereoscopic video (AVCHD 3D) and data rates up to 50 Mbps.

Finally, as technology continues to advance and develop, other video codecs are emerging that build and improve upon existing codecs. One example is the H.265 codec, also called High Efficiency Video Coding (HEVC); a video compression standard intended to be a successor to the H.264/MPEG-4 AVC codec. A Draft International Standard of HEVC was approved in July 2012 and in April 2013 HEVC/H.265 was approved as an ITU-T standard. Although there have been some announcements of commercial video production equipment adopting the HEVC standard, there has been limited rollout to date. Still, HEVC is said to support twice the data compression ratio of H.264/MPEG-4 AVC, while maintaining the same level of video quality. Alternatively, it can be used to provide significantly improved video quality at the same bit rates supported by H.264/MPEG-4 AVC (from 14 Mbps up to 50 Mbps). Likewise, it is presently the only video codec said to be capable of supporting 8K UHD video with resolutions up to 8192 × 4320.

Although video compression may seem esoteric and confusing, your ability to understand and apply the basics of compression is important because it has a bearing on your shooting format, anticipated postproduction workflow, and ultimately, the format of your program's distribution and screening.

Chapter Four
The Equipment

To be truly successful in any endeavor, you want as much information as possible about the "tools of the trade" and how to use them in a professional manner. This approach applies equally, if not more so, to single-camera video production. Learning what video production equipment you need and how to use the various features will help you to shoot outstanding video images, record clear, meaningful audio and, ultimately, make professional-looking projects that effectively communicate.

The minimum tools you will need to produce a video project are a camera and lens, a tripod or other form of camera stabilization, a microphone, a means of recording and monitoring images and sound, a source of illumination, a power supply and the associated cables and connectors to make it all work together seamlessly. However, there is a big difference between a basic set of gear and a professional set of gear. Likewise, there is no end to the gadgets, accessories and other helpful bits of hardware or software available to today's video producers. Of course, your budget, your project's communicative purpose and intended distribution will determine the type, quantity, and quality of the equipment you will need to get the job done. Ultimately, though, to master the craft as well as the art of single-camera video production, you must first understand and learn to use the tools.

Equipment Development

Although a full account of the technical evolution of video production equipment is beyond the scope of this book, the equipment presently used in single-camera video production today is rooted in the history of television itself. Until the mid-1950s, television shows were all broadcast live or were recorded by synchronizing the filming of the program off a video monitor (called "Kinescope" in the United States, "telerecording" in Britain). Although this technique was expensive and produced an inferior quality picture when rebroadcast, it was at the time the only practical way to preserve or delay live broadcast television shows prior to the introduction of videotape. Thus, people on the West Coast frequently watched programs in the late afternoon that originated live on the East Coast in the evening (or vice versa). In 1953, the first commercially viable videotape recorder was introduced, the Ampex VR-1000. The 2-inch reel-to-reel, linear quadruplex format

(named for the tape's width and 4-part record pattern) developed for in-studio use was quickly adopted by broadcasters, not only did it meet NTSC standards for black and white broadcasting, it also had the capacity to support color in the future. Ten years later, Ampex introduced the VR-2000 and the Editec system, the first commercial electronic videotape editor for the 2-inch quadruplex format. However, although the Editec provided "on-the-fly" editing, it was still quite crude; you could switch from playback to record mode at the touch of a button, but the system had no way to synchronize or mark your edit point making precision editing extremely difficult, neither could you record audio or video independently, something later editing systems could do easily. Nonetheless, it soon occurred to many television producers, directors, and journalists that some types of productions could be shot with one camera, recorded on videotape—even out of sequence—and then edited into a form suitable for airing—thus, avoiding the "clumsy" Kinescope method and bypassing the expense and time-consuming nature of using film.

In 1962, Ikegami introduced the first portable video camera, making productions outside of a studio technologically simpler and more economical; this same camera was later used to broadcast the 1968 Mexico Summer Olympics. In 1965, Sony revolutionized video production with the introduction of the CV-2000 (CV stood for Consumer Video), also known as the *Portapak*. The CV-2000 was a black and white 1/2-inch, all transistor reel-to-reel videotape recorder providing an hour's worth of recording time on a 7-inch reel. At US$695 (equivalent to $5,154 in 2013 dollars!), the CV-2000 was less than one-hundredth the price, and one-tenth the size, of a broadcast videotape recorder. Sony also began marketing a "video camera ensemble" (known as the VCK-2000), which consisted of a separate video camera tethered to the CV-2000 videotape recorder, a microphone, and a tripod. Although the CV-2000 was initially aimed at the home market, it was mainly used for medical, educational, and industrial purposes.

During the late-1960s through the 1970s, several manufacturers introduced helical scan videotape recorders that rapidly came to dominate the market. Compared to the quadruplex system, helical scan recorders greatly reduced the complexity of video recording and provided greater reliability, lower energy consumption, lighter weight, and had more feature versatility at a more economical price point. These factors also made it possible to eventually develop a range of videotape cassette formats. Thus, in 1971, trying to again break into the consumer market, Sony introduced the first helical scan videocassette recorder (VCR) using the 3/4-inch U-Matic format (full-size cassettes—about the size of a hard-cover novel—provided 1-hour of record time). However, the

format proved a bit too cumbersome and costly for the home market. Again, it was the industrial, educational, and professional customers that quickly adopted the self-loading cassettes and smaller tape format (later adopted by Panasonic, JVC, and other manufacturers). The new VCR proved very successful for such applications as business communication, educational television, and broadcast news. In 1972, keeping pace with demands for lighter, smaller cameras that could be used in remote locations, Ikegami introduced the first compact hand-held color video camera for Electronic News Gathering (ENG). The Ikegami HL-33, and similar compact ENG cameras from other manufacturers, made live shots easier and—when combined with the more portable 3/4-inch VCRs using the much smaller U-Matic S cassettes (with 20-minutes record time) powered by rechargeable nickel-cadmium (NiCad) batteries—made obsolete the previous 16mm film cameras typically used for remote location television news reporting. With the advent of the 3/4-inch U-Matic format, video edit controllers were also built that automated most of the editing process. They marked edit points electronically, prerolled and synchronized the VCRs, and triggered the record circuit at the edit point. Some could even preview an edit before recording it and were also accurate enough to get within a few frames of the intended edit point. Thus, by the mid-1970s, a number of local television stations and national broadcast networks had adopted the 3/4-inch U-Matic format. News operations wanted portable, lightweight equipment that could deliver broadcast-quality picture and sound instantaneously. Because such a system would be entirely electronic, the picture and sound also could be transmitted over microwave or satellite links for live coverage. Early ENG equipment was initially bulkier and heavier compared to film equipment, but it provided the ability to instantaneously deliver the live pictures desired by broadcast news as well as the ability to easily record, edit and play-back video with very short turn-around times (see Figure 4.1). Not long into the 1980s, film had all but disappeared as a medium of newsgathering.

Sony introduced the Betacam system in 1982 and the BVW-3 camera one year later. Key to the Betacam system was a single-camera-recorder unit (camcorder) that dramatically improved the freedom of the camera operator who was no longer tethered to an assistant burdened with carrying the separate record deck and heavy NiCad battery packs. The Betacam system used the same 1/2-inch cassette format as Betamax—Sony's ill-fated consumer videotape format introduced in 1975—which soon met its demise one year after JVC introduced their Video Home System (VHS) in 1976. But that's the end of the similarity. Betacam had enhanced image and audio quality and greater reliability, so much so that the Betacam camcorder quickly became the standard for both broadcast

Equipment Development

1970s "Creepie-Peepie" 2000s Camcorder

Field Cameras

Flatbed Film NLE Video

Visual Editing

FIG. 4.1 – Equipment designed for electronic field production (EFP) and electronic news gathering (ENG) together make up the field of single camera video production. Over the years, field equipment has gotten smaller, lighter, of a higher quality, and HDTV capable. Visual editing moved from physically cutting to computer-based editing. (Courtesy JVC, Advanced Broadcast Solutions, and Grass Valley.)

news and in-studio video editing. Continued developments during the 1980s, 1990s, and even into the early 21st century saw the introduction of smaller, hand-held camcorders for professional, industrial (or "prosumer"), and consumer markets using charge-coupled device (CCD) or complementary metal oxide semiconductor (CMOS) chips feeding 3/4-inch (D2), 1/2-inch (D3 & DigiBeta), 1/4-inch (DVCam, MiniDV, DVCPro and HVD) or 8mm (Hi8 and Digital-8) high-quality digital videocassette decks, or recording directly onto compact discs (CDs), digital video discs (DVDs), hard drives or solid state memory cards. These developments have moved the art and science of field recording to a new level of higher quality and lower cost. Editing these new signals can now be accomplished with "off the shelf" laptop and desktop computers and powerful nonlinear editing software, providing shorter turnaround time between shooting and delivering a completed news package or making much more creative work possible on dedicated nonlinear editing equipment.

Cameras

When thinking about which camera to use for your project, you are faced with five choices: standard-definition (SD) or high-definition (HD) camera, 4:3 or 16:9 frame aspect ratio, interlace or progressive scan system and an associated frame rate (24p, 30p, 60p or 60i), a frame resolution of 480, 720, or 1080 vertical pixels, and the type of camera (consumer, prosumer industrial, video capable DSLRs, professional broadcast or high-end digital).

Within each of these categories you will find variations in terms of image quality and camera functionality. Recorded images must be of high quality to be edited and duplicated for broadcast, and this usually requires more sophisticated and expensive equipment. Most modern digital video cameras are capable of creating both 4:3 and 16:9 pictures as a selectable menu option. Because most of the circuits within the camera and camera control units are now digital, switching between SD and HD signals is equally easy to accomplish. You also have a choice between frame rates and scanning systems via a simple menu, but you must make your decision carefully and be fully aware of the consequences (see Table 4.1).

With all the options and features in today's digital video cameras, how do you choose the right camera? It depends, of course, on what your finished format is intended to be

TABLE 4.1 – The characteristics of the various types of cameras cover a wide range of technical specifications and output quality.

Camera Types

TYPE	CONSUMER	"PROSUMER" INDUSTRIAL	VIDEO DSLR	PROFESSIONAL BROADCAST	DIGITAL CINEMA
FORM FACTOR	POCKET, "FLIP" OR "PALMCORDER"	HAND-HELD TO MID-SIZE	HAND-HELD DIGITAL STILL CAMERA	MID-SIZE TO FULL-SIZE	HAND-HELD TO FULL-SIZE DEPENDING ON ACCESSORIES
SENSOR	SINGLE 1/8" TO 1/4" CCD OR 1/3.2" TO 1/1.7" SINGLE CMOS	3x 1/3" OR 1/2" CCDS 1/2.84" TO APS-C SINGLE CMOS	SINGLE MICRO 4/3" TO APS-C OR FULL-SIZE CMOS	3x 2/3" CCD 3x 1/3" CMOS OR SINGLE 2/3" CMOS	SUPER-35MM CCD OR 16MM TO SUPER-35MM SINGLE CMOS
COST	LOW TO MEDIUM	MEDIUM TO HIGH	MEDIUM TO HIGH	HIGH TO EXPENSIVE	EXPENSIVE TO VERY EXPENSIVE
PURPOSE	CONSUMER TO SEMI-PROFESSIONAL	SEMI-PRO TO CORPORATE & LOW-END BROADCAST	SEMI-PRO TO INDEPENDANT FILM PROFESSIONAL	HEAVY USE BROADCAST FIELD OR STUDIO PRODUCTIONS	LONG-FORM NARRATIVE FILM PRODUCTIONS
RECORD MEDIUM	MiniDV, INTERNAL HD, INTERNAL FLASH OR SD/ SDHC/SDXC & MicroSD CARDS	MiniDV, DVCPRO, MEMORY STICK, P2 OR SDHC/SDXC CARDS	COMPACT FLASH, SDHC/SDXC OR EXTERNAL SSDs	DigiBETA, DVCPRO, P2, SxS OR EXTERNAL HARD DRIVES & SSDs	"HOT SWAPPABLE" COMPACT FLASH, HARD DRIVES OR SSDs
RECORD CODEC	MOTION JPEG, H.264/MPEG-4, AVCHD	HDV (ARCHAIC) MPEG-2, XDCAM, XF CODEC, AVCHD	MOTION JPEG, H.264/MPEG-4, AVCHD OR RAW	XDCAM, MPEG-2, AVID DNxHD, APPLE PRORES OR AVCHD	PROPRIETARY, APPLE PRORES, MPEG-2, CINEMADNG OR RAW
ASPECT/ LINES	4:3 & 16:9 480I, 720P, 1080P & 1080I	4:3 & 16:9 480I, 720P, 1080P & 1080I	4:3 & 16:9 ALL LINE RATES UP TO 2432P (2.5K)	4:3 & 16:9 480I, 720P, 1080P & 1080I	4:3 TO 2.35:1 ALL LINE RATES UP TO 6144P (6K)
FOCAL LENGTH	FIXED OR ZOOM LENS 5:1 TO 18:1 OPTICAL UP TO 60:1 DIGITAL	FIXED ZOOM LENS 10:1 TO 20:1	INTERCHANGABLE PRIMES OR VARIABLE ZOOM LENS	INTERCHANGABLE HD LENS & ZOOMS 10:1 TO 100:1	INTERCHANGABLE CINEMATIC PRIMES OR VARIABLE ZOOM LENS

and how you plan to distribute your video. Here are a few rules of thumb that should help lower your anxiety when making camera choices.

- Unless you have a very specific aesthetic reason to shoot otherwise, shoot everything in the 16:9 aspect ratio.
- If you anticipate your distribution will be broadcast as an HDTV signal or screened using HD equipment, shoot in HD (720/60p, 1080/60p, or 1080/60i). The superior resolution of HD makes this a good format for almost all of your productions. In fact, if you've got an HD camera, shoot all of your video in HD and down-convert to SD if or as necessary.
- If you anticipate film festival or theatrical distribution, shoot 720/24p or 1080/24p to achieve the higher resolution of HD and the unique visual qualities that define the "film look."
- Finally, except for some consumer HD cameras and a few of the early DSLRs that only provided 720/30p video recording modes, there is no real advantage to shooting in 30p for most video applications.

Camera Types

Even after the introduction of CCDs in the 1980s, analog video cameras were easily divided into two basic categories: big, expensive, and complex professional broadcast cameras that produced high-quality video images, and the smaller, cheaper, consumer-grade cameras for the home video market that produced a far inferior image but were extremely easy to use. With the advent of digital video, everything changed. Small and affordable digital video cameras emerged on the market capable of delivering excellent HD images with high-end user functions and good-quality lenses made by some of the leading companies in lens optics. Many professionals turn to these inexpensive digital video cameras when dangerous or extreme shooting conditions did not warrant risking more expensive professional broadcast equipment (e.g., *Deadliest Catch* used hand-held Sony HDV cameras for most of the series while Ed Safford of *Naked Castaway* relied on palm-sized GoPro cameras to document his travails on a deserted island in the South Pacific). It almost seems unfair to call a number of these smaller, feature-rich cameras that are capable of shooting full HD video in the 16:9 aspect ratio a "consumer" camera.

In comparison to video cameras of even ten years ago, today's digital video cameras continue to trend in the direction of smaller and lighter with increasingly better image quality. However, these digital cameras still perform the same basic functions as their analog counterparts: capture light, separate it into red, green, and blue components, sense and convert the image, and process the resulting signal into a final recording format. Also, like their predecessors, all digital video cameras are single-system camcorders—which simply means the camera and recording device are built into the same unit and the electronic circuitry gathers and records both video and audio simultaneously. Therefore, most digital video camcorders contain the same basic components (varying in quality) and essential functions (varying in number and complexity) as the cameras that came before them. However, as you have no doubt noticed while browsing the video camera options at your local electronics store, digital video cameras come in a wide range of quality, sizes and price categories. Likewise, the proliferation of different HD and digital cinema recording formats makes any neat, clear, and simple classification of digital video cameras into mutually exclusive categories difficult.

Although admittedly a bit arbitrary, there is a range or continuum by which you may distinguish digital video cameras into five basic categories depending on their form factor (size, style, and shape), intended usage, sensor size and quality, record

Camera Types

medium and codec: (1) consumer-oriented pocket, "flip" or "palmcorder" cameras; (2) prosumer or industrial camcorders; (3) video capable DSLR cameras; (4) professional broadcast cameras; and (5) digital cinema cameras. Each category is vaguely separated by price, quality, purpose, and functionality. But there are no hard and fast divisions between camera types. Some consumer-oriented cameras can perform nearly as well as more expensive prosumer cameras. Likewise, many industrial cameras are used in mid-level broadcast news markets for ENG while some "full-frame" video capable DSLR cameras can produce high-quality images as good as some of the more expensive digital cinema cameras. Suffice it to say, the distinction between the two extremes of non-professional, consumer-oriented cameras and the high-end, professional digital cinema cameras will likely remain, but the range of camera types that span the continuum of features and image quality in between these extremes will continue to blur the lines as they become better and more affordable (see Table 4.1).

Consumer Cameras

Today's small, consumer-grade, handheld cameras designed primarily for the home video market pack a lot of features into a compact size. Consumer cameras come in three basic form factors: the "pocketcam" (like the Kodak Zi10 PlayTouch Video Camera), a pistol-grip "flipcam" (like Panasonic's HX-WA3 Active Lifestyle Camcorder), and the more prevalent "palmcorder" (like the Sony HDR-CX210 Handycam)—some are even designed for the tiny hands of small children (like Sakar's Hello Kitty Digital Video Recorder!). The price point for consumer cameras varies widely based upon features and ranges from less than $50 to approximately $2,000 at the higher end. Most consumer cameras use a single image sensor—typically, a 1/8-inch to 1/4-inch CCD or 1/3.2-inch (meaning, 1 divided by 3.2 or 0.3125-inch diagonal measurement) to 1/1.7-inch (or 0.588-inch diagonal) CMOS chip—offer acceptable light sensitivity, scan line resolutions of 480i, 720p or 1080i with frame rates of 30p or 60i, and typically employ a highly compressed version of the AVCHD codec. These cameras record to miniDV tape (although, very few models use tape anymore), internal hard drives, internal flash media, or the more prevalent removable SD/SDHC/SDXC or mini-SD memory cards. You can easily operate the cameras in a basic point-and-shoot mode with almost all functions—focus, aperture, exposure sensitivity, shutter speed, white balance, and audio gain—automatically set. They come equipped with a permanently mounted fixed focal length or zoom lens with an optical range from

FIG. 4.2 – A consumer-grade camcorder may be as small as a palmcorder point-&-shoot or larger, with more professional controls and accessories. (Courtesy of Canon and Panasonic.)

5:1 to 20:1 and a "digital zoom" up to 50:1 or higher. Some models are designed to output directly to the Internet via WiFi for uploading video to popular streaming sites like YouTube; a few even have built-in video projection capabilities. Consumer digital video cameras allow you to shoot quickly (using automatic settings), are low-cost, and produce fundamentally sound video under optimal operating conditions (see Figure 4.2).

As manufacturers want to distinguish their brand above another in a competitive market, there are a wide range of price-points and features available. In an effort to respond to home video enthusiasts who clamor for an ever smaller form factor and for more features, manufacturers had to make certain compromises. For example, first to be compromised is the size of the image sensor. A digital video camera's image sensor size (whether a CCD or CMOS chip) is one of the most important factors in determining image quality. Manufacturers try to compensate having a tiny image sensor with greater pixel density (measured in megapixels) to improve picture resolution. Unfortunately, the result is microscopic pixels that yield a narrower dynamic range and can increase *image noise* (random "grainy" speckled pixels of brightness or color not present in the original subject—especially noticeable in low light and dark areas). In general, a larger image sensor yields a much better image even if the megapixel count is lower. Second, having a small form factor means the camera is also extremely light and when hand-held can result in some nauseating image stability problems. To compensate, many consumer

Consumer Cameras

cameras utilize electronic (sometimes also called "digital") image stabilization technology that selects a much smaller area of the image sensor and—after finding a fixed point in the frame that should remain relatively still (like a tree, for example)—electronically moves the image around to keep the selected point stable. Electronic stabilization can reduce the video's resolution as well as add noise to the picture, further degrading the image. Finally, many consumer cameras utilize an integrated digital zoom in order to extend the zoom range of the camera's lens. Optical zooms get up close and personal by actually adjusting the lens elements to magnify the image. Digital zooms, on the other hand, adjust the video image through in-camera manipulation of the picture. In other words, the camera enlarges the image area at the center of the frame and trims away the outside edges of the picture. The resulting digitally zoomed video can suffer from enlarged pixel blocks making the image look splotchy, blocky, or fuzzy and further reduces image resolution and quality. Thus, although easy to use, feature rich and affordable, most consumer-grade digital video cameras do not necessarily provide the highest quality video output.

Prosumer and Industrial Cameras

The next category of digital cameras available to both demanding consumer and beginning professional videographers alike are the prosumer or industrial cameras. Although the price point demarcation between amateur consumer and professional-quality camcorders has traditionally been around the $2,000 mark, you can now find a prosumer camcorder with cutting-edge features priced from around $1,000 to over $6,000. Likewise, you would be hard pressed to find one that did not provide full HD capabilities (720 or 1080 vertical pixel resolution in interlaced or progressive scan modes, 16:9 aspect ratio, and frame rates from 23.97p to 60p and 59.94i or 60i), and, like all HD camcorders, prosumer cameras can also shoot in SD. Although the price point of an HD digital video camera is a fairly good indication of its over-all quality, more important than any other feature or characteristic that distinguishes a consumer camera from a professional camera is the presence of manual controls. All prosumer or industrial cameras provide you with varying degrees of manual control. Although "auto everything" greatly simplifies video shooting, it can also significantly handicap your creative storytelling abilities. To shoot like a professional, you want to manually adjust the camera's focus (preferably with a "hard-stop" ring on the lens rather than a continuous ring, thumb dial, or button). You also want manual control over the iris or aperture, shutter speed, white balance, and audio levels, as well as have an electronic viewfinder (or large flip-out

LCD monitor, or both), headphone jack for monitoring your audio, and stereo (2-channel) external microphone input jack(s)—either an 1/8-inch (3.5mm) mini or two XLRs (the latter being preferable).

Consumer palmcorders have a very small form factor with little room for manual controls and are quite light, making it difficult to keep the picture steady. The tactile feel of a prosumer camcorder is more substantial and more ergonomic. They tend to have a larger form factor, ranging from hand-held to shoulder mount and also tend to be heavier (but not as heavy as professional broadcast cameras). This larger form factor affords manufacturers the ability to place manual and electronic controls on the camera's body and lens in such a way that your shooting experience is more efficient. In addition, the heavier weight affords greater stability when you have to handhold the camera during production. Most professionals consider a larger camcorder ideal for tactile control, and it gives the camera operator some level of authority when shooting in public (it just looks "professional"). However, you will need to consider whether or not you need this greater level of control or if a smaller, lighter camcorder with fewer manual functions will give you more desirable flexibility in the field.

Many video producers consider a camcorder with three image sensors (CCDs or CMOS chips) as another indicator of professional-grade equipment. However, in many cases a single, larger CMOS chip is better than three very small CCDs. For example, a single Advanced Photo System type-C (APS-C) CMOS image sensor (23.6mm × 15.6mm) may produce better-looking images than three 1/4-inch CCD chips. Given the subjective nature of such a comparison, this may be a matter of debate as it largely depends on the application and which camcorders you are comparing. However, as a general rule, always go for the largest image sensor you can in a professional-quality video camera; and three would be best, if you can get them. Prosumer image sensors range from triple 1/3-inch to 1/2-inch CCDs using a prism system for color separation, or can be a single 1/2.84 (0.352-inch diagonal) to an APS-C CMOS chip (approximately 1-inch diagonal equivalent) with a color separation filter (Bayer pattern) built-in. Although not common practice in prosumer cameras, some manufacturers use three CMOS image sensors (e.g., Panasonic's AG-HMC40 uses three 1/4-inch CMOS—or "3MOS"— image sensor technology to produce full-raster HD images with high resolution image quality). Although videotape-based recording systems are disappearing in favor of removable solid-state memory storage, there are still a few prosumer camcorders that rely on MiniDV tape using HDV or DVCPro codecs. At the higher end of the price range

Prosumer and Industrial Cameras

FIG. 4.3 – Prosumer cameras usually have superior optics and professional-quality camera features but are not as expensive or as flexible as professional broadcast cameras. (Courtesy of Panasonic.)

are camcorders that utilize the same record media as professional broadcast cameras and employ more professional codecs. Common types of solid-state media used in prosumer cameras include Personal Computer Memory Card International Association (PCMCIA) P2 cards, SxS, GFCam, compact flash memory cards, or SDHC/SDXC cards (see Figure 4.3).

You may use these prosumer cameras in the field as a documentary maker, independent feature producer, news videographer, or freelancer working in industry or education. As improvements in digital circuitry provide deeper menus offering increasing functionality, as tactile control differentiates across a range of form factors, as battery life increases, and as flexibility of operation increases, the prosumer camera takes on a new, higher level of creativity for you, the operator, and director. The increase in resolution and contrast range in prosumer cameras moves them from handy production tools to truly high-quality creative tools.

DSLR Cameras

The seemingly recent proliferation of video capable Digital Single-Lens Reflex cameras (DSLR; sometimes also referred to as HD-DSLR, hybrid DSLR, or HDSLR) has given the single-camera video producer and independent filmmaker who can't afford professional broadcast or high-end digital cinema cameras a number of comparable—if

not superior—options. While DSLRs have their drawbacks (mediocre audio, limited recording times and rolling shutter issues), the benefits (lower comparative price-point, excellent image quality, greater dynamic range, interchangeable lenses, full-frame 35mm image sensors and 1080p or higher resolution—among other attributes) far outweigh the shortcomings. In 2008, the world was introduced to this "disruptive" technology with the rollout of Nikon's D90 camera (12.1 megapixel APS-C CMOS chip, 720p at 24 or 30 fps and 16:9 aspect ratio with 5-minute clip record times using the Motion-JPEG codec). This was followed soon after by Canon's introduction of the 5D Mark II camera (21.1 megapixel full-size CMOS chip, down-sampled for video to 1080p at 30 fps and 16:9 aspect ratio with 12-minute clip record times using the H.264/MPEG-4 codec). Although both cameras had obvious limitations and the video capabilities were at the time considered more of a "bonus" to their already stellar photographic pedigree, their large image sensors offered an enhanced dynamic range, better control over depth of field, interchangeable lenses and a "richness" of images with beautiful color depth and each plane of focus clearly inhabiting its own little slice of reality—in other words, the "film look." At a price-point of $1,200 to $3,200 (respectively, with a "kit" lens), contemporary HD digital video cameras with smaller image sensors, fixed lenses with high zoom ratios (among other technical compromises) and the characteristically "uncinematic," flat image with a narrower dynamic range, deep-focus and overly sharp "video look," the new DSLR cameras were far more attractive to indie filmmakers, freelance video producers and students on a restricted budget. In 2010, *House MD,* previously shot entirely on 35mm film, shot their season finale episode, "Help Me," using the Canon 5D Mark II. Likewise, the BBC Two comedy series *Shelfstackers,* first broadcast in September 2010, used the DSLR camera on all six episodes. The DSLR cinema movement was now catching the attention of video camera manufacturers and forcing them to rethink their approach to camera design—especially in their prosumer line.

Today, there is a range of video capable DSLR cameras to choose from varying in image sensor size, audio capabilities, image control functions and price point (see Figure 4.4). Prices range from entry-level DSLRs costing around $500 (with a kit lens) up to full-feature professional DSLR cameras costing upwards of $6,000 (camera body only). Sensor size is most typically used to differentiate DSLR cameras into three groups; Full Frame CMOS (36mm × 24mm) "professional" DSLR cameras (e.g., Nikon D4, D800 and D600, or Canon 5D Mark III or 6D), "mid-range" DSLRs employing the APS-C CMOS chip (23.6mm × 15.6mm like Nikon D7100 and Sony α77 or 22.2mm ×

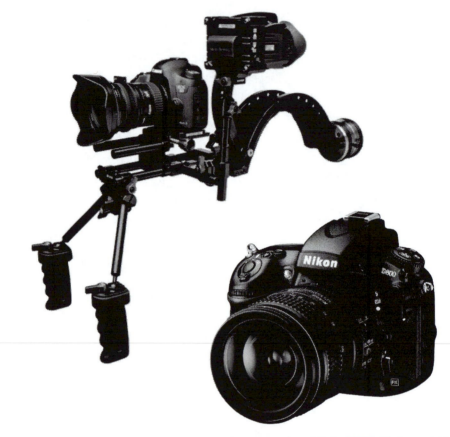

FIG. 4.4 – Video capable DSLR cameras, especially those possessing a full size CMOS chip, have quickly become a favorite camera of students and independent filmmakers because of their light sensitivity, dynamic range, interchangeable prime lenses and ability to deliver the "film look." (Courtesy of Nikon and Canon.)

14.8mm in Canon cameras like the 60D or T3i) and high-end consumer DSLRs with a Micro Four Thirds chip (MFT or micro 4/3, 17.3mm × 13mm like the Panasonic GH3). A fourth emerging category is the Mirrorless Interchangeable Lens Compact camera (MILC), but most of these are targeting the consumer rather than professional market but with many of the same features expected by professionals. The main difference between a DSLR and a MILC camera is—obviously—the mirror and prism system in the DSLR that allows you to peer directly through the camera lens when framing through an optical viewfinder. MILC cameras view the scene using an electronic viewfinder or a LCD screen (often both, but not operable simultaneously) to display the

framed image making the cameras smaller, lighter and usually cheaper. For example, Sony's α3000 MILC camera uses a 20.1 megapixel APS-C image sensor capable of shooting full HD video (1080/60i or 1080/60p) in the 16:9 aspect ratio using the H.264 or AVCHD codecs in a compact DSLR-style form factor and provides many features similar to mid-range DSLR cameras.

Like all HD video cameras—assuming everything else being equal—the larger the image sensor in a DSLR, the more expensive the camera. Likewise, many of the interchangeable lenses for large sensor DSLRs can also be expensive. On the other hand, the larger the image sensor, the easier it is to get shallow depth of field and a wider field of view. Another benefit that generally comes with larger CMOS sensors is better light sensitivity and therefore, greater dynamic range. Smaller image sensors (MFT or APS-C CMOS chips), on the other hand, tend to be in more moderately priced DSLR cameras with a greater variety of less expensive lenses available that can "cover the sensor." If you tried to use a lens designed for a MFT or APS-C camera on a full size CMOS chip, you would get an artifact called *lens vignetting* because the circular image created by the lens could not cover the full surface of the rectangular chip resulting in the edges of the image appearing soft or slightly dark and in some situations the corners of the image may be almost black. This is, of course, less of a problem with smaller CMOS chips. However, smaller image sensors also have reduced light sensitivity (thus, narrower dynamic range), a deeper depth of field and come with what's called a *crop factor.* If a large CMOS sensor yields a larger field of view (more area in your shot), smaller sensors appear to zoom or crop the field of view by comparison. As a result, APS-C chips can crop (or magnify) the field of view by as much as 1.5 to 1.65 and MFT chips have an image crop factor of 2.0. In other words, a full size CMOS camera using a 50mm lens will yield a field of view exactly matching the lens, but an APS-C chip with a 1.5 crop factor (sometimes also referred to as "lens magnification") would give you a 75mm equivalent field of view while a MFT chip would result in a 100mm equivalent. This "lens magnification" resulting from a chip's crop factor can make shooting in close quarters difficult, but can also be useful when shooting outdoors when your subject is at a great distance and you need to get in close.

The form factor of a video capable DSLR is exactly that of a photographic camera; hand-held ergonomics in a light, easily manageable size. This form factor is familiar to a lot of people and presents a distinct advantage when shooting documentaries or "run 'n gun"

DSLR Cameras

video productions on the streets or in crowded locations. Of course, this small form factor can also be a problem for shooting steady images; thus, requiring additional support gear to stabilize the shot. Beyond adjusting shutter speeds or ISO settings on your DSLR (which can have an adverse impact on the "film look" that defines a DSLR camera's signature strength), the light sensitivity of large CMOS image sensors can sometimes work against you when shooting in bright daylight. Matte boxes and neutral-density filters (ND) can be attached to the camera and used to control light intensity. Typically ND filters provide several levels of light reduction (e.g., a .3 ND filter is equal to half an *f*-stop reduction in light intensity, .6 equals a full *f*-stop and .9 equals one and a half *f*-stops; gradient ND filters can also be used that slowly transition from a ND value to clear) and are used in order to allow DSLRs to shoot in any daylight conditions while maintaining the much sought after "film look." Of course, this has an impact on the camera's form factor; the DSLR and matte box rig can be bulky and unwieldy to hold by hand, thus, necessitating a tripod or other support gear to stabilize the shot. As you can easily extrapolate, a production setup can quickly become complicated as supplemental gear is added to enhance or augment the DSLR camera's functionality beyond the built-in technology.

Clip record time is also an issue with DSLRs. Although greatly improved over the first video capable DSLR cameras, today you can only get up to about 29 minutes at the highest HD resolution (1080/60p), depending on the DSLR manufacturer. This limitation is typically not a problem for short interviews, shooting traditional film-style scene coverage or B-roll, but it can be a significant limitation if you are shooting an extended interview, press conference, concert performance, or sports event. HD camcorders don't have this limitation since they can have record times of up to 2 hours, depending on the HD record quality and the media storage used.

Finally, manual audio control is a must-have feature for professional videographers, but many DSLR cameras have poor or clumsy audio controls and a limited means of monitoring the audio beyond headphones. To compensate for this, many DSLR video producers have reverted back to the traditional film-style of shooting *dual-system*, utilizing a separate audio recording source synchronized with the video image using a clap-board slate and matched up later in post-production. The evolution of DSLRs is an ongoing process. As improvements continue to be made, some of their current limitations may fade away. Meanwhile, you probably shouldn't abandon your HD camcorder completely . . . just yet!

Professional Broadcast Cameras

Professional broadcast field cameras are designed to shoot HD news, sports, high-level documentaries, reality programming, and live event coverage. Many of the technical specifications of professional broadcast cameras are similar but considerably greater than they are for the higher-end prosumer camcorders. Special zoom lenses with long ranges of up to 100:1 are needed for some sporting events and live coverage (see Figure 4.5), but otherwise, high-end prosumer camcorders share a lot of features with professional broadcast cameras. Of course, there are significant differences as well. All professional broadcast camcorders are able to use high-quality, interchangeable lenses (mostly zooms) that can cost as much or even more than the camera body. Professional broadcast camcorders also typically use three large CCDs or CMOS chips with 2.2 megapixels each (or single full size CMOS chip with a larger megapixel count), black-and-white or color electronic viewfinders, high-quality digital videotape or removable solid state record media and range in price from approximately $10,000 to over $100,000 (camera body only). Such cameras are capable of delivering high-quality signals that are superior to the more highly compressed HD signals of prosumer cameras and they have greater flexibility to increase the quality level by taking advantage of higher-level technical specifications.

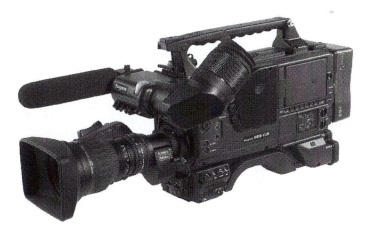

FIG. 4.5 – Broadcast camcorders record directly onto a built-in hard drive, removable disk drive, or large memory flash cards and may be equipped with long-range zoom lenses for sporting events. Broadcast news cameras must be small, lightweight, and offer as many flexible characteristics as possible. (Courtesy of Ikegami.)

Professional Broadcast Cameras

Digital Cinema Cameras

Sometimes referred to as digital movie cameras, digital cinematography cameras or simply digital cinema cameras, in the continuum of video cameras discussed thus far, these cameras represent the top of the market and are the most complex, technologically advanced—and most expensive—cameras available (see Figure 4.6). The concept of "electronic cinematography" is not new; Sony had begun marketing the idea in the 1980s. By the late 1990s, with the introduction of professional HD camcorders capable of recording 1920 × 1080 pixel images at varying frame rates using large CCD image sensors, the idea was rebranded as "digital cinematography" and began to generate excitement among independent filmmakers as a viable (and cheaper) alternative to expensive 35mm film. In 2002, film director George Lucas released *Star Wars II: Attack of the Clones,* shot entirely in HD video. Sony teamed up with Panavision to develop the camera that George Lucas used to accomplish this feat and thus launched the HDW-F900 camera, the first of Sony's CineAlta 24p HD camera brand. Possessing a form factor similar to a professional broadcast camcorder, the F900 used interchangeable 2/3-inch lenses in front of a single 2.2 megapixel 2/3-inch progressive scan CCD image sensor with an effective picture area of 1920 × 1080, a 16:9 aspect ratio and frame rates of 30p, 29.97p, 25p, 24p, 23.98p as well as 50i, 59.94i, and 60i with selectable electronic shutter speeds. As a camcorder, it used the HDCAM videotape format with up to 50 minutes of record time at 24 fps, built-in time code generator, professional XLR audio inputs and gain control and a deep menu system of other functions. The next generation of this camera, the F900R (with a price tag of over $80,000 without lens or viewfinder), was a more refined camera offering additional enhancements and features in an effort to keep pace with competitors (e.g., Panasonic's VariCam line of digital cinema cameras that use three 2/3-inch, 2.2 megapixel CMOS chips at 1920 × 1080 progressive scan and variable frame rates up to 120 fps using the proprietary AVC-ULTRA codec and recording to P2 cards) as well as meeting industry demand for wider dynamic ranges and more cinematic features.

In February 2008, RED Digital Cinema Camera introduced the world to a true marvel of camera engineering and launched a revolution in digital cinema. Intended to be a "DSLR-killer" and designed from the beginning to be a digital still and motion camera (DSMC), the RED ONE was like no digital video camera before it. The camera was initially released with the "Mysterium" sensor (11.5 megapixel 4520 × 2540, 4K progressive scan CMOS with 11 stops of dynamic range), approximately the same dimensions as a super-35mm film frame. The camera could record at several resolutions, frame rates up to 120 fps and

recorded using the proprietary REDCODE RAW codec—the first to allow high bit depth video data—to Compact Flash, hard disk, or SSD media. At the heart of the DSMC concept was the idea that camera components be configurable and interchangeable to allow owners to replace various components as they are upgraded and improved, all centered around the central image processing unit, "the brain" (itself, upgradable). The first "brain" upgrade for the RED ONE was to the Mysterium-X chip, a 13.8 megapixel 5120 × 2700, 5K CMOS sensor with a dynamic range of 13.5 stops. In 2011, RED introduced the new, completely redesigned Epic camera model using the Mysterium-X chip. The Scarlet, originally announced in 2008, was initially intended to be a 2/3-inch (3072 × 1620), 3K CMOS-based camera (equivalent to super-16mm film) aimed squarely at taking on the DSLR market with an anticipated price tag of about $3,000 (body only). However, complications in the design and manufacture caused delays, and the price of the yet to be seen camera began to creep up. Meanwhile, DSLR manufacturers rapidly advanced the video technology in—and capabilities of—their cameras while maintaining a competitive price point. By November 2011, the Scarlet was finally unveiled with many of the same features as the Epic (including the Mysterium-X chip), only in a smaller form factor. Both models, the Scarlet and Epic, share the same DSMC modular design with open-ended upgradeability (see Figure 4.6).

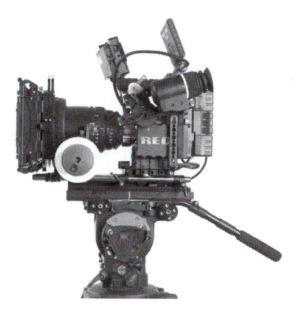

FIG. 4.6 – Cameras may now be equipped with all of the production accessories used in motion picture camera production. They are typically referred to as digital cinematography cameras. (Courtesy of RED Digital Cinema Camera.)

Digital Cinema Cameras

Today, thanks to innovations by companies like RED Digital Cinema Camera with their new flagship Epic-M Red Dragon camera (19 megapixel 6144 × 3160, 6K CMOS sensor with 16.5 stops of dynamic range), Arri's new Alexa XT camera (6.2 megapixel 16:9 2880 × 1620, 2K or 4:3 3392 × 2200, 3K ArriRaw CMOS sensor with 14 stops dynamic range), Sony's CineAlta F65 (20 megapixel 4096 × 2160, 4K CMOS sensor with 14 stops dynamic range), and the new offerings by Blackmagic Design (the Cinema Camera, Pocket Cinema Camera and Production Camera 4K), digital cinema cameras are beginning to take over Hollywood. These cameras have been used on such films as *Evil Dead* (2013, Sony F65), *Oblivion* (2013, Sony F65), *Skyfall* (2012, Arri Alexia), *Life of Pi* (2012, Arri Alexia), *Prometheus* (2012, RED Epic), and *The Hobbit* (2012, RED Epic) as well as such popular television series as *Game of Thrones, Downton Abbey, Arrested Development,* and the Netflix streaming video series *House of Cards* (winner of the 2013 Cinematography Emmy for a single-camera series!). With the primary manufacturers of 35mm film cameras having moved completely into the manufacture and support of digital cinema cameras, and the proliferation of innovative, high-quality, large image sensor cameras used in some of today's block-buster movies and hit television series, it appears that film may be starting its long, slow fade to black.

Specialized Digital Cameras

You may also find a need to use a micro-camera, also called subminiature, "lipstick," or action camera, for security, law enforcement, surveillance, and special shots used to cover sports, documentaries, and dramas where you want to get shots from hard-to-reach or nearly impossible positions. Such cameras are small enough to mount on helmets, on race cars, on skiers, and on athletes who participate in other fast-moving sports. Many of this type of camera are waterproof or come with shock-protective, waterproof housings that allow you to shoot video underwater. Micro-cameras have many of the same features of more traditional cameras. However, because a sports oriented micro-camera is most often used during moments of action, there are usually fewer lens features. A micro-camera typically has no built-in viewfinder but may use a WiFi connected remote viewing screen (or smart phone or tablet app which enables full camera control and scene preview). Most micro-cameras also feature all automatic operations and have either a remote-controlled zoom lens or a single fixed focal length lens (see Figure 4.7). Despite their diminutive size (as small as 2 inches by 2 inches by 2 inches, plus a lens not much larger), these digital cameras can generate full HD images in the 16:9 aspect ratio, have variable frame rates and can meet the required

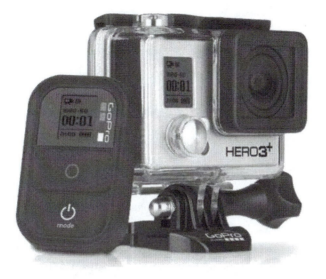

FIG. 4.7 – A miniature HD camera's small size allows it to be used in places a regular-sized camera would not fit or would be too dangerous or inconvenient to place. (Courtesy of GoPro.)

output quality necessary for professional productions. Some of the more competitive (in terms of features and price) and useful action-oriented micro-camcorders include GoPro, Sony Action Cam, and Drift HD Ghost. By far the most popular, weighing in at only 2.6 ounces, the HERO3: Black Edition action camera is wearable and gear mountable, comes with a waterproof housing, is WiFi enabled and capable of capturing ultra-wide 1440p 48fps, 1080p 60 fps and 720p 120 fps video as well as 12MP still photos at a rate of 30 photos per second all recording to a removable micro-SD card using the H.264/MPEG-4 codecs. Perennial drawbacks for most micro-cameras have typically been poor battery life (just over 80 minutes for most, though some, like the Sony Action Cam come in at just over 2.5 hours) and poor audio record quality since few have external microphone inputs and those with built-in omnidirectional microphones tend to record muffled audio resulting from the protective housings or they pick up a lot of extraneous noise.

From the perspective of a cinematographer, you must not get caught up in the hyperbole of the latest and greatest in video camera technology marketing. Remember, a camera is a tool of storytelling. So, whatever tool best helps people have an emotional reaction to the story you are telling is the right tool to use. In the past, you had a

Specialized Digital Cameras

limited selection of tools; now, you have many more camera options at your disposal. As a single-camera producer, you need to be well versed in using multiple tools—consumer, prosumer, DSLR, professional broadcast or even digital cinema and special purpose cameras—and then choose the one, or more than one, that helps you best tell your story.

Image Sensors and Optics

An *image sensor* is a device that converts an optical image into an electronic signal. In older video cameras, before the mid- to late 1980s, a vacuum camera tube or pickup tube was used to do the conversion. Several types of camera tubes were developed and used from the 1930s to the 1980s. Video camera tubes typically had a certain maximum brightness tolerance that, if exceeded, would result in burn-in or smear—among other known problems inherent to this technology. With the introduction of the camera "chip"—beginning with the charge-coupled device (CCD) and later the complementary metal–oxide–semiconductor (CMOS)—superior image sensors were finally available. Because the technology of the CCD and CMOS chips far surpassed that of camera tubes, camera manufacturers stopped making tube-based cameras around 1990.

CCD and CMOS Chips

While most camcorders on the market have traditionally used the CCD chip, more and more are being introduced with CMOS chips. While they ostensibly do the same thing—transduce light into an electronic signal—they go about it in different ways and have unique properties that make each suitable for different types of production situations. Traditionally, "passive pixel sensor" CCD chips have been thought to produce better-looking images with less visual noise and distortion than CMOS "active pixel sensor" chips (meaning, each pixel has its own amplifier). In order to do this, CCDs also draw more power (up to 100 times more) and provide slower data-throughput speed (due to their passive pixel sensor design) than the CMOS image sensor. The benefits of CMOS sensors also extend to improvements in light sensitivity technology (e.g., backside-illumination) and noise-reduction techniques allowing them to become more efficient in low-light situations while narrowing the noise gap with CCD sensors. Operationally, however, CCD image sensors still have advantages related to global shutter mechanics over CMOS cameras during video capture and

until the CMOS rolling shutter system can scan and readout the image as fast as a global shutter CCD, this difference will remain. Finally, CCDs are typically more expensive to manufacturer than CMOS chips, causing many camera manufactures to transition from CCD sensors to CMOS sensors in their consumer and prosumer lines. Interestingly (or confusingly!), large format CMOS image sensors are also showing up in the very high-end digital cinema cameras because of their image processing speeds and low-light sensitivity. Whereas, some aspects of how CCD and CMOS chips function (and their respective drawbacks) have been covered in Chapter 3 or referenced in discussions of specific camera types in this chapter; it can still seem confusing. This is why you should not judge a camera based on the image sensor type alone, you also need to consider the size of the camera's sensor.

Next to the lens itself, a digital video camera's image sensor size is the essential element that ensures the quality of video you can capture. An image sensor's format, sometimes referred to as *optical format* or sensor size, refers to the shape and size of today's CCD or CMOS sensors and harkens back to a set of standard designations given to Vidicon camera tubes in the 1950s. The image sensor format is usually listed in the camera's specifications and is required knowledge if you need to select appropriate interchangeable lenses to cover the sensor. There are two ways an image sensor's format can be described: the inch-based format (1/4-inch, 1/2-inch, 2/3-inch or 4/3-inch) and Advanced Photo System (APS) format (APS-C, APS-H and APS-F or full frame). The size designation in the inch-based format does not actually define the diagonal of the sensor area but rather the outside diameter of the glass envelope of a Vidicon camera tube. A Vidicon tube with an outside diameter of 1-inch had a corresponding imaging area of 16mm diagonal (roughly, 1/2-inch). This resulted in the seemingly odd image sensor inch format: 1-inch (tube) equals 16mm (pick-up area) expressed as the nearest imperial fraction. This designation stuck even though the corresponding Vidicon tubes have long since been retired. Therefore, using the inch format, a 4/3-inch CMOS chip would have a 34mm diagonal measurement, a 2/3-inch CCD would be 11mm diagonal and a CCD that was 8mm diagonal would be a 1/4-inch chip. When image sensors exceed 4/3-inch, the APS format standard is used to describe the size of sensors and usually given as the true rectangular dimensions of the imaging sensor in millimeters (see Figure 4.8).

Sensor size and field of view (crop factor) have already been discussed. Likewise, sensor size impacts lens selection if you wish to avoid lens vignetting. However, the

CCD and CMOS Chips

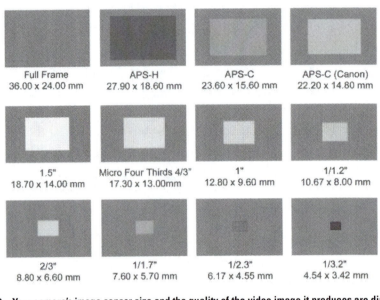

Full Frame
36.00 x 24.00 mm

APS-H
27.90 x 18.60 mm

APS-C
23.60 x 15.60 mm

APS-C (Canon)
22.20 x 14.80 mm

1.5"
18.70 x 14.00 mm

Micro Four Thirds 4/3"
17.30 x 13.00mm

1"
12.80 x 9.60 mm

1/1.2"
10.67 x 8.00 mm

2/3"
8.80 x 6.60 mm

1/1.7"
7.60 x 5.70 mm

1/2.3"
6.17 x 4.55 mm

1/3.2"
4.54 x 3.42 mm

FIG. 4.8 – Your camera's image sensor size and the quality of the video image it produces are directly correlated. Although surface pixel density (Megapixels) is an important factor influencing image detail, light sensitivity and depth-of-field, the physical dimensions of the chip in your camera has greater bearing in determining the video's ultimate image quality. (Courtesy of gizmag.com.)

size of the sensor also impacts the depth of field in several ways. Because of sensor crop factors, for an equivalent field of view utilizing the same camera lens and f-stop, a small image sensor camera will have at least 1.6 times more depth of field than a full frame sensor camera (of course, you'd have to move the full frame camera closer to match the field of view). If you don't move the cameras, utilizing the same lens and f-stop, the full frame sensor will have at least 1.6 times more depth of field than the smaller sensor, but the field of view would be wider. It seems confusing, but really isn't. This is what you need to remember: depth of field is inversely proportional to the chip format size of the camera (other things being equal, see the depth of field discussion below).

Finally, as has been discussed earlier, certain high-end prosumer and most professional broadcast cameras utilize a prism to split the beam of light into its three primary additive colors (red, green, blue) that make up all the colors of the video image. Because they are a relatively flat piece of technology, the CCD (or CMOS) image sensors are mounted directly to the surface of the light-splitting prism inside the camera. This avoids any changes in registration between the chips, thus making

the camera more rugged. Single chip cameras, whether consumer or digital cinema, CCD or CMOS chips, achieve the separation of primary additive colors by using a color filter array (typically employing the Bayer mosaic pattern) overlaid on the surface of the chip. Because both types of image sensor chips are solid-state components just like transistors, they last as long as any other component in the camera.

The purpose here is not to try to convince you that one technology is better than the other. As you have already figured out, depending on what type of production you are doing, you might need a different type of camera with a different type of sensor. At the end of the day, both CCD and CMOS image sensors can provide magnificent results.

Optics

For your camera to operate, it must be able to concentrate light reflected from the surface of subjects on to the light-sensitive image sensor. This function is provided by the lens, a series of optical glass or plastic elements cemented together and mounted in such a way as to focus light on the surface of the image sensor chips.

A unique feature of some higher-end consumer and most prosumer camcorder lenses is optical image stabilization (sometimes labeled OIS). Image stabilization technology helps reduce the blur in your video that results from shaky hands or body movement. Image stabilization is important for all lightweight camcorders, but it is particularly crucial in camcorders that have long optical zoom lenses. When a lens is zoomed all the way in to its maximum magnification, it becomes extremely sensitive to even the slightest motion. Electronic or digital image stabilization has already been discussed and is a function of the chip in entry-level consumer cameras. An image stabilization technology is considered "optical" if it features moving elements inside the camcorder lens. Camcorders with OIS typically feature tiny gyro-sensors inside the lens that quickly shift pieces of the lens glass to offset your camera's motion. Optical image stabilization is the most effective form of image stabilization.

The lens is mounted permanently on the front of all consumer-quality cameras and most prosumer cameras. In DSLR cameras and equipment used at the professional level, interchangeable lenses may be employed. The three basic characteristics of a lens are its focal length, its focus range, and its aperture settings.

Focal Length

The focal length of a lens is a measurement of the ratio between the diameter of the lens and the distance from its optical center to the focal plane (the location of the image sensor's face), usually given in millimeters. The important factor to remember about the focal length of your lens is that the longer the measurement, the narrower your field of view (or, greater the enlargement of your subject); the shorter the measurement, the wider your field of view, the smaller your subject will appear. Put another way, the longer focal length allows space for fewer subjects in your frame, and the shorter focal length allows more subjects to be included in your frame (see Figure 4.9).

In addition, the longer the focal length, the more compressed the distance appears going away from the camera (called the Z-axis) due to background magnification. Also, movement across the front of the camera (the X-axis) appears to be accelerated while movement on the Z-axis is diminished. The apparent distances on the Z-axis using a short-focal-length lens appear to be increased (due to foreground magnification), and movement on the X-axis appears to be slowed down while movement on the Z-axis (toward or away from the camera) accelerates. The focal length of a lens also determines its ability to focus over a range from close to farther away from the camera, called *depth of field*. Other characteristics of lenses determined by the focal length are explained later in this section.

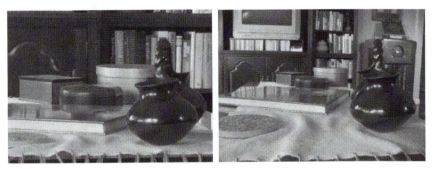

Long Focal Length Short Focal Length

FIG. 4.9 – A long-focal-length shot (on the left) enlarges the subject and compresses the appearance of distance on the Z axis. A short-focal-length shot (on the right) decreases the size of the subject and increases the appearance of distance on the Z axis. © Robert Musburger.

Focus

The ability of the lens to concentrate light reflected from a subject to create the sharpest image is called *focus*. Focus is a relative term, because a lens is in focus on an image when that image appears to you as sharply and clearly as possible at the *plane of focus*—typically, the surface of the image sensor(s). You may focus an image in two separate parts of the optic system: front focus and back focus, both of which must be accurately set in order to achieve that sharp, clear image.

The most obvious way you bring your image into focus is the front focus. You achieve front focus by adjusting (usually by turning the barrel of the lens) until the image has the sharpest clarity at a point behind the lens called *the focal plane*. Almost all manual focus lenses have focusing marks on the barrel of the lens (in feet or meters). If the focus barrel is turned to line up, say the 10 feet indicator with the focus mark, then the plane of focus is 10 feet from the surface of the camera's image sensor(s). All consumer, a few prosumer, and most DSLR cameras also utilize one of two types of *autofocus* (AF) systems: active AF (used by less expensive, consumer camcorders) and passive AF (used by more expensive camcorders and DSLRs). Active AF cameras emit pulses of infrared light (effective within 20 feet or 6 meters of your subject) that are picked up by a sensor and judges the distance based on the amount of time it takes or the intensity of infrared light reflected back from the subject. A microprocessor circuit in the camera computes this information and sends it to the focus motor that adjusts the focus accordingly. The passive AF system determines the distance to the subject by analyzing the image itself. In other words, the camera's AF processor actually "looks" at the scene and drives the lens back and forth searching for the best possible focus in much the same way you would in manual focus—only, much faster. Although autofocus can be useful under certain production situations, if the subject is not typically in the center of your frame, many AF cameras have a hard time accurately focusing on your desired subject.

The second way to focus your lens is via the back focus. Back focus involves adjusting either the lens body or the image sensor's position relative to the lens until an image located an infinite distance from the camera is in sharp focus on the surface of the chip(s). The back focus is seldom in need of adjustment on fixed lens consumer or prosumer cameras, but can become an issue when working with interchangeable lenses on DSLRs, professional broadcast, or digital cinema cameras. Typically, this is a technical

adjustment done by a video technician and should not have to be readjusted unless the camera or lens is jarred or bumped out of adjustment.

Focusing your zoom lens is a bit more complex than focusing a prime or fixed-focal-length lens. The lens must be zoomed in to its maximum focal length, framed and focused on the intended subject (if framing people, the eyes are a good target for this), and then zoomed back out to the desired framing. This process is called *calibrating the zoom* and once done—provided subject to camera distance does not change radically—all subjects located the same distance from the camera as the original subject will be in focus. An added benefit of calibrating the zoom is that, as you zoom out to the widest framing, everything will remain in focus throughout the entire zoom range without further adjustment (unless the back focus is out).

Another important term used in describing the focal properties of your lens is its *hyperfocal distance.* This is the distance from the camera's plane of focus to the first point where objects are in focus when the lens is set at infinity. If you are shooting live, breaking news or any live action where there is little time or ability to focus your subject (and quickly adjust your lens to keep it in focus), the hyperfocal distance of your lens will give you an indication of how close you can be to the subject while keeping everything (to infinity) in your field of view in focus. It is important to note that the hyperfocal property of your lens can be greatly affected by your aperture setting.

Aperture

The third basic characteristic of your lens is its aperture or iris setting. To better control the amount of light that strikes the surface of your camera's image sensor(s), an iris or variable opening is built into the lens. In the early days of photography, a numbering system was developed that is still in use today—not only in photography, but also in cinematography and videography (see Figure 4.10).

The carefully calibrated sizes of the opening in the aperture are labeled with numbers called *f*-stops. Although the numbering system may seem strange to you, each full *f*-stop doubles (if opening) or halves (if closing) the amount of light allowed to pass through the lens. The *f*-stop number is the ratio of the focal length to the diameter of the aperture opening. The common full *f*-stops used in videography are *f* 1.4, 2, 2.8, 4, 5.6, 8, 11, 16, and 22. One of the confusing aspects of *f*-stops is that as the number increases in size, the aperture diameter decreases, allowing less light to pass through the lens. The

FRONT FOCUS - BACK FOCUS

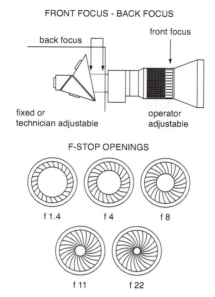

F-STOP OPENINGS

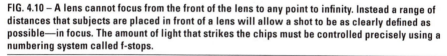

FIG. 4.10 – A lens cannot focus from the front of the lens to any point to infinity. Instead a range of distances that subjects are placed in front of a lens will allow a shot to be as clearly defined as possible—in focus. The amount of light that strikes the chips must be controlled precisely using a numbering system called f-stops.

converse is also true: the smaller the *f*-stop, the more light that passes through the lens. In addition, the term *stop down* means to close the aperture or increase the *f*-stop number; to *open up* means to increase the size of the aperture opening but lower the *f*-stop number. An easy way for you to remember the change is to think of *f*-stops as fractions: 1/22 is smaller than 1/1.4.

Depth of Field

A fourth characteristic of lenses, depth of field (DOF), is dependent on the three characteristics already described: focus (camera to subject distance), focal length (field of view), and aperture (how much light you let in). The DOF of a lens can be increased or decreased by altering any one of these three variables. For example, if you wish to increase the DOF of your framed image, you can either increase the subject-to-camera distance, decrease the iris aperture or decrease the focal length of your lens. The converse is also true (see Figure 4.11). Many interchangeable lenses used on DSLRs and Digital Cinema cameras provide DOF markings for specific *f*-stop numbers right on the lens. However, most video camcorder lenses have no such markings. A good rule of

Deep Depth of Field Shallow Depth of Field

FIG. 4.11 – Increased depth of field allows subjects to spread out closer and farther away from the camera to remain in focus (on left), and it allows the camera operator flexibility when covering action sports and news. Shallow depth of field (on right) concentrates the audience's attention to specific parts of the frame or specific subjects. © Robert Musburger.

thumb used by many photographers and cinematographers in estimating their DOF is the "one-third/two-third rule." Simply stated, for any given *f*-stop, the depth of field expands twice as far behind the plane of focus as in front of it—so, if you focus on a subject 10 feet away from you and the image looks in focus 5 feet in front of your subject, the picture will be in focus 10 feet behind your subject as well.

Depth of field is critical when you try to focus on close-ups, on rapidly moving subjects, such as in sports, and when light levels are limited. You also may use DOF creatively to exclude some subjects by placing them out of focus but within the frame. The selective use of focus and defocus that defines an image's DOF is called the *bokeh effect*. Bokeh (pronounced bow-kay) is Japanese in origin and refers to blur or a blurry quality of an image's background that helps to define and focus viewer attention to the foreground subject and a definitive quality of the "film look" sought-after in digital cinematography. The most common technique used to create the bokeh effect is a shallow DOF created through a wide-open aperture.

Viewfinder and Camera Controls

Viewfinder

To see subjects you have included in your picture frame, you need an accurate viewfinder designed to accompany the camera. The viewfinder is usually attached to the camera body so that the camera may be either handheld or tripod mounted.

A viewfinder is simply a small electronic video monitor with an attached eyepiece to protect your eye while viewing. When looking through the viewfinder you will see what the camera sees and exactly what is being recorded by your camcorder because the picture appears in the eyepiece after it has been processed. Most cameras have menu selectable demarcations for the frame size (matching the aspect ratio you are using) as well as a screen center mark to assist in image framing or subject placement within the frame. Most cameras utilized small signal lights inside the viewfinder hood so that you can monitor the operational characteristics of the camera without taking your eye from the viewfinder. Signal lights may tell you that you are recording (this *tally light* may also be mounted outside your camera informing your subject as well), if the light level is too low, if the tape is about to run out, or if the battery is running low. In addition, an indicator shows when you have achieved white balance during the white-balance action (see Figure 4.12).

Most viewfinders are mounted on the left side of your camera, making it difficult if you use your left eye to operate the camera. If you wear eyeglasses, you also may experience difficulties looking into the viewfinder. Some viewfinders on professional cameras can be rotated to the right side of the camera for operators who wish to use their left eye for viewing. Many viewfinders can be rotated into positions that are more comfortable for you if the camera is held under the arm or over the head. Most digital cameras include a flat screen viewfinder (or monitor) that swings out from the side of the camera, usually the left side, again designed so you may view your subject with either the right eye or both eyes.

The majority of viewfinders include contrast and brightness controls for adjusting the monitor in the viewfinder. You must not adjust these controls except when the camera

Viewfinder Menu Choices

FIG. 4.12 – Depending on the camera manufacturer and model indicator lights viewed inside, a viewfinder may indicate if the tally light is on, if the light is too low to operate, battery level, audio level, and length of recording time. A menu may give the operator a choice of using auto or manual iris, white balance, shutter speed, frame rate, aspect ratio, gamma settings, and other technical controls. (Courtesy Panasonic.)

Viewfinder and Camera Controls

is either focused on a well-lit test pattern or is generating an internal test pattern called *color bars.* If you attempt adjustments while shooting anything other than a test pattern, the viewfinder may be incorrectly adjusted in an attempt to compensate for a poorly lit subject and result in your actual recorded image being too dark. Most professional broadcast camera viewfinders provide only a black-and-white image for more accurate focusing, but the newer flat screen viewfinders are color monitors. All digital video cameras provide a series of menus visible in the viewfinder or as a separate screen mounted on the side of the camera (or both), enabling you to set camera features and lens controls.

Camera Controls

You will find that each brand and model of camera and recorder may have different controls and, more than likely, different labels for the same controls. The description in this section uses the usual labels for the most common controls on digital video cameras. The same controls described here, plus others specific to a particular model of camera, may be accessible through the menus. Always consult your operation manual before attempting to operate any piece of equipment as complex as a digital video camera.

Bars/Gain Selector

If you are using a high-end prosumer or professional broadcast camera, the first control you set is the bars/gain selector. Generally, the two functions are combined on one control, but on rare occasions they are separated. When the selector is set to "bars," a color test pattern generating SMPTE (Society of Motion Picture and Television Engineers) color bars will appear in the viewfinder; these usually originate internally in the camera. This test signal is necessary for you to set the brightness and contrast controls on the monitor accurately. In addition, you should always record color bars for 30 seconds to 1 minute at the head of each tape, disc, or solid-state recording media at the start of each shooting session (repeat this each time you change recording media). This signal will be invaluable later for troubleshooting if there are problems with either the camera or the recording. The gain selector, which also may be labeled "sensitivity," provides a variety of increases in video gain in case you find light levels are too low for shooting at the normal gain position. The switch usually is marked with several steps: 6 dB, 9 dB, 18 dB, and so on. Each of these steps provides you with the equivalent of one more *f*-stop of amplification. For DSLRs and Digital Cinema cameras, you achieve this function by adjusting the camera's ISO setting; higher ISO levels are roughly equivalent to "boosting" the gain in a video signal. The price paid for the use of this control is that video

Side Panels and Controls

FIG. 4.13 – The location of specific controls situated on the sides of cameras will vary depending on the model and brand of the camera. Check your operator's manual before working with any video equipment. (Courtesy Panasonic.)

noise increases as higher gain/ISO levels are used. Video noise appears to your eye as random pixel artifacts, or "crawling," on the surface of the picture (see Figure 4.13).

Color Temperature Control/Filter Selector

Color temperature is a characteristic of visible light that has important applications in lighting, photography, cinematography and videography. Color temperature is conventionally stated in the Kelvin scale (the unit of absolute temperature measurement abbreviated as K). For example, candlelight is around 1,800 K, the lighting in your home tends to be 2,700 to 3,300 K while most television studio lighting is 3,200 K, overhead florescent office lighting is around 4,600 K and bright daylight ranges from 5,400 to 6,500 K. In the Kelvin scale, blue occurs at higher temperatures, while red occurs at lower, cooler, temperatures. This is the opposite of the cultural associations attributed to colors in which red is considered "hot" and blue is considered "cold."

Most professional-quality video cameras will have built-in filter wheels (sometimes more than one on broadcast cameras) that allow you to color correct for different lighting conditions and for light intensity reduction. You can access the color temperature control from the side or the front of the camera. Turn this wheel to select a particular filter or no filter. The no-filter position is intended for use under quartz or metal-halide studio lighting. For outdoor shooting, you will need to match the color temperature of daylight, the filter you use to do this is either an 85 (yellow), or it may be labeled as a

5,600 K or 85 + ND (neutral density) filter designed to add the yellow that is missing from the blue daylight. The ND filter added to the 85 compensates for bright sunlight, which might provide too much light for the video camera. The standard one-wheel camera— prosumer or professional broadcast—will have several ND filter intensities to choose from in combination with the daylight color filter. Typically, in use are the daylight + 1/4 ND for open sunlit areas on clear days (allows 25 percent of light to pass through), and daylight + 1/8 ND (allows 12.5 percent of light to pass through) for very bright daylight scenes. In addition to these positions, you may have several other choices of different intensities of ND filters. On two filter wheel professional broadcast cameras there may also be an 80 (blue) filter, labeled 3,200 K for interior studio lighting correction, or an FL-M filter (magenta) to help compensate for fluorescent lighting. You may find additional camera controls on menus visible either in the viewfinder or on a panel on the side of the camera.

White Balance

Once you have chosen the proper color temperature filter to match the lighting under which the shoot is to take place, you must white balance the camera. Fill the camera with a pure white source, generally a card or the back of a clean white T-shirt (never use snow, it will cause your video to take on a bluish hue), and then hold down the white balance or auto-white button for several seconds. This electronic process tells your camera that, under the lighting conditions present, "this" frame is white. With this information, the camera calibrates the red, green, and blue mix to render white. Many cameras include a built-in automatic white balance that does not need setting except under extreme lighting conditions (see Figure 4.14).

Rear Panels and Controls

FIG. 4.14 – Most controls are located in logical positions so that the camera operator can manipulate them easily without taking his or her eye from the viewfinder during production. (Courtesy Panasonic.)

On better cameras, the following controls will likely be found on the camera body itself:

- You may use a power selector switch to indicate whether the camera has a battery mounted on it, is powered with its own separate AC power supply, or derives its power from the recorder's power supply or battery.
- A record start switch may be mounted on the camera body, but more than likely it is mounted on the lens handgrip close to the thumb for easy use. This switch allows you to start and stop the recording with your thumb without leaving the camera or taking your eye from the viewfinder.

The following controls are usually located on the lens or lens mount:

- The iris mode control allows you to choose between setting the iris manually or letting the camera's automatic iris circuits set the iris.
- The iris inst. control is designed so that you can zoom in on the surface that is reflecting the average amount of light for that scene, such as the face of the subject. Press the iris inst. control, which locks the iris at that setting, and then zooms back or pans to whatever framing is needed or to the beginning of the scene. A DSLR camera's built-in spot meter performs the same function.
- The zoom mode control allows you the same option for the zoom lens. You can either zoom the lens manually or use the lens's motorized control to zoom the lens.
- The zoom lens control is usually a rocker switch (or servo) that allows you to press one end to zoom in and the other end to zoom out. The harder you press, the faster the lens zooms. A gentle touch produces a slow, smooth zoom (also called a "creep" or "sneak"). On some cameras, an additional control allows you to set the speed range of the zoom control from very slow to very fast.

One additional control may be mounted on either the lens or the camera body. The return video control is a button that, when pressed, feeds the picture being played back from the record deck into the viewfinder, allowing you, the videographer to review the images just recorded.

Camera Supports

One of the first visual characteristics separating a novice from a professional videographer is the stability of the picture. Although you may be able to handhold most cameras—and some professional digital cameras are so small that a tripod seems redundant—a

Camera Supports

steady, controlled picture is still essential if you wish to produce a professional-quality video picture.

Tripods and Body Mounts

The standard method used to support a video camera is a tripod, also called *sticks*. A tripod has three legs that you may collapse and individually adjust in length to provide a solid, level support for the tripod head. The head of the tripod is designed to fasten to the tripod legs and allow you to swivel the camera from side to side on a horizontal plane, called a *pan*, and pivoting the camera up and down is called a *tilt*. To make smooth movements, the camera's center of gravity must be perfectly balanced on the tripod head, better tripod heads provide you a method for precisely leveling the head by viewing a leveling bubble built into the tripod. The less expensive tripods require you to adjust the length of the legs to achieve a level camera, but most professional tripods utilize a "ball and bowl" leveling mechanism where the "ball" of the tripod head (typically 75mm or 100mm) fits into the tripod "bowl." By loosening the bowl clamp, you can swivel the ball head until the leveling bubble is exactly centered; tightening the bowl clamp secures the leveled head. Most cameras are equipped with a quick-release camera plate that fastens to the bottom of the camera and allows you to easily snap the camera onto the top of the head or snap it off for easy removal (see Figure 4.15). Another attribute of the tripod head is the pan handle(s) that allow you a means of initiating and controlling camera movement; in some situations you may attach controls to the pan handle(s) that allow you to adjust camera focus, zoom in or out, or start/stop recording without having to physically touch the camera itself.

Depending on how professional (and expensive) a tripod you want, you will find heads manufactured in a variety of designs. The critical factor in the design of tripod heads is the method you use to provide enough back pressure or drag so that you can make smooth steady pans or tilts. The method for creating drag separates the amateur tripods from the professional tripods. The least expensive and most common heads for the consumer-model tripods are friction heads that develop drag by the friction of two metal-surfaced or fabric-surfaced plates rubbing against each other. It is difficult, if not impossible, for you to pan or tilt smoothly while recording with a friction head.

The next most expensive and higher-quality head available to you develops its drag through a set of springs. In some designs with lighter weight cameras, this system works well. The most suitable and expensive is the fluid head. The movement of a thick fluid

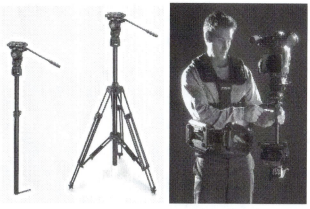

| Monopod - Tripod | Body Mount |

FIG. 4.15 – Camera mounts must perform two critical functions for the operator: provide a means for controlled, steady pans and tilts, and at the same time, if needed, give the operator the freedom to move the camera in space without being tied to the earth. (Courtesy Sachtler, GlideCam.)

from one chamber to another creates the drag. This provides the basis for you to make the smoothest and most easily controlled pans and tilts (see Figure 4.15).

Body mounts range from a simple shoulder hook and pistol grip to hold the camera to a complex gyroscope or spring-controlled full-body vest that encloses your body. Such a mount allows you complete flexibility to walk, run, climb stairs, or turn in any direction without losing framing or disorienting the audience. As cameras became lighter and easier to handhold, the problem of developing methods and systems of accurately controlling the positioning and movement of the camera has brought about a variety of new and flexible mounts to fulfill the needs of whatever shot an operator is called upon to create.

Cranes, Dollies, and Pedestals

In the professional world, many other support systems are used for single-camera production. Some of them are cranes, booms, dollies, camera sliders, and pedestals. Most of these systems are expensive, bulky, and large. However, they do contribute a wide variety of potential movements that the director in a production may use when needed (see Figure 4.16). Some tripods are equipped with pneumatic pedestals that allow you to smoothly raise or lower the camera, however, these tend to be dedicated studio support options and are seldom used in the field. More typical of single-camera productions in the

Camera Supports

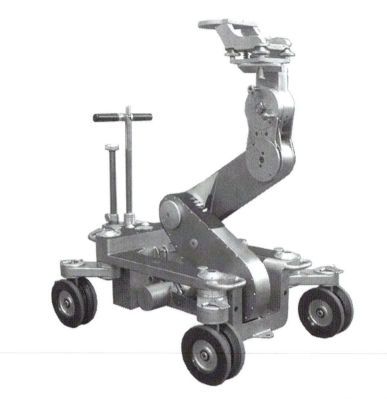

FIG. 4.16 – Dollies, cranes, jibs and pedestals are manufactured in a variety of sizes and styles. (Courtesy Chapman and Losmandi.)

field are cranes or booms. Filmmakers love crane or boom shots. These shots start out high and wide (or low and close), and the camera slowly descends (or rises) to eye level (or overhead) by the end of the shot. A crane is typically mechanical and steerable, accommodating the camera operator, camera, and camera mount on a platform that is raised or lowered at the end of a long arm. A boom accomplishes this same movement, but the camera is either remotely mounted on the end of an arm and controlled by the camera operator at the opposite end, or, the camera operator stands next to the camera and manually raises or lowers the camera on the end of the boom arm while controlling camera framing. A dolly is a movable device with wheels that allows you to mount your camera on a tripod and roll it about. The most common type of dolly is called a *doorway dolly.* Dollies typically move about on large, soft inflated tires that give a smooth ride over flat surfaces or utilize hard wheels that roll over track (or rails). Initially designed for DSLRs and prosumer camcorders, another type of camera support called a *slider* provides another means of

smooth movement for the camera operator. Camera sliders consist of a set of bracketed tracks that may mount to either a tripod or a light stand—sometimes two—or have feet allowing you to use them at ground-level. The slider has a movable carriage that you can attach your camera to directly, or you can attach a tripod head between your camera and the carriage for panning, tilting or other angle options. Some sliders can also accommodate a motor that can be set to move the camera at a constant speed or according to parameters that allow for time-lapse shots with movement. The idea behind using a camera slider—or any other movable support system—is to give you the ability to shoot compelling *tracking shots*. Tracking shots create a sense of movement and add an air of professionalism to your work; lending a cinematic feel to any kind of scene you shoot.

Some of the same camera movements may be created by exploiting simpler pieces of equipment such as raising or lowering the camera while attached to a monopod, or having the camera operator seated in a wheelchair or grocery cart while being pushed or pulled. Another way for you to move a camera while recording is to simply add wheels to the tripod, but this is not a very stable or satisfactory method compared to those already discussed. Alternatively, you could sit in a van to shoot from a side or rear door as a means of getting movement into a sequence. It helps to let a little air out of the tires first to smooth out the ride a bit. Handholding the camera in a moving vehicle—whether it is an automobile, airplane, helicopter, or boat—absorbs some of the shock and vibration, but the more you can isolate the camera from the movement of the vehicle, the better. You might try supporting the camera in a harness made of the heavy nylon or rubber bungee cords used by motorcyclists and truck drivers, which may provide a type of flexible but vibration-proof support (see Figure 4.16).

It is possible for you to duplicate a 360-degree crane shot by placing the camera and tripod on a slow-moving merry-go-round. A friendly electrician or telephone installer may allow you to ride in the bucket on the crane truck for a raising or lowering shot, or you could rent a scissor lift from an equipment rental company to accomplish the same shots. Even riding up or down in a glass-sided elevator can provide you with an opportunity to take a long vertical shot. You can use a low mount without tripod legs, called a *high hat,* to mount the head near the ground or on the hood of an automobile or boat. One method of duplicating this effect is to clamp the head to a heavy board, such as a short length of a 2-by-12. Then you either set the board on the ground or clamp it to the hood or deck. A safety rope is a necessity for this type of operation. Finally, inexpensive "bean bag" camera rests are available from a number of manufactures that provide a soft, secure

Camera Supports

means of resting your camera on the ground, stabilizing a shot out of a vehicle window, or strapping the camera to the hood of a car for POV (point of view) shots.

Handholding the Camera

Sometimes videographers may feel constrained by mounting the camera on a tripod or any other support; it could be that you do not have time because you are covering a breaking story as it happens, or handholding the camera contributes an aesthetic that is called for in your script. Although it is always preferable to use a tripod or other means of stabilizing your camera during production, if this is not possible, here are some helpful hints on handholding a camera.

The first rule of handholding your camera is to replace the tripod with your body, even though the body is only a "bipod"—and a fairly unsteady one at that. By leaning against a third support to create a tripod, the unsteadiness of handholding can be minimized. Leaning against a wall, a post, an automobile, a building, or any other stable support to steady yourself while shooting is an acceptable substitute for the third leg of the tripod.

Hold the camera firmly on your shoulder, with your elbows held tightly against your rib cage. For an even steadier platform, hold the camera under your right arm. This works only if the lower camera angle is proper for the shot, and it is only possible if the camera's viewfinder can be swiveled up so that you can look down into it. An extended shoulder mount can also provide some stability (see Figure 4.17).

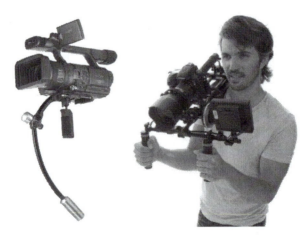

FIG. 4.17 – Handholding a camera is not only an art, but it requires a certain level of physical strength and body awareness. Breath control is critical when handholding a camera. Slow, steady breathing, rather than taking in large gulps of air, causes smaller changes in the position of the camera. (Courtesy SteadiCam and Redrockmicro.)

If you are attempting a "walking shot," remember that the professional body mounts are designed around springs and gyroscopes that keep the camera pointed in one direction and level at all times while dampening the typical bobbing motion of walking. You may partially duplicate this effect by using your body. Hold the camera on your shoulder or under an arm, watch through the viewfinder, relax your knees and keep them partially bent as you walk, holding the camera like a very full and very hot cup of coffee. This works better if you are walking backwards, but make sure someone is spotting you the whole time so you don't bump or trip into something. If the shot is supposed to be the POV of someone walking, then the slight weaving and bobbing that accompanies how we walk is acceptable. If not, you will have to spend a lot of time practicing before you can make a smooth tracking shot while handholding the camera.

When panning with a handheld camera, place your feet in a comfortable position at the finish of the pan. Then twist your body into the starting position. This unwinding effect allows your body to relax as it approaches the end of the pan, instead of building tension and the shakes that go with such tension. This same technique works somewhat the same in a lengthy tilt. Position your body in a comfortable position at the end of the tilt, not at the beginning.

Remember, your body was never meant to handhold a camera, and only through much practice, some additional equipment, and physical conditioning can you reasonably achieve a satisfactory shot by handholding.

Digital Recording

Recording

The fourth segment of your camera body is the recording section. This may be a tape deck, a CD or DVD burner, a flash drive, various types of solid-state media, or a digital hard drive. Each of these drives may be either removable or permanently mounted within the body of your camera. The design of each camera is somewhat dependent on the recording medium, and this area of camera design is rapidly changing.

The function of the recorder—whether an integrated camcorder or separate recording device (e.g., Aja Ki Pro or Atomos Ninja-2)—is to store the digital pulses that represent the sound and picture created by your camera and microphone in the form of ones and zeros, rather than as a continuously varying stream of electrons. The

storage for a digital signal is not that much different than storage for an analog signal, but in many ways it is a much simpler signal to record. Despite its simplicity, the digital signal must be recorded in such a manner that you may retrieve the digital impulses easily in as close to their original form as possible. Digital recorders, whether they are recording an audio or a video signal, produce checking and compensating signals designed to correct any errors that may inadvertently have been recorded.

The audio signal is fed either as a separate signal, or the signal is recorded with the video signal by embedding the audio within the video signal. The audio signal then becomes a segment of the video signal.

If your recorder is tape based, the tape is wrapped around a drum containing one or more video recording heads that rotate inside the drum in the opposite direction from that taken by the tape as it is moving around the drum. The video heads touch the tape just enough to record the video and audio signals in a series of segmented, slanted tracks across the tape. A digital tape in the pause mode shows you a single field of each frame.

If your recorder is disc based, the audio and video signals are cached internally to volatile memory (meaning, non-permanent) and recorded as impressions on the front or back of the disc (which is a slower process than capturing the video images and audio), depending on the individual system. The disc may be a standard DVD-R or CD-R, a Sony XDCAM optical disc, or a small 8-inch DVD-R disc. The signals must be encoded specifically for each type of disc.

If your camera records signals on solid-state media like SDHC cards, Compact Flash, or specialized media such as Panasonic's P2 or Sony's SxS, the cards must each be encoded for that particular media. The amount of programming allowed on each medium varies from a few minutes to hours, again depending on the specific medium and the codec used by the camcorder (see Figure 4.18).

Hard drives are designed and operate the same way the hard drive on your computer does, whether the drive is internal or external to the body of the camera. Solid-state drives (SSD) are like other flash media except they operate like very fast hard drives. They are more robust and less susceptible to data corruption or data loss than hard drives, but are more expensive than comparable-size hard drives.

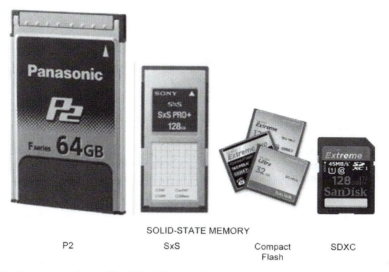

SOLID-STATE MEMORY

P2 SxS Compact SDXC
 Flash

FIG. 4.18 – Many means of recording digital data may be used to record the output of a digital camera. The recorder may be built internally or an externally as a memory system using any of several different solid-state memory recording devices. (Courtesy Panasonic, Sony, SanDisk, and Toshiba.)

Recorder Operation

Today's digital desktop video record decks are relatively easy to operate because their controls parallel the functions of other universal recorders—from audio recorders to DVRs. Once you insert the tape, disc, or solid-state media correctly into the machine and you apply power, either from batteries or from an AC power adapter source, operations take place via the familiar functions of record, play, fast-forward, rewind, pause, and stop. Most camcorders also have the ability to playback video to an external source (or to the built-in viewfinder or LCD monitor) by switching from camera to VCR mode; the controls are the same as on a desktop deck.

All desktop decks contain some means of measuring the amount of programming that has been played or recorded. On some video tape decks, if you set the counter at zero when a new tape is loaded into the deck, it is possible to keep approximate track of where shots have been recorded on the videocassette, thus enabling you or the editor to find that same shot at a later time. Professional and higher-end consumer record decks—whether tape or other digital media—measure usage by reading time code (TC), a signal recorded on the media at the time of the original recording. TC indicates the amount of time in hours, minutes, seconds, and frames that has elapsed from the

Digital Recording

FIG. 4.19 – Although the simplest means of downloading digital signals from original recordings is directly to a computer, there are situations when a computer may not be available or when monitoring or logging without a computer is needed. In that case, a multiformat player/recorder may be used to play back any format for monitoring or for dubbing one format to another without losing quality in the signal. (Courtesy Panasonic, AJA, and Atomos.)

moment you zeroed it and provides a frame-accurate "address" for every image (and synced audio) recorded (see Figure 4.19).

Most recorders include a multipurpose meter and a switch that you can set to read the video level, audio level, or state of the battery charge. You can find a switch that allows manual or automatic gain control of the audio located near this meter. Several warning lamps may also be a part of the control panel of the deck. These indicate when the machine is recording or is paused, when the battery is running low, or when the stock is about to end. On more advanced machines, there may be lamps that indicate high humidity, lack of (video tape) servo lock, or other malfunctions of your machine.

DVD and CD decks may offer additional controls: skip, program, repeat, or pause. Some DVD controls appear on screen, and you can access them by scrolling through menus and choosing an operation. Solid-state and hard drive readers also provide indications of shot location, timing, TC, levels, and operational controls.

Audio

Audio, in the past, has been the forgotten half of the audio-video production world. One of the biggest mistakes that beginning videographers make is to forget the importance of audio. With the arrival of digital audio and increased audience awareness of the value of quality sound, audio production now has become more important than in years past. Whether you are shooting news, corporate video, television entertainment, or independent film, nothing undermines the quality of your production faster than bad audio. Two important developments in audio have contributed to your ability to improve the quality of your production audio: digital audio and the condenser microphone. Both

have reduced the size of audio equipment and measurably increased its sensitivity and frequency response. But with HD and other digital productions, audio now becomes that much more important. Audio provides the clean, clear sound to match digital video, but at the same time, any noise, poor equalization, or other deficiencies you create in the audio become all the more obvious to the audience.

Microphone Types

Microphones (mics) are categorized in three ways: by their electronic impedance, by their element construction, and by their pickup pattern. Microphone choices are also made on the basis of their specific purpose or the type of audio pickup required.

Electronic Impedance

Microphones are classified as either low impedance or high impedance. Impedance is a complex measurement of resistance that also includes inductance and capacitance. All professional mics are low impedance. You need to connect a low-impedance mic to a two-conductor-plus-shield cable typically using XLR connectors. This allows you to connect to a balanced circuit, which provides you the best audio pickup. You may connect high-impedance mics to a single-conductor cable and either an RCA or miniplug, but these mics should not be used more than 5 to 10 feet away from an amplifier.

Element Construction

The microphone element (transducer) types today are the dynamic (moving coil), the ribbon, or the condenser. The dynamic mic is the most common, most rugged, and, for fast-moving coverage such as news or documentaries, the best frequency response for the least cost. The pickup coil converts sound-wave energy to electric energy without an outside power source or amplification. These mics can be designed to be relatively small and are available in any pickup pattern (see Figure 4.20).

The ribbon mic should be used for studio or booth work only, as it is expensive, heavy, large, and sensitive to movement, shock, or wind. It creates a fine warm vocal quality, especially for the male voice. Its transducing element is a thin corrugated ribbon suspended between the two poles of a heavy magnet. Although you may use a ribbon mic on electronic field production (EFP) shoots if the environment is controlled and the mic is kept out of inclement weather, ribbon mics are actually seldom used in the field due to their sensitivity and expense. The condenser microphone is gradually replacing most

MICROPHONE ELEMENTS

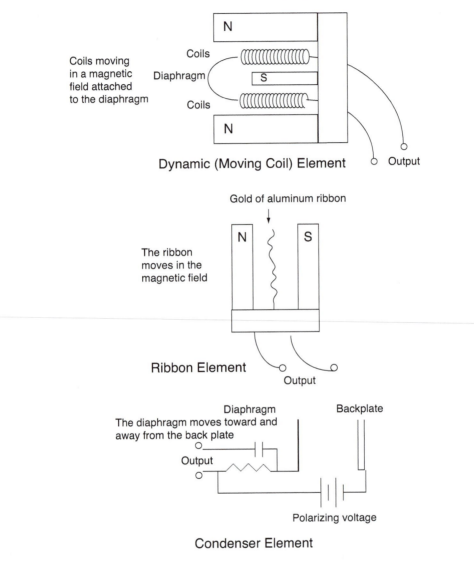

Coils moving in a magnetic field attached to the diaphragm

Coils

Diaphragm

Coils

N

S

N

Dynamic (Moving Coil) Element Output

Gold of aluminum ribbon

The ribbon moves in the magnetic field

N S

Ribbon Element Output

The diaphragm moves toward and away from the back plate

Diaphragm Backplate

Output

Polarizing voltage

Condenser Element

FIG. 4.20 – Microphone elements are constructed of three types of transducers: dynamic (moving coil), ribbon, or condenser.

other mics. Originally, it was expensive, heavy, large, and required amplifiers and power supplies located adjacent to the mic. With solid-state circuits and mini-preamplifiers powered by small batteries or by current supplied from the amplifier (48 volts "phantom power"), the condenser mic has become much more practical and universal. With its

built-in preamplifier, it is sensitive, has a fine frequency response, and is small and light-weight. The condenser mic can be designed in any pickup pattern and is manufactured in a variety of forms and price ranges.

Pickup Pattern

There are three basic pickup patterns: omnidirectional, unidirectional, and bidirectional. You will find little use for bidirectional mics in field productions, and you should reserve them for studio productions. If you stage the shoot in a controlled environment or interior location, a bidirectional mic may be used for interviews. The name is derived from its ability to pick up sound from two sides equally well while suppressing sound from the other two sides (see Figure 4.21).

Omnidirectional mics pick up sound from all directions, 360 degrees around the mic, with nearly equal sensitivity in all directions. Your ENG audio kit should contain at least one good omnidirectional mic for use by your reporter during direct address to camera or for "person-in-the-street" interviews (also called *vox populi* or *vox pop*).

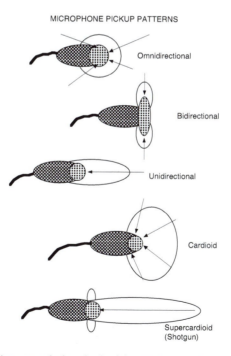

MICROPHONE PICKUP PATTERNS

Omnidirectional

Bidirectional

Unidirectional

Cardioid

Supercardioid
(Shotgun)

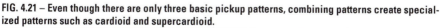

FIG. 4.21 – Even though there are only three basic pickup patterns, combining patterns create specialized patterns such as cardioid and supercardioid.

There is often general background ambient noise at any location, wild sound or nat (short for natural) sound, or sometimes room tone (the sound of a room with no one talking). You will find wild or nat sound is valuable material to record for use in editing to provide an audio transition between scenes and to create the atmosphere of the original location for later voiceover narration.

The most useful mics are unidirectional mics and have two styles of pickup patterns: cardioid and super-cardioid. A true unidirectional mic picks up sound only from the end of the mic. An extreme example of a unidirectional mic is a shotgun mic with a super-cardioid pickup pattern. It is designed to have a narrow (as narrow as 5 degrees) pickup pattern. Its sensitive area is predominately straight out from the mic, but there are nodes or areas to the side and behind within which you also may pick up sound. This cannot be avoided, even with the best and most expensive shotgun mics. Your EFP audio kit should contain several shotgun mics of various lengths and pickup patterns.

The cardioid mic is a special type of unidirectional mic designed to combine the pickup pattern of the unidirectional and omnidirectional mics to create a heart-shaped pattern in front of the mic. When this pattern is combined with a small capsule that can be clipped to your lapel or the lapel of the person you are interviewing, you can record clear, clean audio with minimal background noise. If you carry only a single mic, then a handheld cardioid mic is your best choice.

Some professional microphones are designed with variable directional settings. There will be a switch on the microphone capsule that changes the pickup pattern from omnidirectional, to unidirectional, to cardioid, for example. As with all equipment, multipurpose electronic equipment seldom performs as satisfactorily as equipment designed to perform a specific function.

Remember, the output of all microphones is an analog signal. You will need to convert that signal to a digital signal either in the preamplifier or in a digital-to-analog (D-A) converter located in your camera.

Mounting Devices

Besides the electronic design of a microphone, mics also are designed to fulfill a specific purpose. The purpose or how you mount the mic for a particular shot may determine partially the shape of the body of the mic you use as well as how it is physically mounted.

Top - Shotgun
Bottom - Handheld and Lavalier

FIG. 4.22 – Microphones are designed for specific purposes or frequency requirements and may include lavalier, handheld, or shotgun types. (Courtesy Sennheiser, and AudioTechnica.)

Four basic body styles and mounting methods fulfill most purposes: lavalier (lapel), hand-held, stand mount, and shotgun (see Figure 4.22).

You place a small capsule lavalier cardioid mic on the body of the subject. You may attach the mic in plain view, clipped to the talent's necktie, shirt, or blouse, or to a jacket lapel. A more specialized lavalier is worn on a headband, placing the mic near or to one side of the subject's mouth. You will use such a mic for vocalists and on-stage perform-ers. In many single-camera film productions where a shotgun microphone is impractical, you may hide small "rice grain" lavalier microphones tucked into lapel seams, under shirt buttons, in hairlines, or on the earpiece of glasses. These types of lavalier mics come in a range of colors in order to blend in with background clothing or skin tone.

You may use a handheld mic on a table or a floor stand mic. You may mount a micro-phone at the end of a small handheld boom called a *fish pole* or on a small, movable,

tripod-mounted boom called a *giraffe*, or, if space allows, on a large-wheeled boom that the operator rides called a *perambulator*. You usually use a cardioid or short shotgun mic mounted on booms. You can hang the same type of mic from a gaffer hook from the ceiling, from a hanging light fixture, door, or window frame, or from any other stable piece of tall furniture in the room. Mics may also be hidden behind objects that are between the talent and the camera: floral arrangements on a table, books, telephones, or any other set piece large enough to hide the mic and its stand. You may handhold a shotgun mic, but more often you should mount it on a stable stand mount to avoid inducing unwanted noise from handling (see Figure 4.23).

You may wire your mic directly to the camera, or it may be a wireless mic feeding a small transmitter hidden on the talent's body and picked up by a small receiver wired to the camera. Wireless mics are becoming more popular as the price and their sensitivity to other RF (radio frequency) signals in the area are reduced. Today's transmitters are designed to be smaller and more powerful, thereby correcting many of the past problems of interference.

For some field productions—sporting events, game shows, and live event coverage—you do not need to hide the microphone. Those situations allow you to place the mic or mics in the best position for maximum quality or sensitivity of audio pickup.

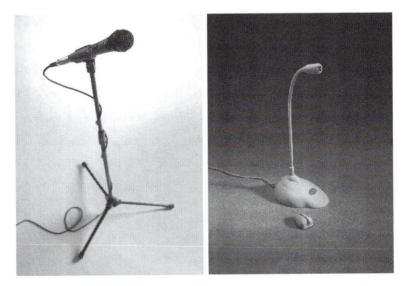

FIG. 4.23 – The mounting hardware for microphones depends on the need to reach the audio source and may include boom, stand, or desk mounting. (Courtesy AudioTechnica.)

Make certain you place the mic in direct line with the performer's mouth, below the face (or off-axis to the face so the mouth is visible), and depending on the type of microphone, approximately 6 to 12 inches from the mouth. A good rule of thumb is to literally use your extended thumb and fist to approximate the best distance from the speaker's chin to the mic; but learn to estimate this visually so as not to alarm your talent! The microphone should be close enough for clear pickup and the exclusion of unwanted sounds, but it should be far enough away to avoid picking up the popping of "Ps" or the breath flow from "Fs" or "Ss" and other plosive and fricative sounds.

In addition, you should place the mic so that its pickup matches the approximate perspective of the picture. If it is an extremely wide shot, then the audio should sound off mic; if it is a tight close-up, then the pickup should be intimate and the mic should be close. Often the type of environment—closed-in small room, outdoors, or a large, echo-filled auditorium—partially determines the best choice of microphone.

Non-microphone Audio Sources

In addition to recording audio from microphones, you may find it necessary to record non-microphone audio sources without using any mics. Such sources may be the output of amplifiers, public address systems, or tape or CD decks. Each of these produces high-level output, and you must feed the signal into a high-level, high-impedance input on the recorder. You must match impedance and level for a satisfactory recording. Do this by checking the output specifications of the high-level source and match it to the specifications of the recorder being used. If they do not match, then you must insert a matching transformer or amplifier into the circuit to guarantee a proper match. If not closely matched, either the audio will be badly distorted or the level will be too low for any practical use (see Figure 4.24).

Which Audio Track to Use

Another consideration is your choice of which audio channel to feed to a camera or record deck. All professional cameras and record decks offer at least two tracks for audio recording.

Midlevel cameras using such videotape formats also have audio tracks recorded in different positions on the tape stock. These formats record the audio digitally within the

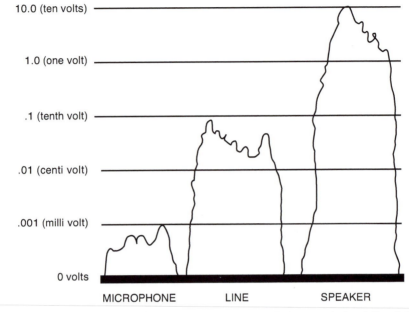

COMPARISON BETWEEN AUDIO LEVELS

10.0 (ten volts)			
1.0 (one volt)			
.1 (tenth volt)			
.01 (centi volt)			
.001 (milli volt)			
0 volts	MICROPHONE	LINE	SPEAKER

FIG. 4.24 – The three primary audio levels vary in voltage, from the very weak signal directly from a microphone, pickup head of turntable, disc, or tape deck, to the middle level of the output of a preamplifier signal called line level, and finally to the high level of the output of an amplifier intended to power a speaker or speaker system.

video signal as a pulse code modulation (PCM) integrated signal as well as longitudinal tracks. The digital tracks are stereo and are very high quality.

Audio pickup, whether it is analog or digital, is often ignored or thought of last, when in reality, audio often carries more than half the critical information in a story. It is important, then, for you to plan seriously for and spend time properly setting up microphones, mixers, and cables, and choosing audio channels for the best possible audio recording to match the quality of image you get from digital video recording.

Connecting Equipment

Before you consider connecting equipment, you need to understand the somewhat confusing world of cables and connectors. Unless a cable is permanently wired into a piece of equipment—such as a microphone, recorder, camera, monitor, or power source—the specific type of cable and specific cable connectors must be assembled and properly

connected. The connector at either end of a cable is a plug; the connector mounted on the wall or on the side of a piece of equipment is a jack. There are both female and male plugs and jacks, and it takes one of each to make a connection. The contacts on a female plug are contained within the plug; the contacts project out of the male plug. There are four major types of plugs/jacks: power, audio, video, and specialized digital connectors.

Cable Coiling

Before handling audio-video cables, you need to learn to coil a cable professionally after it is used. The professional method prevents damage to both the cable and the plugs on each end and provides an efficient means of quickly gathering a cable for proper storage and moving (see Figure 4.25).

Place one plug in your left hand pointing toward you with the cable strung out on the floor ahead of you. Slide your right hand down the cable (right thumb up) for about 15 inches (depending on how large the loop in the coil will be), grasp that point on the cable, lift it, and lay the cable across your open left hand (your right thumb should be pointing toward

FIG. 4.25 – Professionally coiling a cable seems to be confusing and difficult, but once mastered flows easily and quickly. Just remember to alternate the coils of cable in the loops held in your hand. The size of the loops depends on the weight of the cable. Heavy power cables need larger loops; lighter audio cables need smaller loops. © Robert Musburger.

Connecting Equipment

you as you make the loop), handholding the plug and creating a loop that hangs straight without any snags or twists. Then slide your right hand down the cable (thumb down this time), grasp the next section of cable and, as you bring the length of cable up, lift and twist it so that the loop now runs in the opposite direction (your right thumb should be facing away from you as you grasp the cable in your left hand). Alternating this procedure creates what are called over and under loops. If you follow these directions properly, you will end up with cable coiled in a solid set of loops. One way you can tell you did this correctly is to hold the two cable end plugs (one in each hand) and throw the cable out in front of you; if you coiled it correctly it will lay out flat without any kinks, twists, knots, or tangles.

Power Connectors and Plugs

Power connectors for your equipment carry either 110/220-volt AC or 12-volt DC power. Connectors for AC power are the same as the connectors on home appliances and are mounted on the walls of homes and offices. It is important for you to maintain polarity and proper grounding on all cables and plugs. Connect DC power using either DIN (a German connector), a special multipin XLR connector, or, for most digital equipment, a special microplug used only for 6-, 9-, 12-, or 15-volt DC. Each piece of equipment may require its own specific microplug, so check to make certain the correct voltage is applied to the equipment (see Figure 4.26).

Audio Connectors

As with video cables and connectors, you will find no universal standard for audio connectors. Some differences exist because of the origins of the equipment, the level of production professionalism, and the physical size of the equipment.

Professional microphone audio connectors are called *XLRs* and have a clip on the female plug or jack that either locks the plug to the jack or locks two plugs together. You must release the clip to separate the plug from the jack. XLRs are the best audio connectors to use because they cannot be unplugged accidentally, they are *balanced* (impedance is the same at both ends), and they contain two conductors (one positive, the other negative) twisted around a "core" (which adds strength) in addition to a shield (ground) that is never part of the audio path. XLR cables and connectors can run for both long and short lengths and provide the best audio connections and cable channels.

Many manufacturers use a miniplug (an 1/8-inch or 8mm mono tip/sleeve or stereo tip/ring/sleeve phone plug) or an RCA plug (a phono plug). You may use both of these

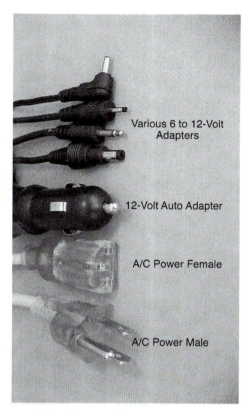

Various 6 to 12-Volt
Adapters

12-Volt Auto Adapter

A/C Power Female

A/C Power Male

FIG. 4.26 – Power connectors vary from micro or mini low-voltage plugs, to DIN, BNC, or standard 110-volt or 220-volt connectors. © Robert Musburger.

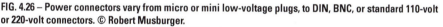

connectors for microphone and high-level audio connectors, but they can be easily mistaken for each other. However, they are not compatible, and damage can occur if you force an RCA plug into a minijack or vice versa. You can easily accidentally disconnect either of these plugs, mini or RCA, because they are held in place only by friction (see Figure 4.27).

You will discover that some professional equipment utilizes RCA (phono) plugs for line-level input and output audio connectors. This implies that the cable is a single conductor with a shield and is designed to operate with an unbalanced circuit. With line-level signals, the higher signal is less affected by outside signals. You may find that an unbalanced line may pick up FM signals from nearby radio transmitters and noise generated by any equipment operating in either the audio or radio frequency (RF) ranges. You should not use an unbalanced mic line longer than 5 to 10 feet to minimize picking up

Connecting Equipment

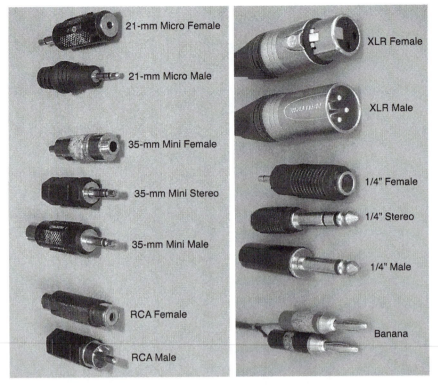

Small Audio Plugs Large Audio plugs

FIG. 4.27 – Audio connectors may be RCA, mini, XLR, or, in older equipment, ¼-inch phone or a banana plug. © Robert Musburger.

such noise and interfering signals. Some other audio circuits, such as headphones, may use a miniplug as a connector.

An older audio plug is the 1/4-inch TS (tip/sleeve or phone) plug, used by the early telephone companies. Because it is easy to confuse the terms *phono* and *phone*, it is preferable to differentiate audio plugs by the alternate terms listed previously. All 1/8-inch mini and RCA plugs and most 1/4-inch phone plugs are *unbalanced.* Unbalanced audio is what is typically found in home entertainment systems and should never be used in lengths longer than 10 feet. The cables used with unbalanced connectors have a single center conductor and a shield, for the audio signal to travel on. Audio also travels on the shield of the cable, which means that any interference that the shield picks up, will be inserted on the audio signal as "hum." If you mix balanced and unbalanced cables together in your production, you could get an annoying fault called *ground loop.* Ground loop faults can create a hum that can overcome

your audio signal. The best way to avoid a ground loop fault is to use only balanced cables and plugs. If this cannot be avoided, you can prevent ground loop hum by using an XLR DC block capacitor or a direct box inline between the balanced and unbalanced cables.

Video Connectors

There are six basic video plugs in common usage today. The RCA connector, unfortunately, has become standard for consumer and some small video equipment. Because it is a friction plug, you can unplug it unintentionally and easily, and because it is a common audio connector, you may misconnect cables by accident.

Professionals use a connector called a *BNC*, a name for which no two video specialists can agree upon the derivation. The BNC is designed so that it twists and locks into place, making a sure connection, but it is still easy to connect or disconnect with one hand.

BNC connectors are designed to carry only the video signal and are all male connectors. If BNC cables need to be connected together, you must use a female adapter called a *barrel* between the cables (see Figure 4.28).

You may use two methods of transmitting both audio and video information through the same cable. The first uses separate conductors inside the cable for audio and video. The multipin camera and 8-pin monitor cables and plugs are examples of multiconductor cables. You may use the second special cable and connectors. RF or F. To use an RF cable, you must combine the audio and video signals into one signal using a circuit called a *modulator*. On the other end of the line, you must use a *demodulator* to separate the audio and video signals again. Cable companies use the RF connector to connect their signal to a home receiver, and antennas are often connected with RF cables and plugs. The German DIN plug also is used on some European-manufactured equipment to carry both audio and video or, only video or power voltage signals.

You may use an S-VHS cable to carry video signals; it is split into two separate signals, Y and C, for higher-quality transmission of video.

Digital Connectors

Because digital signals are different from analog signals, you will need to learn an entirely new set of plugs, jacks, and cables designed and accepted by the industry. Also, since the digital world is in a state of constant flux, new connectors and cables are

Connecting Equipment

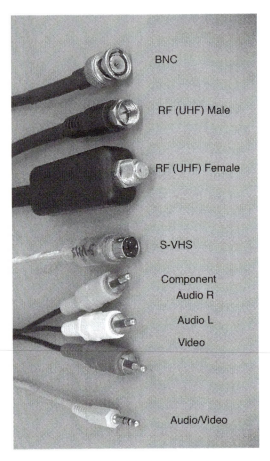

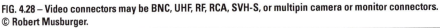

FIG. 4.28 – Video connectors may be BNC, UHF, RF, RCA, SVH-S, or multipin camera or monitor connectors. © Robert Musburger.

designed and placed in use periodically, usually for new and specific uses. The S-VHS plug listed previously also may be used for digital VHS (D-VHS) circuits. You use DIN plugs for connecting computer peripherals to the main central processing unit (CPU) of a computer (see Figure 4.29).

Quickly becoming the default digital audio-video connectors in common use today are the HDMI (high definition multimedia interface) and the SDI (serial digital interface) or HD-SDI (high definition-SDI) plugs. SDI (and HD-SDI) is a family of digital video interfaces standardized by SMPTE for professional broadcast video that utilizes the standard BNC or mini-BNC connectors with nominal data rate of 1.485 Gbit/s. HDMI is a compact

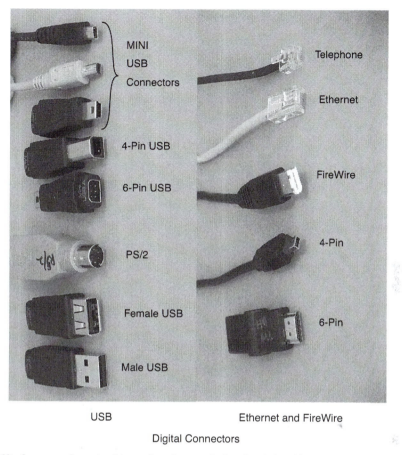

USB — Ethernet and FireWire

Digital Connectors

FIG. 4.29 – As new equipment and types of services are designed and placed into operation, there will be new connectors and cable systems. Pay close attention each time you connect or disconnect a cable to make certain you are matching the plugs and jacks properly. They are the weakest link in any system and most prone to damage at critical stages of a production. © Robert Musburger.

audio-video interface for transferring uncompressed video and either compressed or uncompressed digital audio data. Several professional HD video and video capable DSLR cameras capable of outputting uncompressed video to external recording devices or monitors use the HDMI interface, often called *Clean HDMI*.

Ethernet systems were designed in the 1970s and are still in use for local area networks (LANs), although, wireless local area networks (WLAN or, more commonly, WiFi) connections are now being built-in to some consumer and DSLR cameras. The Ethernet plug looks much like a standard telephone plug but is wider and carries more signals. You will

Connecting Equipment

find it useful for connecting equipment at greater distances than other cables without loss of signals. The standard telephone plug in use today is also capable of carrying digital signals when used in a digital subscriber line (DSL) to feed broadband data down a telephone line. You may also use F and RF cables to carry digital signals if the modulators and demodulators are designed for digital transmission (see Figure 4.29).

A leading standard digital connector is the universal serial bus (USB). Each end is shaped differently, even though both are modified female connectors. You connect the smaller end to the peripheral, the larger end to the computer. Extension cables and breakout boxes are designed to allow more than one cable to be connected to a single computer outlet for a flexible and faster means of moving data from printers or keyboards than you would attain from serial connectors and cables. USB 1.0 was introduced in 1996 with data speeds up to 12 Mbits/s. After going through several upgrade iterations, USB 3.1 (also called SUPER-speed+) was announced in late July of 2013 and anticipated to deliver data speeds up to 10 Gbits/s and is backwards compatible with USB 3.0 and USB 2.0; although, as of yet, no devices have incorporated the new interface. Another system of cables and connectors labeled by the Institute of Electrical and Electronics Engineers IEEE 1394, also known as iLink and FireWire, was introduced in 1996. Firewire 400 can support up to 63 devices at distances of up to 15 feet on one cable with a data speed of 400 Mbits/s. The latest iteration is Firewire 800, offering up to 800 Mbits/s while the Firewire S1600 and S3200 offer speeds of 1.6 Gbit/s or 3.2 Gbit/s using the same connectors as the existing FireWire 800. There are two types of FireWire connectors: a four-pin you use on camcorders and a six-pin you will find connected to computers and hard drives. Finally, although developed by Intel in 2009, Apple introduced the world to Thunderbolt, a new hardware interface in 2011 that allows for the connection of external peripherals to a computer at speeds up to 10 Gbits/s. Thunderbolt was originally conceived as an optical technology, however, Intel switched to copper connections to reduce costs.

Lighting

The function of lighting at its simplest is to provide enough illumination so that the camera can reproduce an image. You draw the complexity of lighting and lighting techniques from the need for the instruments to serve the aesthetic needs of the medium: to set mood, time, and location, and to draw attention to the critical portions of the frame.

Lighting instruments have evolved from both the stage and motion picture industries, just as most audio equipment evolved from the radio and motion picture industries. Digital

production has only increased the need for your careful and thoughtful consideration of lighting designs and techniques. The high quality of digital signals allows a greater creative range because of its increased sensitivity and dynamic contrast range, but that sensitivity also reveals errors in poorly designed and executed lighting plans.

Properties of Light

Of all the tools of the trade discussed thus far—cameras, lenses, tripods, microphones, cables, and connectors—lighting is perhaps the most critical to understand. Anything that gives off light, from the noonday sun on a cloudless summer day to a match struck in a dark room, can be used as a lighting source. *Natural light* is a term used to describe a nonelectric light source coming from nature without artificial alteration or augmentation. Usually, this means the sun, but more broadly it encompasses other natural light sources such as campfires, candles or lightening flashes. *Artificial light* is any light source generated through electricity—from a small LED flashlight to large 18 K Arrimax HMI movie set lights. Artificial lights are typically described as being either household incandescent (your traditional light bulb), professional studio tungsten/halogen or quartz (often referred to as lamps or globes), fluorescent (tube or compact), or light-emitting diodes (LED). Frequently, in single-camera productions the term *available light* is used to refer to light sources that normally exist in a given location. Available lighting most often includes a mix of natural and artificial light sources and can create its own unique set of lighting complications (as will be discussed later). More often than not, though, you will find that available lighting may not be sufficient to allow you to record properly exposed images. Augmenting your scene with artificial light sources is the logical choice, but you also want your audience to believe that the illumination of the scene still looks "organic" or natural to what they would expect from the scene's environment. Therefore, your lighting scheme for augmenting (or creating) a natural-looking scene should follow the logic of *motivated lighting*—in other words, your artificial light sources must augment or imitate existing sources in ways your audience expects. Manipulation of the lighting environment through motivated lighting separates your efforts from amateur lighting and is essential for creating natural lighting designs.

Light Intensity

There is no such thing as generic light; all light sources emit light with varying characteristics or properties. One characteristic or property of light is its intensity, strength, or brightness. Direct sunlight is obviously a more intense light source than an average

Lighting

household incandescent light. Artificial light intensity depends on the wattage of the lamp used (150-watt lamp is half as intense as an identical lamp at 300-watts), however, this is not the most accurate way to describe the intensity of the light source, just the electrical energy it consumes to produce light. Light intensity is sometimes indicated in lumens, the total amount of light output produced by a light source. The discrepancy between the wattage consumed by a light source and its light output in lumens is due mostly to energy produced as heat (unseen, but felt) and that produced as luminance (light); the more efficient the lamp, the less wattage needed to produce comparable luminance. For example, a 100-watt incandescent lamp emits about 1,300 lumens while a 23-watt compact fluorescent lamp emits about 1,500 to 1,600 lumens. Many video projectors use lumens to indicate the power of the light they are able to project onto a screen. On the set or location of your video production, you would measure light intensity not in lumens but in either foot-candles or *lux* (Latin for light). Foot-candles and lux are both units of measurement used to indicate the brightness of the light falling on (or reflecting off) your illuminated subject, while lumens measure the power of the light radiated by the light sources you use.

Hard vs Soft Light

Another property of light is a function of the directionality of the light source and the quality of light produced. At this point, it is impossible to describe the quality of light without taking in to consideration shadows and their edge; the area of transition between what is lit and what is not. A light source that produces a highly directional light (all light rays fall on the subject from a single angle) is also called a *hard light* because of the bright highlights and dark, sharp shadows it produces. Hard light sources tend to provide the majority of illumination in a scene and the sharper shadows create texture and depth. *Soft light,* on the other hand, lack directionality and provide smoother highlights and softer shadows. Soft lights also tend to be more diffused (light rays do not fall on the subject from the same angle) and appear to wrap around the subject's contours smoothing out features. It is important to note that the larger the area of the diffused light source, the softer the light will be.

Color Temperature of Light

All light sources are not equal in their actual color. Your eyes and mind compensate for this variation by creating the illusion that light within a certain range appears

white. To your eyes, light in your home at night appears the same color as outside at noon. However, to the "objective" camera, the color of light in these two situations is very different. As stated earlier, the actual measurement of the color of light is in Kelvin, based on the color of carbon heated and measured at certain temperatures. The Kelvin scale is an absolute, thermodynamic temperature scale and, unlike the degrees Fahrenheit and degrees Celsius you may be familiar with for measuring temperature, the Kelvin scale is not referred to as a degree but simply abbreviated with the unit symbol "K." The lower the Kelvin temperature, the more reddish yellow and "warmer" the color of the light. The higher the Kelvin temperature, the bluer and "cooler" the light appears.

There is no actual "white light" on the Kelvin scale. Typically, candlelight measures around 1,800 K. An ordinary incandescent light bulb measures 2,800 K. Professional tungsten-halogen or quartz lamps measure 3,200 K. Daylight varies from approximately 4,000 K to over 12,000 K, but the standard is considered 5,600 K. Today's film and digital cameras can be adjusted to operate accurately within a range of 3,200 K to above 5,600 K, but you must make proper adjustment to the camera to compensate for the color differences (see Table 4.2).

The critical factor concerning the color temperature is that a camera sees and reproduces the actual color of the light source as it is reflected from the subjects. You are able to adjust an electronic camera to compensate for any variation in the color temperature by the process of white balancing. To light a scene properly, though, it should be lit with consistently color-balanced light sources.

Professional lamps are accurately rated for their color output, but when shooting in the field, you may be in an environment where you cannot control the light source. Home incandescent lighting is warmer than studio lighting; office fluorescent lighting is bluer and greener. Because fluorescent light does not emit a specific color temperature, you can either filter the light at the camera or place filters on the tubes themselves to correct the temperature to match the camera settings. Newer fluorescent tubes now are available that have been designed to match either 3,200 K studio or 5,600 K daylight color temperatures.

If you are shooting next to a window, the daylight does not match the color temperature of the production lamps. As mentioned earlier in the discussion of available light, this situation is called *mixed lighting*. Mixed lighting presents your camera with several

Hard vs Soft Light

TABLE 4.2 – The differences in the actual color of light sources range from the full summer sun to the candle flame. Fluorescent sources also vary over a wide range, but not as widely as incandescent and natural light sources.

COLOR TEMPERATURES OF LIGHT SOURCES

SOURCE	DEGREES KELVIN	MIREDS
Match flame	1700K	588
Candle flame	1850K	541
Sunrise or sunset	2000K	500
Consumer lamps	2650K-2990K	317-345
Standard tungsten/halogen	3200K	313
Photoflood	3400K	294
Early morning, late afternoon	4300K	233
Daylight photoflood	4800K	208
HMI	5600K	179
Typical noon	5400K-5800K	185
Carbon arc	5800K	172
Overcast sky	6000K	167
Summer shade	8000K	125
Full summer sun	10,000K-30,000K	100

Comparable Degrees Kelvin for Fluorescent Sources

Warm white	3050
White	3500
Natural white	3700
Cool white	4300
Daylight	6500

light sources of different color temperatures; but, when you white balance your camera, you may not be able to accommodate all the variations in "white" present in your scene. This will result in some part of your scene appearing "bluish" or "reddish" or even "greenish" (if fluorescent lights are present). You should consider the color temperature of the available light sources by measuring them with a Kelvin temperature meter or by arranging to have all light sources be of the same color temperature. To change the Kelvin temperature of a light source, you may filter the source with large gels. Color temperature blue (CTB) gels, for example, change 3,200 K lights to match daylight, color temperature orange (CTO) change 5,600 K daylight to match tungsten/halogen or quartz lights, plus-green color temperature gels match 3,200 K lights to fluorescent fixtures while minus-green does the converse. These gels allow you to change the color temperature of your lighting instruments without effecting intensity or the property of your lights. Likewise, you can cover complete office or home windows with

CTO gels to balance the blue sunlight with the warmer tungsten/halogen or quartz production instruments.

Light Instruments: Floodlights

Besides available light (natural or artificial), you will use three basic types of field lighting instruments when shooting on location: floodlights, focusing spotlights, and fixed-focus instruments. Floodlights provide a broad, relatively uncontrolled, soft diffused light that you use to cover large areas and to fill in shadow areas. The most common field floods are fluorescent or LED (light emitting diode) banks, softlights, broads, and umbrella lights. LED banks are groups of LED instruments arranged in a frame for mounting on a gaffer stand (also called a Century stand or C-stand). LED banks are extremely energy efficient, durable and dimmable without suffering color temperature drift (they stay 3,200 K or 5,600 K through the entire dimming cycle from 100 percent to zero), but can also be quite expensive. Fluorescent lighting for film or video production use specially designed tubes that radiate light within a reasonable range to match the Kelvin temperature of either daylight or tungsten. These fluorescent lights use high-frequency ballasts that are flicker-free and do not produce the hum of standard fluorescent lighting. The newer units are portable and can be equipped with dimmers for better lighting control in the field. Like LED lights, banks of fluorescent lights can be used as key or fill lights and produce bright, soft, and very even lighting.

Softlights (soft-boxes) are the largest floodlights, but because they are now constructed of folding aluminum frames with a cloth reflector "box" and a light-diffusing translucent face, they are quite portable. Broads are smaller, boxlike instruments usually equipped with some type of adjustable flaps called *barn doors* to control the coverage of light. They commonly contain only one lamp. Umbrella lighting is more of a technique than a specific type of instrument, because you can fit any spotlight with an umbrella. The purpose of umbrella lighting is to focus light from a spotlight onto an umbrella-shaped reflector mounted on the instrument so that light strikes the inner concave surface of the umbrella and is reflected back in the opposite direction (see Figure 4.30).

Hard vs Soft Light

Light Instruments: Focusing Spotlights

Focusing spotlights are hard, directional light sources and are either open faced without a lens or lensed with a Fresnel or plano-convex lens. Lensed spotlights provide a higher

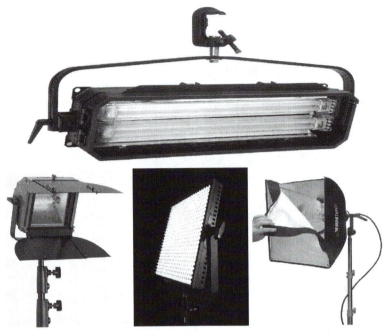

Top - Fluorescent
Bottom - Open-faced flood, LED, Softlight

FIG. 4.30 – Floodlights are designed to provide a soft, smooth, shadow-free source of light to act as fill or supplemental light. (Courtesy Arriflex, Lowell Lights, and LitePanels.)

degree of control with smoother, more controllable and cleaner shadows. Open-face spotlights have no lens and are, therefore, less controllable, but this lack of shadow control is made up for by the intensity of the light they produce. In fact, an open-face light will be far more powerful than an equivalent wattage lensed light.

Focusing spots are essential for your critical creative lighting. Generally, spotlights are used as the main or key source of light in a scene that requires the equivalent of sunlight as the apparent source. Spotlights come in a wide range of sizes from small handheld battery-powered spots to huge brute spots powered by generators or special power sources used on feature film and major television productions (see Figure 4.31). With the arrival of cost-effective LED lights that can be both battery or AC powered, the single-camera video producer has access to efficient, rugged and reliable illumination for both field and studio productions. Professional LED lighting come in all sizes—from camera mounted spot/fill lights to large banks of 1-foot square

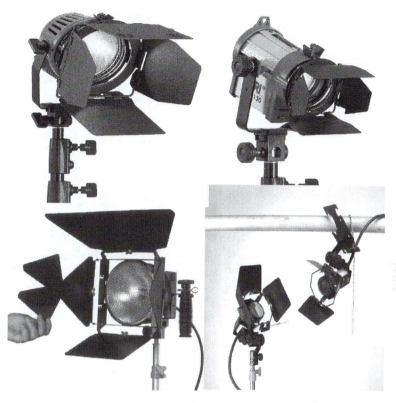

Top - PAR, Fresnel
Bottom - Open face, LED

FIG. 4.31 – Spotlights have been the workhorse fixtures of the production industry but are slowly being replaced by flexible and lightweight instruments to fit the subtle nature of digital productions. (Courtesy Arriflex and Lowell Lights.)

Hard vs Soft Light

panels—and produce enough light to illuminate your subject sufficiently for acceptable video images. Unlike standard tungsten/halogen quarts lights, LED lights can be dimmed to reduce intensity without changing the color temperature of the light. The film and television industry are quickly adopting LED lighting as the new "universal" light source of the future.

Light Instruments: Fixed-Focus

Fixed-focus instruments are designed around a sealed beam lamp (meaning the globe, reflector, and lens are combined in one, usually weatherproof, unit), similar to an auto

headlight. These lighting instruments use interchangeable lamps with highly efficient, fixed-focus parabolic reflectors. A lamp with a completely clear lens is called a *very narrow spot* (VNSP) and a lightly textured lens makes it a *narrow spot* (NSP). The nature of these lenses allows the lamps to project a beam of light with very little spread, making them excellent choices when you need to illuminate a distant background object that cannot otherwise be reached. With a more stippled effect on the lens, the light becomes a *medium flood* (MFL) and, if the stippling is more pronounced, the light is a *wide flood* (WFL) instrument. These fixed-focus lamps have a much wider beam spread than the VNSP or NSP lamps and can provide a great deal of light over a broad area. Fixed-focus lighting instruments are referred to as PAR (parabolic aluminized reflector) lights if their output is 3,200 K, and FAY if they are dichroic daylight lamps with a color temperature of 5,600 K (typically used for daylight fill). Single light instruments come in two varieties, those typically used on film sets that have solid rotary housings, barn doors, and scrim holders (e.g., MolePar), and cheaper theatrical versions, PAR cans, that lack these features and are popular as concert lighting. Alternatively, a bank of these lamps can be built into a group light (e.g., MaxiBrute) that allows each lamp to be turned on and aimed individually. You use such a group of PAR (or FAY) lamps to light a wide area with an even but controlled field of light.

You may operate both of these instruments from portable floor stands, and they may be driven by 110- or 220-volt AC power. They also can be mounted from a variety of gaffer mounts on walls, doors, or other sturdy objects.

Controlling Light

Because you seldom will have the opportunity to use a portable light dimmer board, control over the light output in the field becomes critical for creative shooting situations. Many of the spotlights you would use in the field have barn doors and scrim holders that allow you to control spill (unwanted light on your set) or to adjust the intensity. You can also use two simple and inexpensive portable instruments: reflectors and tents. Reflectors are large foam boards (foam core) covered on one side with a variety of surfaces: plain white, black, colored, or textured. You use these reflectors to throw a soft fill light into areas not easily reached with instruments or to provide light that will not cast an additional shadow. Black foam core can be used to block or prevent light spill. Tents diffuse light by allowing the lighting instruments mounted behind the fabric of the tents to create even light without creating unwanted shadows (see Figure 4.32).

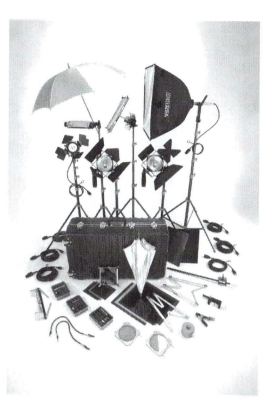

FIG. 4.32 – Even in the field, gaffe equipment designed to mount, hold, and position instruments, filters, flags, umbrellas, and scrims is important to properly place all of the lighting equipment required to create the professional setup. An EFP lighting kit should contain a set of gaffer's accessories: gobos, clamps, stands, weights, brackets, reflectors, and gaffer tools. A gaffer is a lighting technician. (Courtesy Lowell Lights.)

Power Sources

In the field, you may use three sources of power: the alternating current present in most buildings, batteries, and portable generators.

Portable generators are expensive, noisy, and, for video cameras, an uncertain source of stable power. The instability presents no problem for lighting directors, but the noise and expense might present problems for you or the director. Batteries for electronic news gathering (ENG) crews are becoming more dependable and last long enough for most ENG production situations, but they require care in handling the charging and discharging functions. The most dependable source of power for lighting will be the AC circuits in most buildings. Because lighting instruments draw much more current than any other piece of equipment, you need some knowledge of wattage, current, and voltage. The standard

power in the United States is delivered either at 110 or 120 volts. The lamps in lighting instruments are rated in watts, and the rating on power circuits in buildings is measured in amperage (amps). You can perform the simple translation of watts to amps or vice versa by using Ohm's law: wattage equals voltage multiplied by amperage. If voltage is treated as a constant of 100 (this provides a built-in 10 percent safety margin), then to find wattage simply multiply amps by 100. To find amps from known wattage, simply divide wattage by 100. Both can be done easily without a calculator (see Figure 4.33).

APPLICATION OF OHM'S LAW TO TYPICAL LIGHTING SETUP

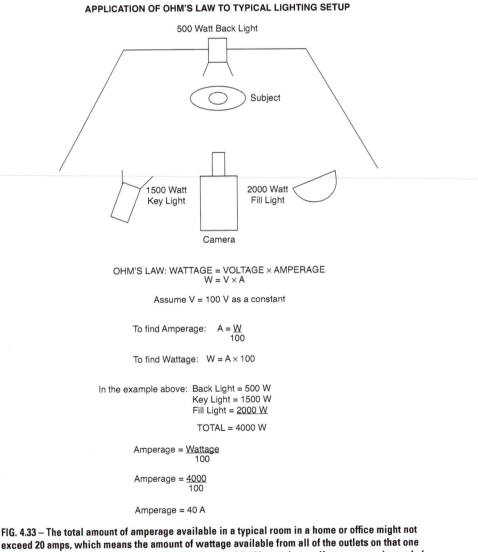

OHM'S LAW: WATTAGE = VOLTAGE × AMPERAGE
W = V × A

Assume V = 100 V as a constant

To find Amperage: $A = \dfrac{W}{100}$

To find Wattage: $W = A \times 100$

In the example above: Back Light = 500 W
Key Light = 1500 W
Fill Light = 2000 W

TOTAL = 4000 W

Amperage = $\dfrac{\text{Wattage}}{100}$

Amperage = $\dfrac{4000}{100}$

Amperage = 40 A

FIG. 4.33 – The total amount of amperage available in a typical room in a home or office might not exceed 20 amps, which means the amount of wattage available from all of the outlets on that one breaker cannot exceed 2,000 watts, or 1-1,000-watt and 2-500-watt lamps. If more power is needed, additional power cords must be run to other sources served by other breaker circuits.

A janitor or building engineer will control and know the location of the circuit breaker box that controls the AC circuits in the building. Find that person and the box before connecting more than two lighting instruments in one room. Most breaker circuits are limited to provide 20 amps or less. Each breaker is marked. Check before connecting your instruments, especially in any one room at a time.

Measuring Light Intensity

In addition to measuring the Kelvin temperature of the light sources for the best lighting, you must measure the intensity of the light sources and the light reflected from the subjects. Light intensity is measured in foot-candles or lux and both represent a unit of measure for quantifying the intensity of light falling on an object. One foot-candle equals about 10.08 lux (or, for a rough conversion, multiply foot-candles by 10 to get lux). A foot-candle represents the light from a "standard candle" at a distance of one foot. One lux is the illumination produced by a "standard candle" from a distance of one meter. To provide some points of reference, average daylight ranges from 32,000 to 100,000 lux (or, 3,175 to 10,000 foot-candles), while typical TV studio sets are lit at about 1,000 lux (or 99 foot-candles), whereas your typical office has about 400 lux (40 foot-candles) of illumination.

You measure the light coming from the light sources (incident light) by pointing an incident light meter directly at the light source. An incident light meter is typically the most accurate as it reads the light falling directly on your subject and will create an accurate and consistent rendition of your subject's tonality, color, and contrasts regardless of reflectance, background color, brightness, or subject textures. Incident light meters are also useful when setting up certain lighting ratios. To measure the light bouncing off of your subject (reflected light), use a reflected light meter or spot meter pointed at specific areas of the subject. Reflected meters do a good job of reading the amount of light bouncing off of your subject—the trouble is, they do not take into account any other factors in the scene, like variances in tonality, color, contrast, background brightness, surface textures, and shape. For example, reflected measurements of any single tone area will result in a neutral gray rendition of that object. A spot meter—like the kind that are internal to most video capable DSLR cameras—are a type of reflected light meter. Spot meters are useful in avoiding under- or overexposing your video by allowing you to measure the reflected light from a number of tightly defined areas (spots) in your image. With experience, you can check the light levels in your image's shadows, midrange, and highlights to determine the best exposure (see Figure 4.34).

Measuring Light Intensity

Light falling on subject:
Incident reading

Light reflected from subject:
Reflected reading

FIG. 4.34 – To take an incident light reading, your meter must be placed near the subject so that the key light falls on the meter (on left). To take a reflected reading, your meter should be placed between the camera and the subject with the meter aimed at the subjects (on right). © Robert Musburger.

Some light meters are designed to permit both types of meter readings, but professional-quality meters are designed specifically to read either reflected or incident light levels. You need to use both methods of taking light-level readings in order to determine the two types of lighting ratios necessary for quality lighting.

Lighting Ratio

Regardless of the cost of your digital camera, some minimum amount of light is required to produce an acceptable picture; this is called a *base light*. An incident light reading of the amount of light falling on the subject gives you or the lighting director two pieces of information: the base light level necessary to produce an acceptable picture and the ratio of fill light to key light. When you point the meter at the lights from your subject's position with just the fill light turned on and then take another reading with fill and key lights on from the same position, a numerical ratio, called *the lighting ratio,* is determined. The standard starting lighting ratio is 2:1, twice as much light from the key and fill as from

the fill alone. Separately, the fill light should never exceed half the intensity of your key light or you will likely have double shadows. A backlight ratio may also be taken, and it should be close to 1:1; the backlight should approximately equal the key light.

Contrast Ratio

The measurement for contrast ratio is a little more complex. You use a spot meter to accurately measure the amount of light reflected from the brightest object in the picture and then compare the light reflected from the darkest object. The difficult part is that when there are either highly reflective or very dark objects in the frame, it is not necessary to include these areas in the readings if you do not need to reproduce detail in either of those areas (see Figure 4.35).

Top - Reading reflected light from lightest object
Bottom - Reading reflected light from darkest object

FIG. 4.35 – To determine the contrast ratio of a scene, take a meter reading of reflected light from the brightest portion of the set and compare it to a meter reading from the light reflected from the darkest portion of the set. © Robert Musburger.

Measuring Light Intensity

Whereas, much of what you can do with lighting for proper exposure versus light for emotional or communicative effect depends greatly on your message and desired aesthetic, the dynamic range, or contrast ratio, of your camera will be the primary influencing factor. If your digital camera's contrast ratio is typical, it will likely be about 40:1. Therefore, the amount of light reflected from the brightest portion of the frame in which detail is necessary should not reflect more than 40 times the light than the darkest areas need for detail. If your lighting environment exceeds your contrast ratio, then more fill light will likely be needed on the dark areas or the light intensity will have to be reduced on the lightest areas. If you carefully light for the contrast ratio (or dynamic range) of your video camera, you avoid having areas blooming or flaring into a white mass or important areas appearing so dark that they look muddy.

Today's large-chip DSLRs, professional broadcast, and digital cinema cameras can accept a broader range of contrast than analog cameras, but because a digital image will show much more fine detail, you must accomplish the proper level of lighting. Lighting for digital productions simply requires more attention to small details that might not appear in images taken with an analog camera but will become obvious in images taken with a digital camera. Digital video cameras may operate with less light, but the light must be well balanced within the dynamic range of the camera.

Regardless of the changes in technology and advances in electronic signal processing, basic media production equipment operation varies little from the analog to digital. The care you take and the understanding you have of your equipment will mean more in the quality of finished production than will the cost or the technological advancement of the equipment. Remember, it isn't the paintbrush, but the artist that makes the difference.

Chapter Five
The Production Process: Preproduction

You can easily understand the organization of the production process: preproduction, production, and postproduction. Each step involves specific functions and operations that are interdependent and critical to the final production. Before either the production or the postproduction tasks can be accomplished, the foundation of any media project lies in the time and effort spent during preproduction.

Preliminary Forms

Before any serious work can begin on a video project, you must find a source of funding. You need to locate an interested party who will commit money for staff, crew, cast, research, facilities, equipment, and expendable materials. Sources of funds may be clients who have contracted for the specific project, such as television stations, networks, or cable networks. You should not overlook other funding agencies such as government agencies, the Public Broadcasting System, money-lending agencies, banks and savings and loan companies, or insurance companies as funding sources. Support for your production also may come from your school or local non-profit organizations that need media productions.

The Proposal

Regardless of the source, there is common information that must be supplied to the funding source. The first document you will create in your preproduction process is a proposal. A proposal generally is your responsibility as the producer, but it is better written with the assistance of the writer(s) and director. You must possess considerable knowledge of the subject to avoid mistakes, misinformation, or serious inaccuracy. You need to complete a site survey, interviews, library and Internet searches, and other research before the proposal can be written.

Once you have completed your research, organize all of the information into a concise, meaningful package that briefly explains the objectives of the production, the target audience, and the distribution methods. You need to clearly explain key

The Proposal

SAMPLE PROPOSAL FORMAT

Rivers and Streams Productions, Inc. will produce a ten minute, color program, to be used as a training medium for new and present employees of Mountain Industries. The program will target specific safety procedures necessary to be followed in the unique operation of logging in the mountains of Montana. The program will emphasize personal safety actions and procedures required by the Occupational Safety and Health Administration.

The shooting schedule will last for ten days, weather and other acts of nature notwithstanding. Postproduction will last for four weeks following the completion of principal videography. Shooting will start within two weeks of final script approval. Research and preparing of the treatment will last three weeks following the acceptance of the proposal. The final script will be prepared within three weeks of acceptance of the proposed treatment.

The program will be budgeted at approximately $35,000.00, depending on specific technical requirements of the script. Because the script calls for a series of dangerous actions requiring stunt actors and technicians, some allowances for costs and shooting overruns may be required.

The format will be semi-documentary/instructional with the program narrated and techniques explained by an actor representing a skilled and knowledgeable logger. Both incorrect and correct operational procedures will be illustrated. Employees, equipment, and facilities of Mountain Industries logging operation will be required for the production of this tape.

FIG. 5.1 – The proposal must be written succinctly and accurately, yet as a sales tool to convince a potential funder of the value of the project, the possibility of its completion, and the capability of the producer to create and complete a professional and viable production.

production factors, basic style and genre, unusual production techniques, and special casting and location considerations—along with the length, recording, and release formats—in easily understandable lay terms. You must be acutely aware of how you plan to distribute the completed project: the Internet, podcasting, streaming, broadcasting or cable-casting, or by converting it to a digital format on disc, hard drive, or memory media. You must understand that a non-media person may be reading the proposal and reaching a funding judgment. You must write the proposal so that all aspects of the production are presented clearly and avoid the use of production jargon (see Figure 5.1).

You must complete the proposal package with an approximate timeline and budget. You need to prepare both of these carefully and realistically. Too much or too little of either can discourage a client or funding source. Worse yet, either miscalculation can place you in a position in which it is impossible for you to complete the project because of insufficient funds or time.

The Treatment

Once the proposal has been written, your next step is to prepare the treatment, i.e., a narrative description of the production. Like the proposal, the treatment is intended to be read by the potential financial backers and is designed to assist them in making a decision as to whether they are willing to invest in your production and you.

In the first paragraph of the treatment, repeat key information from the proposal: title, length, format, and objective of the production. You can assume that the proposal and treatment will be presented and read at the same time.

You should write the treatment as if you are describing what the audience will see when watching a playback of the completed production. Dialogue is not used, but indications of the types of conversations or narration should be included. Also, you should avoid technical terminology such as dissolve, medium close-up, and voiceover. Remember, the person reading the document is not necessarily a media professional. Any person who controls financing should be able to make sense of the proposal and the treatment, which are, in essence, sales tools designed to sell your ability to successfully complete your production within budget and on time, while accomplishing the stated objective.

The Treatment

SAMPLE TREATMENT FORMAT

TITLE: Safety Training PAGE: 1
WRITER: T. Bartlett LENGTH: 10 min
CLIENT: Mountain Industries DATE: 10-10-09

The ten-minute training program will open with a montage of incorrect logging operations followed in each case by the possible disastrous and life-threatening results of such actions. Examples of such scenes are:

A logger without a safety belt steps back and falls from a tree stand.

A chainsaw jams and flips back into the logger.

A tractor tips over on the driver because it exceeded its tilt limit.

A logging truck driven too fast forces an on-coming car from the road.

A log falls from a truck being loaded and strikes a logger who was standing too close to the truck.

A logger refuels his saw improperly, causing a fire.

A truck or tractor becomes a runaway when left improperly locked down.

A logger dumped into the river and crushed by logs.

A log avalanche occurs because of careless blocking of a log stack.

This series of accidents will be enhanced with sound effects and dramatic music as well as the actual sound of each accident.

Following this montage, the narrator will walk into the scene and describe in general the dangers and reasons for following OSHA safety requirements for those working in dangerous occupations such as the

(continued)

FIG. 5.2 – The treatment must support the proposal by filling in more details of the production that the script will reveal when produced. It should read as an exciting description of action, characters, and plotlines, and it should sell the value of the production to the possible funder. The treatment also may become an outline for the script-writing process.

The potential financial backers should be able to read these two documents, proposal and treatment, easily. They should be able to imagine exactly what the production will sound and look like without any other explanation or verbal description from you (see Figure 5.2).

In reality, you may write both the proposal and treatment after the script has been finalized, because the proposal and treatment must accurately reflect the script. From a practical point of view, you may prepare the three preproduction writing functions simultaneously.

Your next step in preparing a production is gathering the information needed to create an accurate budget. Your budget form must include every conceivable value in materials, labor, equipment, travel, graphics, distribution, and legal costs. Budgeting is a science that combines economics and production knowledge. You need to complete a thorough study of the price of each item in the budget before any proposal is presented to a funding entity. To ensure accuracy while creating the budget, you need to check the costs of leasing equipment, renting facilities, labor agreements, and the prices of expendable items such as recording stock, makeup, and gaffer tape (see Table 5.1).

Your budget must be as accurate as possible, indicating you have carefully considered every aspect of the production and the best method of creating each aspect at a reasonable cost. You need to include enough flexibility in your budget to cover a certain number of uncontrolled activities that occur during any production, but you must keep within as tight a range as possible to avoid over budgeting and thereby frightening away a funding source. You should include a contingency item at the bottom to cover unexpected items, but you may include it in the final billing if the funds are not used during the production. Overhead is your profit value that covers normal business expenses such as office operation and non-crew staff costs.

The Treatment

TABLE 5.1 – The summary page of a budget indicates the total of each category summarized from one or more pages of the full budget.

PRODUCTION BUDGET

TITLE:	DATE:
PRODUCER:	DIRECTOR:
CLIENT:	PHONE:
ADDRESS:	MEDIUM: FORMAT:
CONTACT:	PHONE:
ALTERNATE:	PHONE:

1. SCRIPT (Rights, research, writing, duplication) _____ 0

2. STAGING (Sets, costumes, location fees, props) _____ 0

3. EQUIPMENT (Rental, lease, use fees) _____ 0

4. SPECIAL EQUIPMENT (Mounts, aerials, submarine) _____ 0

5. RAWSTOCK _____ 0

6. DUPING (Time code copies, off-line copies) _____ 0

7. AUDIO (Effects, fees, rights, sweetening, looping, etc.) _____ 0

8. MUSIC (Fees, rights, performance) _____ 0

9. GRAPHICS (Titles, animation, art) _____ 0

10. EDITING _____ 0

11. PERSONNEL: Staff _____ 0
 Crew _____ 0
 Talent _____#REF!_____ #REF!

12. TRAVEL (Transportation, lodging, per diem) _____ 0

13. DISTRIBUTION (Dubs, promotion) _____ 0

14. POSTAGE/INSURANCE _____ 0

15. OTHER _____ 0

SUB-TOTAL _____ 0

OVERHEAD _____ 0

CONTINGENCY _____ 0

GRAND TOTAL _____ 0

PRODUCTION BUDGET WORKSHEET

PRODUCTION:XXXXXXXXXXXXXXXXXXXXXXXXXX DATE:XX/XX/XX

Legal Considerations

You are responsible for obtaining filming permits, permissions, and releases. Permits for shooting on federal property, national parks, and monuments can be difficult, time consuming, and sometimes expensive to obtain. Likewise, state, county, or city jurisdictions will require you to obtain a film permit and pay a daily use fee if your production will be blocking sidewalks (or using a tripod or dolly on a public sidewalk), interrupting vehicle traffic (which may also require you to pay for police traffic control), impacting public parking, or if you will be shooting in a state or city park. Film permits are a critical component whether you are filming on public property or staging vehicles or equipment on public property while shooting on private property. Permission to use personal property and copyrighted works, such as specific locations and music, require negotiations with the property owners. For example, if you wish to use a piece of popular music in your production, you need to obtain permission from both the owner of the musical recording or CD, such as Sony Music, and the publisher of the music, such as ASCAP, BMI, or SESAC. By obtaining personal releases signed by people appearing in the film or video, you can avoid subsequent legal suits brought by them against you, especially when they are dissatisfied with the final product or outcome.

Script Formats

Preparing a script for a production may take you several steps before reaching the shape of the script containing all of the information needed for both the cast and crew. The first script is the scene script, followed by the shooting script. Each script may be rewritten several times depending on your demands and those of the client (see Figure 5.3).

Step Outline

Simply stated, a step outline is your entire story, written in simple outline form. It is a method of depicting each scene of your script using one- or two-sentence statements to describe the action in the scene and how it builds. Starting with Act I and progressing through rising and falling action in Act II, to the story's climax in Act III, and conclusion in your denouement, you build an outline of your story one statement per scene. A step outline is your road map, where you find the direction of your story. At this point, you are not really concerned about the details: no dialogue, no set dressing, no minor characters unrelated to the central action of the scene. All of that will come later.

Script Formats

FADE IN:

1. INT CLUB CAR OF MOVING TRAIN DAY 1.

The desert landscape of central Arizona flashes by outside the window.
A drunken MAN staggers up the aisle holding a cocktail glass. He notices
ROBIN BALLARD, a delicate, thirty year old woman, who stares blankly
out the window. He holds the glass out to her.

<div align="center">

MAN
(slurred)
Buy you a drink pretty lady?

</div>

Robin continues to stare out the window.

<div align="center">

ROBIN
(coldly)
No.

</div>

The Man pulls back the drink.

<div align="center">

MAN
Well, pardon me.

</div>

He turns and walks away. Robin's reflection in the window returns her gaze.

<div align="right">

(DISS)

</div>

2. EXT UNION STATION, LOS ANGELES DAY 2.

Robin, surrounded by other disembarking passengers, frantically searches
the crowded platform. She brightens as she recognized LAUREN CHANDLER,
a beautiful, fifty year old, self-possessed woman, walking through the crowd and
waves at her.

<div align="center">

ROBIN
Mom!
(calling louder)
Mom!

</div>

Lauren spots Robin, waves and hurries toward her. The women embrace.
Robin starts to cry.

<div align="center">

LAUREN
(concerned)
Baby, baby....What's the matter?

</div>

<div align="center">

ROBIN
I. . .I left Tom.

</div>

FIG. 5.3 – Scene scripts are summaries of all of the information needed to shoot a scene or sequence.

Scene Script

After you have worked out all the essential action and the direction of your story, you're ready for the next step, the first completed draft of a script, the scene script. Include in the scene script a detailed description of each scene and the action occurring during that scene, but not specific shots. Each scene description should indicate whether the scene is set during the day or at night and in an interior or exterior setting. You must describe the characters, key furniture or objects present, character movements, and all dialogue and narration in the scene script. You may go through several rewrites of your scene script before you reach "script lock." In script writing, locking the pages is one of the final things to happen before it is ready to be produced.

Shooting Script

Typically, the director will take the locked script and begin marking it for production. This is the shooting script and is a more detailed version of the locked scene script. As the producer, you would number each scene in script order with suggested camera setups. You indicate the framing—WS, MS, MCU, CU, and sometime indicate transitions like CUT TO, or DISSOLVE—but you allow some leeway for the director's creativity in shot selections to cover each scene. Working with your director, you will provide specific shot descriptions so that you and the director are on the same page in interpreting accurately what is intended in each sequence, scene, or shot. Likewise, a shooting script should include as much detail as possible in order to guide the work of the lighting director, art director, sound director, technical director, and editor (see Figure 5.4).

Shooting Script

FADE IN:
1.　INT　CLUB CAR OF MOVING TRAIN　　　　　　DAY　　　　　　　1.

WS: Through window
The desert landscape of central Arizona flashes by outside the window.
MCU: Down aisle of train car a drunken MAN staggers up the aisle holding
a cocktail glass. He notices
MS: drunk/Robin

ROBIN BALLARD, a delicate, thirty year old woman, who stares blankly
out the window.
2-shot drunk/Robin: He holds the glass out to her.

> MAN
> (slurred)
> Buy you a drink pretty lady?

Robin continues to stare out the window.

> ROBIN
> (coldly)
> No.

CU: Drunk: The Man pulls back the drink.

> MAN
> Well, pardon me.

MCU up aisle: He turns and walks away.
2-shot Robin & her reflection in window
Robin's reflection in the window returns her gaze.

> (DISS)

**FIG. 5.4 – A shooting script also may indicate overlapping shots, special effects, graphics, or any other
details needed to complete the scene.**

Script Formats

Professional scripts will be instantly recognized by the format used. Every studio, station,
or other production facility may design and mandate its own specific script formats, but
the basic formats indicated in this text will be accepted in the field if they are profes-
sionally prepared.

Single-Column Format

You may use two basic script formats in preparing scripts for electronic field production
(EFP): the traditional film single-column format and the traditional television dual-column
format. The single-column format evolved from stage play format to motion picture

MASTER SCENE SCRIPT FORMAT

(Margins and tabs set as indicated below, assuming 80 space wide paper)

5	15	20	40	45	55	60

FADE IN:
1. INT./EXT. BRIEF SCENE OR SHOT DESCRIPTION DAY/NIGHT 1.

In upper and lower case, a more detailed description of the scene giving setting, props, and CHARACTERS position if needed with margins set at 5/60.

<div align="center">

CHARACTER
(Mode of delivery, upper and
lower case, margins at 20/40)
[NO ACTION]

</div>

The dialog is typed in upper and lower case centered within 15/45 margins.

Any other descriptions of shot framing, movement of CAMERA or CHARACTER is at margins set at 5/60.

[If needed] (TRANSITION) or
(CONTINUED)

FIG. 5.5 – The single-column format evolved from stage, film, and radio formats and remains popular in feature motion pictures, soap operas, and in some commercial, animation, game, and music video scripts.

format to radio before it was adapted again for video productions. The format defines various aspects of the scripts by varying the width of the margins and by capitalizing certain portions of the copy. The rules at first seem complex, but can be summarized as follows (see Figure 5.5):

- Each shot starts with the shot number at the extremes of the right-hand and left-hand margins. In uppercase type, either the word DAY or NIGHT indicates lighting conditions, followed by either INT or EXT, to indicate location.

- Camera directions, scene descriptions, and stage directions are typed next, within slightly narrower margins. How the line is to be delivered is typed in still narrower margins within parentheses, and dialogue is typed within even narrower margins.

- The name of the speaking character is centered above his or her line in uppercase letters.

- Single-spacing is used for dialogue, camera angles and movements, stage directions, scene descriptions, sound effects, or cues.

Single-Column Format

- Double-spacing is used to separate a camera shot or scene from the next camera shot or scene, a scene from an interceding transition (FADE IN/FADE OUT, DIS-SOLVE), the speech of one character from the heading of the next character, and a speech from camera or stage directions.
- Uppercase type is used for INT or EXT in heading line, to indicate the location, to indicate day or night, for the name of a character when first introduced in the stage directions and to indicate the character's dialogue, for camera angles and movements, for scene transitions, and (CONTINUED) to indicate that a scene is split between pages (avoid if at all possible).

Dual-Column Format

The dual-column television script format evolved from audiovisual format and instructional film format. The format is based on separating audio instructions and information from visual instructions (which is why it is sometimes referred to as an "A–V Script"). Two columns are set up on the page. The video is located on the left side of the page, the audio on the right. This is not an absolute rule; some operations prefer the opposite, and some include a storyboard on the left, right, or down the middle of the page.

Each shot number is identified in both the video and audio columns, matching the appropriate audio with its video. All video instructions are typed in uppercase letters, as are all audio instructions. Copy to be read by the performers is typed in uppercase and lowercase letters. Many performers, especially news anchors, prefer all uppercase letters in the misguided belief that uppercase copy is easier to read. However, all readability studies indicate the opposite, and today most computerized prompter systems display copy in both uppercase and lowercase letters (see Figure 5.6).

Video instructions should be arranged in single-spaced blocks; audio copy, in double-spaced blocks. Triple-spacing between shots helps both the talent and the director follow the flow of the script. The name of the talent is typed in uppercase letters to the left of the right-hand column. If the same audio source continues through several shots, it is not necessary to repeat the source's name unless another source intervenes.

You should avoid hyphenating words at the end of a line and avoid splitting shots at the bottom of the page. Spreading copy out on the page allows for notes and additional instructions to be added during actual production.

DUAL-COLUMN SCRIPT FORMAT

TITLE:
WRITER:
CLIENT:

PAGE:
LENGTH:
DATE:

VIDEO	AUDIO
1. SINGLE SPACE VIDEO INSTRUCTIONS	1. ANNCR: Audio copy is lined up directly across the page from its matching video.
2. TRIPLE SPACE BETWEEN EACH SHOT	2. Double space between each line of copy.
3. EACH SHOT MUST BE NUMBERED ON THE SCRIPT	3. The audio column's number must match that of its video.
4. EVERYTHING THE VIEWER IS TO SEE; ALL VISUALS, VIDEO TAPES, CG, CAMERA SHOTS, ARE INCLUDED IN THE LEFT-HAND COLUMN.	4. Everything the viewer hears; narration, music, voices, sound effects, all audio cues are in this column.
5. EVERYTHING ON THE VIDEO SIDE IS TYPED IN UPPER CASE,	5. Everything spoken by the talent is typed in upper and lower case letters. All instructions in the audio column are typed in UPPER CASE. (FADE IN NAT SOUND)
6. THE TALENT'S NAME STARTS EACH NEW LINE, BUT DOES NOT HAVE TO BE REPEATED IF THE SAME PERSON OR SOUND SOURCE CONTINUES.	6. SAM: Note--the name is in caps, what Sam says is in upper and lower case.
7. DO NOT SPLIT SHOTS AT BOTTOM OF THE PAGE.	7. Don't split words or thoughts at the end of the line or page. If the story continues to the next page, let the talent know by writing-- (MORE)

FIG. 5.6 – The dual-column format clearly separates visual and aural aspects of the script. This makes it easier for audio operators to concentrate on their responsibilities and for graphics and camera operators to do the same. The most common use of the dual-column format is in live-action television productions, commercials, sports, and game shows.

Dual-Column Format

You repeat information concerning the production at the top of each page; this will include the title, your name, and other pertinent information. You must number each page in sequence. If pages are added, you add letters or other indicators to keep the pages in order (e.g., page 25a falls between pages 25 and 26). Some production types,

such as documentaries and interview segments, use an outline format, rather than either the specific dual- or single-column format.

Computer programs are available to facilitate the preparation of scripts by allowing you to concentrate on the creative part of writing and not the formatting. These computer applications are specifically designed for both single-column and double-column scripts in a variety of formats: television, audio/video, multimedia, motion pictures, and radio.

Organizing Forms

Once you prepare the script, the next line of paperwork begins. You give all members of the production team storyboards, location scouting information, site surveys, and plots as handy tools to maintain consistency and to help others understand what you are trying to accomplish with this production and how it will be accomplished.

Storyboards

Storyboards are paper visualizations of the production. You provide a flexible means of working out sequences, framing, and shot relationships before bringing an expensive cast and crew together for the actual production. Storyboards are usually organized in three parts: picture, copy/instructions, and shot number (see Figure 5.7).

Generally, a storyboard form displays a 4:3 or 16:9 area, with rounded corners; it contains the video frame, with a small space above the frame for writing in the shot number. Below the frame is an area, usually slightly smaller than the frame, designed to contain the audio or other specific instructions for that shot. Storyboard forms are available in preprinted packets or as a computer program template. Such templates allow you to draw and redraw until the design is satisfactory without creating stacks of printed boards. Such templates may be passed among creative staff for alterations and feedback before the final script is created.

Sketch the key objects in the shot into the frame block. These visual representations can be as simple as stick figures or as accurate as color photographs. The more accurate the drawings, the more serviceable the storyboard will be in solving problems during preproduction and production. The matching space for instructions may contain "pan," "dolly," or other camera movement or composition concepts. The shot number must match the shot number on your script. If you make additions or deletions, you must change the shot

POISON CONTROL Distribute to employees		30 sec. 8/23/06
VIDEO		**AUDIO**
1. FADE IN MS CHILD PLAYING IN FRONT OF KITCHEN CABINET		1. VO: Your home contains some of the
2. MCU FRONT OF CABINET WITH DOORS OPENING-CHILD APPROACHES. BOTTLES OF CHEMICALS MARCH OUT OF CABINET		2. half million poisons that can be
3. CU CHEMICAL-ZOOM TIGHT TO LABELS		3. disabling, if not deadly
4. XCU CROSSBONES POISON LOGO		4. MUSIC: URGENT VO: The life and well being of someone you love may depend on how quickly you reach
5. CU HAND WRITING DOWN EMERGENCY NUMBERS		5. A Poison Control Center at these numbers: 831-6633 or 471-6026

FIG. 5.7 – Storyboard can be as simple or as complex as needed to provide the critical information to all crew members. The images in a storyboard can be as sophisticated as photographs or simple line drawings as long as they accurately depict what is to be shown and heard. © Robert Musburger.

number on both the script and storyboard. You should represent each shot by at least one storyboard frame. In some cases, additional frames may be necessary to show beginning and ending frame positions if a pan, dolly, or zoom is indicated.

Once completed, you can place storyboard frames on a wall or corkboard so they can be rearranged easily. Standing back and looking at all of the storyboard frames gives everyone in the production a better overall view of the production and can provide the means to spot problem areas or solutions to problems.

Storyboards

Because the storyboard frame, description, and shot number can be separated from other storyboard frames, you can manipulate them until you reach the best possible shot sequence. This process may prevent continuity problems by avoiding jump cuts and may create a more organized method of shooting the production. Once you have arranged the complete storyboard order, then you can write the final shooting script.

Location Scouting

You should visualize the type of shooting location you require early on in the production conceptualization process. Specific locations can be chosen after the scene script has been written, but you must finalize the location before the shooting script has been completed.

Besides the obvious characteristics you should look for in a location—accessibility and having the right setting or appearance—some are less than obvious. You want a cost-free location near parking, power, and convenient storage space for equipment and materials. The availability of temperature-controlled areas and sanitary facilities for cast and crew to use between takes is also important. Once you choose a location, arrange a meeting with the site authority.

At this meeting, you must gather and document the following information: the names, phone numbers, and exact locations or addresses of the authorities who control the areas and locations to be used—the resident, building engineer, building manager, janitor, department head, or a civil employee in charge of public areas. Make certain the person who has given permission to use the location actually has the authority to do so, and then get it in writing, along with a location release (see Figure 5.8).

While meeting with the site authority, the producer should explain fully how the site will be used, the changes that may be necessary, how restoration will be handled, and what access the production crew will have to the location. Discuss every contingency that could occur during the production so that no unresolved differences crop up during actual production.

Place in writing all agreements, have the site authority sign them, keep copies, give the site authority copies, and send copies to the ultimate authority of the location. Perform this act well before the shoot is scheduled so that any problems can be resolved before the cast and crew arrive for the shoot.

MOUNTAIN PRODUCTIONS
LOCATION RELEASE

I hereby irrevocably grant to ___Mountain Productions___ the right to use the property described below which is owned and/or controlled by me at

(full legal description of property)

in connection with the production, duplication, and/or distribution of the video, film, or sound recording program, segment, or shots recorded on:

_____ , by Mountain Productions.
 (Date)

 I hereby assign to Mountain Productions all rights, title, and interest in the materials as they are integrated into the final master film, videotape, or audio recording, granting full and unrestricted permission and authority to Mountain Productions to record, reproduce, and use in any manner, media, or form whatsoever including securing copyrights for the final master and subsequent copies of all media materials produced which includes the image of my property, warranting that I have unrestricted right to make this grant an assignment and hereby release and agree to indemnify and save harmless Mountain Productions, its staff and agents for any and all liability, claims, actions, and damages arising in a manner from the material which contains the image of my property.

 For the use of the above described property and the right described in this clearance, Mountain Productions agrees to compensate me as follows:

I express my intention to be firmly and legally bound this _____ day of

_____, 20____ .

_____ _____
 (Signature) (Witness)

_____ _____
 (Print Name) (Print Name)

_____ _____
 (Street Address) (Street Address)

_____ _____
 (City-State-Zip) (City-State-Zip)

Location Scouting

FIG. 5.8 – A location release is a legal document and should be treated as such. Make certain it is accurately filled out and properly signed and dated, and keep a copy in a safe location for future reference. The purpose of the release is to provide written proof that you have permission to shoot in the indicated location in case police or other authorities question your presence.

Site Survey

Make certain to visit the location at the time of day, day of the week, and, if possible, day of the month the production will be shot. This precautionary act may help you to avoid unplanned traffic, noise, lighting, and ambient sound problems. You need to measure each room or space to be used accurately, and you need to plot a scale drawing indicating the location and sizes of windows and doors, the furniture placement, and placement of walls and power sources. In addition, you need to determine the location of power outlets and the location of the fuse or circuit breaker box. Discuss with the site authority whether you may tap into the fuse box or if it can be left open in case a fuse or breaker blows. If the box is left open, the crew can correct the problems without waiting for the box to be unlocked or handled by an assigned person. While checking the location of the fuse box, check and make a note of the power rating of each circuit and determine which circuits control specific outlets that you may use.

Once all of the measurements have been taken and the plot is drawn, then you should identify possible locations for performers and cameras. Note the movements of the performers as well as camera movements. If furniture needs to be moved or extra furniture or set pieces are required, this should be indicated on the plot. The plot is a scale diagram drawn as if you are looking straight down on the location. Do not draw it in perspective, as it is useless if not drawn to an accurate scale (see Figure 5.9).

Before leaving the site meeting, determine from the site authority where production vehicles may be safely and legally parked and the location of a loading area. When possible, choose a loading/parking location that is well lit and under some security. If the location does not provide security for vehicles, it may be necessary to hire or provide your own security personnel. If permits for parking or loading are required, determine the process and authority for getting such permits. Remember that not even public property can be used for any production purpose without permission, a permit, and often a fee.

Before leaving the site during the survey, recheck all of the information gathered and make certain you have all the facts, permits, measurements, and telephone numbers. Make sure that there are no conflicts or contradictions in your lists.

SITE SURVEY PLOT

SHOT RUNDOWN

Camera Position "A"	Shots 1, 3
Camera Position "B" follow	Shots 2, 4
Camera Position "C"	Shots 5, 7, 9
Camera Position "D"	Shots 6, 8

FIG. 5.9 – A plot must be drawn accurately and to scale. Measure accurately while on site survey and then with plotting tools accurately draw the plan to reveal exactly the relationship between camera and subject positions as well as physical objects such as buildings, stairs, and sidewalks.

Site Survey

Organizing Equipment and Crew

With the completed shooting script and plot in hand, you can sit down at the site later and determine which shots are to be made from each camera location. You should indicate on a shooting list, shot rundown (shot sheet), which shots are to be taken at each camera location and the order in which they are to be shot. The most efficient use of cast, crew, and equipment should be the key factor in this determination. Make certain all possible shots are planned from each location before the camera and lights are moved to the next location.

Once the site survey has been completed, meet with your camera operator, gaffer, and audio operator to list the equipment required for the shoot. These three key crew members should accompany the director on the site survey if at all possible. Each crew chief is responsible for the equipment needed to fulfill his or her responsibilities, but a production meeting should be held to double-check all aspects of the production and to exchange ideas, generate solutions to problems, and resolve unanswered concerns.

Make a list of equipment to ensure that everything has been thought of that will be needed. This list may also be used as a checklist when packing up the equipment to make certain that nothing has been left behind at the end of the shoot. Confer with the crew chiefs on the number and skills of crew members required. Most EFP shoots are organized to use a minimum number of people, but the complexity of the production determines the size of the crew.

Once all the lists are completed, you as producer or with your producer work out a detailed schedule that starts with that day and ends with the delivery of the finished product. Each stage of the production must be organized on a timeline so that production can proceed unaffected by delays in other stages, if at all possible. The interdependency of media production makes a timeline critical in the efficient completion of any project (see Table 5.2).

Once all of the preproduction planning has been completed, you can move the cast and crew into the production stages toward completion of the project.

TABLE 5.2 – A timeline provides a general guide for planning on when cast, crew, and equipment must be ready to work. It also gives the producer a schedule to refer to while preparing the writing aspects of the production. A copy of the timeline often accompanies the proposal/treatment/budget package presented to the funding source.

TIMELINE PLOT

DATE	RESEARCH WRITING	PRE-PROD. SURVEYS	PRODUCTION	POST-PROD.
Jan. 1	Begin research			
Jan. 15	Develop concept			
Feb. 1	Deliver proposal			
Feb. 15	Deliver treatment			
March 1	Compete research			
March 15	Treatment approved			
April 1		Location scouting		
April 15	Scene script approved	Sign location contracts		
May 1	Shooting script approved	Cast-crew equipment contracts		
May 15		Begin rehearsals	Set up for shooting	
June 1				Begin editing
June 15			Complete major videography	
July 30			Pick-up shots	Review rough cut
Aug. 1				
Aug. 15				Deliver answer print
Aug. 30				Deliver completed master

Chapter Six

The Production Process: Production

Production Stages and Setup

In the production process, you will follow four standard stages in the actual shooting of an electronic field production (EFP): setting up, rehearsing, shooting, and striking.

Setting Up

First, unload the equipment and move it to the first shooting location. A word about security: Professional video equipment is expensive and looks attractive to thieves. You must never leave equipment unguarded, and never leave the production vehicle unlocked. You and the crew move the equipment from the vehicle efficiently to the first camera setup, unless you use the vehicle as a field control room.

Field Equipment Considerations

Field equipment is much more susceptible to damage and technical problems from the environment than is studio equipment. Because the majority of the operating parts are electronic, at a certain level of humidity your equipment becomes inoperative. This is particularly true of disc decks. In addition, keep all liquids away from all electronic equipment. Severely cold weather slows mechanical works, such as the motors that drive decks and zoom lenses. Extreme heat affects circuits inside the camera and decks. In most cases you can compensate for these factors, but they must be taken into consideration when planning a field production. If your camera records directly onto a computer hard disk, memory card, or disc medium, you need to take this into consideration to prevent moisture or dust from entering the medium case. If your signal is recorded onto a chip, that process does not require any moving mechanical operations, making your camcorder much more rugged and less susceptible to temperature and humidity changes.

Camera Setup

Once you determine the camera's position, set up your tripod. Its legs need to be set in a wide enough stance to provide a stable base, but not spread so far apart that they are in the way of traffic or the operator. The height of the tripod should be adjusted to the eye level of the subject, unless you require a special angle.

After adjusting the tripod legs to accommodate uneven terrain, you should next level the head of the tripod with the bubble level, attach the camera plate from the tripod head to the underside of your camera and then you can mount the camera on the head. Make certain the pan and tilt locks are tight, or if the tripod head does not have locks, tighten the drag controls so the camera will not tilt out of control. Set the drag controls tight enough so that there is enough back pressure to allow for a smooth, even pan or tilt, not so tight as to cause a jerk when you try to pan or tilt. You should set the legs of the tripod so you can stand between two legs and do not need to straddle a leg (see Figure 6.1).

If you mount the camera on a body mount, a second person should help balance the camera and rig until all of the controls are balanced and set. If you handhold the camera, you need to adjust all of the controls ahead of time instead, before placing your camera

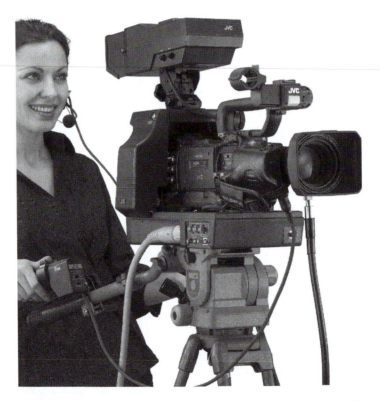

FIG. 6.1 – Solid, stable, yet flexible camera mounting equipment gives the camera operator the maximum freedom to operate the camera according to the needs of the director of the production. (Courtesy JVC.)

on your shoulder. It is difficult to look at the menu to set all of the variables—such as aspect ratio, frame rate, white balance (automatic or manual), and the choice of scan rates—and balance the camera at the same time.

Depending on your choice of power source for the camera, check to make certain the battery is fully charged or make certain the power cord is long enough to allow for whatever movement is required. Also, all power cords should be protected from accidental disconnect; have a gaffer tape the cable both at the end where it is plugged into the source and close to the tripod, but do not tape the power cable to the camera.

Audio Preparation

While the camera operator and gaffer set up their equipment, the audio operator strings mic cables or sets up the receivers for wireless mics. If a mixer is used, then the operator needs to string cables to the mixer and the output of the mixer to the recorder or camcorder if RF mics are not used. Make certain levels are checked to determine if the entire audio system is operating and is balanced.

If you use a boom mic, its position needs to be checked with the camera operator, lighting director, and director. If you use body mics, the operator needs to place them on the performers, check batteries, show the performers how to turn the mics on, and check to be sure a signal at the proper level is being received at the mixer or recorder. Check RF levels on the receiver or the wireless mics (see Figure 6.2).

The audio operator is responsible for all sound. If playback audio is required, then the audio operator must set up the speakers, cables, and audio source, such as a CD, or iPod player. If the production involves live music, then the audio operator has the responsibility of placing mics on the band, soloists, or other music sources. In some cases, you will require that the audio be recorded on a separate recorder, usually a digital medium of some type. This arrangement is also the responsibility of the audio operator. Headphones, audio monitor circuits, and any other source or control of sound belongs to the audio operator.

Audio Preparation

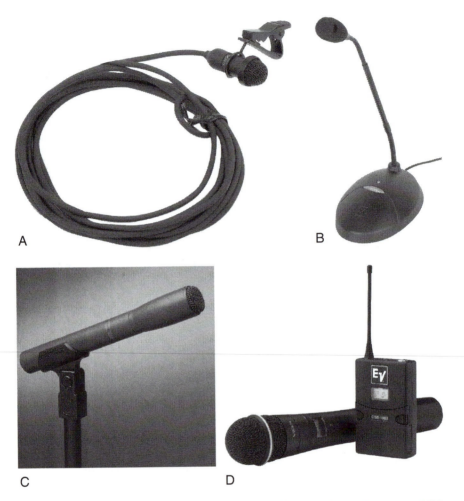

FIG. 6.2 – Stable and secure mounting equipment and secure cable connections are key responsibilities of the audio operator. The decision about what type of mic works best for each shot or sequence should be made by the audio operator and the director. (Courtesy Electro Voice and AudioTechna.)

Prompting Devices

Often you will require some type of prompting device, especially for commercial shoots. There are three basic types of prompters: handheld, camera-mounted, and in-ear devices.

Handheld prompters are pieces of poster board bearing either the entire copy lettered in large bold type or an outline of keywords that the performer ad-libs around. These cards have been called idiot cards in deference to the talent.

The most common prompting device today is a monitor mounted above or below the camera lens with two angled mirrors reflecting the monitor image directly in front of the camera lens. This gives the members of the audience the impression that the talent is looking directly at them, but in reality, the performer is looking at the image of the copy reflected from a mirror mounted in front of the camera lens. The source of the copy can be scripts that are taped together in a continuous sheet and passed under a black-and-white camera or from a dedicated prompter computer or character generator (see Figure 6.3).

The third method requires a special skill on the part of the performer. A small headset is placed in the performer's ear, and a recording of the copy (which the talent previously made) is played back in the performer's ear. Skilled announcers can repeat vast amounts of their own words slightly delayed from the original as if they were speaking from memory. Of course, the best option is for the performer to take the time and trouble to memorize all of his or her lines.

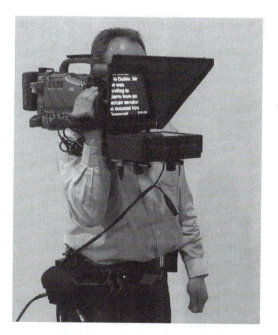

FIG. 6.3 – Prompting devices should be as invisible as possible to both the audience and the rest of the production process. As cameras decrease in size, a large set of monitors and reflectors mounted on the front of the camera can become a problem. In that case, the prompter can be mounted on a gaffer stand close to the side of the camera or immediately below the lens. (Courtesy Autocue-QTV.)

Prompting Devices

Sets and Properties

For most field productions, sets and properties (props) exist at the chosen location but need to be carefully checked and inventoried before or during setup. The convenience of using already existing rooms, furniture, and other props may be one of the main reasons you choose to shoot a production in the field. At the same time, a careful choice of a location is critical in the field production process.

There are four levels of items in this category: sets, set pieces, set dressing, and hand props. Sets are backgrounds. They may be actual walls, trees, construction made of cloth or wood, or simply the actual location suitable for the particular production. Set pieces are items of furniture, carpets and area rugs, plants, automobiles or other items placed within a set that establishes the location, era, and story purpose of the production space. Generally, set dressing includes paintings or posters on walls, books and nick-knacks on bookcases, photographs in frames, pillows, drapery and other important details that help set the tone and contribute to the authenticity of a set. Hand props are items small enough to be picked up and handled, but for the most part, they are items that the talent needs to handle during the production (see Figure 6.4). An important consideration you should keep in mind

FIG. 6.4 – A set and its decoration should match the time and mode of the production. Everything on the set should have a purpose, including balancing the frame. The arrangement must fit the action of the scene and the movement of the performers. © Robert Musburger.

is to ensure that you have several exact duplicates of some hand props, especially breakable or consumable ones (e.g., food or drink) to maintain picture continuity over multiple takes of a scene.

You make choices in each of the categories with the art director. These items should match the tone, time period, quality, and attitude of the production. A beautiful painting should not hang in a set that is supposed to be a dingy office. At the same time, a cheap, poorly done painting should not be seen hanging in a room that is supposed to be the office of a Fortune 500 CEO. You make these choices on the basis of your and your team's knowledge of art, architecture, and interior design. Likewise, you should pay attention to the use of copyrighted art on your set—if you do not have written release to use it, no matter how perfect it is to your story, you will have to find a suitable replacement or do without.

Designing for high definition (HD) is more critical than designing and executing for standard definition (SD). The increased detail of HD shows every small defect in appearance, every sloppy paint job, and every poorly matched or worn and outdated set piece. Design for HD needs to be examined with a magnifying glass to check each detail in the completed design before cameras start looking.

As in lighting design, your set design sends a clearly defined message and must match the rest of the production details to avoid confusing and misleading the audience. You need to make set design decisions during preproduction planning, but often you cannot finalize the plans until the setup period with the crew on location. This is when you should rearrange furniture, rehang paintings, and remove unnecessary or conflicting items from a room being used as a location site.

Lighting Preparation

As soon as you and the crew arrive at the location, the lighting director or gaffer should run the power cable to your camcorder or recorder and then string power cables to the lighting instrument locations. Once you place your camera in position, the gaffer can start placing the instruments. The crew should run power cables where there is the least amount of foot traffic, out of sight of the camera, yet with as short a run as possible. As mentioned earlier, you must give close consideration to the amount of amperage drawn by the lighting instruments to avoid blowing breakers or fuses.

Lighting Preparation

Whereas, your first priority is to light for "visibility" (optimal image exposure), proper lighting is also an artistic endeavor. While there is much science and practicality to lighting design, lighting is probably the most artistic portion of video production. There are no hard and fast rules, only guidelines. There are typical and traditional setups as well as genre-specific styles of lighting (e.g., horror or film noir), but every lighting situation is unique and must be approached from an individualistic direction. The lighting depends partly on you and the writer's concept of the production and partly on the requirements set by the location, budget, availability of equipment, and time to create the lighting ambiance desired.

You might use one of three types of basic EFP lighting: realistic, abstract, or neutral. Dramatic productions, documentaries and some types of commercials require as realistic a lighting setting as possible. You may require abstract lighting that goes beyond realism for music videos, some commercials, and science fiction dramas. You may use neutral lighting for game shows, newscasts, situation comedies, and some commercials. Hard and fast rules defining each of these types of lighting do not exist, but the end result must match the director's requirements.

Lighting for a HD production requires greater attention to detail and the needs of the highly critical cameras. It is not a matter of more light, rather a better placement of lighting instruments and the shadows and light patterns that follow.

In addition to your requirements for the lighting—that it set the mood, time, and type of production—the lighting must provide enough base illumination for the camera to create a usable image. As mentioned earlier in this text, the camera or chips reproduce what is presented to them. The light must be of the correct color and intensity and be within the contrast range (exposure latitude or dynamic range) of the particular type of camera in use. These three factors—color, intensity, and contrast—control the basic lighting setup. Once they have been satisfied, you may use creative and innovative lighting techniques.

Controlling Color Temperature

You control color temperature in studio productions by installing lamps with the same color temperature output in all lighting fixtures. In the field, controlling color temperature is not that simple. Even though all of the instruments may be lamped with the same

Kelvin temperature bulbs, windows, fluorescent lighting fixtures, and even standard incandescent fixtures create variations in color temperature. If possible, you should light a set only with lighting instruments lamped with the proper bulbs. Alternatively, cover windows with drapes, blinds, or a large sheet of Wratten 85 (yellow-orange) or CTO filter material. If you are using newer LED fixtures, many have the ability to adjust their color temperature to match your shooting environment.

A second method you may use if daylight is entering a room is to convert the field lighting fixtures to approximate daylight by covering them with Wratten 82 (blue) filter material or a CTB dichroic filter. This helps match the mixed lighting, but it does not help you to balance the difference in light intensity between the daylight and the lighting instruments. This is because the blue filter reduces the lighting instrument output by about half, requiring more powerful or a greater number of lamps.

If many incandescent fixtures are present and you cannot cover or turn them off, the white balance circuits on most digital cameras will reach white balance without a filter in place.

If you must shoot in a location lit by existing office fluorescent lamps, you may consider several possible solutions. First, the process you use to white balance when only fluorescent lamps are present is to determine the type of fluorescent tube in use. Newer tubes designed specifically for media production are intended to match either daylight or tungsten lighting Kelvin temperature. New portable fluorescent, halogen metal iodide (HMI), and light-emitting diode (LED) lighting fixtures balanced close to daylight are now available, providing another method of field flat lighting (see Figure 6.5).

You may set white balance automatically with built-in circuits in some digital cameras, or you may shoot a white board within the light source of that shot and press the white balance button on the camera. You can correct white balance using color filters mounted between the lens or on the lens.

Controlling Color Temperature

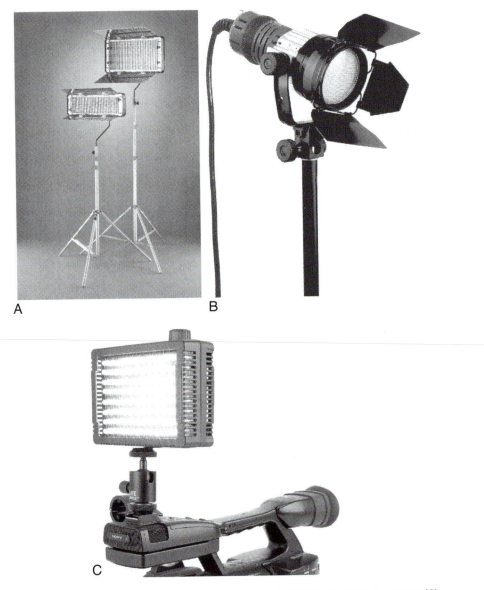

FIG. 6.5 – Color temperature can be controlled with filters and digital circuits within the camera (C), on light instruments (B), and by a choice of specifically designed light instruments such as LED, HMI, and fluorescent (A). (Courtesy Arriflex, Lowell Lights, and Lite.)

Controlling Light Intensity

You may control light intensity in a studio setting in a variety of ways: by varying the voltage to each instrument through a dimmer board, by adding filters or scrims to the instruments, or by mounting or moving instruments closer or farther away from the subject.

In the field, you are limited with light intensity controls by the types of portable equipment available. For the average EFP production, simpler means of light control than those used in the studio are necessary. Generally, the lighting instruments you use in the field are open-faced instruments, which means that the light is harsher and more difficult for you to control. You can use scrims and filters and bouncing the light to soften, diffuse, and lower the light level to that required for fill lights. Small portable dimmers are available for field use, but lowering the voltage of a tungsten lamp changes the color temperature approximately 100 degrees for each 10-volt variation.

The most practical way to control light intensity in the field is your placement of the lighting instruments. Because light levels follow the *inverse square law,* a relatively small movement of a lamp makes a major difference in the light level falling on the subject. If a lamp provides 100 foot-candles of light at a distance of 10 feet from the subject, moving the lamp to 5 feet boosts the light level to 400 foot-candles (the inverse square of 1/2 equals 4 times the original light level; therefore, 100 becomes 400). If you move the lamp back to 20 feet, the light level falls to 25 foot-candles (the inverse square of 2 is 1/4 times the original light level of 100, resulting in 25 foot-candles) (see Figure 6.6).

Controlling Light Intensity

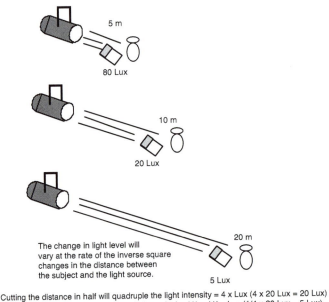

INVERSE SQUARE LAW

5 m
80 Lux

10 m
20 Lux

20 m
5 Lux

The change in light level will
vary at the rate of the inverse square
changes in the distance between
the subject and the light source.

Cutting the distance in half will quadruple the light intensity = 4 x Lux (4 x 20 Lux = 20 Lux)
Doubling the distance will cut the light intensity by 1/4 = 1/4 x Lux (1/4 x 20 Lux = 5 Lux)

FIG. 6.6 – Most EFP lighting directors find they can achieve the light levels and effects required by the director with a combination of lighting instrument placement and the judicious use of scrims, filters, barn doors, and flags.

Contrast Range

The control for contrast is a little more complex. You need a reflected spotlight meter to measure the amount of light reflected from the brightest and darkest objects in the picture. These light measurements are called reflectance values. If you measure the amount of light reflected from the brightest portion of the frame in which detail is required more than 30 to 40 times the light in the darkest area needed for detail, then you need to add fill light to the dark areas or you need to remove some light from the lighter areas. By carefully lighting for the contrast range of the video camera, you can avoid having important areas "bloom" or "flare" into a white mass or having large areas appear so dark and black that they look flat with a complete lack of texture or form.

You will find the most difficult situations for maintaining proper contrast range are those shots taken in the bright sunlight or at night with available light. During a cloudless

bright day, it is nearly impossible to balance the bright sun with any other light source to maintain contrast range. The best method to balance the lighting is to use the sun as the backlight and reflect the sunlight back toward the subject.

Night lighting is more difficult. Some source of fill is needed to overcome the bright, harsh light from streetlights, automobile headlights, advertising signs, and other lights. The easiest method is for you to shoot at dawn or dusk, except that the time period when there is enough light to shoot and still have it look like night is very short.

Basic Three-Point Lighting

Lighting practice is based on two suppositions: that there will be enough light for the camera to create a reasonably useful picture and that the appearance will fulfill the look that you desire. Basic three-point lighting is designed to satisfy both of these requirements. Three-point lighting derives its name from the three lighting instruments used to achieve satisfactory levels and appearance: key lights, fill lights, and backlights. The key light duplicates the major light source in our lives, the sun, and, secondarily, the overhead lighting present in most homes and workspaces. The fill light balances the key light, reducing the contrast ratio and softening the harsh look of a one-light source. The backlight adds a rim of light around the subject to separate it from the background and adds a third dimension to the two-dimensional video field (see Figure 6.7).

Backlight

The backlight is the first instrument set in place, because once performers, set pieces, and props are in place, it is difficult to reach the proper position for a backlight. You set the key light next; then the fill, kickers, set, and extra lights are set. The backlight instrument is mounted above and slightly behind the major subject and directly opposite the camera position. Because this lamp is focused toward the camera, you must use barn doors or flags to avoid having the backlight shine directly into the lens of the camera.

Key Light

You use the key light as the main source of light. It should always have motivation—that is, there should be a reason for its angle and position. If there is no apparent motivation, then set the key about 45 degrees above the camera and from 60 to 40 degrees to one side of the camera. The key should be the brightest light under normal circumstances. It can create shadows, adding depth to the picture, and should set the major color temperature for that shot or scene.

BASIC LIGHTING PLOT

Fixed Single Subject

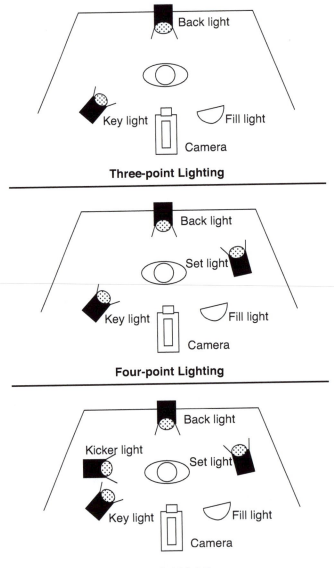

Three-point Lighting

Four-point Lighting

Five-point Lighting

FIG. 6.7 – Basic three-point lighting must be approached as a starting point for establishing the appearance needed for a particular shot or sequence. Three-point also is the starting point for adding instruments as needed for four- or five-point lighting.

Fill Light

The fill light represents the reflected light from clouds, the sky, buildings, and multiple light sources found in buildings. In some ways, it is like the backlight, an artificial light, but it is very important in video production to bring the contrast ratio down to a level that a video camera can handle. You mount the fill light on the opposite side of the camera from the key; this is of a lower intensity (no more than half the intensity of the key light), softer and more diffused, and should not create any visible shadows.

Kicker and Set Lights

You may require a variety of other lighting instruments to create either realistic light or the effect desired in the scene. The two most common are the kicker and the set light. Mount the kicker light to one side of the subject so that it throws its light along the side of the subject. This light acts much like the backlight, helping to separate the subject from the background, thus adding depth to the frame.

The set light is designed to highlight specific areas of the set. Sometimes it also separates the subject from the set, but more often it is designed to draw attention to particular areas of the set, such as a logo, important set piece, or a lit area of an otherwise dark background.

Multiple or Moving Subjects

Lighting a single subject that does not move during the recording, such as an interview, is relatively simple. The lighting process becomes complicated when there is more than one subject in the frame and those subjects begin to move about on camera.

You may light multiple subjects by spreading the light wider to take in more than one subject, but this method is usually unsatisfactory. Unless both subjects are facing the same direction and are an equal distance from the light source, they will be lit unevenly. Another solution is to *cross-key light*—that is, use the key light for the subject on one side as the backlight for the subject on the other side, and vice versa. You would then use a single fill light to accommodate both. If you are shooting more than two subjects, you may require key lights for each subject and a widespread series of fill lights covering the entire area. You can avoid multiple shadows by washing out some of the shadows with fill and set lights or by focusing the keys so that the shadows fall outside of the area covered by the camera frame (see Figure 6.8).

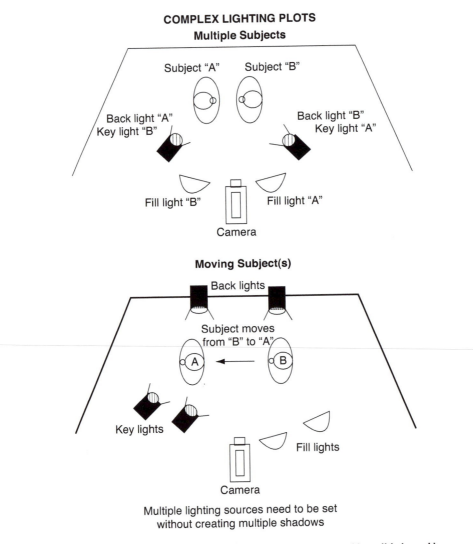

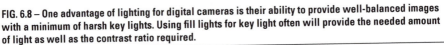

Multiple lighting sources need to be set
without creating multiple shadows

FIG. 6.8 – One advantage of lighting for digital cameras is their ability to provide well-balanced images with a minimum of harsh key lights. Using fill lights for key light often will provide the needed amount of light as well as the contrast ratio required.

If subjects move, lighting becomes even more complex. One solution is to arrange key lights and backlights so that they throw a relatively even pattern of light over the area of movement at an equal distance from the light source. Fill is easily flooded out to cover the entire area. Another solution is to break the movement down into several shots. Each shot will cover only a small portion of the movement area and can be more easily

lit because the subject can be lit in roughly the same intensity for each shot. This latter option will, of course, require careful attention to lighting continuity and slow down the pace of a production as you and your crew must frequently stop and reset lighting between camera setups when covering the scene.

Creative Lighting

Beyond providing enough light for the camera to produce a usable picture, lighting is also a key creative visual element. Light sets the mood and may be used to indicate the time, the date, and the location of a production.

Mood Lighting

From the first moment an audience sees the opening shots of a situation comedy, the viewers are made aware that they are in for some light-hearted entertainment. Much of that realization comes from the high-key, low-contrast, nearly shadowless lighting used, known as *Notan lighting.* This term derives from Japanese artists who painted brightly lit scenes without any shadows in an attempt to achieve "harmony" in the interplay between the brights and darks in an image's composition. The brightly lit set without any cast shadows and very controlled attached shadows defining texture, line, or form lets the viewers know the mood the director wants them to experience.

On the other hand, if you light the first shot of a scene with low-key, high-contrast, heavy, dark shadows, the audience is made aware that this is a heavy drama. This type of lighting is called *chiaroscuro* (or sometimes, Rembrandt lighting after the Dutch painter), borrowed from the Italian painters who used the same high contrast to set the mood of their paintings. Of course, you may use all creative techniques in contrast; a comedy scene may be lit in low-key to make it funnier because that visual approach is unexpected.

Lighting for Time, Date, and Location

You may use lighting to indicate time, date, and location as a more subtle but important consideration when designing a scene. Early morning and late afternoon light is different from that at high noon. The colors are different (early and late in the day, the light is warmer, redder), and the angle of the light is lower. Winter sun is bluer and colder; the lights of summer, fall, and spring each have their own colors and contrast levels.

Creative Lighting

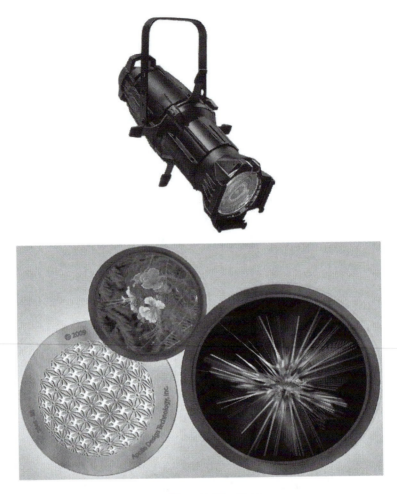

Top - Ellipsoidal Spotlight
Bottom - Cukaloris (Gobo, Cookies)

FIG. 6.9 – An ellipsoidal spot with "cookies" installed may created a variety of patterns on a background. (Courtesy ETC and Apollo Design Technology.)

You also may use light simply as an abstract creative object in and of itself. Light slashes across the background create a feeling of prison bars, window slats, venetian blinds, or other settings not actually present. *Cukaloris* patterns on a plain background tell the audience an infinite number of characteristics about a scene. A cukaloris (also known as a cookie or gobo) is a metal disc inserted into an ellipsoidal spotlight that creates a light pattern or mottled design on the background (see Figure 6.9).

Directing and Rehearsing

Directing Talent

Once all of the physical setup procedures have begun, you then concentrate on the human values that make up a production. Direction of actors is the most complex part of your job. The performance of an actor depends on many variables beyond your control. An actor's training, background, experience (both in acting and in life), and mental state during the shoot all affect a performance. You must then blend this knowledge with the results of an in-depth study of the script and the plan the director has for how to accomplish his or her interpretation of that script.

Interpersonal communication is the key to working with actors, who are in a vulnerable position. It is their faces and voices that the audience will view. If the production comes off poorly, it is the actors the audience will remember. You must clearly communicate to the actor exactly what you need, how it fits into the overall production, and how the actor will look and sound. The more precise the direction, for most actors, the better the performance. Without delving into various acting schools and methods, actors perform better if they are aware of why they are doing what they have been asked to do. Supplying this motivation makes their work easier and their acting generally more realistic.

Rehearsal

While the crew is setting up equipment, you work with the talent and supervise all of the other operations. You also check on all sets, props, prompting devices, and other materials to be used in the first sequence. The setup period blends into the rehearsal period, but actual—except for table readings when the director and actors *voice perform* a script and discuss the specifics of motivation and intent in each scene—rehearsal cannot take place until cameras, lights, and microphones are in place and the crew has received preliminary production instructions. You must include a written instruction sheet for each crew member or crew section. The lighting director and key grip receive the instructions if a full crew is used; the gaffer and grip receive the instructions if there is one crew member for each position.

For the lighting and stage crew, a plot shows the position of the camera for each setup, talent positions and movements (*blocking*), key furniture, and backgrounds or other set pieces. The camera operator receives a shot sheet listing the camera positions in the

order of setup and shots to be completed at each camera position in the order they will be shot. A plot also is helpful for the camera operator (see Figure 6.10).

During setup, you make certain that all performers are present, in makeup and costume, and prepared to shoot their scenes. You lead general discussions about movements, line delivery, motivation, and relationships between actors and other objects while the crew is completing the setup process.

LIGHTING PLOT AND SHOT RUNDOWN

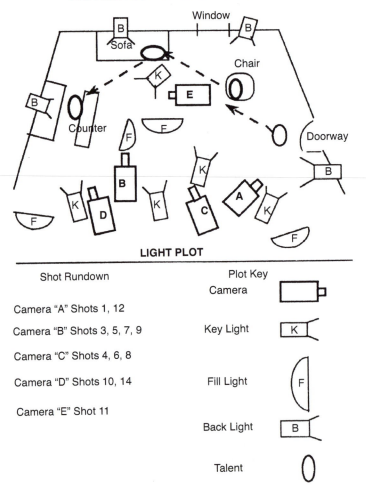

Shot Rundown	Plot Key
	Camera
Camera "A" Shots 1, 12	
Camera "B" Shots 3, 5, 7, 9	Key Light
Camera "C" Shots 4, 6, 8	
Camera "D" Shots 10, 14	Fill Light
Camera "E" Shot 11	
	Back Light
	Talent

FIG. 6.10 – An accurate plot of the set helps the rehearsal to run more efficiently by mapping out the camera positions, lighting instruments, set piece placement, and, as important, the planned movement of the performers.

Once the location is ready, you walk the actors through their starting locations, blocking, and movements, if there are any. You have the camera operator watch the blocking rehearsal so that she or he can visualize the camera movements needed for each shot. At this time the actors should deliver their lines with mics properly placed so the audio operator can set levels and determine if any audio problems exist.

You play the role of a benevolent dictator to the cast and crew. You must have absolute control, but at the same time, you must respect and listen to the members of the crew for the benefit of their knowledge and expertise. No crew or cast member should argue with you, but a professional difference of opinion leading to a discussion is permissible if there is time. At the end of the discussion, your decision is final and must be accepted by all of the cast and crew as such without rancor or spite. Your decision should be based on your knowledge of the entire production, not on the relatively narrow view each cast and crewmember might hold.

Once you have completed a successful walk-through rehearsal, you should run several camera rehearsals. This involves everyone on the cast and crew completing their roles as if the shot is being taped. Once you are satisfied with the performance of both cast and crew, then you order a take.

Shooting

The actual process for shooting a take is as follows: You call for quiet on the set by calling out, "Quiet" or "Stand by." At that command, complete silence is expected from all cast and crewmembers. If the shoot is at a public location, a crewmember may have to circulate and quiet the adjacent crowd unless the noise of the crowd is part of the audio ambiance. At the "Stand by" cue, all cast and crew assume their starting positions and prepare physically and mentally for the beginning of the shot.

When you feel everyone is ready, you call, "Roll tape," "Roll it," or maybe even "Roll 'em." As soon as the deck is up to speed, either the camera operator (if a camcorder is used) or the audio operator (if a separate recorder is being used) calls out, "Speed," or "Locked in," or "Framed." You perform a 5-second count, either silently or out loud, and then call, "Action." This 5-second delay is necessary to make certain the deck has recorded at least 5 seconds of clean sync and control track or time code, which is needed for editing purposes. Professional actors will pause a beat and then start their movement or lines. The crew will follow the action as directed during rehearsals (see Figure 6.11).

HAND CUES

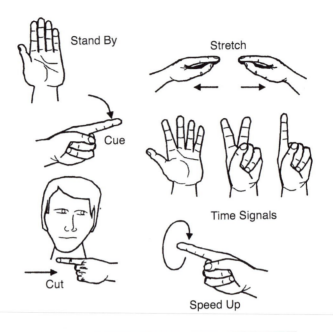

Stand By

Stretch

Cue

Time Signals

Cut

Speed Up

DIRECTOR'S VERBAL CUES

STAND BY This is a call for quiet on the set or location, especially from the cast and crew. It means they must give the director their undivided attention and wait for the next cue.

ROLL TAPE This is the cue to the tape or camera operator to start tape rolling and recording, and must be followed by--

SPEED (By the tape or camera operator)
This cue indicates to the director that the tape is rolling and recording, up to speed and locked in, ready for the call for action.

ACTION This indicates to both the cast and crew to start their rehearsed action, speech, movement, etc.

CUT This cue means to stop recording, acting, or any other action. It is an indication from the director that either the required material has been recorded or that something has gone wrong and to continue would be a waste of time.

FIG. 6.11 – Silent hand cues are a necessity to communicate quickly and accurately without disturbing the performers, adding unwanted noise to the sound track, or interfering in any way with the efficient operation of a scene. Most hand cues are understood universally within the media production industry, but as with any language, variations do exist.

During a take, there are three people who may shout, "Cut." The major responsibility lies with you, but either the camera operator or the audio operator also may cut a shot. If the camera operator sees in the viewfinder a visual error bad enough to make the take unusable, he or she may yell, "Cut." It is best if the camera operator quickly consults with you before doing so in case the audio portion of that take is usable even though the video is not. The audio operator has the same responsibility in monitoring the recorded audio. If a noise is present that makes the take unusable, the audio operator also may call "Cut," but once again, because there is always a chance the video is usable, the audio operator seldom cuts a take without a quick conference with you. In fact, an audio operator seldom cuts a take because most audio can be looped or rerecorded in a Foley session during postproduction if necessary. Any crewmember may shout "Cut" or "Safety" if a situation occurs that may hurt either a cast or crewmember. During both rehearsals and actual recording, standardized electronic media communication, hand cues, and signals should be used.

Shooting and Framing

A relationship of trust and communication must exist between you and the camera operator; you must trust the camera operator to frame, focus, and expose the shot as the director wants. Detailed communication from you to the camera operator provides the best first step toward accomplishing that relationship. If the camera operator understands what you want and need in a shot, sequence, or scene, she or he is better equipped to provide it.

Standard Shot Names

Over the years, starting with motion pictures, the different placements of objects in the field of the camera, called framing, have acquired specific names. As in every aspect of media production, there are some variations in these names; nevertheless, the following definitions are accepted and understood by all professionals.

When the angle of view varies from the narrowest angle (tightest shot), it is called an *extreme* or *extra close-up,* abbreviated ECU or XCU. A wider angle is a *close-up* (CU); continuing wider are the *medium close-up* (MCU), *medium shot* (MS), *wide shot* (WS), and *extreme* or *extra-wide shot* (EWS or XWS), the widest shot. You can call shots by specific framing: a head-to-toe shot is always an MCU. Others prefer to make their shot variations in reference to the widest or narrowest shot. For example, in a football game, a shot of the entire field from a blimp is obviously an XWS, while a shot of the

quarterback from the waist up is an XCU. However, in a television commercial where a football player holds a product in his hand, the XWS is a head-to-toe shot, and the XCU is the shot of the label of the product (see Figure 6.12).

Other names of shots are derived from the objects included in the field of view. A *two-shot* contains two objects, usually two people; a *three-shot,* three objects. An *over-the-shoulder* (OS) is a typical news interview shot in which part of the interviewer's shoulder appears in the foreground and the person being interviewed faces the camera.

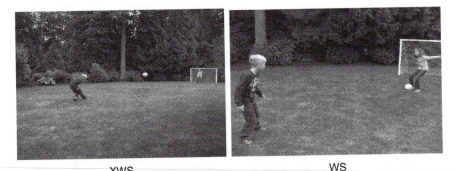

XWS WS

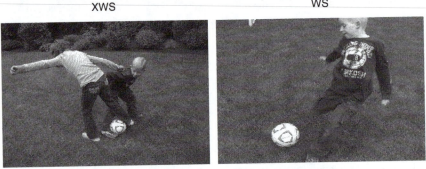

MS MCU

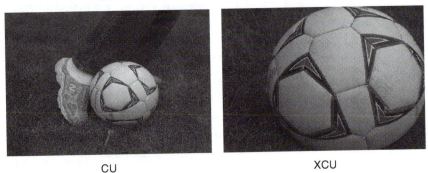

CU XCU

FIG. 6.12 – Shot nomenclature describes how a shot is framed from XCU to XWS. © Robert Musburger.

A *point-of-view* (POV) shot appears to be what persons in the scene are actually seeing from their position in the set (see Figure 6.13).

An entire set of shots is called for by each shot's relative framing on the human body: *head shot, bust shot,* or *waist shot.* One caution on this type of nomenclature: no shot should cut objects off at logical cutoff points. If a human head is framed so that the bottom of the frame cuts off the head at the neck, it appears in the shot that the person has been decapitated. This is called, *illogical closure,* and should be avoided. It is better to employ *open framing* and include just a small portion of the shoulders so as to indicate that the body continues out of frame. The theory of closure also applies to objects other than body parts. A series of houses may appear to be just the two visible, or if parts of others on each side are visible the appearance is of an entire chain of houses, not just the three visible (see Figure 6.14).

OS POV

FIG. 6.13 – Specific types of shots carry their own titles such as OS or POV. © Robert Musburger.

FIG. 6.14 – Closure allows a shot to tell more than the obvious. If three objects are shot with empty space between the objects on the end and the side of the frame, then the audience's perception is that the objects are all that exist. On the other hand, if a portion of the objects on the outside edge of the frame is cut off, then the audience's perception is that there may be more than the two visible objects. © Robert Musburger.

Shooting

Framing Principles

Aspect Ratio

The original video standard (SD) frame ratio was 4 units wide by 3 units high. HD standard is 16:9. This means that to fill the video frame without exceeding its boundaries, you must fit subjects into a horizontal rectangle 75 percent wider than it is high or nearer 50 percent wider than it is high. This is an absolute. If you turn the camera on its side to frame a predominantly tall, slender subject, it will result in an image that is lying on its side.

On the surface, this does not seem to offer much of a problem to you or the camera operator, but in reality there are very few objects that fit neatly into either a 4:3 or 16:9 space. Either you will cut off some of the object or you will need to add items to the picture to create an acceptable composition. Either ratio becomes especially critical when you shoot images of people. Unless one lies down, the human body does not fit into a horizontal rectangle; neither do most tall buildings, ships, airplanes, or any number of everyday objects.

The new digital (HD) standard frame ratio is 16:9—that is, 16 units wide by 9 units high. This ratio is a compromise between several motion picture wide-screen frame ratios. Translation circuits are included in digital cameras to enable the equipment to be switched between ratios. As always with a major change in technology within an existing system, there will be a period of time for transition during which both ratios will be used. Digital cinema is shot in 16:9, as are many commercials and music videos. You should plan all productions with both ratios in mind when composing action in the frame, as it will be several years before all receivers and consumer recording media will be able to view in both formats; you should allow for conversion when necessary or required (see Figure 6.15).

Critical Area

Besides the 4:3 or 16:9 horizontal aspect ratio, you must deal with an additional framing problem in video. Not all of the video signal created by the camera reaches the television receiver or monitor. In addition, the scanning sweeps of most receivers have increased because of age or misalignment. This means that the audience cannot see as much as 5 to 10 percent of the picture. The 80 percent of the center portion of the frame is considered the critical or essential area. The industry accepts this 80 percent (allowing

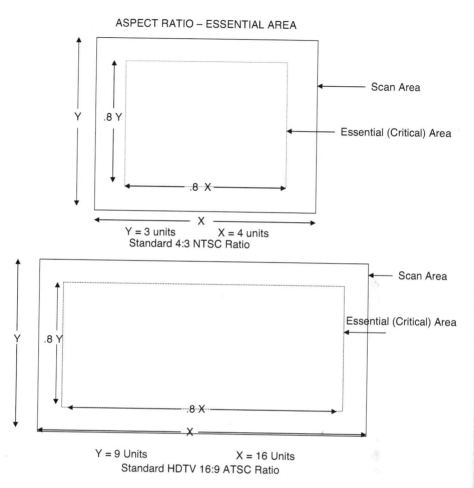

ASPECT RATIO – ESSENTIAL AREA

Scan Area

Essential (Critical) Area

Y

.8 Y

.8 X

X

Y = 3 units X = 4 units
Standard 4:3 NTSC Ratio

Scan Area

Essential (Critical) Area

Y

.8 Y

.8 X

X

Y = 9 Units X = 16 Units
Standard HDTV 16:9 ATSC Ratio

FIG. 6.15 – It is important for camera operators as well as directors and designers to keep in mind that nearly all productions may soon be reproduced in both 4:3 and 16:9 ratios. Placement within the frame of critical objects must neither be lost in the transition between formats nor look awkward with unnecessary empty space.

Framing Principles

a 10 percent border on all four sides) as the critical area standard. You should frame all important information—names, addresses, phone numbers, and prices—well within the critical area to make certain that all viewers receive it.

Any objects framed in the 10 percent border may be seen by some viewers, so unwanted objects should not be framed in this area, which is called edge bleed area. For sports or other action-oriented coverage, the acceptable framing limitations are a little broader

than the critical area, allowing approximately a 5 percent border. The difference in philosophy is that in an action sequence, closure fills in any portions of objects that momentarily appear beyond the critical area (see Figure 6.15).

Lead Room or Edge Attraction

Psychological studies indicate that objects in the area near the edge of the frame create a different perception than those in the center of the frame. A major factor is what is called *edge attraction theory,* in which an object appears to move toward the edge, even if it remains stationary in the frame. This effect increases when the object near the edge is a person's face. This lack of nose room makes the audience uncomfortable and should be avoided. The attraction of the edge is compounded when you move the subject toward the edge. That is why you should give moving objects plenty of space ahead of them as the camera follows them on a pan or tilt (see Figure 6.16).

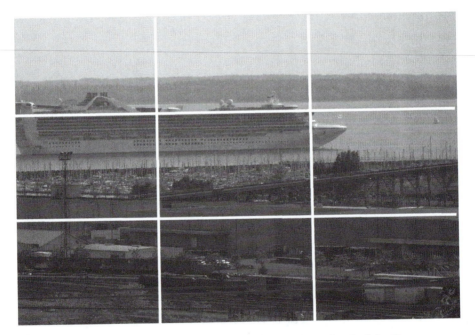

FIG. 6.16 – Framing rules may seem arbitrary, but years of experience and study of visual response shows that the rules work when properly applied. Like all rules, they may be broken when the need arises and there is valid reason to do so. Placing critical objects or information on the one-third lines in the frame helps the audience understand what is most important. Also it is important to leave extra space in front of any moving object. © Robert Musburger.

The Rule of Thirds

Some of the conventions of creative visual composition have been around for a long time, but one of the most important is the Rule of Thirds and can be traced back to the ancient Greek notion of the Golden Mean (also called the golden ratio, golden section or divine proportions). The lines themselves are often used as guides for placement of horizons or eye-line while the intersections provide dynamic placements for locating primary subjects. The rule of thirds states that the most aesthetic location for a predominantly vertical form is one third of the way in from either the left or right side of the frame. Conversely, a predominantly horizontal figure's most aesthetic position is either one third of the way up from the bottom or down from the top of the frame.

Creating Movement

Even though video is a moving art form, the individual frame is essentially a still photograph. The manner in which each picture is framed can add to or subtract from its perceived movement. You can create movement in either video or film in three basic ways: by moving the subject, by moving the camera, and by editing. Within each of these three basic movements are ancillary movements.

Subject Movement

You can move subjects in three directions within the frame: on the horizontal (X-axis) and vertical (Y-axis) planes in front of the camera or moving toward or away (Z-axis) from the camera. The Z-axis is the most powerful, and you should use it judiciously. In Western culture, moving from left to right suggests moving ahead; conversely, moving to the left signifies returning or backing up.

The Y-axis movements are more complex and less universally accepted, except when you move from the upper left to the lower right, which implies the most powerful movement forward, except for straight toward the camera on the Z-axis (see Figure 6.17).

Interestingly, the cultural values attributed to these movements also affect the relative value of positions within the frame. If you divide the frame into nine areas—upper left, upper center, upper right, middle left, center, middle right, lower left, lower center, and lower right—the position considered the most beneficial for passing information to the

FIG. 6.17 – Some frame and movement rules are culturally oriented. For that reason, a producer should consider the culture or nationality of the intended audience.

audience is the lower right. That conclusion is based on the philosophy that in Western culture, the eye starts at the upper left and proceeds to the lower right and comes to rest there. For that reason, better newscasts place the visuals on the right, and, almost universally, you should frame prices, addresses, and other critical commercial information on the right.

Camera Movement

The second means of creating movement is by moving the camera: on its pan head, panning left or right, or tilting up or down. If you have the means to raise and lower the camera on a center shaft, this movement is called *pedestaling* up or down. Depending on whether the camera base is a tripod on dolly wheels, a pedestal mount with wheels, a wheeled dolly, crab, or crane mount, the movements may be a dolly in or out, a truck (or crab) left or right, or a combination of both to move in an arc. The crane mount also permits additional combinations of movement up, down, in, out, left, and right (see Figure 6.18).

CAMERA MOVEMENTS

PAN RIGHT
Handle moves to the left

PAN LEFT
Handle moves to the right

TRUCK RIGHT OR LEFT
Camera points at subject,
but moves parallel to
the subject

TILT UP
Handle moves down

TILT DOWN
Handle moves up

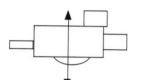

PEDESTAL UP
Camera moves straight up

PEDESTAL DOWN
Camera moves straight down

DOLLY IN
Camera moves
toward subject

DOLLY BACK
Camera moves
away from subject

FIG. 6.18 – Camera movements provide the second most powerful tool of creating interest in a moving picture (editing is more powerful). All camera moves should be made purposeful with full intent, not just random for the sake of moving the camera and creating movement in the frame.

Creating Movement

Movement through Zooms

Supplementary movement created within the lens is the zoom. You create a zoom movement by varying the focal length of the lens, increasing or decreasing the angle of view. The zoom movement does not change the perspective of a shot; the angle narrows and the picture appears to become larger, the camera's angle is not

closer. Instead, it shows a smaller portion of the picture. Also, aesthetically, this movement appears to bring the subject closer (or further away). You can achieve the same movement with a dolly, and it is more realistic because as the camera moves closer to the subject, the perspective also changes. Aesthetically, the dolly movement mimics the viewer approaching (or departing) the subject. The zoom, especially with a motorized control, is an easy and flexible movement. But it is an unrealistic movement, so you should use it with great caution. Amateur videographers use the zoom instead of advance planning. Most consumer-grade and some prosumer digital cameras can zoom digitally by enlarging the pixels. At a certain point in the zoom, the quality of the picture degenerates as the pixels increase in size.

Although even the most professional film and video camera operators now use zoom lenses, they do not use them during a shot. Instead, they use the zoom lens as it was intended to be used, as a means of varying the focal length of the lens without changing lenses.

You may use a zoom on a flat, two-dimensional object, because there is no perspective involved, or as a special effect. The *dolly zoom* effect (also called the *zolly* or *Vertigo* effect after the Alfred Hitchcock film in which it was first used) is an in-camera special effect that produces an unsettling look where the subject appears to be stationary while the background changes in size (zoom in, dolly out). It can also be executed to make the foreground change in size while the background stays the same (zoom out, dolly in). But like all special effects, you should use a zoom or zolly sparingly and with specifically planned intent rather than just tightening or loosening a shot or because you think it looks "cool."

Z-Axis Movement

Video—like painting, photography, and cinematography—is a two-dimensional art form. The picture has only a height and width as received on a television/monitor or shown on a screen. The depth, or third "Z" dimension, of the picture is perceived; it does not actually exist as a third dimension, but it appears to exist. This three-dimensional appearance is important to any visual medium. Standard definition (SD) video particularly depends on the Z-axis to compensate for its smaller screen and lower resolution as compared to HD, photography, or motion picture film. The development of both film and

digital 3-D productions moves forward slowly, but the techniques and philosophies of productions are the same as for 2-D, only more complex.

Therefore, it is imperative that the camera operator and you specifically think about and design the shots so that the Z-axis is exploited to its maximum. You should move subjects in the frame or move the camera around the subjects, arrange the objects in patterns that appear to be in perspective, and use as short a focal length lens as possible. Next, arrange objects and subjects in the frame to create a background, middle ground, and foreground to help create a usable Z-axis. If you line up objects in front of the camera in neat rows, at an equal distance from the camera, and place all objects on surfaces of the same height, size, or color, you decrease the appearance of the Z-axis (see Figure 6.19).

If you arrange objects in the frame so that, even at rest, there appears to be movement—by utilizing the object's graphic forces—this composition also improves

Straight - In line

Angled

Creating Movement

FIG. 6.19 – Because the Z-axis is the most powerful of the three axes, and the one that does not actually exist in two-dimensional media, using techniques to develop the appearance of such an axis may be critical to creating interesting and informative productions. Avoid framing objects on the X-axis only; instead stagger the objects. © Robert Musburger.

the three-dimensional perception. Do not shoot a person or object straight on. Not only is this boring, but it adds pounds and width to that person. Instead, you should rotate the actor so the camera is getting a three-quarter view, but always keep both eyes visible. Avoid having two people stand next to each other talking to the camera or each other; place them so they are facing each other, with the camera shooting past first one and then the other.

Graphic Force Movement

Another aesthetic theory you should consider when framing a shot is the graphic weight of the objects within the frame. Each discernible object has some graphic weight or value. A large, dark object has a greater value than a small, light-colored object. An object with jagged, irregular edges has more weight than an object with smooth, rounded edges. Two small objects may equal the weight of one large one, even though their actual square measurement might be slightly smaller.

In addition to the perceived graphic weight of an object is its *graphic force*. The graphic force is derived partially from its graphic weight, but also from its movement. An object at rest has less graphic force than an object moving across the frame. Objects shaped like an arrow, a row of objects arranged to lead the eye in a specific direction, or a series of shots that show an object in a position of potential movement all carry more graphic force than an object the same size without the same graphic forces present (see Figure 6.20).

Color also becomes a factor in determining the weight of an object. "Hot" colors like red, yellow, orange, and light versions of other colors tend to extend toward the viewer. These colors appear to be heavier in graphic weight. The "cool" colors like blue, violet, green, and darker versions of other colors tend to recede from the viewer. These colors tend to appear lighter in graphic weight.

In the midst of all these "rules," don't forget that there are no absolutes in any aesthetic field. All of the suggestions made in this section are intended to be used only as guidelines. Each individual production situation determines to what extent you follow or ignore these suggestions. The final production will chronicle whether the best choices were made.

GRAPHIC FORCES

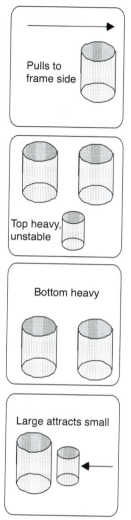

FIG. 6.20 – Of all of the framing rules, graphic forces are the most difficult to tie to absolute criteria. Part of the value of graphic force is that the observer feels movement without any existing. The arrangement of objects in a frame may create a feeling of movement or a sense of movement by their relative position to each other or their relative relationship to the edge of the frame.

The Third Movement: Editing

Shoot to Edit

Regardless of the skill of both you and the camera operator in planning and framing shots, unless the shots have been recorded to be edited together, the aesthetic values will be lost. In EFP, each shot is recorded separately, often out of script sequence (but convenient to location or actor availability, or both). To be able to assemble the shots in a meaningful manner close to the original intent of the production, you must shoot them with editing in mind.

First, consider the electronic aspect. For nonlinear editing, any editor will always appreciate extra head and tail footage, regardless of the editing method. Sometimes referred to as *clean in* and *clean out,* this added footage—devoid of action—at the beginning and ending of each shot for a scene allows action to move into and out of the shot and provide flexibility in editing. Head and tail footage also makes certain each frame you expected to be recorded is technically usable, and the extra footage can assist in matching continuity.

Second, consider the practical aspect. Each shot should be recorded so that its action overlaps both the preceding and following shot. Directors do this by having action *ramp* into a shot (picking up with the preceding action as you go into the present action) as well as *trail* out of the shot (continue present action into the next action). Of course, this requires your actors to repeat their actions exactly the same (called, personal continuity) for each shot of the action you wish to shoot. This allows the editor greater protection in case a shot did not start or end exactly as intended. This overlap also gives you a wider range of choices as to the best segment of an action to cut (see Figure 6.21).

The third aspect to consider is the aesthetic aspect. To edit in a seamless fashion, you must maintain continuity. The action from one shot must flow into the action of the next, unless there is a transition or change of scene. There are three basic types of continuity that generally must be matched in each edit: continuity of action, direction, and location.

Continuity of Action

As the actor picks up the pencil in the wide shot (WS), you must shoot the close-up so that the rate of picking up the pencil is the same and the same hand and pencil are

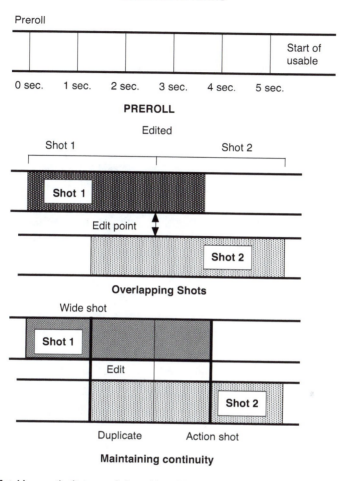

EDITING PATTERNS

Preroll

0 sec. 1 sec. 2 sec. 3 sec. 4 sec. 5 sec.

Start of usable

PREROLL

Edited

Shot 1 Shot 2

Shot 1

Edit point

Shot 2

Overlapping Shots

Wide shot

Shot 1

Edit

Shot 2

Duplicate Action shot

Maintaining continuity

FIG. 6.21 – Matching continuity can only be achieved if the camera operator makes certain that every shot has footage overlapping the shot preceding and following, especially if there is specific action.

used. This seems like a logical action, but even the best directors and camera operators make action continuity mistakes. For that reason, a continuity assistant, also known as a *script supervisor,* is an essential member of any major production crew. The continuity assistant watches every shot carefully and records the information on the script or a continuity report form inserted with the script, or even takes digital still photos of the beginning and ending of each shot to check continuity.

Continuity of Direction

If the WS shows the actor facing to the left and the actor's right hand reaches across the frame to the left, then the close-up must show the hand moving to the left. If a shot shows an actor moving to the right, then the next shot must show the same actor still moving to the right, unless there is a change of direction shown on camera in the shot or a cutaway is inserted between the two shots. A cutaway can even confuse the audience, however, if viewers remember that the actor was moving in one direction and the next time he or she is seen moving in the opposite direction. You can use a straight-on shot from directly in front or from the rear of the actor as a transition. This same rule applies to all movement whether it involves automobiles, airplanes, people walking, running, or falling, or objects being thrown, dropped, or moving on their own. Psychologically, movement from the left to right is moving forward, from right to left is a returning movement.

Continuity of Location

Continuity of location includes lighting, background, and audio. If you light the establishing shot low-key with heavy shadows, then all of the close-ups must also be lit the same way. If one shot shows the ocean in the background, then unless a change of direction is shown on camera, all shots should indicate the ocean is the background. Audio continuity becomes an aesthetic tool as well as a continuity rule. If the scene is in a large, empty hall, all of the audio must sound as if it were recorded in the same ambiance. However, the ambiance of a wide shot in the same location sounds different from that of a tight close-up of two people talking and standing close to each other.

Cover Shots

There are three types of cover shots that are the friends and saviors of the editor: cover, cutaway, and cut-in shots. Any capable director will call for them to be recorded, and any professional camera operator will shoot them even if you forget to do so.

A cover shot is an illustration of what is being talked about or referred to. If an announcer speaks of the use of a product, then a shot of the product being used in that manner is a cover shot. The announcer does not need to and probably should not appear in the shot.

Instead of a single shot, a series of shots or a sequence would better illustrate what the announcer is talking about.

Cutaway and cut-in shots are similar, except that a cutaway is a shot of items that are not part of the primary action or included in the previous or following shots—for example, when two people are sitting talking in a railway station and there is a shot of the train arriving. The two people in the scene do not refer to it (if they did, it would be a cover shot), and, most important, they must be sitting or they are not included in the shot of the train. But the audience realizes this train has something to do with the action. Generally, cut-away shots provide two important characteristics of a sequence. First, the shot gives the audience information that the main action does not reveal. Second, it can be used to cover an edit that would be a jump cut unless an intervening shot can be inserted.

A cut-in is a close-up of some object that is visible in the present action and shown in close-up in the preceding or following frame. If a woman's purse is visible in a close-up as the two characters sit in the train station, it is a cut-in shot if the purse is also visible in the WS.

These three types of shots afford the editor the chance to correct mistakes made in the shooting continuity, or they can be used to speed up or slow down a sequence or to correct a continuity problem in the production (see Figure 6.22).

Cover Shots

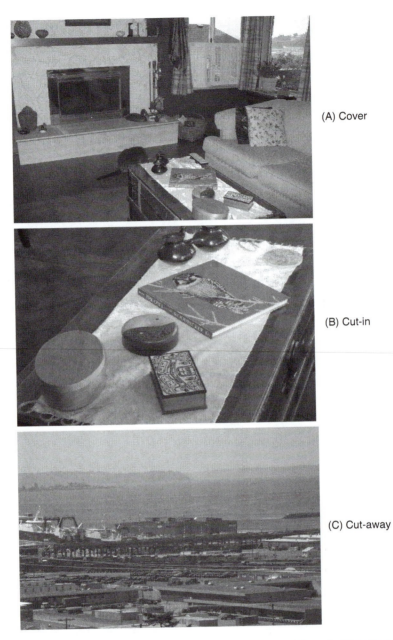

(A) Cover

(B) Cut-in

(C) Cut-away

FIG. 6.22 – Three types of shots that editors depend on are valid cover (A), cut-in (B), and cutaway (C) shots. Each provides the editor with a means of maintaining continuity and best telling the story visually. © Robert Musburger.

In-Camera Effects

Technology exists that allows you to produce a series of special effects simply by utilizing the controls necessary for the normal operation of a camera. As technology advances, newer cameras have many digital special effects capabilities built into them. Several effects may be produced with digital camcorders: iris fades, rack focus, swish pans/ zooms, reverse polarity, and manipulation of pedestal and gain, including electronic fades (see Table 6.1). However, their use should be carefully considered and planned since they are "burned in" to the recording of the scene and may present difficulties should the story, or editing, later dictate a different approach.

Iris Fades

You create an iris fade-in or fade-out by placing the iris control on manual and setting the iris opening stopped all the way down. While shooting, you may slowly open the iris up and bring it to the proper setting. This creates a fade-in. A fade-out is created by reversing the procedure: you start a scene with the camera rolling and the iris set properly; at the right moment, you stop the iris down until the picture fades to black. Neither of these effects works well unless the light level is low enough that the iris is nearly wide open at the proper setting.

Roll or Rack Focus

To roll or rack focus simply means to start a scene in focus and rapidly turn the focus control until the picture is totally out of focus. The shot to be edited next should start totally out of focus and, on cue, you turn the lens into proper focus. Once again, this effect only works well when the light level is low enough so that the depth of field is

TABLE 6.1 – The number of in-camera effects depends on the design of the camera and related equipment. Check the owner's operation manual for instructions on how to manipulate the controls to achieve the effect you want or need.

IN-CAMERA EFFECTS

- ❖ Iris Fades
- ❖ Rack Focus
- ❖ Digital Zoom
- ❖ Polarity Reversal
- ❖ Solarization
- ❖ Pixilation
- ❖ Color Modification
- ❖ Level/Pedestal Modification

In-Camera Effects

quite shallow and the focus change should be rapid enough to appear intentional, not an error in shooting.

Swish Pans and Zooms

A swish pan is a transitional shot. It moves the camera at a high enough rate to create a blurred image. The next shot starts with a fast pan and ends properly framed. The first of these is easy to accomplish, but for the second, it is difficult to stop at the exact framing without jerking or missing the mark.

A swish zoom is a little easier, especially if the zoom is motorized. The process is the same as a swish pan in that you start the shot at a normal focal length and, on cue, you operate the zoom control at its maximum speed, usually zooming in rather than out. The second shot starts with a zoom out and ends properly framed.

Reversing Polarity

Reversing polarity is achieved by your throwing a switch, on some cameras internally and on others externally. This cannot be done while you are recording because there is a momentary loss of sync. The picture areas that were red become cyan, those that were green become magenta, and blue areas become yellow, and vice versa. Light areas become dark, and dark areas become light. The effect is the same as looking at a color film negative.

Digital In-Camera Effects

If the camera has built-in digital circuits, it may be possible for you to *solarize, freeze frame,* or *pixilate* the picture, among many other effects, depending on the individual camera. The solarized effect appears as if the picture is melting or reversing in polarity. A freeze frame effect locks a single frame of the picture as if it were a still photo. Pixilation is the process of removing a certain number of frames of the picture so that objects and subjects appear to move about in an irregular, jerky fashion. Each of these effects requires a separate control on the camera. You also can accomplish pixilation if the deck can record a single frame at a time. A control sets the number of frames per second at which the recorder will operate. This compresses the action in any time elapse required for the production. You can better accomplish in-camera effects through the camera's control unit or, in some cases, during postproduction.

Logging and Striking

A manual operation often overlooked in the concentration on electronic operations in a video production is the manual continuity record keeping or logging process. A written

record of each shot is kept on a log sheet in a form that supplies you and the editor with the information you need to accomplish your tasks. The log registers, in the order of shooting, the shot and take number, the location on the medium (counter or Society of Motion Picture and Television Engineers [SMPTE] time code number), comments on whether the audio or video take was good or bad and why, and any other comments you want noted (see Table 6.2).

TABLE 6.2 – Logging can become a critical stage in the editing process if not completed accurately as shooting continues. The logs help the director, production manager, and editor once final shooting is completed and the project moves to the postproduction stage.

RECORDER LOG

RECORDER LOG PAGE _____

DATE _____

LOCATION _____

PRODUCTION _____

CAMERA/MEDIA _____

REEL/DISC # _____

PRODUCER _____

OPERATOR _____

DIRECTOR _____

D/V _____

TIME CODE	TAKE	DESCRIPTION	REMARKS

In-Camera Effects

The log is invaluable to the editor. If not accurately logged during the shoot, the recordings have to be previewed and logged in the postproduction process, which is a slow and painstaking procedure. One person should keep the logs, and logging should be her or his main responsibility. The person's title in a large crew is continuity assistant (CA) or script supervisor. In a smaller crew, the director or an assigned production assistant is in charge of logging. The importance of this function cannot be ignored. The person keeping the log must be familiar with the critical aspects of continuity and well versed in that particular production.

As each shot is set up and rehearsed, the logger notes positions of props, set pieces, lighting, or anything else that may be moved or changed. Because the production will be shot out of sequence, there may be hours or days separating the actual shooting of some shots in the same sequence, and every aspect of each shot must match in order to maintain continuity. As each shot is completed, the CA logs any deviations from the script and minute details, such as with which hand an actor handled which prop. A digital still camera is invaluable to a CA. After each shot, you, the camera operator, and the audio operator dictate comments to be added to the log.

If the editing is on a nonlinear digital editor, the logs become even more important. The tedious and time-consuming activity of dubbing in real time all of the footage shot into a digital format before editing can begin can be reduced by converting only those shots that are good enough to be used in the final production. All other shots are left in their original form to be dubbed later if they are needed in an emergency.

Striking

Once the excitement of the actual production has evaporated and the actors, directors, and producers have disappeared, the last stage of the production process begins. It is just as important as any other stage, but it occurs when everyone is tired and let down, after the tension of the shoot has eased and everyone is thinking about tomorrow.

As soon as you give the order to *strike* (a term borrowed from the theater), or when the order is given by the production manager on a larger crew, all power is killed except for any work lights that are present. Then all other cables are disconnected to prevent crew members from tripping over them and pulling equipment or lighting instruments down. Each crew person is responsible for striking equipment. Cables are properly coiled and

stored in their cases. Once equipment has been cleaned and returned to the proper cases, a check is made to be sure that all equipment has been packed and is ready to be loaded.

The strike should be as organized as the setup. The next use of the equipment may come the following day. Note, in writing, any damaged equipment, and notify maintenance immediately. The location has to be restored to its original condition. You should repair any damage or report it to the owners in writing and negotiate a satisfactory compensation before you leave the site (see Table 6.3).

TABLE 6.3 – Strike list.

STRIKE LIST

1. CAP CAMERA

2. TURN OFF ALL POWER SWITCHES EXCEPT WORK LIGHTS

3. DISMISS TALENT

4. DISCONNECT ALL CABLES, BOTH ENDS

5. LOWER ALL LIGHT STANDS, MOVE GENTLY OUT OF THE
WAY TO COOL

6. PICK UP AND PACK ALL PROPS, SET PIECES,
LOAD SETS, LARGE SET PIECES

7. COIL CABLES PROPERLY, OVER-UNDER,
NOT AROUND ELBOW

8. WIPE DOWN CABLES AND SECURELY FASTEN ENDS

9. REMOVE CAMERA FROM TRIPOD,
PACK IN CASE WITH ACCESSORIES
(TRIPOD PLATE, POWER PACK) WHICH BELONG IN CASE

10. PACK ALL CABLES, BATTERIES

11. PACK ALL GAFFER EQUIPMENT

12. IF COOL, DISMANTLE LAMP HEADS AND STANDS
AND THEN PACK

13. INVENTORY ALL EQUIPMENT CASES
AND LOOSE EQUIPMENT

14. MOVE EQUIPMENT TO VEHICLE
** NEVER LEAVE ANY EQUIPMENT UNATTENDED **

15. LOAD EQUIPMENT INTO VEHICLE

Striking

Equipment is then moved to the vehicle, loaded, and returned to its storage locations. Each piece of equipment needs to be carefully checked off with the person responsible, whether it is the production manager or a leasing company. Take the same pre- cautionary measures during striking as you did during the setup. Never leave equipment or the equipment vehicle unattended until all equipment has been secured.

The "fun" part of the production has now ended for you. It consumed the shortest period of time and in many ways the least amount of effort—that is, mental and aesthetic effort. Once you have worked several EFPs, you will appreciate the physical effort required for the production process.

Chapter Seven
The Production Process: Postproduction

The Soul of Production

As the final stage of the media production process, postproduction affords you the last opportunity to reach the goal(s) you originally set in preproduction. There is a widely accepted Hollywood axiom that every film is made three times: when the script is written (preproduction), when it is shot (production), and finally, when it is in postproduction. That third version of the story is the most elusive, and the image of a stressed-out person obsessively poring over footage in a windowless room for weeks is fairly close to reality. Editing—the process of selecting and combining video segments into a desired sequence after they have been shot—is often called the "invisible art" by its practitioners because a good editor will make a film so fluid that the audience will not be aware of the editing. But, your audience will certainly notice the editing if it is bad! Editing can be as simple as inserting a dissolve between two shots or it can be so complex that it alters the meaning of a scene or the entire work. Editing can also seem daunting and mysterious. You must live up to the artistic vision of the director, maximize the emotional integrity of the performances, and you have an inviolable responsibility—first and foremost—to serve the story.

You have heard it before—probably even said it yourself—but editors really despise the saying, "Fix it in post." Those are probably four of the most dangerous words in the video production lexicon! Editors know that with that simple statement their workload just doubled and, most likely the final cost of the project as well. Although there are a lot of things a seasoned editor can do—thanks to advanced computer programs—it is probably more accurate to say, "Cheat it in post." Production mistakes do happen (e.g., shaky handheld shots, low audio levels, boom mic appears in the shot) and sometimes they can be "cheated" in post (a stabilization feature in your software, boost the audio's gain or increase image size to push the mic out of the shot). However, you cannot expect postproduction to correct all errors in judgment, miscalculations, and poor production techniques. If the material is not available or is technically deficient, you may not have any means of replacing it or rectifying the problems created in preproduction or production. You cannot bring out of focus shots into focus, reframe poor or incorrectly reframed shots (except by using expensive and advanced digital applications), re-zoom

a poorly zoomed shot, or retrieve clipped audio. You may partially correct poor lighting, but at a cost in image quality, time and energy diverted from the important work of the edit. If you forgot a shot, you do without it, or you return to the location and reshoot—assuming you have room in your budget and can once again secure the location, crew and actors.

The Mind of an Editor: Equipment, Technique, and Aesthetics

The way a story unfolds and grabs the attention of your audience is one of the most important and creative elements in media production. To ensure that the story flows effortlessly from beginning to end, each shot must be carefully chosen and edited into a series of scenes, which are in turn assembled to create the finished program. Your aim is to manipulate plot, score, sound, and graphics to make all the different parts acquired during the production process into a continuous and enjoyable whole. This highly creative, challenging, and rewarding job is the work of the editor, who works closely with the director in deciding how to maximize the potential of the script and craft the shot footage into a coherent whole. To be an editor you must have a high technical aptitude and wide experience in the production and postproduction processes. As most film and video programs are now edited on computers, you must also be able to use a variety of computer editing equipment and software. You should understand dramatic storytelling and narrative structure and be able to create rhythm, pace and tension. Other key skills would include an ability to be creative under pressure, possess excellent interpersonal communication skills, a highly developed aesthetic visual awareness as well as be detail oriented with good organizational skills, disciplined, and infinitely patient.

The technical factors depend on the capabilities of the equipment available to you for the editing session. It is possible to complete a wide variety of productions using an inexpensive, consumer-oriented computer with an amateur editing application. But the wide range of available editing hardware, operating systems (Windows, Mac OSX, and Linux) and the capabilities of specialized editing applications like AVID, Final Cut Pro, Adobe Premiere, and other commercial non-linear editing software provide you with a nearly infinite means of editing a production at any level depending on how the material was shot. You need to know the limits of your equipment and acquire the ability to use the equipment to meet those limits without creating technical problems or greatly slowing down the editing process. Learning the specific characteristics of both the hardware and software used in editing and the

technical requirements of the final master version requires you to study, concentrate, and possess the willingness to assimilate technical characteristics of the editing process.

Editing technique is as much a function of aesthetics as it is your technical skills and the capabilities of your editing equipment. Although the shot is traditionally defined as a single run of the camera, it is, in fact, defined by editing and editing's job, in part, is to adjust shots and join them together. There are many ways of effecting a transition from one shot to another, some more evident than others. In the analytical tradition, editing serves to establish space and lead the viewer to the most salient aspects of a scene. In the classical continuity style, editing techniques avoid drawing attention to the actual edit. Discontinuity editing (also known as complexity editing), organizes shots based on meaning rather than location or chronology, resulting in disorienting image sequences and narrative ambiguity—a popular editing technique for music videos, some commercials, many movie trailers and most avant-garde productions. Knowing how and why to employ which technique, when to end one shot and begin another, the type of transition to use, and the sequence in which to place the shots relies on your understanding of the overall narrative of the story, the specific communicative purpose of the scene you are editing and the desired emotional content, rhythm and pace needed to engage the audience and carry the plot forward.

Media production combines many different disciplines, each with their own set of aesthetic traditions. The screenplay draws heavily from literary and rhetorical traditions and the aesthetic conventions of creative writing in its storytelling. Cinematography is closely related to the aesthetics of visual arts and photography. Sound recording and mixing is often closely associated with the aesthetic traditions of musical composition. Likewise, actor performances, set design, costume and make-up are informed by theatrical aesthetic traditions. However, editing is probably the one discipline that is unique to film, video and television production possessing its own unique traditions and techniques while drawing from many other disciplines as well. The aesthetic factors of editing call on your knowledge of psychology, art, music, theater, and the rest of the performing arts. To be able to communicate effectively, you must understand the demographics and psychographics of your intended audience. Knowledge of art provides a background for framing, color, settings, and visualization. No production exists without some music in some form. Music can be as important at setting a feeling or mood for a production as the color of the graphics or costumes. An understanding of how a theatrical production is organized and created to bring the maximum effect on the viewer is critical in your understanding of how to bring your message to your audience (see Figure 7.1).

The Mind of an Editor: Equipment, Technique, and Aesthetics

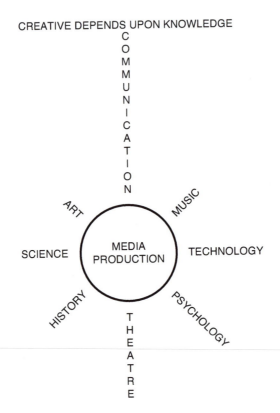

FIG. 7.1 – All artistic processes, including digital video editing, rely on a wide variety of creative fundamentals found in the basic humanities of communication, history, and psychology as well as the arts in music, theater, and fine art.

Editing is often a long, tedious process that may stretch even the most patient people to their limits. There are no shortcuts. Editing is tedious, detail oriented, and requires tremendous concentration on both the editing process and the creation of the production itself.

Editing Workflow and Interface

Basic Process

The complexity brought about by the digital revolution has both simplified as well as complicated digital postproduction for film and video. On the surface, digital equipment and techniques appear to be simple, straightforward, and easy to approach and learn. Even without any formal training, with a few basic tutorials (provided by the manufacturer or found on the Internet), occasional reference to the user's manual, and a couple of

TABLE 7.1 – At this point in the evolution of media production, there are several workflow pathways a project can take and each has a significant impact on the budget of the project, the technical process and the range of distribution and exhibition possibilities.

Postproduction Workflow Pathways

1 Originate on Film	Develop Negative	Print Dailies (positives)	Edit Dailies on Film	**Conform Original Negative - Answer Print**		
2 Originate on Film	Develop Negative	Transfer Negative to Video thru Telecine	Digital Nonlinear Editing	**Conform Original Negative from NLE - Answer Print**		
3 Originate on Film	Develop Negative	Print Dailies	Transfer Dailies to Video thru Telecine	Digital Nonlinear Editing	Conform Dailies to Digital NLE	**Conform Original Negative - Answer Print**
4 Originate on Film	Develop Negative	Transfer Negative to Video thru Telecine	Digital Nonlinear Editing	Print Positives that conform to NLE edit	**Conform Original Negative - Answer Print**	
5 Originate on Video	Ingest or Transcode Original Video	Digital Nonlinear Editing	Original Video conformed to final digital edit. **Final "Answer Print" in Video**		Or **Transfer Final Video thru Telecine to Film - Answer Print**	

days with the equipment and you can be editing your video. Unfortunately, the simplicity of digital media has also created a complex combination of technologies and techniques that you must consider from the very beginning of a project—before shooting and certainly before editing—based partially on how you intend to distribute the project. The process and format path that your project will take from acquisition of images and sound to distribution and exhibition is called *workflow*, and it can follow any of several paths depending on shooting format, editorial format, finishing process, mastering format, and distribution formats (see Table 7.1). More than any other technical area, you can easily lose your way in the workflow stream—often with unintended and expensive consequences. To avoid nasty surprises, you need to research the technical stages of your project—from camera choice, to shooting format, to the editing system's capabilities and your intended format for distribution and exhibition—and the interface between the various production phases and how format choices will interface with each other. This begins in preproduction with how you answer such questions as:

- What is the shooting format: type of camera, record media, HD or SD, compression codec (or "raw" uncompressed) and color standard, aspect ratio and resolution, interlaced or progressive scan, and frame rate (drop frame or non-drop frame)?
- How will the video be edited? You must match shoot format (above) or you will have to contend with *transcoding* your footage.

Editing Workflow and Interface

- What is the intended final master of your project: HD or SD, mono, stereo or 5.1 surround-sound audio, with or without secondary audio program, compressed or uncompressed media file(s)?
- How will the final product be distributed: broadcast format, converted to film, digital cinema, DVD, Blu-ray, the Internet, or a combination?

At a broad level, workflows can appear quite similar. However, there can be a lot of variability in the details and things can change from year to year. This is why you need to research your complete workflow before you start shooting. A little bit of research up front will save you endless frustration, wasted time and a great deal of money down the road.

Not long ago, a video camera, regardless of its price or purpose, created an electronic signal that you could edit on any linear editor manufactured at that time. Today, that is no longer true. Digital cameras and, most important, the recording systems and codecs built into the camera or any other means used to record the digital signal (e.g., externally connected hard drive and solid-state media recorders like the Aja Kia Pro or Atomos Ninja), determine the type of signal available for you to edit. How the editing process may begin and proceed will depend on the method and technology of the signal you recorded. The signal generated and its form must either match your editing system or you must introduce a conversion process (called transcoding) between the camera and the editor.

The exact match between your camera output and the input of your nonlinear editing (NLE) computer will depend on the capabilities of the particular NLE program and computer you use. This text cannot describe every NLE application and computer combination. Make certain you carefully read the operator's manual for both the digital editing application as well as the computer to determine your workflow options (see Table 7.2).

Process Background

The earliest films were not edited. They were continuous film runs of usually unscripted action, typically shot from a single camera position with a single, usually wide-angle lens. At the time, the mere fact that they showed motion on a screen was enough of a marvel to attract a large and usually amazed audience! However, as early filmmakers began experimenting with storytelling by stopping in-camera film exposure to move the camera or re-stage the scene before resuming shooting—effecting a "cut"—or back-rolling the film and then re-exposing new action for a "dissolve" effect, these early in-camera transitions and effects proved cumbersome to set-up and awkward to pull-off effectively. Eventually, early filmmakers realized their heretofore unedited films could

TABLE 7.2 – The wide variety of characteristics that separate digital video signals from each other create at least 18 different formats.

DIGITAL VIDEO SIGNAL CHARACTERISTICS

Level of Definition:	High Definition (HD) or Standard Definition (SD)
Scan Type:	Interlace or Progressive
Scan Rate:	24, 30, 60, 23.976, 29.97, 59.94 or for Europe 25, 50 Frames Per Second (FPS)
	Drop Frame (DF) or Non-Drop Frame (NDF)
Frame Size:	720 x 480, 1440 x 1080
Raster Size:	1280 x 720, 1920 x 1080
Bit Rate Quantization:	8, 10, 24 bit
Color Standard:	4:1:1, 4:2:0, 4:2:1, 4:2:2
Aspect Ratio:	4 x 3, 16 x 9
Compression Ratio:	2:1, 4:1, 5:1, 7:1, 8:1

Format Combinations:		
	720p/23.976	DF
	720p/25	Europe
	720p/29.97	DF Flagged 59.94
	720p/50	Europe
	720p/59.94	DF
	1080p/23/976	DF
	1080/24	Film Projection
	1080/25	Europe
	1080i/50	Europe
	1080i/59.94	DF

File Type:	Quicktime, AVI, MPEG
Medium Format:	Raw footage, DV, HDV, AVC-HD, Full HD, DVCam, DVCPro
Audio Rates:	16 bit, 44.1 kHz, 24 bit, 49 kHz
Audio Format:	Material Exchange Format (MXF), Open Media Format (OMF) AIFF-C, WAVE
Audio Channels:	2, 4, 8 (or more)

Editing Workflow and Interface

benefit greatly from editing—cutting out some parts, moving shots around, varying camera angles, and changing the length and positions of shots. By rearranging and manipulating different shots an editor could create a story sequence. Edwin S. Porter was the first American filmmaker to edit his films and his *Life of an American Fireman* (1902) is considered the first edited film. The techniques used in this film were later improved and applied to his next film *The Great Train Robbery* (1903). Editing was further advanced by D.W. Griffith when, in 1915, he released his film *The Birth of a Nation* in which he used

camera and storytelling techniques that would become the standards for most feature films to the present day. Thus, editing changed film from a novelty to a medium of storytelling and set the course of film—and by extension, television and video—to become one of the primary means of modern entertainment and information distribution.

Today, editing systems range from sophisticated and expensive digital suites with all the bells and whistles to very basic single-source systems consisting of a camcorder, a computer and an Internet connection. Still, the functions of editing remain the same as they were in the early years of film:

- To connect shots into a sequence that tells a story or records an event.
- To correct or delete mistakes.
- To condense or expand time.
- To entertain or communicate a message.

Whether you're creating an independent feature film, a music video, a commercial or simply editing a client's wedding video, the challenge remains the same—to take raw footage, and within the limitations of equipment and budget, transform it into something compelling and watchable.

Three basic editing systems exist today. The earliest form of electronic video editing, linear editing, has been supplemented almost completely by digital nonlinear editing, which is itself based in part on the "analog" nonlinear editing system long used in the motion picture industry (see Figure 7.2).

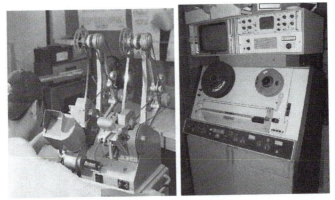

Manual Film Editing Linear VTR Editing

FIG. 7.2 – Editing on the original professional 2-inch quadraplex video system and editing film at television stations have been replaced with nonlinear digital editing systems. (Courtesy KEPR and Ampex.)

Nonlinear Film

Film editing has always been a nonlinear process. Each clip may be assembled in any order. Individual shots may be moved and combined with other shots and transitions and rearranged at will without affecting other shots because the shots are physically taped together. As film productions became more complex and frequently shot out of script order, editors were frequently working on different portions of the overall film out of sequence. As the "dailies" came in, the editor (or the assistant) would cut the new footage into the existing sequences assembling the film. After principle photography was wrapped, the director and editor would recut the assembled footage (according to the director's vision) into the "director's cut." Depending on contractual obligations, the film could undergo an additional "producer's cut" before reaching "picture lock" and advancing to the next level of editing the audio, music and inserting the title sequences (front and back). The sound tracks, both dialog, Foley effects, and music, are typically edited separately and then combined with the locked picture in the final printing process form (the "answer print") ready for duplication and distribution.

You accomplish the cutting and assembling of shots in film nonlinear editing by using a copy of the original negative film called a "work print." You physically cut and splice the film together into a complete first edit, which allows you to try different combinations without harming the original negative. Once you complete the final edit, the original negative is matched to the work print edit in a process called *conforming*.

Linear Electronic

Linear video editing is a video postproduction process of selecting, arranging and modifying images and sound in a predetermined, ordered sequence from the beginning of the program through to the end. The first professional electronic editing of videotape required you to physically cut the tape at a precise spot between frames and splice the cut videotape with a special tape. The process required great skill, and often resulted in edits that would roll (i.e., lose sync) and each edit required several minutes to perform. Although shots could be moved from one position to another, the process was destructive (meaning, once done it could not easily be undone) and so primitive as to be impractical.

Another method of linear editing let you use at least one tape deck as a source tape, a computer-like controller to determine in and out points for shots as well as controlling the operation of both the source deck and a master deck used to record the final edits.

Editing Workflow and Interface

You used two basic edit techniques: either you would use *assemble editing* to simply add one shot after another by copying the desired footage in its entirety (image, audio, time-code and control track) onto a blank master edit tape, or you would use *insert editing* to record an image or audio (or both) over previously assembled video or on a tape that was "pre-blacked" (previously recorded with timecode and control track but without image or audio). When using the insert editing method, you could add close-ups, cutaways or different camera angles to a master shot, or add effects in the middle of the master shot. You could also edit audio separately or simultaneously depending on the placement of the original audio track (see Figure 7.3).

A-B ROLL LINEAR EDITING

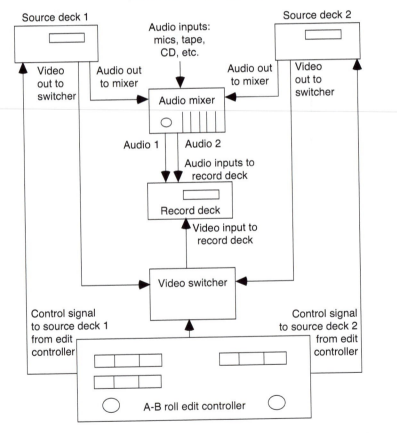

FIG. 7.3 – Linear electronic editing systems offer a relatively inexpensive and easy-to-operate videotape editing process. For news and simple productions, linear electronic editing systems were popular but now have been replaced with digital nonlinear systems.

As linear digital tape controllers became more sophisticated, you could create complex shot and sound patterns despite the linear nature of the system. The "A–B roll" linear editing system represents the most complex system of linear videotape editing. This system allowed you to have a primary source deck (the "A-roll") and any number of secondary video or audio sources ("B-rolls") that were interconnected to a video switcher (similar to that used to mix a multi-camera television program) on which you would select or perform transitions and a special A–B roll edit controller to program and synchronize recording the transitions from the A-roll to any one of the B-roll sources and back. To be effective, this style of linear editing worked best if the system was in the insert editing mode and the record tape had been pre-blacked prior to editing. As is the defining nature of linear editing, once you edited together a series of shots, a change could not be made to a shot in the middle of the sequence without changing all of the shots following the changed shot.

Digital Nonlinear

The preliminary philosophy and techniques of linear editing apply directly to digital nonlinear editing. Digital nonlinear editing allows you to assemble your video in sequential order (i.e., assemble editing) as well as to overwrite existing video images or audio with alternative sources (analogous to insert editing). However, you can also perform a "ripple insert edit" that pushes ("ripples") footage following the inserted shot further down the timeline. Transitions other than cuts can also be performed after the fact far more simply than can be afforded by an A-B roll editing system. These latter techniques for editing video replicates that used in non-linear film editing, except digital nonlinear editing allows you to "undo" edits you do not like (so it is non-destructive) while affording you greater flexibility and a wider range of easily attained techniques (see Figure 7.4).

Virtually all film and video projects, whether destined for broadcast, DVD or theatrical release and regardless of being shot on film, SD or HD video, are now edited on a digital NLE system. Editing in the digital domain using a computer and specialized software means that all visual and audio components of your project, no matter their original form, must be transferred (*encoded*) as digital data called *media files*. If your source media was captured digitally, you simply need to copy the digital media files to your computer; unless the captured format is different than what your editing software can read, in which case you will need to transcode your media into a format you can edit. In the appropriate digital format, any piece of source media can be instantly accessed through your computer's

Editing Workflow and Interface

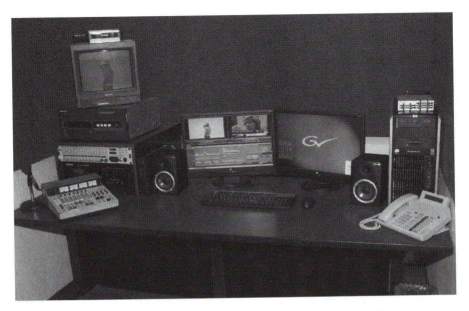

FIG. 7.4 – Modern nonlinear digital editing systems provide for the maximum in flexibility and creativity, and, with today's high-end CPUs, they offer a relatively inexpensive and easy-to-learn process to fulfill the editing needs of anyone, from the amateur to the professional. (Courtesy Advanced Broadcast Solutions and Grass Valley.)

random access capabilities and easily labeled, organized, duplicated, arranged, rearranged, trimmed, mixed, and manipulated with a few keyboard commands or a simple click, drag and drop of your mouse. The key to digital NLE is the use of *virtual clips* (referential to your original encoded media files with instructions on in/out points), not the actual original footage. The process is based on an ability to assemble clips from a variety of sources in any order and then rearrange and modify them without affecting other clips. You accomplish all of your editing using virtual clips, not the actual media files. Once you complete the editing process, then the edited virtual clips that make up your program's timeline are rendered into an actual self-contained movie file (all the in and out points for each clip, transitions, graphics, color grading, special effects, audio and music are copied from the source media files by your editing software into a single "master" file) and ready for further encoding (if necessary) for distribution. The digital NLE process allows you maximum flexibility to assemble clips accurately without compromising the potential; you can experiment with different combinations and selections of clips to achieve the purpose that you, the writer, producer, or director intended. This flexibility gives you the opportunity to, without destroying the original footage, modify a scene or sequence through trial and error until the best combination of clips satisfies you.

Digital NLE Equipment and Interface

Hardware

Regardless of the complexity of the editing project or the editing suite, you need basic equipment in one form or another. This can present a "chicken or egg" choice in that frequently you would match your hardware to the editing software you wish to use, or vice versa. In either case, be sure to read the specifications of your hardware and software carefully to ensure operational compatibility. Assuming an "agnostic" approach to hardware selection—whether PC or Macintosh—you will need a computer with a higher-level of internal components not usually found in your typical home computer. These include such components as your computer's central processing unit or CPU, the "muscle" of your computer, a graphics card with sufficient onboard memory to boost your editing power, random access memory or RAM to speed-up and provide stability to your editing workflow, large or multiple media file storage capabilities, one or more large computer monitors, and specific input/output ports for all your peripheral components.

For today's video editing software you will want a fast (measured in GHz), preferably multi-core, 64-bit CPU—the more CPU cores, the more power your computer will have for such tasks as transcoding, rendering and compositing. Your budget will easily determine how many cores and at what speed your CPU configuration will be. You will also want to get the best high-end graphics card with maximized video RAM you can afford. Simply referred to as GPU (Graphics Processing Unit), your graphics card actually plays a more important role in video editing than your system's CPU as today's video editing software now makes greater use of the GPU. When selecting a video editing computer, many editors recommend you aim at getting a top-end GPU and not worry as much about the CPU as most computers are dual- or quad-core CPUs (regardless of speed) and are quite up to the tasks of HD video editing. So, if your budget is tight, spend money on the GPU over CPU.

Your next consideration will be RAM. Most professional editors recommended that you have at least 8 to 16 GB of RAM. Although most editing software state in their hardware specifications a minimum of 2 or 4 GB of RAM, this is somewhat misleading in that the software needs a minimum of 2 to 4 GB just for itself, excluding RAM needed for your computer's operating system and other functions. Your editing computer system's performance would be greatly improved (and more stable) with additional RAM, up to 128 GB or more if you can afford it and your system can support it.

Digital NLE Equipment and Interface

Because HD video files are quite large you also want a couple of large-capacity hard drives—one as the computer's system or start-up drive (on which is installed your operating system and all your programs) and the other to store your media files (sometimes referred to as a "scratch" drive). Hard drives are the slowest components of any computer system. Today, there are three types of computer storage available: spinning hard disk drive (HDD), solid-state drive (SSD), and hybrid drives. HDD storage devices have platters that spin, like DVDs, and come in 5400 RPM and 7200 RPM speeds. For video editing, 7200 RPM is pretty much mandatory. The drawback is that HDDs crash and die more often than solid state drives, due to the mechanics of writing and reading from spinning platters. They are also the slowest drive type. SSDs are much faster at reading and writing data—since there are no moving parts—and SSDs are less likely to crash than an HDD. Faster speeds mean they are better for video editing, however, the drawback is they do not have the storage capacity of, and are much more expensive than, HDDs. Hybrid drives are also making inroads into video editing computer systems. Apple Computer, Inc. has branded their version of a hybrid drive the "Fusion Drive." This is a storage device that has one SSD and one HDD drive in a single enclosure. The computer's operating system and most used applications and files are stored on the SSD side for speed. Less frequently used files are kept on the HDD side allowing for larger and more affordable storage capacity. These are a very good choice for internal system drives, but may be impractical for use as your secondary or scratch drive(s).

You have several choices of how to connect your secondary drive(s) and other peripherals to your video editing computer. The slowest is USB 2.0 and the data transfer speeds of USB 2.0 make it unacceptable for video editing. Your better choice is USB 3.0; it is much faster and better suited as a scratch drive connection for video editing. Be sure your computer does in fact have USB 3.0 ports, or your USB 3.0 drive will drop to the speed of your USB 2.0 port—thus, defeating the purpose. FireWire 800 has been a long-standing staple of video editing for external, secondary scratch drives. Some editors, however, consider FireWire 800 just barely fast enough for HD video editing and too slow for heavy compositing, color grading, and other complex editing functions. Given the choice, you should go with USB 3.0 before resorting to FireWire 800. But if you have no choice, FireWire 800 is acceptable. Another means of connecting external storage is External Serial Advanced Technology Attachment (eSATA); a much faster option for connecting to external scratch drives provided your computer has PCIe expansion slots into which you can install an eSATA PCI card. There are FireWire adapters that allow eSATA HDDs to connect to a FireWire 800 port, but you will not get the full speed that eSATA

can deliver. Introduced by Apple Computer, Inc. and rapidly gaining acceptance among PC-based video editors, Thunderbolt appears to be the future of peripheral connectivity. It is the fastest external connection for nearly every device—from HDDs to large LCD monitors—and version 2.0 is much faster than version 1.0 which was released in 2011. Thunderbolt with SSD drives is incredibly fast for video editing. Thunderbolt with an HDD RAID (redundant array of independent disks, a large capacity storage technology that combines multiple HDDs into a logical unit for data redundancy and performance improvements) is the preferred storage option used by many professional editors outside of employing the more expensive Storage Area Network (SAN). If you can afford it, a RAID on a Thunderbolt port is absolutely the fastest connection for video editing and storage. The only drawback is the price, but as more devices are manufactured and purchased, you will find the prices are likely to come down.

Finally, a large, widescreen LCD monitor is important; some editors even prefer working with two or three monitors to maximize editing workflow, but make sure your graphics card can support multiple monitors.

Before today's digital HD camcorders were capable of recording to HDDs and flash memory, video was still recorded to linear video tape and in order to edit it, you needed some way to transfer the linear video signal (whether analog or digital) from your camcorder into a digital file format for your computer to access for editing. This transfer required you to log and capture your video using your editing software via an analog video capture card or with a FireWire connection between your computer and camcorder or a separate videotape deck for linear digital videotape. This process was a laborious, real-time process and incredibly exasperating if there were any control track or timecode breaks in your video. Additionally, if you wish to use a source of audio, other than that from originally shot clips, you need a means of ingesting and mixing the audio signal; typically, you use either an audio editing application installed on the computer, or a simple external digital audio mixer connected to the computer via USB or FireWire, or via an external digital audio workstation (DAW). You may add external audio from CDs, MP3 players, cassettes, mics, or even vinyl discs (LPs) if a turntable is available. Most computer audio mixers allow multichannel mixing, so you may lay down tracks that were loaded individually and then edited within the computer. You also can add external video sources from film (via telecine—a film-to-video transfer process, or vice versa, either directly to/from tape or digital file), slides, a character generator, or a graphics generator, or you can create visual material within the editing computer from a built-in graphics application.

Digital NLE Equipment and Interface

Although less common, you can also use an external camcorder or video switcher to feed live shots through the editing computer for Internet streaming or recording to HDDs for subsequent "sweetening" prior to distribution.

When it comes to hardware specifications for setting up your video editing system your options are quite expansive. If you have the money, a top of the line computer with the largest number of CPU cores, fastest CPU "clock-speed," the most powerful GPU, maximum RAM, and fastest Thunderbolt SSD drives would be ideal. But many independent editors cannot afford to spend upwards of $10K for a top-of-the-line professional video editing system. So balancing out what you can afford, the type of programs you plan to produce, and what you want to accomplish in your editing, as well as knowing which components will effect your video editing experience and how they might impact your choice of editing software, can help you more easily configure the computer and peripherals that are right for you (see Table 7.3).

Software

As was stated earlier, when it comes to choosing video editing software, it all depends on the computer system and other peripheral hardware you select. The pedigree of commercially available NLE software dates back to 1989 with the introduction of both AVID and Lightworks, and the list of Hollywood films and television programs edited on these two systems include some of the most iconic films and TV programs of the last 25 years. These hardware-based NLE systems were mostly operated by industry professionals, at least through the late 1990s, and could cost tens of thousands of dollars. What broke down the entry barrier to NLE editing for non-Hollywood editors was the introduction of the NLE software Final Cut Pro 1.0 at the National Association of Broadcasters convention in 1999—which could run on an "off-the-shelf" mid- to high-end Macintosh. Incidentally, this also coincided with the arrival of FireWire-enabled digital video camcorders. As a result, digital video's democratization spread inexorably. Looking back, you can almost trace a straight line from Final Cut Pro and the introduction of the DV codec to the evolution of HDV (though short-lived) to DVCPro HD. Likewise, the rise of small form factor HD camcorders, Internet streaming, cheap SDHC cards to record on, digital cinema cameras (specifically, the RED) usurping film and cheap video-capable DSLRs challenging digital cinema cameras' supremacy.

Your budget will likely impact which NLE software (and, thus, computer platform) you select. Entry-level, consumer NLE software like Windows Movie Maker, Apple's

TABLE 7.3 – The one simple and user-friendly aspect of digital nonlinear editing is the hardware required. All it takes today to complete a digital edit is a computer with enough RAM and hard drive storage space installed with an "off-the-shelf" editing application. Obviously, there are choices in types and levels of equipment used in the postproduction process. Be sure to consult your editing software's hardware recommendations to determine which workstations, laptops, and input/output connections satisfy operational specifications.

Postproduction Digital Video Hardware

Mac-based Computers	
OS	OS-X 10.8 Mountain Lion, 10.9 Mavericks, or higher (64-bit)
Processor	Dual-core, Quad-core or Multi-core (configurable to 24-core) processors at 2.5 GHz or faster
Memory	4 GB RAM minimum (6+ GB recommended, up to 128 GB)
Graphics Card	NVIDIA GeForce family 3 (recommended), Intel HD4000, ATI Radeon family or AMD FirePro family (as supported by Apple)
System Hard Drive	Up to 3 TB 7200 rpm SATA drive, up to 512 GB SSD or 1TB Fusion drive
Secondary Hard Drive	Internal or external; not necessary, but recommended for long projects or large amounts of digital footage. HDDs at 7200 rpm (up to 3 TB) or RAID storage.

PC-based Computers	
OS	Windows 7 Professional, Windows 8 Professional or Enterprise (64-bit)
Processor	Dual-core, Quad-core or Multi-core (configurable to 16-core) processor at 2.6 GHz or faster
Memory	4 GB RAM minimum (6+ GB recommended, up to 192 GB)
Graphics Card	NVIDIA Quadro FX family 3 (Q600 or higher recommended) or Intel HD4000
System Hard Drive	Minimum 250 GB 7200 rpm SATA drive (up to 3 TB), 128 GB SSD (up to 512 GB)
Secondary Hard Drive	Internal or external; not necessary, but recommended for long projects or large amounts of digital footage. HDDs at 7200 rpm (up to 3 TB) or RAID storage.

Input / Output Connections	
Mac & PC	Firewire (IEEE 1394) 400 or 800 (preferred), USB (Universal Serial Bus) 1, 2 or 3 (preferred), Thunderbolt. Also, third-party SDI / HD-SDI, HDMI or analog PCI cards or external converters (as supported by Apple or Windows OS).

Digital NLE Equipment and Interface

iMovie, or Adobe Premiere Elements are inexpensive, robust, and capable of supporting simple assemble edits, "drag-&-drop" insert edits or trim functions, a range of transition effects, limited color correction and image stabilization effects and support a range of popular consumer digital video codecs with an ability to output your video to DVD or directly to the Internet. However, for feature-rich, professional NLE software running on a Windows PC, the popular choices are Adobe Premiere Pro Creative Cloud (or CS6), AVID Media Composer 7, Grass Valley's EDIUS Pro 7 or Sony's Vegas Pro 12. For Mac users, the choice is between Final Cut Pro X (or Pro 7), Autodesk Smoke, AVID Media Composer 7, or the Media 100 Suite 2. All of these NLE software-based systems operate on the 64-bit CPU architecture with dramatically faster importing, transcoding,

rendering and output as well as rock-solid stability, instant timeline loading and flaw-less playback of real-time effects in H.265 (twice the resolution or compression efficiency of H.264), stereoscopic 3D, 4K image resolution and beyond. Even EditShare's Lightworks has been resurrected as a powerful 64-bit multi-platform NLE (Windows, Mac, and Linux). On the whole, these NLE software options offer most (if not all) of the latest camera codecs, codecs for proxy editing and finishing, timelines that accept mixed codecs, resolutions and frame rates, motion effects capabilities, sophisticated image stabilization, at least primary color correction (sometimes secondary, though this is best left for specialized applications), audio mixing (however, better control is afforded if done on a DAW), a range of effects plugins, sophisticated titling, support for third-party hardware, multi-camera editing, stereoscopic 3D editing, extensive meta-data tagging of media clips, enhanced media management across myriad drives and sources, sophisticated output compressions, and project/timeline interchange with other applications (e.g., for compositing and color grading), other NLEs and stand-alone audio editing programs (see Table 7.4).

TABLE 7.4 – The choices of which application to use will depend on available hardware, budget restrictions on costs of software, matching the output of cameras, and personal preferences from past experiences. Once an editor learns and becomes comfortable with a specific system, both hardware and software, it may be difficult to switch to another system.

Nonlinear Digital Editing Applications

Consumer	
Windows Only	Windows Movie Maker, CyperLink PowerDirector, Corel Video Studio Pro, MAGIX Movie Edit Pro, Sony Movie Studio, Roxio Creator, AVS Video Editor, Pinnacle Studio Ultimate, Movie Plus, Roxio MyDVD Video Lab, Corel DVD Movie Factory, Power Producer, Nero Video
Mac Only	iMovie
Windows & Mac	Adobe Premiere Elements, VideoPad
Professional	
Windows Only	Sony Vegas Pro, Grass Valley EDIUS Pro 7, AVID Newscutter
Mac Only	Final Cut Pro 7, Final Cut Pro-X, Autodesk Smoke, Media 100 Suite (Boris FX)
Windows & Mac	Adobe Premiere Pro Creative Suite 6, Adobe Premiere Pro Creative Cloud, AVID Media Composer 7 (also with Symphony option, Mojo DX or Nitris DX), EditShare Lightworks (Mac in development)
Other Platforms	
iOS & Android	iMovie (iOS), Pinnacle Studio (iOS), Magisto, Movie Aid (Android), Montaj (iOS), Viddy, VidTrim (Android), Video Edit (iOS), HighlightCam, Animoto (Android), Cute CUT (iOS), Qik Video, Cinefy (iOS), Lapse It, VideoGrade (iOS), Splice, ReelDirector (iOS), AndroMedia Video Editor (Android), Socialcam, YouTube Capture
Linux	EditShare Lightworks (public Beta version)

Finally, since the introduction of the iPhone 3S, you have been able to not only shoot video with your smart phone, you could also perform simple editing through iMovie or any number of third-party Apple iOS apps. Now available on the popular Android operating system as well, today's smart phones can shoot highly compressed 1080 HD video (just remember to hold your phone horizontally, not vertically, when you shoot!). Likewise, available video editing apps for the iOS and Android OS have pretty much kept pace with the capabilities of your smart phone. Whereas these video editing apps do not have anywhere near the same features or capabilities of your desktop computer, they do let you trim and join video clips, add basic transitions with modest titling and color correction abilities, so you can shoot and edit HD video on your smart-phone and then share your creations via email, SMS, or YouTube without ever having to use a camcorder or desktop computer.

Accessories

Although some NLE software systems have been, or are currently, offered as a suite of individual but closely integrated applications (e.g., Apple's Final Cut Pro-X software "bundle" or Adobe's Creative Cloud) that integrate seamlessly across the various modalities of the editing process—from transcoding (e.g., Apple's Compressor or Adobe's Media Encoder CC), compositing (e.g., Apple's Motion or Adobe's After Effects CC), color grading (e.g., Apple's Color, now integrated into FCP-X, or Adobe's Speedgrade CC), audio (e.g., Apple's SoundTrack, now integrated into FCP-X, or Adobe's Audition), animation (e.g., Adobe's Flash CC), and output encoding for multi-platform distribution (e.g., Apple's Compressor or Adobe's Media Encoder CC). There are also a number of third-party applications and plugins now available that greatly enhance the NLE experience and most are compatible with the top professional NLE software. Some applications, like Adobe's Photoshop and After Effects integrate well with the workflow of most NLE systems. Other stand-along applications like Autodesk's Maya 3D, Blackmagic's DaVinci Resolve, Apple's Logic Pro or AVID ProTools, are powerful, special purpose programs for 3D modeling and animation, color grading or audio composition and mixing which can import from, and export to, popular high-end NLE systems. Plugins, on the other hand, are applications that install inside existing NLE systems and provide additional or enhanced operations to your editing program. The plugin may be for such purposes as synchronizing audio and video from a dual system production (e.g., PluralEyes), special effects (e.g., Boris Continuum Complete or Tiffen DFX), color correction and grading (e.g., Magic Bullet Looks or Digital FilmTools), noise reduction (e.g., Red

Digital NLE Equipment and Interface

Giant's Denoiser II), graphics and animation (e.g., Red Giant's Text Anarchy 2.4 or New-Blue Titler Pro 2), or transcoding, conversion and compression (e.g., Sorenson Squeeze or MPEG Streamclip).

You can also include hardware accessories like accelerator cards installed in your computer that speed up your editing workflow, hardware bundles specific to your editing software that accelerate video capture, monitoring and output, and special controllers or touchscreen control surfaces to make color grading and video or audio editing more efficient. At the very least, you might consider purchasing a specially color-coded keyboard (or keyboard overlay) that highlights the keyboard short cuts and functions of your specific software to help you edit faster and easier. You might also consider adding external hard drives or RAID storage, extra monitors, speakers, an outboard audio controller, or a digital audio workstation (DAW).

Technical Choices and Editing Workflow

Choices and Decisions

Your first critical decision requires you to match the camera specifications to the NLE application and computer platform (see Tables 7.2, 7.3, 7.4 as well as Tables 3.4 and 4.1). You should make some if not all of those decisions in preproduction as you discuss the best distribution plan for your final video as well as choices in production format, scan lines, aspect ratio, frame rate and video codec. It is imperative that you thoroughly consider your possible distribution options before actual shooting begins, technical standards have been established, and choices of equipment and formats have been made. Once these key technical decisions are made at the preproduction stage, certain production equipment choices are then set to match the chosen specifications; future changes to the technology employed at this point may be difficult, time consuming, and costly. Once set, these decisions also set the parameters of your postproduction workflow: again, depending on your initial plan for the final project's distribution (see Figure 7.5). Although discussed in previous chapters under technology and equipment, the following variations should be reviewed.

In today's video production environment, there is little need (or desire) for you to shoot in the Standard definition (SD), NTSC video format. All modern digital camcorders, as well as recording and editing equipment, are designed to work in HD. However, most HD equipment can also be set to operate in SD should this actually be desired as the

The Postproduction Process begins in Preproduction

Preproduction	Start Production	Finish Production	Postproduction Continues

Format choices made in preprod. effect camera choices for prod. that set specifications for postprod.

Start Editing

DIT ingests video & prepares it for postprod. at the start of principle photography; editing commences soon after & continues until Picture Lock.

Assembly of Picture

Directors Cut

Producers Cut

Picture Lock

Normally, many more working cuts are made; these are just highlights

Depending on contractual agreements, editing may end with the Director's Cut

At Picture Lock, no further editing of the project takes place. Images are color graded, titles, credits & VFX are integrated & sound is mixed for the Final Answer Print—ready for duplication & distribution.

Picture Lock	Picture goes to Color Grading	Negatives Cut or Video Conformed	FINAL MASTER or ANSWER PRINT
	Titles, Credits & Visual Effects		
Postprod. Sound	ADR, Dialogue, Foley & Sound Effects	Final Sound Mix	
	Music Composed & Recorded		

FIG. 7.5 – Decisions made in preproduction concerning distribution will have an impact on technical specifications that will determine production equipment choices and will in turn dictate the editing hardware, software and workflow you use in postproduction.

Technical Choices and Editing Workflow

distribution format of choice. It is still recommended that you acquire all of your program footage in HD, edit in HD, and then convert the final program to SD prior to distribution; if, or as, necessary.

There are two scan choices for HD video, interlace ("I") and progressive ("P"): These were developed separately but are now both available on the same equipment. Interlace was part of the NTSC system for the SD broadcast standard developed in the United States and is still used for some HD broadcasts. NTSC developed interlace to increase resolution by scanning each frame twice, interweaving each scan line to make a full frame. Interlace is still used on some high-level systems to take advantage of its superior resolution without increasing bandwidth.

On the other hand, progressive was developed in Europe for both the PAL and SECAM scan systems and has been incorporated into the acceptable HD formats sanctioned by ATSC in the United States. Each frame is scanned with a complete set of lines for each frame—top to bottom in progressive order. In retrospect, for most conditions progressive scan HD video is a superior system—although some problems can occur when the camera pans rapidly from side to side. Progressive is easier to edit because each frame may be cut individually, whereas in interlaced the edit must be made at the beginning or end of a frame, not in between the scan fields.

Whether interlaced or progressive, the number of frames per second varies from 23.976, 24, 25, 29.97, 30, 59.97, to 60 fps. Each frame represents a complete picture made up of a series of horizontal lines or a series of pixel patterns changed at the frame rate. The wide variation in rates is due to the differences between SD and HD, differences between 50 cycle and 60 cycle voltage rates, compensation for color systems, and compatibility with motion picture film systems (see Table 7.2).

Only to complicate matters further, the NTSC developed the drop frame (DF) and non-drop frame (NDF) systems. The drop frame system was designed to compensate for the approximate 3 minutes lost in an hour's recording using the 29.97 or 59.97 frame rates. The camera, audio recorder (if dual-system), and editing equipment must be set to match either DF or NDF to make certain the final production will be correctly timed for audio and video edited on separate equipment to stay in synchronization.

The size of the fame depends on the setting of the number of lines vertically and horizontally. The two common sizes for HD video are 1280 x 720 and 1920 x 1080; 720 HD

video is considered slightly lower in quality but easier to handle because of its lower bandwidth requirements (see Table 7.2).

Another consideration related to the frame is the aspect ratio, or the relationship between the width of the frame and the height of the frame. The two systems now in use are 4 × 3 and 16 × 9; 4 × 3 was the original Academy of Motion Pictures aspect ratio that was adopted by early television. Motion pictures in the 1950s expanded their width to make "wide-screen" projection possible. The aspect ratios in film increased to as much as 2 × 1, or the width twice the height. When the industry began designing HD, it was obvious that a wide-screen format was desired. A mathematically determined ratio of 16 × 9 was chosen (closely matching the dimensions of the Golden Ratio). It does not exactly match any film aspect ratio, but it is close enough for relatively easy conversion between the media. The numbers 16 × 9 mean the screen is 16 units wide and 9 units high. (See Figure 6.15 for relative aspect ratios and conversion problems between ratios.)

Understanding color space and color subsampling, can seem confusing at first read. However, it really is simple to understand once you break it down. Your video image is composed of little squares called pixels. Each pixel can have luminance (luma or brightness value) and chrominance (chroma or color value). If you have no chroma data, your image will be in grayscale—black and white. But if you have no luma data, you get no image at all! Because the human visual system has lower acuity for color differences than for luminance, chroma subsampling encodes images by compressing color information. Therefore, to have a reasonably good picture, every pixel needs to have its own luma data; however, you can save a lot of space by forcing chunks of pixels—or reference blocks—to share the same chroma information. These reference blocks are two pixels high and can sometimes be as many as eight pixels wide or as few as three, but usually they are four. Now, this is where it gets confusing because there are two different approaches in referring to color subsampling and to make it worse, both are written out exactly the same way: 4:x:x. The first color subsampling approach uses three 2 × 2 pixel reference blocks matrixed into a luma component (Y') which is always "4," or full sampled (the green value is interpolate from this luma information). The next two blocks reference chroma as (C_B), indicating the first color value (blue), and the second chroma block (C_R), indicates the second color value (red). Subsampling C_B and C_R can reduce color detail; however, providing full luma detail (Y') is maintained, no degradation in color is perceptible. Thus, for example, an image compressed using the 4:2:2 $Y'C_BC_R$ subsampling scheme halves the horizontal chroma resolution and only requires

two-thirds the bandwidth of a 4:4:4 (R-G-B) color sampling scheme. Using this color subsampling scheme, standard definition NTSC video is 4:1:1, PAL, DV and DVCAM are 4:2:0, broadcast HDTV is 4:2:2 and uncompressed, full-information HD video is 4:4:4 (sometimes an additional ":4" is included to represent an alpha channel—when present it is always equal to the luma channel). The second approach to representing color subsampling has the first number indicating the number of pixels wide the reference block is going to be (each pixel having full luma value). The second number indicates the number of pixels in the first row of the reference block that get chroma samples while the third number indicates the number of pixels in the second row that get chroma samples. If every pixel in the 4 × 2 reference block gets chroma samples, there is no subsampling going on (every pixel is sampled) and the sampling scheme is written 4:4:4. If the chroma subsample scheme is 4:2:2, every two pixels on the first row of the reference block share a chroma sample, and every two pixels on the second row share a chroma sample. The result is a reduction of bandwidth by one-third, but with little to no visual difference from an uncompressed video image. This is the subsampling scheme used in Panasonic cameras that record in AVC-Intra 100 (i.e., P2 cards), DVCPRO HD and Sony cameras that record in XDCAM HD422 as well as in editing codecs like Apple's ProRes 422. With a 4:2:0 subsampling scheme, the first row of the reference block samples every two pixels which is then duplicated (but not separately sampled) for the second row—resulting in a 50 percent reduction in bandwidth but with the same chroma information as 4:2:2. This is the color subsampling scheme used in DVCam, HDV, AVCHD and AVC-Intra 50, Apple Intermediate Codec, most variations of the MPEG codec as well as DVD and Blu-ray Discs.

One usually thinks of 1080 HD video as being of fairly high quality. But what is the difference between 1080 HD video at 5 Mbps and at 23 Mbps or even 50 or 100 Mbps, the image for each is made up of the same number of pixels—why the variability? It is probably best if you think of these figures as representing the color resolution and image clarity measured in the amount of space required to record/store the information (or bandwidth to transmit/play-back the image) per second of video. The variable that impacts the video's quality is the sampling bit rate, the level of quantization used in the digitization of the signal (discussed earlier in Chapter 3). The higher the rate (from 3.5 Mbps for SD video, up to 9.8 Mbps for DVDs using MPEG-2 codec, 8 to 15 Mbps for HDTV, up to 24 Mbps for AVCHD and up to 40 Mbps for Blu-ray Disc), the more information per sample unit, the better the video's quality; but also, the greater the bandwidth and memory requirements needed to handle the signal. Sampling bit rates also hold true

for audio quality: 16 bit, 44.2 kHz, or 24 bit, 48 kHz. The frequency attached to the bit rate indicates the highest workable frequency of your audio signal. The indicated frequency is actually double the best-reproduced signal—that is, a 48 kHz signal will handle 22 kHz and their overtones without distortion; 44.1 kHz is the standard for most recordings, 48 kHz is used only for the highest quality signals (see Table 3.3).

The compression standards 2:1, 4:1, 5:1, 7:1, and 18:1 indicate the amount of compression you apply to either an audio or video signal, although audio signals require far less if there is any compression. You always compress video except when you are working on extreme high-end productions using raw footage and 4:4:4 signals. Compressing signals saves bandwidth and memory requirements by reducing or removing from each frame unnecessary or repeated parts of the signal that may be replaced in the demodulation stage. The specific codec (compression-decompression) application or circuit sets the compression and restoration levels (see Table 3.5).

Operational Interface

Each of the major editing applications—AVID Media Composer (MC), Apple Final Cut Pro-X (FCP-X) or Adobe Premiere Pro CC (AP) as well as the many other minor editing applications and plugins—uses its own terminology for the equipment, the interface windows, icons, and menus on the screen as well as the process that works best for that individual application. Before starting any editing project, you must carefully read and comprehend the terminology, menus, and process of the application you will use.

A word of advice, software developers are constantly releasing fixes, updates, and new versions of their NLE applications—some are minor tweaks that fix "bugs" in the software that allow it to operate smoother and more efficiently, other updates add functionality (like new codecs) while version upgrades may present major usability enhancements, improved or revised media management and hundreds of big and small improvements that you may be tempted to install right away. If you are in the middle of a project, DON'T UPGRADE! Finish your project first with the existing version of your NLE software, *then* upgrade.

Depending on your system, begin your edit session by turning on your computer and, if necessary, log on using your username and password. Once your computer's startup sequence is complete, launch your editing software by clicking (or double-clicking) on

Technical Choices and Editing Workflow

the application icon. After the application opens, you may be prompted to create a new project or open an existing project, some NLE applications will automatically load the project that was last open. Once the various window screens appear you will likely see the following four basic NLE workspaces:

- A Project window (MC), Project panel (AP) or Libraries window (FCP-X)—this is where you create and organize "bins" (MC & AP) or "events" (inside a Library folder in FCP-X) that function like folders for storing and organizing your editing elements (collectively referred to as "media files"); video clips, audio clips, graphic files and your timeline sequences (called projects in FCP-X).

- A Source (MC) or Viewer (AP) monitor or Browser window (FCP-X)—this is where you preview clips and determine edit parameters (in and out points) for your source clips.

- A Record (MC), Canvas (AP) monitor or clip/program Viewer (FCP-X) window (in a dual-monitor system, this might appear on the second monitor)—this is your timeline playback window (also functions as the Browser clip preview in FCP-X when you are editing a clip in the Browser window), where you can view, or review, the sequence of shots you have assembled in edited order.

- A Sequence (Project in FCP-X) window containing the Timeline workspace (which, in a dual-monitor system could appear below the Record, Canvas, or Viewer window on the second monitor)—this is where you arrange your edited shots and sound tracks into story order to create your project sequence.

In order to start editing, most NLE systems require you to create and save a project (MC and AP) or library (FCP-X) first or open an already existing project or library. A project or library is where you will store all your media files and sequences while editing. If it helps, Projects Library window (MC) or Project panel (AP) contains "projects" in which you create "bins" (or folders to organize your bins) that can contain your media files and timeline "sequences." FCP-X's Libraries window contains "libraries" in which you create "events" (or folders to organize your events) that can contain media files and "projects" (your timeline sequence). These files are created, saved, and accessed from a Projects Library window (MC), Projects panel (AP) or Libraries window (FCP-X) that may or may not be initially visible on your screen when you start up your NLE application. You can open the Project Library window (MC), Project panel (AP) or Libraries window (FCP-X) either through selecting from the drop-down menu options or clicking an icon in the

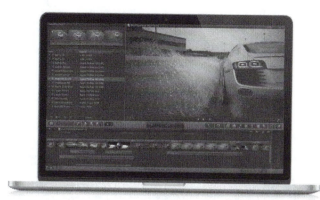

FIG. 7.6 – The parts of the edit window may be arranged for the convenience of the editor or to follow specific instructions provided in the manual for the application. (Courtesy Apple Computers, Inc.)

Sequence window (MC and AP) or Project window (FCP-X). As you can see, the names of the workspace windows will vary with the NLE application you are using, but the functions are similar in operation (see Figure 7.6).

Before you create your project, you may want to revisit a few of the technical choices and decisions mentioned earlier because now is the time to implement that knowledge. You need to be able to answer at least these three basic questions before you can begin editing your footage:

- What is the expected format and frame size of your final product? Unless you were involved in the preproduction discussions, it is advisable to double-check with the production team to determine if the footage was shot in SD 4 × 3 or HD 16 × 9 and if the latter, in 1920 × 1080 or 1280 × 720. Always match your edit settings to the dominant frame size of your shot footage.

- What is your footage's line scan system? Chances are, you will be editing in progressive scan, but most HD camcorders have selectable line scan abilities; so, your footage could have been shot in interlace scan mode. Always check with the production team in order to match your editing setup to the shot footage. In the event of mixed line scan footage, work in progressive mode and use your NLE's "de-interlace" effect to conform all footage to progressive scan.

- What is your frame rate? The choice of frame rate in production goes hand in hand with your image format and line scan system and represents another example

of matching editing standards with production standards. It is generally recommended that you not mix frame rates; the same goes for drop frame and non-drop frame footage. If you have footage of different frame rates that you must edit together, set your sequence for 29.97 and insert your 24p or 30i footage, your NLE application will convert and blend the frames to smooth out the image (with marginal loss of image resolution). The goal, however, is to maintain a consistent frame rate throughout the project.

Once you have the answers to the above questions and understand the nature of the source footage you will be editing, you can create a new project, set the video properties, and define your audio and render properties. Some NLE systems assume the way you shot your footage is the way you wish to edit, therefore, the first video clip you drag on to your Timeline will set the video properties automatically for your sequence. If this is the first time you have launched your editing software, certain default properties will be assumed by the NLE system (like the above mentioned option); otherwise, edit properties established by previous project settings may become the default settings for new projects. Be sure to review your property settings carefully before continuing; it is much harder to change project property settings once you start editing—more often than not, you will have to abandon your project mid-stream and start over or waste a lot of time rendering.

The Project window (MC), Project panel (AP), or Libraries window (FCP-X) lists all of your organizing folders, media bins, or events and sequences (projects in FCP-X) that you will use to organize your source media and use to build your edited program—make certain you leave this window open until the end of your editing session. Your captured or imported media, called *clips,* should be organized into bins or events for easy access during editing. The clips themselves are virtual representations of your actual footage (i.e., files that refer to your encoded, original shot footage); your physically ingested media files are stored elsewhere on a scratch drive or RAID depending on your editing system (never store your original media on your program or start-up drive). Name the bins or events to suit yourself, but think of a logical system because you may end up with many, many bins or events containing similar shots and you want to be able to access the individual shots easily and quickly—many editors organize their bins or events by the production day or date and the clips inside the bins by the scene, shot and take information contained on the production slate or recorded in the script continuity report. With the new file-based NLE systems, you could also input additional information about

each clip (called, metadata) that will allow you to identify, search and sort your clips into keyword bins or events or "smart" bins or events (FCP-X). Each bin or event will contain the series of shots (clips) you recorded on a single tape, DVD, hard disk, SSD or flash media card. Once ingested into your NLE system, you may manipulate these files any way you wish because you are working in a nondestructive system (edited clips merely tell the NLE system to play from one point to another from the original stored footage). If you want to change an edit or experiment with different edited versions of a sequence or project, no problem! Your original footage is actually unmodified until the entire sequence or project is rendered into a self-contained movie file (when the NLE system "prints" a copy of the original footage according to the edit information contained in the timeline sequence—the original footage still remains unmodified). When you click on a bin or event icon, the list of individual clips included in that bin or event appears with their recorded timecode. You monitor clips or events by clicking on different views or dragging your mouse cursor through the clip in the event browser window, depending on your NLE application. Each view shows additional information you may need in order to make your decisions on where to edit (see Figure 7.7).

When you select a clip icon, the clip appears in the Viewer (AP), Source (MC) monitor, or Event Browser (FCP-X). In FCP-X and MC, you can "scrub" through individual clips (if you open the bin window in MC set to frame view) and set in/out points in the Event Browser (FCP-X) or bin window (MC) that is also mirrored in the clip/program Viewer (FCP-X) or Source monitor (MC). Alternatively, all three NLE applications provide an editing toolbar beneath the Viewer or Source monitor and a position bar with an indicator. The toolbar buttons indicate commands that you may issue when clicked. They are the "IN" button and the "OUT" button, you will also find common VCR type controls for play, pause, rewind, fast-forward, and play "in-to-out." You use these buttons to indicate where you want a shot to begin and where the shot will end or to review your edit prior to placing it into the sequence timeline.

The Canvas or Record monitor or clip/program Viewer shows what the shots look like when edited together in a sequence. The Canvas or Record monitor also contains a position window, position indicator (also called the "play-head"), and a toolbar.

The Timeline is a graphic representation of the shots in your program's edited sequence showing video and audio tracks labeled V1, A1, A2, and V2, A3, A4 as needed (note: there are no track labels in FCP-X). The Timeline contains viewer, source and canvas, record

Apple Final Cut Pro-X [Image courtesy Larry Jordan, larryjordan.biz]

Adobe Premiere Pro Creative Cloud [Image courtesy J. Vidmore]

FIG. 7.7 – Each segment visible in the editor's window shows the different stages of the action required to complete an edit. (Courtesy Apple Computers, Inc. and Adobe Systems, Inc.)

track selectors, scale and scroll bars, and a position indicator or play-head and for FCP-X, a scrub-line.

Your computer, installed with the NLE application of your choice, will respond to the instruction you give it through drop-down menus, mouse clicks, drag and drops as well as keyboard short-cuts. Some editing applications come with key stickers for labeling short-cut keys, or you can purchase a special color-coded keyboard, or keyboard overlay that shows you the special editing commands unique to your NLE system. The keys "J"

(play backwards), "K" (pause), "L" (play forward) as well as "I" (mark in point) and "O" (mark out point) are—among all NLE systems—the most common commands designed to speed up your editing process.

Once you become familiar with the editing interface, as well as all of the operations, menus, and commands of the application installed on your NLE computer you use to edit, you are ready to edit your project.

Editing Workflow

Workflow is about efficiency and organization. However big or small your project is you will work more efficiently and with less frustration if you develop an organized routine or a standard operating procedure (SOP). Prioritizing your edit workflow is extremely important to ensure that the project you submit is one that you can be proud of and satisfies your director, producer or client. The postproduction workflow, or SOP, presented here is not an exhaustive, end-to-end workflow. Rather, it is a representative compilation of the essential stages of the postproduction process in order to illustrate "best practices."

- Ingest your footage—all usable footage and audio, as well as other project elements, should be captured or transferred into your NLE computer, labeled, logged with additional information (metadata) and organized into bins. Ideally, you have been doing this since the first day of production. If the production was shot dual system, this step is usually combined with the next.
- Sync captured or transferred footage—match all video clips with their separately recorded audio. It is strongly advised that, after completing this stage, and prior to beginning the actual editing, you back up to a separate hard drive, all of your newly organized and synced content.
- Watch your footage—all ingested footage needs to be reviewed, evaluated, and logged (or compared to the script continuity report and camera logs). At this stage, many editors select the best portions of each clip, marking in and out points, saving "favorites" (FCP-X) and taking notes on each clip in preparation to begin editing the footage.
- Gather all other needed material—your notes from earlier, a copy of the shoot script, storyboards for important scenes, and the script continuity reports all become helpful information as you begin editing the footage together.

- Assemble your first edit—all the scenes and sequences are loosely arranged in script order to determine broad sequencing and story structure. The trick is to not worry about being too precise at this stage but to keep progressing, leaving the more difficult fine-tuning until later in the process.
- Design your story—you now have all the right files in your timeline, if you are not required to follow a strict storyboard (as with most commercials), scenes can be cut and recut with essential audio through several versions, progressively tightening the project. This becomes the *Rough Cut* edit of your project. At this point, it is recommended that you consider showing the project to others in order to get "fresh eyes" on the project. After you get feedback on your rough cut consider making alterations that will fine-tune the project even further.
- Complete the *Final Cut*—small edit adjustments, transitions, visual effects (if any) and additional sound tracks are added to finesse the project into its final form. Once this process is completed, you will have achieved *Picture Lock* and not one frame will be added or subtracted from the project!
- Finishing—the project undergoes color grading, all titles and visual effects (if any) are fine-tuned and the various tracks in sound design are polished, sweetened and mixed. Once completed, you have what is referred to as the *Master* or *Answer Print,* or a finished copy of your video project ready for duplication and distribution.
- Exporting—creating your master copy depends on the distribution needs of your project (Internet, broadcast, theatrical projection, DVD, Blue-Ray). Based upon distribution requirements, you will render and export a self-contained master media file that can be used for duplication, uploading to the Internet or broadcast. You should also keep an archive copy of the project file containing your edited sequence and your original media files even though they are large and might take up space on your hard drives. Never forget the necessity of keeping a backup of everything!

Each studio, facility, or station lists a SOP and a set of technical specifications (for quality control) that designates exactly the format you are to use in preparing to edit—including use of color bars and tone, slate, and labeling of discs, memory media, and containers— as well as the technical quality expectations of the final product. If your final product is to be delivered on videotape or intended for broadcast you should ensure the beginning of your tape or file contains a standard video leader consisting of 30 seconds to 1 minute of 1,000 Hz tone for audio and SMPTE color bars as the video image. If you do not set these two test signals at the exact levels to be used in the recording, they will be useless.

Technicians use these test signals to prepare to play the tape or media file back, to set the playback levels, and to make electronic adjustments. Following the "bars and tone," you would record 10 to 20 seconds of a slate that specifies the program title, total run time (program length), client, and date of recording. Your next clip needs to be a countdown with descending numbers from 10 down to 2 with a 1 second tone (often referred to as the "2 pop"), followed by a minimum of 2 seconds of clean black and silence before the beginning of the first audio and video of the first clip of your edited program (see Figure 7.8).

At the end of the production, record at least 10 seconds of a clean black and silent clip. These periods of clean black and silence furnish a guard band of neutral signals in case there are errors in switching during a playback or they provide a logical space for dubbing. Some NLE applications allow you to input the specifics of the leader build information, including bars and tone, slate, and a 10 second countdown as well as how much time after the program ends the system should record black and silence. This information will be automatically added when you render your finished edit in order to "print to tape" or generate a self-contained movie file.

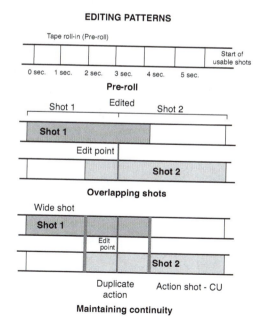

EDITING PATTERNS

Tape roll-in (Pre-roll)

0 sec. 1 sec. 2 sec. 3 sec. 4 sec. 5 sec.

Start of usable shots

Pre-roll

Shot 1 Edited Shot 2

Shot 1

Edit point

Shot 2

Overlapping shots

Wide shot

Shot 1

Edit point

Shot 2

Duplicate action Action shot - CU

Maintaining continuity

Editing Workflow

FIG. 7.8 – Every studio and station requires countdown, slate, and protection areas at the beginning and at the end of a completed edited project. Output to disc does not require such signals, but the signals should be recorded on the master file and removed for disc duplication.

Basic Editing

Your first action in beginning to edit a project is to choose the first shot from the bin or event collection containing that shot. When creating your video, you may be tempted to start with the most exciting footage in order to get your viewer's attention. This might be inadvisable because the narrative portion of your video project is often the most essential. Sometimes, especially for an interview-based video, you should edit the sound bites together first. The story can then be enhanced with the use of cutaways and B-roll interspersed throughout the interview footage that cover-up jump cuts and contribute visually to the interview narrative. However you choose to begin your edit, once you have found the first clip there are several ways you can add this clip—and all subsequent clips—to your Timeline. The simplest way is to click, drag and drop the clip to your sequence Timeline. But, this merely joins clips together; you are not critically evaluating, selecting, trimming, or correcting clips to ensure the most salient parts are being used to their full potential. To do this, you need to understand the basics of *Three-point editing*. Conceptually, you need four bits of information to perform an edit; a start and stop point for your source media and, begin and end points to specify the duration of the source clip on your Timeline. Three-point editing holds that, in most cases, only three edit points are necessary to perform an edit, the fourth edit point is inferred automatically by your NLE application. To begin editing, open your first clip in the Viewer, Source monitor, or Event Browser. Play the clip to make certain it is the correct take. Choose the tracks in the Timeline where the video and audio items from your source clip should appear (MC and AP, FCP-X has no track designations). You now have several choices in performing a basic three-point edit into your sequence Timeline:

- Specify which part of a source clip you want to place in your sequence. You do this by scrubbing through the clip and setting your IN and OUT points using the keyboard shortcuts, or by clicking on the associated command buttons. If you only set the source clip's IN point, the OUT point will be determined by the sequence IN and OUT points (if set prior, see below) or the clip's end time.

- Specify your source clip's IN and OUT points, then drag and drop the edited clip on to your sequence Timeline (in FCP-X, the Timeline is "magnetic" and clips automatically "sap" to the beginning of the sequence or to the previous clip in your Timeline).

- Specify your source clip's IN and OUT points, then drag and drop the clip from the Viewer or Source monitor to the Program or Record monitor (MC and AP), or you

can click the "splice-in" (MC) or the "insert" or "overwrite" (AP) or the "append" or "insert" buttons (FCP-X) from the respective NLE tool bar.

- Specify where you want the clip to appear and for how long in your sequence by setting IN and OUT points in your Timeline. Then, set an IN or an OUT point on your source clip. If the sequence Timeline has both IN and OUT points set, these determine the edit duration; with an IN point on your source clip, the edit will begin at this point and run for the duration of the OUT point in your Timeline, alternatively, if you only set an OUT point on your source clip, the edit will end at this point and "back-fill" the source media to the Timeline's IN point.

If no IN or OUT points are set on your Timeline prior to performing your edit, the Play-head in your Timeline is assumed to be the IN point of the edit (or, if enabled, it would be your Scrub Line in FCP-X). Now return to the Viewer or Source monitor or the Element Browser and find the next clip and repeat the process with the appropriate Three-point edit technique best suited to the edit you wish to perform. Although most NLE applications have an automatic save feature, you should remember to frequently save your work by using the keyboard combination of Command/S on the Mac or Control/S on the PC to save all of your edits—this is a good practice and should become a regular part of your editing SOP.

The editing process, including transitions, and audio editing, becomes much more complex from this point on, but the general steps of the process are as indicated above. Creative, aesthetic methods of editing follow in the next section.

Transitions

Any type of transition requires connecting two shots together. The most common transition in editing is a cut. In live, multi-camera television, it would be called a take. You create a cut by simply editing one shot onto the Timeline followed by another. An instantaneous change of picture will appear at the point where the two shots meet when played back. The point where you want a shot change from one to another may be trimmed frame by frame at the point of connection (see Figure 7.9).

A dissolve—also called a cross- or lap- (as in "overlap") dissolve—is a type of soft transition. A dissolve requires the "tail" of your first clip to overlap the "head" of your second clip. Some NLE applications do this by transitioning between two parallel video tracks. However, most NLE software simply overlay the transition icon over the edit point of the two adjoining clips (on the same video track) with the size of the icon representing

Basic Editing

FIG. 7.9 – Depending on the editing application, a variety of different functions may be accessed by searching menus visible on the screen. (Courtesy AVID Technology, Inc.)

the duration of the dissolve. Using the two-track metaphor, the first shot is on one video track, the following shot is on a second track and both clips overlap slightly. The amount of overlap between the two shots will determine the length of the dissolve. A 1-second dissolve (not a very fast dissolve) will depend on the frame rate of your footage; typically, either 24 frames or 30 frames of each shot would be required. The tail of the first shot will slowly disappear, and the head of the second shot will slowly appear as the first shot completely disappears. Midway through the transition, the two clips are equally superimposed. A dissolve is a minor type of special effect that you should treat with care and not use injudiciously but for a specific reason in the story; for example, to indicate a change in story location, to signal the passage of time or to transition to a parallel story-line. A dissolve must be programmed by the application used in editing. You must find the drop-down transition menu or open the appropriate effects tab, indicate a dissolve, and click on the spot between the two shots indicating the midpoint of the dissolve or drag and drop the transition effect's icon onto the point where the two clips meet.

A superimposition, or super, is basically a dissolve stopped and frozen in mid-transition. Alternatively, this can be accomplished by overlapping video clips on two parallel video tracks with the opacity of the top clip adjusted to allow the clip on the bottom track to show through to the extent desired.

A wipe is the next step up in transitions. A wipe is a hard transition—unlike a dissolve—where one shot is replaced by another with a hard line between the two shots. The transition effect has one shot being "pushed" out of the frame and replaced by the

second shot. The editing process is the same as for a dissolve, but the transition menu indicates what the wipe pattern will look like. In dissolves and wipes, both shots must have enough tail and head to allow for the overlap to accommodate the transition's desired duration.

You create a split screen by stopping a wipe halfway through the transition. Again, such a transition requires enough footage of each shot to last for more than the duration of both sides of the split.

The final transition is a digital effects transition, best considered as a complex wipe. Depending on the editing application, with a digital transition, you may create a page turn; you may create multiple screen wipes in fancy, specially created shapes; or you may move screens in different directions and at different speeds. Don't attempt such a transition unless you have a great deal of time to experiment and solve problems. These transitions call attention to themselves and should be used in moderation, nothing marks a project as "amateur" more than an edit where every shot transition is a different type, pattern or style—keep it simple and if the transition is distracting or does not serve the story, consider an alternative.

Titles

Titles constitute an important part of your production's appearance. Audiences expect titles, and they expect them to be clear, fulfill a purpose, and add to the production. Your most common titles are opening and closing titles, also called front and end credits. For interview-based productions, you would also use lower third titles (so called because they are placed in the bottom third of the frame under the individual on screen) to identify who is talking and their title. At the very least, your opening titles tell the audience what the name of the production is, who is responsible for it (producer, director, writer, videographer, editor), and indicate what the project is all about. You may gain or lose your audience with your opening titles, so choose and design them carefully. A title can be a shot opening your timeline or an overlay graphic with the underlying video of your first clip(s) visible behind it. Most NLE applications have a built-in titling ability on a drop-down menu or an associated "suite" or "bundle" application you can use to design a title clip, or you can use a specialized third-party application. You can set the font size, style, color, and arrangement of the title. Keep the copy of your titles within the critical area of the frame. Once you create the title, save it and move on to the next page or create a series of title pages as part of one file, depending on the program used. You may use the title

functions of the application as transitions and within special effects, as well as for the important closing titles that must credit everyone who contributed to your project.

Adding Audio

Audio is as important as any visual, perhaps even more. Unfortunately, you are surrounded by mostly accidental or even unpleasant sound (noise) and you have learned to ignore it. This suppression of sound renders the human relationship with sound as largely unconscious, but sound still affects us physiologically (alarms stimulate anxiety while the sound of ocean waves or bird songs soothe), psychologically (music being the strongest at generating an emotional response or memory association), cognitively (choosing what to pay attention to), and behaviorally (avoiding unpleasant sounds and gravitating toward pleasant sounds). Tests show conclusively that more than half of the information an audience comprehends from a video production comes from the audio portion of the program. It is hard to think about a film or television program without also being influenced by that program's sound effects, laugh track or musical score. In fact, the right kind of music can make your audience suspicious of an otherwise innocent-seeming character, evoke feelings of delight watching a benign scene, or even cause false memories for images that were not even present in your video. When working with your audio, you want to make sure that it is congruent with your visuals (or visual message) and not working against your visuals. Also, your audio should be appropriate to the situation presented in your visuals. Finally, if possible, the audio should be of value to your audience; in other words, informative, providing psychological cues to the emotional intent of the scene or stimulating a physiological or behavioral response. You must treat your audio with respect and care—poor quality audio and poor audio choices will destroy a production more quickly than any one other aspect of your production.

You may edit your audio using separate audio editing software, a DAW or on one or more audio tracks laid parallel to the video Timeline in your NLE application. If you include audio in a shot and both were edited simultaneously, the audio for that shot will be linked to the video and appear in parallel to the shot on one of the audio tracks in your Timeline. You may add additional audio by dragging music, sound effects, or narration onto one of the other tracks of your Timeline (it is good SOP to keep your dialogue, narration, music and sound effects tracks separate) and placing it in proper relationship to the matching video. Most NLE applications have features designed to make processing and editing audio easier. For example, you can analyze and automatically enhance your audio to address problems such as noise or hum, add effects to your clips, synchronize video and

audio clips automatically, match audio levels between two clips or fade audio clips in or out. Your NLE application may represent your audio as waveforms associated with a given video clip's audio on tracks directly below the video clip, or as a detached, stand-alone audio clip. An audio waveform's amplitude and length change according to the underlying sound's volume and duration. A short, loud sound such as a car horn or a door slam has a sharp, peaked waveform, whereas low-level traffic or crowd noises have a lower, more uniform waveform. These properties make it easier to find specific edit points when trimming clips. When editing audio, most NLE applications provide you with audio peak meters that let you see and track the audio levels of your clips and warn you if a particular clip or section of a clip reaches peak levels (changing from green, to yellow to red), which may result in audible distortion or clipping. You can edit your audio in two ways; at the clip-level, you can make edits and adjustments to individual clips, or you can work at the more advanced multichannel audio editing level in mixing different audio channels (or tracks), adjusting levels, applying effects and "sculpting" your project's soundtrack. At the simplest level, you may merely copy, drag, and place an audio clip where you want it on your sequence Timeline, raise or lower your audio levels using the tools in the audio toolbar or interface of your NLE application, or you might equalize or modify the audio as required by using the other tools available in the editing application (see Figure 7.10).

Basic Editing

FIG. 7.10 – The audio timeline is a visible indication of each audio clip, its relative level, and the relationship between channels if more than one channel is used in that particular editing session. (Courtesy Advanced Broadcast Solutions.)

Rendering

As you near the end of your project, you will want to output your video program for others—whether it is a rough cut for the director, producer or client to review and give notes on, or the finished video is ready for the world to see. Regardless of whether you have completed editing your project, it has been reviewed by others and you have fine-tuned it to reach picture lock prior to color grading, titles, VFX and sound mix—or, your video is now in its finished form (the master or answer print) and ready for distribution—you should save and backup the entire project prior to moving forward. Remember, you have been working with virtual clips through much of the editing process, so you should backup the original media files as well. After backing up your project and prior to exporting your video, make certain both audio and video levels meet technical standards. If either your audio or video is over-modulated the signal may be distorted and broadcast operations will not accept your program unless the technical standards of your audio and video are within the levels set by the Federal Communications Commission (FCC). Once you are assured of the technical quality of your program, you must convert the edited project into a final digital file (your master or answer print) for outputting and storage by combining them with the original media files. This process is called *rendering* and is either a separate stage of finishing a project or may be completed automatically depending on the specific NLE application used. Therefore, depending on your NLE application, you would select "File > Export Settings" option (or "Share" for FCP-X) from your NLE's top drop-down menu and select the appropriate output or function that matches either what a third-party application can use for color grading, VFX and sound mixing, or that matches your final distribution format. If the file is moving from picture lock to finishing, you may want to check the third-party software specifications to match not only the rendered file format but also the metadata interchange format it uses. Because your Timeline is composed of mostly virtual clips, you will want to render a self-contained file upon export. Most NLE systems do this by "reading" all the media (and metadata) referenced in your Timeline—including transitions, audio tracks, effects and titles—into a separate copy of the original media in edit order leaving the original media untouched. If your finished program is ready for mastering, you should select the appropriate format from among those supported by your NLE application and that matches the desired distribution method.

Once you render the project, it may be exported to film, a disc, a tape, or a storage medium for archiving or a later decision on distribution. If you export to film, the file

must match with the film rate of 24 fps and is usually processed through a Telecine. For broadcast distribution, the project must match the broadcast frame rate and line scan mode and have a standard leader as discussed earlier. All of your projects should include several seconds of a clean black silent clip as a protection at the beginning and end of the project. Creating a disc (DVD or Blu-ray) from your master file does not require the broadcast leader but must be in the format that matches the disc burner and playback. Outputting to tape requires you to "print to tape" using the format of the signal that matches that of the tape. The signal used to feed a Web program also must have the standards set to match the requirements of that Web program. A Web feed restricts the bandwidth of the signal so a highly compressed codec is necessary for such an output.

When a project is finished and delivered to the client, burned on disc, sent to broadcast, or posted to the Web you might be tempted to think that your job is done. Professional editors always backup their final projects as self-contained movie files—sometimes by consolidating the Timeline sequence and conforming all original media files to just the footage used—using the least compression possible. This ensures that you preserve the color and audio detail of your finished project in a high-quality backup that helps ensure against data loss and can be recompressed and delivered again in the future. It is recommended that your "future-proof" master file is backed up to multiple locations and on at least two different types of storage media to keep it safe.

Aesthetics of Editing

Editing has been an Academy of Motion Picture Arts and Sciences award category since 1934, when Conrad Nervig took home the first editing Oscar for *Eskimo.* Yet editors acknowledge that even after all these years of assessing excellence in their field, the aesthetic qualities of editing are difficult to judge. Everything else—music, cinematography, costumes, art design, acting, and directing—can be judged at face value, but when you look at the art and technique of editing, you cannot know what the totality of the material was, and you do not know the working dynamic between a director and an editor. Among professionals who work in postproducton—from producers and directors to editors, sound designers and VFX technicians—there is one fundamental and overriding principle: you make the film from what you have, not solely from what is written in the script. As you have discovered—or, no doubt will—"stuff happens" in production, the scenes, performances and shot footage may be different from the

script. Actors improvise lines or action, directors run out of time, videographers reconceptualize framing, sound files can be corrupt and unusable or camera frame rates vary by who was shooting that day—it happens to everyone. This does not mean that your video is a failure, just that you have a slightly different video program . . . the one that you will find in the editing process. Provided the director "shot for the edit" and gave you multiple options for each scene, you will have maximum creative flexibility in postproduction. Therefore, for you to assemble clips to tell a meaningful story will require your maximum energy, concentration, and creative effort. The editing stage requires the greatest amount of creativity and skill from the beginning to the end of the process of producing a media project. You may solve or compensate for some errors, mistakes, and misjudgments made during preproduction and production. "Post" is the last chance to make the production tell the story that was intended in the manner you intended to tell it. However, postproduction is not just the mechanical construction of the original ideas contained in the script, it also constitutes the further creative development of the story. But there exists a nearly infinite number of methods you may use to assemble clips and thereby accomplish any one creative task in editing the story (see Figure 7.11).

There are several principles that most editors try to adhere to when editing. One is the principle of *continuity editing*—attempting to avoid confusing the audience while condensing exposition and simultaneously preserving cause-and-effect relationships as well as unity in space and time. Another principle that reinforces continuity is one of the broader and more essential creative considerations in the editing process, *story order*—the shot-by-shot and scene-by-scene unfolding of events in the story. Finally, editing for *dramatic emphasis* can also reinforce continuity editing by cutting to a close-up at just the right emotional peak in the scene or to yield a moment of discovery. Alternatively, dramatic emphasis may break the expectations of continuity editing in order to communicate character confusion, chaotic action or other effects of *complexity editing*—juxtapositioning of shots to intensify the events (or emotions) on screen.

Beyond the above principles, rules have been developed over the years for how best to edit clips together, but because editing is the most creative aspect of media production, rules must either be ignored or used as a guide. The rules are based on how audiences have come to comprehend what the media tells them. Some of the rules are culturally based; others have developed to fulfill a technical limitation. Regardless of the origination

EDITING METHODS

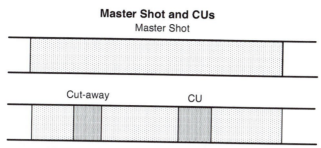

Master Shot and CUs
Master Shot

Cut-away | CU

Master shot with CUs inserted at appropriate times

Shot Sequencing

| Shot 1 | Shot 2 | Shot 3 | Shot 4 | Shot 5 | Shot 6 |

Individual shots assembled one after another

Final Video Edited to Audio

Audio recorded first

| Shot 1 | Shot 2 | Shot 3 | Shot 4 | Shot 5 | Shot 6 |

Video edited to match audio

FIG. 7.11 – Basic editing methods include combining a master shot with cut-ins and cutaways, arranging the shots in order chronologically as a series of related shots, and adding special video effects (VFX), and audio in the form of music, special sound effects (SFX), or narration, to be inserted to create a finished edited project.

of the rules, they can help an editor avoid creating a message that may confuse the audience or they may totally misunderstand. Here are the rules you should consider:

1. Show everything the audience needs to see in order to understand what you are trying to say.

 a. Do not show anything the audience does not need to see. Do not use every shot recorded, regardless of how important it may have seemed to be when shot. During post, look at every shot as a new piece of information. Use only what is necessary to show clearly what the audience needs to see.

Aesthetics of Editing

b. Every shot has to have a reason. Each shot must say something that moves your story forward. Each shot must add something to the flow of information to keep the audience in tune with your program and wanting to watch more.

2. Build tension and excitement by showing critical information, but leave something for the audience's imagination. Make the audience want to keep watching to find out what is going to happen next or how the story will end. Each shot in your story should build to a turning point in each scene and each scene should build to a mini-climax for each Act. Likewise, each Act should build tension until your story reaches its major conflict (typically, in Act 3) that must be resolved prior to the final *dénouement* of your story.

3. Either leave the audience satisfied and fulfilled or slightly unfulfilled and wanting more of your story.

4. Remember, there are three forms of editing movement: movement of subject(s), camera movement, or movement created by shot changes. Use each at appropriate moments in your scene, but do not overuse any of the three. Movement keeps an audience involved and watching, but movement just for the sake of movement becomes boring and confusing when you improperly apply it to a scene. Keep movement direction consistent. If subject A moves to the right on the first shot, make certain the subject keeps moving in the same direction in following shots unless there is reason to show a specific change in direction (which should be seen on screen). Western cultural rules indicated a movement from left to right is a forward movement, whereas movement from right to left is backward or returning movement.

5. A corollary of movement consistency is consistency of continuity. There are two important aspects to consider: you must first maintain consistency of relationships between subjects by observing and not violating the 180-degree line. Pay close attention to small details such as hand positions, placement of props, and relationship between subjects and backgrounds. Three types of shots you might use to avoid such errors are cover shots, cutaways, and cut-ins.

A cover shot is a wide shot showing all of the subjects, props, foreground, and background relationships. This is a shot that a continuity assistant should have photographed during production to use not only for shooting related shots but also to help the editor make certain that continuity is followed during post. A cut-in usually is a close-up (CU) showing significant detail that is important to the scene.

Such a shot can cover a movement or lack of continuity in a wide shot by forcing the audience's attention to a small and important detail.

A cutaway provides the editor with an even handier tool by having a shot that relates to the scene but may not show anything significant in detail that must match continuity. An example of such a use of these three shots is a wide-shot (WS) of a couple sitting in a park with children playing in the background (BG). A medium close-up (MCU) of one of the two could be considered a cut-in, but if the children playing in the BG don't match the WS, you can use a CU of the couple's hands that does not show any of the BG and then cut back to an MCU of either one of the two members of the couple, even though the children have moved on (see Table 7.5).

6. Last, but definitely not the least important, concerns your audio. Audio must be considered with as much effort as you put in to perfecting the picture. Audio carries as much information as the video and in some cases makes more sense to your audience, who can more quickly comprehend the action if the sound is accurate and well edited. You use sound to support the picture, but it should not duplicate the picture. Sound can be contradictory, but not so much so that it confuses the audience. Each change of sound does not have to occur simultaneously with the matching shot. You can slightly anticipate a shot change with a minimally advanced sound change that may heighten the tension and increase interest in the sequence. Use music and sound effects to create a critical sense of what is happening in a scene. Both are important, but they should be used carefully and thoughtfully.

Aesthetics of Editing

There are many styles, methods, and traditions of editing visual and aural media. Some are based on the traditions of Hollywood feature film editing, others on *cinema verité* or the avant-garde; these systems reveal the extreme opposites in the philosophy of editing. In between are other forms of storytelling, such as, news, documentary, music video, archival footage, TV commercials, film trailers, and dramatic, comedic or action-oriented editing techniques and aesthetics, all of which provide you with various means of expressing your vision in the final edit. Because editing is the most creative of all stages of media production, it allows the widest range of techniques to fulfill the effort of the editor. Also, the creative nature of editing refuses to allow absolute rules and restrictions on how you may assemble the material at hand. There is only one rule: what works and tells the story best is the right way (see Table 7.5).

TABLE 7.5 – Editing styles vary according to the type of production, the intended audience, and, in some cases, the budget.

EDITING STYLES

❖ **Single-camera dramatic**

A master shot covering the entire scene
Cut-ins and cutaways illustrating specific points and dialog
Reversals for dialog
Shots combined in postproduction with audio/SFX/music

❖ **Multiple-camera dramatic**

Three to four cameras recording simultaneously
One wide for cover
Others focused on individuals or CUs
Recording played back simultaneously and edited as if "live"
Additional editing as needed—audio/SFX/music added in post

❖ **Documentary**

Interview shot with one or two cameras
One focused on subject, second on interviewer or cut-aways
In field—one or more cameras covering subject(s) and action
Additional shots of topics and information shot separately
All shots assembled in post with narration, music, SFX

❖ **Electronic news gathering (ENG)**

Shots gathered on scene by one or more cameras
Wild sound, interviews, and cover shot as available
All shots assembled in post with narration, SFX

❖ **Commercials and other short forms**

Shots and material gathered in same pattern as dramatic
Edited in post with SFX/music/narration

Finishing, Output, and Distribution

Finishing Workflow

Once your video project has achieved picture-lock, you can now initiate the finishing work. This does not mean that there are no more creative choices. Finishing is that phase of postproduction where such aesthetic considerations as color grading, sound design and mixing, visual effects (VFX), titles and credits as well as matching technical specifications for SD or HD broadcast formats, DVD or Blu-ray mastering, optimal codec(s) for Web or mobile device distribution must be carefully managed.

Standard to any finishing workflow, color correction, or color grading, is generally one of the last steps in finishing an edited program. Some NLE applications include a non-destructive (meaning, it is reversible) automatic color-balancing feature. The automatic color-balancing feature samples the darkest and lightest areas of the image's luma channel and adjusts the shadows and highlights in the image. In addition, this function adjusts the image to maximize image contrast, so that each clip occupies the widest available luma range. For most of your color grading and color correction needs, the standard color correction tool incorporated into your NLE application is quite powerful. The primary reasons for color grading/correcting your footage include:

- To make sure that key elements in your program, such as skin tones, look the way they should.
- To match color and brightness values across all clips in a single scene or your entire sequence.
- To correct errors in white balance, color temperature or exposure.
- To achieve a "look" or mood by enhancing colors to create subtle tonalities or make a scene warmer or cooler.
- To create special color effects by manipulating the colors and exposure.

Using the audio mixer tool for your NLE application, you may want to first "normalize" the audio in your edited sequence—you do this by systematically lowering (attenuate) or increasing (amplify) the levels of all audio clips in your Timeline to achieve an optimal and aesthetic balance (while preserving necessary creative dynamics) in your audio before applying any other effects. Some NLE applications can do this automatically by analyzing the highs and lows in your audio tracks and adjusting them to the middle, but this could also wipe-out any creative dynamics that contribute to the aesthetics of your audio track—use this function selectively rather than globally. Once you have accomplished normalization of your audio tracks, you can then apply EQ or other audio effects or you can use the NLE's audio mixer tool to fine-tune the volume of different sections of the audio in the sequence. When you work with surround sound sequences, you can also use your NLE's audio mixer tool and X–Y pan grid to pan tracks to their appropriate speakers. If your sound design requirements are more complicated, you would be best served by exporting your audio to a DAW for finishing and sweetening prior to importing and relinking it to your picture-lock video.

Finishing, Output, and Distribution

Titles play a critical role in your video project, they provide important "bookends" (e.g., opening titles and closing credits) and titles in the lower third of the screen are also used in documentaries and informational videos to convey details about the subjects or products onscreen. Likewise, subtitles can be a critical element for any video project originating in a different language. You can create titles and credits within your NLE application using the internal title effects generator. Titles are synthesized clips and, therefore, do not refer to any original media on your hard disk. You can insert a title clip at the edit point between two clips in your Timeline, replace an existing clip in the Timeline with a title clip, or overlay a title clip directly above another clip. When you add a title as a clip overlay, the underlying clip appears as the title's background, sparing you the need to perform any further compositing to create that effect.

Most of the high-end NLE applications have a limited ability to create special visual effects (VFX) such as chroma-key, compositing, repositioning, cropping, skewing, or tracking a clip and animated movement of still images (also known as the "Ken Burns" effect). Beyond these, you are better served by special plugin applications or third-party software specializing in the type of VFX you wish to incorporate into your video project.

Output Process

Your picture is locked, sound mixed, color corrected, and VFX (if any) and titles are inserted—you are now ready to export your video project off of your NLE computer and out to the world! The first step is to create a full-resolution program master (or answer print). Mastering is what you call the process of getting your video into the highest quality format supported by your original media for exhibition or distribution as well as archiving. NLE applications offer a wide range of output options depending on your intended distribution avenues, each using a different codec intended for different end uses (e.g., MPEG-2 codec for making DVDs or MPEG-4 or H.264 codec for Web and mobile devices). The recommended method for mastering your video project is to simply output your video to a file or long-term storage device with the same codec and to the same format in which you shot and captured the video.

Of all the stages of the production process, postproduction is the one stage in which the technology of digital equipment and software cannot be ignored. There are some processes that you can operate without understanding the technology, but only if all of

the equipment and software are matched by either the manufacturer or the technician supervising the editing suite. A basic knowledge of the technical standards may not be necessary, but they certainly will be helpful as you pursue a career in digital editing. Many of the technical specifications were described in previous sections of this text, and for precise instructions, study the operating manual of your editing software and equipment and follow all directions.

Some professional editors recommend that mastering your video project for exhibition or distribution is all in knowing how to apply filters in order to properly compress the audio track and bring video levels within legal broadcast specifications or for optimal presentation of your video through other distribution means (e.g., disc, Web, or mobile devices). This does require you to have a modest level of technical knowledge. If you are at all uncomfortable doing this on your own, seek assistance from a professional post-production company or authoring house. Fortunately, your NLE application—if properly matched and configured to your computer system and hardware accessories—can make this process less confusing by presenting you with preconfigured export settings for popular distribution options. Prior to exporting your finished video project, you may want to consider applying a low ratio audio compressor across the master sound track to roll-off any peaks in order to prevent clipping and then boost the mix up a bit. The objective is to keep the mix levels reasonable so as to preserve your sound track's dynamic range. The video equivalent to an audio compressor is the broadcast safe limiting filter—most NLE applications have this feature. Technical broadcast specifications will vary with the network or station receiving your files or tapes, so check first. It is often a good idea to reduce the overall video levels by about five percent prior to the application of a broadcast safe filter, simply so you avoid "blowing-out" your highlights (clipping) or "crushing" your shadows (also a form of clipping). It is also a good idea to tone down your chroma saturation above 90 IRE and below 20 IRE. You want the maximum luminance levels (white peaks, or highlights) to be limited to no more than 100 IRE and chrominance not to exceed 110, 115 or 120, depending on the specs of the broadcaster to whom you are delivering your video. Your NLE application has software scopes (waveform monitor, vectorscope, and histogram) that will prove useful as you work the video signal and modern computer display monitors are surprisingly accurate and match surprisingly well to calibrated broadcast video monitors.

However, if your video project is to be sent to a postproduction or authoring house for mastering or duplication, the signal must be an uncompressed version in either

Finishing, Output, and Distribution

QuickTime, Audio-Video Interactive (AVI) format, or Advanced Authoring Format (AAF) delivered on a portable hard drive. All clips, project files, rendered files, and graphics must be on the same hard drive. If a complete QuickTime file or QuickTime conversion file has been created, including all of the assets, then that one file may be shared with a postproduction or authoring house via any number of Internet-based cloud storage services.

As a video editor, you work in a multi-standard world. Frequently you will work with HD footage that may need to be down-converted to SD content, or transcoded to a different HD resolution or frame rate. At other times, you may need to generate versions of your video for Web distribution or mobile devices. The best production and post *lingua franca* format today for mastering your video project is 1080P at 23.976 fps. Many professional editors believe this format fits a "sweet spot" for the Web, DVD, Blu-ray, and modern HD distribution. It is also readily available in just about every camera in almost all price ranges. If you shoot, edit, and master at 1080P at 23.976 fps, then you can easily transcode your program to NTSC, 720P at 59.94 fps or 1080I at 29.97 fps for broadcast. Even if your program is only intended to be distributed as SD video or highly compressed HD via the Web or on mobile devices, it is a good idea to future-proof your project by working in the highest quality HD format your production equipment supports.

The last step for your video projects is to create deliverables from your master file. Usually this involves creating three separate broadcast files in SD (a standard 4 × 3 conversion, a 720P 16 × 9 letterboxed to 4 × 3 and a 1080I 16 × 9 letterboxed to 4 × 3) and two self-contained 1080P, 23,976 fps HD formats using NDxHD, ProRes HQ, XDCAM, or uncompressed codecs (depending on your NLE application). It is also recommended that you generate an Internet version (without bars, tone, slate, and countdown) that is a high-quality H.264 file as either a .mov or .mp4 file-type.

Distribution Choices

You may feed a completed project to a line-out signal to the input of a video switcher, to a tape or disc recorder, to a hard drive, or to a telecine (for film transfer and lab processing), or you may convert the project to a digital cinema projection, to stream on the Web, or distribute to a mobile device. Cable, satellite, and broadcast operations will accept your production if you have properly prepared it to fit their format and technical specifications. Check with their respective engineering staffs to determine what they expect and will accept. Each of these sources offers a potential for earning back some of the

funds you invested in and committed to in order to complete the project (e.g., theatrical distribution fees, broadcast acquisition fees, cable video-on-demand, Netflix or Amazon streaming, or iTunes downloads). However, there are no guarantees of any return on your investment from any of these sources. Competition is strong, and demand for video programming from untried, new producers is slim at best. But that does not mean you should not try to sell your work. Client-based freelance and "work-for-hire" corporate video production is a popular way to launch your career. Begin at a low, local level and be willing to accept a minimum return as you build your experience and reputation, and depend on some exposure (and positive word-of-mouth) to lead to greater success with future productions (see Table 7.6).

Finally, you should arrange to create an archival copy of your project and all original media files associated with the project. If supported by your NLE application, export a self-contained QuickTime movie with discrete audio channels (or multi-track "stems") with separate channels for dialogue, sound effects and music. Naturally, there is the question of which codec to use now for reliable access to your files in the future. The preferred codec families these days are AVID's DNxHD, Apple's ProRes, uncompressed,

TABLE 7.6 – The final edited signal may be fed out to tape, disc, hard drive, solid-state flash memory, or uploaded directly to the Web; it could also be broadcast on "over-the-air" television, or distributed via cable or satellite.

POTENTIAL DISTRIBUTION GOALS FOR DIGITAL VIDEO

STANDARD DEFINITION (4:3 OF 16:9)

HIGH DEFINITION or WIDE SCREEN (16:9)

DISC (DVD or BLUE RAY)

MEMORY CARDS or DRIVES

DIGITAL TAPE

BROADCAST

CABLECAST

SATELLITE

INTERNET

STREAMING

MOTION THEATRE (FILM OR DIGITAL)

MOBILE

Finishing, Output, and Distribution

OP1a MXF (Sony's XDCAM), or IMX. Whichever format you standardize on, make multiple copies. Even a backup copy on a SATA hard drive or SSD placed in a safe and secure location will protect you from losing your hard work.

A properly polished production with audio and video levels that conform to broadcast standards is an essential aspect of delivering a professional video product. Developing effective mastering and archiving SOP will protect the investment you have made in your production. Even better, a reliable archive routine will bring you greater peace of mind because it will be easier to return to the project in the future.

Chapter Eight
Your Future

Introduction

The future of electronic media, including motion pictures, and the Internet, is only partially dependent on the advances in the development of new equipment. Smaller, less expensive, higher quality equipment will make a difference, but knowledge and the inventive use of communication are the keys—software and "wetware" (your brain or mind with respect to your knowledge-base, creativity, analytical and computational capabilities), not hardware, will determine the future of electronic media, especially for you as a media producer or practitioner.

Regardless of your function in media production, you will need to study and follow the trends in equipment and workflow and changes in distribution methods, because media convergence now questions which mode of delivery will best serve which market. Today, new technology and audience demand provide you with a range of delivery choices: Ultra HD in a theatre or on an appropriate widescreen monitor, compressed HD streaming over the Internet, or as variable image definitions on the miniature screen of a mobile device. HDTV and mobile devices each demand a different type of technical production and, as of now, there is no certainty as to what type of creative production will best serve either of them. Today, no one knows what form the next distribution method or technology will take—the Internet, film, DVD, or sold state. It is essential that you be prepared to work and be familiar with all forms of electronic media.

The term *media convergence* is used a lot these days but few are familiar with its multi-layered meaning. At the surface, convergence means the intersection of old and new media—the interconnection of information and communications technologies, computer networks, and traditional media content. This is frequently seen as a direct result of the digitization of media content and the popularization of the Internet. Typically, this has become manifest in Internet-based consumer services collaborating with print or broadcast communication companies in repurposing material from one medium for delivery on another. However, the implication of this type of convergence goes beyond the repackaging of information. Today, we see the emergence of "second screen" technology (use of an additional electronic device—computer, tablet, or smart phone—for synchronized

interactive television program viewing) and off-cycle webisodes (an episode of a series, typically a side-plot to the main story, distributed as web video) of popular television series that augment the viewer's experience or increase their participation during or between episode broadcasts. Some experts see this as evidence that convergence will eventually lead to the fusion of all forms of media, resulting in the creation of an entirely new medium.

Just below the surface, convergence has another meaning. Within the communication industry, convergence has also brought about compression, not by way of media file size or delivery bandwidth but in terms of combining the jobs, functions, duties, and responsibilities of individuals working in all communication fields. Companies that specialize in print, public relations, advertising, motion pictures, billboards, application designs, and digital games, as well as television, satellite, and cablevision companies, expect employees to be able to understand and create in all communication fields, not just an employee's chosen field. Related to this is the expectation that employees of today's modern media companies should be able to deliver content for multi-modal distribution to their customers who increasingly expect "on-demand" content, when, where, and how they want it. Thus, reporters must be able to research, interview, shoot, edit, and produce complete packages of news for delivering as a newspaper, TV, radio, or Web-based story. Producers, videographers, editors, and talent must think and create with the understanding that whatever they are working on will be distributed or exposed to an audience in more than one transmedia distribution method. Information technology employees, besides writing and managing applications and operating servers, must understand and appreciate the production processes and workflow necessary in all media productions.

Deeper still is the use of "media convergence" to refer to the consolidation of communication corporations into fewer and fewer mega-corporations that dominate the delivery of information and entertainment in all areas of communication. Although not necessarily within the purview of this book, contemporary research demonstrates increasing levels of consolidation with many media industries that were already highly converged and dominated by a very small number of firms. Since 2012, The Walt Disney Company has been the largest media conglomerate in the United States, followed by News Corporation, Time Warner, and Viacom coming in as second, third, and fourth, respectively. Most media scholars frequently see the concentration of media ownership as a problem. However, the U.S. media industry produces much of the world's feature films and many of its television programs. Although the industry is dominated by several large studios,

based mostly in Hollywood, the increasing popularity and worldwide availability of cable and satellite television, digital video recorders (DVRs), DVDs, and the Internet, means that many small and medium-sized independent production companies have sprung up to fill the growing demand—especially in those states or local areas that have a skilled labor force or provide production incentives (usually by way of sales tax rebates).

One take-away from the above discussion is that changes brought about by the disruptive influence of media convergence (in all its layered meanings) are altering traditional media jobs and work patterns. To succeed in this new world of communication, you must realize that you face increased competition for fewer jobs and for jobs that require a much broader range of skills and knowledge at a professional level. To meet this challenge, you must use your best knowledge and training, combined with passion and dedication. You should approach your search for employment based on three steps:

1. Research and exploration;
2. Personal and professional preparation;
3. Presentation and interview preparation.

Before starting a job search, decide what type or work you want to do, for whom you want to work, and where you want to work. It most cases, a wide-ranging search with few limitations in each of these categories is a wise choice. Opportunities abound, but many are squirreled away under job descriptions that do not necessarily fit under the traditional communication or media job market categories (e.g., educational technology, corporate communication, new media, public information, or video games). Although you should certainly look in your local area before jumping on a plane to Hollywood, it is advisable to widen your geographic horizons as well—you must go where the jobs are and work for the organization that will hire you to do the job you have prepared yourself for and are capable of performing at a professional entry level (see Figure 8.1).

Your search should include everyone you know in the business, family, acquaintances, classmates, and friends. Reach out in every direction, and leave no possible contact untouched—it is not uncommon in the media industry that "who you know" frequently gets you that first job, but "what you know" keeps you employed! Use the Web and written sources to research possible companies. Many states and major metropolitan areas have a film and television commission charged with attracting media productions (including movies, TV, and commercials); contact a local or nearby film commission about possible production jobs. Likewise, local entertainment and media production directories

Introduction

CAREER SEARCH POSSIBILITIES

❖ FAMILY

❖ FRIENDS AND THEIR FAMILIES

❖ PREVIOUS WORK CONTACTS

❖ INTERNSHIP CONTACTS

❖ PROFESSIONAL ORGANIZATIONS – STUDENT BRANCHES

❖ INDUSTRY NEWSGROUPS & BLOGS

❖ ACADEMIC CONTACTS

❖ PROFESSIONAL PUBLICATIONS

❖ NETWORKING

❖ PERSONAL RESEARCH

FIG. 8.1 – No possible area of searching for contacts should be overlooked.

FIG. 8.2 – Production indices and directories, whether in print or online, are excellent sources of information when seeking a job in media production. (Courtesy Media index Publishing Group.)

(e.g., *Northwest Production Index, LA 411, New York 411* and the *Toronto 411*) or the *Broadcasting-Cablecasting Yearbook* are available in most major libraries or accessible on the Web. Another source of information is the semiannual *Motion Picture, TV and Theatre Directory.* The publisher, Motion Picture Enterprises Publications, Inc., provides copies of the directory to schools, and it is available online at MPE.net. These publications or websites list a wide variety of companies involved in electronic communication (see Figure 8.2). Such listings include the names of the managers and administrators

of each company along with mailing addresses, phone numbers, and email addresses. If you use any of these listings, call to make certain the person you are contacting still holds the listed position. Personnel changes, especially at the middle-management level, occur rapidly and frequently.

The next step requires you to collect every possible bit of information about yourself. You will need this file of information to write professional résumés and cover letters and to prepare yourself for the interview process. You need to create a written (computer) file of your most recent three to five jobs as well as your supervisors' names, addresses, and phone numbers (and emails, if available). You will need to write a brief description of your duties and successes at each job. You also need to list your most recent three or four residences and, if possible, the property owners' names and contact information. Once you accept a position, you might also be required to present a list of family contacts. At that time, you will also need to make decisions about health and life insurance, retirement benefits, and beneficiaries. All of these matters turn up suddenly in the final stages of accepting a position, and they will have long-range effects later in your career and life (see Table 8.1).

TABLE 8.1 – Your personal information list must include all information that a prospective employer or human resources director may ask for or that you may need in order to fill out employee forms.

PERSONAL INFORMATION FILE

- ❖ YOUR NAME YOU WANT USED PROFESSIONALLY
- ❖ BIRTHDATE – BIRTH LOCATION
- ❖ CITIZENSHIP
- ❖ SOCIAL SECURITY NUMBER
- ❖ GRADUATION DATE
- ❖ OFFICIAL DEGREE TITLE
- ❖ MAJOR AND MINORS
- ❖ LIST OF HIGHER EDUCATION SCHOOLS ATTENDED, DATES
- ❖ COLLEGE HONORS (IF MEDIA OR MANAGEMENT ORIENTED)
- ❖ LAST THREE JOBS, SUPERVISOR'S NAME, PHONE, EMAIL
- ❖ LIST JOB RESPONSIBILITIES OF EACH
- ❖ LAST THREE RESIDENCES, OWNER'S NAME, PHONE, EMAIL
- ❖ CAREER-ORIENTED SKILLS, INCLUDING LANGUAGES
- ❖ COMPUTER SKILLS, INDICATE LEVEL
- ❖ FAMILY CONTACTS, MAILING ADDRESS, PHONE, EMAIL

Introduction

Internship

A critical aspect of preparation includes your academic work, your professional work, and—it is hoped—your internship experience. An internship should be the cumulating stage of your training, a combination of the knowledge and skills learned in the classroom and your work experience. An internship is frequently a competitive position and must be earned. Depending on the policies of your school and those of the company offering the internship, there are minimum qualifications. Although frequently offered for course credit—and many companies require interns to be enrolled students—an internship does not replace coursework. Don't expect an intern host to teach you everything you need to know to work in your chosen field; the nature of media productions makes it very difficult for people to teach an intern how things are done. The knowledge and skills you acquired in school should prepare you to qualify for an internship, but, if you wish the internship to lead to an entry-level position, you must learn on the job—and literally—on your feet (see Table 8.2).

The best internships are those designed to be true beginning work experience—that is, they provide actual work experience (and sometimes pay, although most are unpaid positions) in a variety of areas where skilled employees supervise and evaluate your work on a continuing basis. Companies, organizations, and associations that clearly understand the virtues and values of internships, to themselves and to the industry as a whole, set up competitive internships, for example, the Academy of Television Arts and Sciences and the Belo Corporation.

Once you obtain an internship, you must demonstrate your willingness and ability to work and perform every reasonable task, no matter how menial that task may seem. Interns do everything nobody else wants to do; your objective should be to try and work yourself out of the menial jobs by being too valuable to "waste" on such tasks. But do not forget, being a production intern is a "test" with only one question—are you willing to become the best intern you can even though you know that you do not want to be an intern for long? If you have chosen your internship well and continue to display enthusiasm for your work, you may be given a bit more responsibility and an opportunity to gain experience with a greater variety of work areas, tasks, and duties as your internship progresses. The logic behind this is that those individuals now above you paid their dues, proved their passion for the work, and they now expect you to do the same.

TABLE 8.2 – An internship is not automatic. You must earn the right to serve. Meeting certain criteria will provide the basis for your acceptance in most intern situations.

INTERNSHIP CRITERIA

❖ INTERNSHIP TYPES

Competitive

Paid (with or without academic credit)

Unpaid (must be for academic credit)

Volunteer at non-profit organization (with or without academic credit)

❖ INTERNSHIP REQUIREMENTS

Professional preparation

At least two years of college

Sufficient media skills and knowledge

Mentally/physically prepared for work pressures

Approval of academic unit

Acceptance by host

❖ INTERNSHIP CAUTIONS

Remain under close faculty supervision

Maintain close relationship with the Human Resources office of host

Avoid unfulfilling non-value busywork

Accept intern-level work matching your experience/knowledge

Accept every assignment as an opportunity to gain knowledge/experience

Always present professional appearance in action, dress, relationships, and speech

Accept and understand the intern level in the hierarchy of the host

Use the experience to develop career contacts

Immediately report any physical or sexual harassment to your faculty advisor and the Human Resources office

Internship

It is often recommended that you should wait until near the end of your academic career before enrolling in an internship program. There are two reasons for this. First, you need the education and background to prepare you for the internship. Second, if the internship works well and you are offered a full-time job, you do not want to face the "devil's choice" between accepting the offer and quitting school before you

graduate, or turning down the offer because you must wait to obtain your degree. Any company that offers you a full-time position while you are completing an internship will be willing to wait if you are in your last semester of school. Also, if you accept an internship during the fall or spring term, make certain you carry as light an academic load as possible. If you apply for an internship during the summer, expect very heavy competition, because many schools allow students to intern only during the summer.

To take full advantage of an internship, free yourself of as many obligations as possible to concentrate your energies and time on the internship. During the internship, work to prove you will make a good employee. Perform any job assigned to you, and be positive about all of the activities that your host asks you to do, even if some of them are boring, repetitious, and not at all what you thought the industry was about. Ask questions; do not hesitate to ask if you can perform work not assigned to you, but first make certain you know what to do and then do the job well.

Be aware of two negative incidents that may occur during an internship. First, if your assignments consist of only clerical work—answering telephones, getting coffee, running errands, or sitting around just watching people work—you have the right to report this to your school's intern supervisor, your supervisor on the job, or the company's human resources (HR) office. Expect to be assigned to low-level jobs during an internship, but an internship is also an educational activity; if there is no potential for learning, it is of limited value to you, and your school needs to be aware of your insufficient work assignment.

The second is the more serious matter of sexual harassment. If you feel threatened at any time or are approached by an employee in an offensive manner, report the incident immediately to the HR department and to your school's intern supervisor. At the same time, make certain you dress appropriately and act professionally toward all employees at all times.

The Application Process

Once you have completed your internship and are close to being granted your degree, your next step is to begin the process of finding, applying for, and earning your first paying job in the media communication field. As suggested at the beginning of this section,

the first step in this process is gathering information about yourself and about any potential employers.

Résumé Writing

Once that process is completed, then it is time to write your résumé and cover letter. Even though the cover letter actually precedes the résumé in the process, you should prepare the résumé first. The résumé is a concise description of who you are, while the cover letter states where you are going. The résumé should list your academic record, your work record, and include references. Generic, catchall, résumés seldom attract an employer's attention. If you are applying for multiple job openings, it is better to have a different résumé for each position you are seeking. It is recommended that you have at least two, if not three, résumés: one for production work, one for office work, and perhaps one that is more specialized, such as for audio mixing and sound design, animation, or postproduction. A well-written résumé should run no longer than one page; you may add a second page for references, but your potential employer should be able to read the first page at a glance. The reader should be able to make a judgment about your experience and capabilities. Pay attention also to how your résumé looks. Résumés are a first indication of your organizational skills. Your layout should be well planned, the type should be easy to read, not be too small, and items you wish to highlight should easily stand out on the page. If you can, have one of your references or an advisor look your résumé over and provide feedback. To many potential employers, a sloppy résumé indicates a sloppy worker (see Table 8.3).

If a potential employer is impressed, the next step will be checking your references. List at least three, better five, people who know you well, will speak honestly about you, and can be reached from the contact information that you list on your reference page. Make certain that all of the contact information is accurate, complete, and current— name, title, telephone number, email address, and mailing address. Also, always ask permission to list someone as a reference, and it might be helpful to send each person an updated copy of your résumé so that he or she will be able to give you an accurate reference. It is best not to list a reference from a religious organization. Such a person is highly unlikely to say anything negative about you, and a potential employer does not necessarily want to hear only the good things.

Résumé Writing

TABLE 8.3 – A résumé must be concise, accurate, error free, and provide the critical information a potential employer needs to make a decision as to your ability to fit the requirements for the position.

	Megan O'Brien	
816-532-3625	2835 Granite Kansas City, MO 64131	sjones@comcast.net

EDUCATION	The University of Missouri-Kansas City Bachelor of Arts Major: Communication Minor: Computer Graphics GPA 3.6	June, 2010
EXPERIENCE May 2008-present	Brandon, Fife and Lewis, Advertising Receptionist Handled telephone and guest duties Entered data and typed letters, proposals and scripts	Kansas City, MO
May 2007-May 2008	Outback Steakhouse Waiter/bartender Accurately handled cash register, tended bar, and waited tables Trained income employees	Overland Park, KS
HONORS AND ACTIVITES	Communication School Scholarship, two years Member Omicron Delta Kappa Honorary Writer, Producer, Director UH TV Volunteered for various community fundraisers Internship, WDAF-TV	
ADDITIONAL INFORMATION	Proficient with both PC and Mac Operating systems, MS Word, Excell, Power Point, FileMaker Pro, Photoshop, Illustrator. Final Cut Pro and other editing systems. Attended NAB conference, completed media production workshops, and attended broadcast lectures and panels	

REFERENCES

Michael J. Brandon
Partner
Brandon, Fife, and Lewis, Advertising
1235 North Loop West
Kansas City, MO 64105
816-862-1860
mjbrandon@att.net

Wendy Adair
Manager
Outback Steakhouse
2100 195th St.
Overland Park, KS, 66207
913-3650-4122
wadair@outback.com

Jennifer Ayles, Ph.D.
Director, School of Communication
UMKC
Kansas City, MO 68108
713-743-2108
jayles@umkc.edu

Composing a Cover Letter

Like your résumé, your cover letter needs to be written individually for each job to which you are applying. The letter should briefly summarize who you are, but leave the details to the résumé, which should be attached to the cover letter. The rest of the cover letter should highlight your knowledge of the company and explain why you would make an excellent employee (see Table 8.4). Professionals who review numerous job

TABLE 8.4 – A cover letter must be written for a specific job application; do not expect a general letter to cover all application situations.

Megan O'Brien
2835 Walnut
Kansas City, MO
64131
816-532-3625
mobrien@comcast.net

May 20, 2010

Mr. Charles Profiot
Operations Manager
KGFO-TV
P. O. Box 7777
Kansas City, MO
64555

RE: Production Associate Position

Dear Mr. Profiot:

My media production experience and academic training provide the basis for consideration as a Production Associate at KGFO-TV. I will graduate this month with honors in Communication and a minor in Computer Graphics. While at the University I worked all positions at the student operated television station including writing, producing, and directing a weekly public affairs program.

I spent last semester as an intern at WDAF-TV as a Production Assistant operating studio equipment and assisting the directors and producers. I suggested ideas for programs at channel four where they were accepted and aired successfully. During that time I watched your operation and believe I could be of benefit to you and KGFO-TV.

I feel my broad liberal arts education including study of theatre, art, and music as well as the study of media history, communication law, and audio, video, and computer graphics production courses with a GPA of 3.6 prepares me for a career in media production.

I worked part time while attending school, paying for part of my education and gaining valuable work experience. My former employers and references will honestly evaluate my work habits and potential for a career in electronic media.

I look forward to meeting you and will call on Monday May 25th to discuss my application and for an interview. Thank you for your consideration.

Sincerely,

Ms Megan O'Brien
816-532-3625
mobrien@comcast.net

Enc: Resume, references

applications recommend that applicants take a two-part approach to cover letter writing: in the first paragraph, identify what position you are seeking, why you want this specific position, and why you want to work for this specific company—let your passion and goals shine through. The second paragraph should highlight how your skills and experiences qualify you for this job, and be sure to reference specifics on your résumé. Make the sentences concise. Although allowing a little bit of your personality to come through is fine (anything that suggests you are well-rounded), leave the creative writing for other tests, not for either the résumé or the cover letter. The final paragraph of the letter should indicate that you look forward to meeting and will call the potential employer in a week or 10 days to follow-up, and then make certain that you do. Don't necessarily expect an immediate answer; you may be one of hundreds of first-timers applying for the one job, and it will take time for the human resources department to read applications and check references and other cross sources. Remember, your potential employer can and will read anything you have placed on the Web and all social networks to which you subscribe. Clean out or delete information that indicates you are anything but a mature, intelligent, and hard-working individual. That includes information and photos about you that your "friends" have listed on their sites.

The Portfolio

A portfolio—sometimes also referred to as a "demo reel" or "sizzle reel"—should never be an afterthought. It is the calling card of your talents and abilities, a succinct and engaging summary of your best work, and it is the culmination of several years of accomplishments. Throughout your academic career, you should be designing, planning, and completing short works of high quality that help build your portfolio—these could be from class assignments or extracurricular projects. You should submit these works to student film, video, audio, and Internet contests, screenings, festivals, and exhibitions where your work might receive recognition. Your portfolio allows you to show what you are capable of doing and have accomplished in the past.

The approach you use for your portfolio may follow two different paths: (1) prepare a portfolio that shows at least one example of each type of production that you are capable of, or (2) create a portfolio that contains only one type of work. The latter selection is best used if you are applying for a specific job, such as an editor or a news videographer for a television station. Some jobs require a range of work, from short spots or news clips to lengthy documentary or longer dramatic shooting. A portfolio for that type of job should include as wide a range of samples as possible (see Table 8.5).

TABLE 8.5 – A portfolio must illustrate the best aspect of you and your capabilities. It needs to show only your best work, and it should be presented in a format that is easily accessed and clearly identifies you as the creator.

PORTFOLIO PREPARATION

1. Research Company

 Know who will view portfolio

 Learn what they will look for

 Choose works that fit the job

2. Choose Selections

 Review all of your work

 Select ONLY the best

 Select ONLY professional quality examples

3. Create Portfolio

 At this time DVD is the best format

 Clean each selection: no bad edits, clean audio, black in and out

 Begin recording with Slate:

 Name, email address, phone numbers, mailing address

 Table of contents: title, length, medium each selection

 End recording with repeat of slate

 Restrict recording to ten minutes, maximum, better a tight five minutes

4. Mounting

 Clearly label disc

 Clearly label disc sleeve

 Place in foam shipping pack with slate label on outside

 Include a self addressed return label inside pack

Expect to leave cover letter, resume with disc

Do not expect the disc to be returned.

The Portfolio

An important consideration requires that you include only your best work. The impulse to include every piece that you like or have an emotional attachment to creates a mediocre portfolio. It is better to have one excellent example of your work rather than one good one and several mediocre ones. The viewer will remember the mediocre samples. Choose wisely and critically as if you are looking at someone else's work, not your own. It is suggested that you open with your absolute best work and close with your second best work—leave the viewer with a favorable impression. If there were production

restrictions beyond your control, you may explain, but do not rationalize or excuse poor or mediocre work—just leave it out of your portfolio. Once you have chosen the works you wish to include in your portfolio, use only clean copies, preferably on a DVD or some other ubiquitous digital format. Media formats change, but most operations today can review a standard burned DVD without region restrictions. Alternatively, consider posting your portfolio to an online portfolio venue like *Vimeo* or *Bēhance* in the highest acceptable quality and share the link with your prospective employer through your cover letter. Check every clip for production errors or bad edits—how you present your portfolio, like your résumé and cover letter, says a lot about your attention to detail. Make certain each video clip is carefully slated with the title or subject matter of the clip, your role in the production, date, sample running time and total running time, and any awards it may have won. Because few reviewers will look at the entire contents of a job candidate's portfolio, it may be beneficial to compose a "sizzle reel" of no more than 2 to 3 minutes that cuts your best work together in a way that highlights your production capabilities as well as your creativity. If you take this approach, be sure to provide a couple of your best works in their entirety for subsequent viewing, should the reviewer wish to see them. Otherwise, make certain the first few clips of your portfolio are the very best and will entice the viewer to look further into the samples.

If your portfolio also includes written material (e.g., samples from appropriate scripts, storyboards, or award certificates), all should be placed in some type of a loose-leaf binder. The DVD jewel case should have a clean, professional appearance; again, save your creativity for what is inside the DVD, not the jewel case itself. It should be carefully labeled both on the front surface and on the disc. The label needs to be visible and to contain your name and contact information. If your presentation does not grab the viewer within the first 30 seconds, your work may never receive full consideration.

Every portfolio won't appeal to every interviewer; you need to redesign the portfolio for each type of job to which you apply. Often your portfolio will not be viewed until you have been given an interview, and as a part of that interview you will be given the opportunity to show your portfolio. If you have prepared it well, your portfolio should speak for itself; you will need only to explain certain issues, if asked, or to provide more detail about your experience. If you mail your portfolio, be sure to keep original copies of all of the work contained in the package. Carefully package the DVD and any other accompanying material so that it will not be damaged in shipment and will arrive on time. A little money spent at this point will pay dividends in the long run. Also include

a prepaid, self-addressed return-shipping label if you expect the portfolio to be returned. Finally, it is recommended that you maintain a portfolio demo reel online on your web page for continual updates and additions of your production work.

The Interview

For most people, including those who have gone through the process more than once, interviewing for a job can be uncomfortable. It doesn't have to be, if you prepare yourself and your materials well. Remember, both you and the interviewer have a common goal—to find out if you fit the requirements of the position. The session with the interviewer should not be a confrontational battle, but a give and take conversation during which you explain who you are, what you are capable of doing, and how your experience and skills fit the needs of the company. This is also your opportunity to further explore the company and to determine whether it is a good fit for you. If you are not hired, do not take the rejection personally. Likewise, it is better if you do not accept a position that falls short of your interests or capabilities than to end up in a job that will make you unhappy and not allow your creativity to blossom.

Be sure to convey to the interviewer that you are a dedicated and task-driven potential employee. In the media industry, people like other people with energy, passion, and enthusiasm; convey that you want to be the "go-to" employee and that you will handle every task with a smile—no matter how unpleasant. Be willing to start at or near the bottom. Of course, no one wants to stay in that position very long—more than two years in an entry-level position may mean that there is no possibility of moving up and that it could be time to look for a job at another company. The amount of money you make should not be the major motivating factor in the choice of your first position. Find work that gives you the opportunity to prove yourself, get experience, and develop those all-important networking contacts.

Prior to the interview, thoroughly research the company, the job you want, and the work you may be expected to perform. Be prepared to answer questions that reveal your knowledge of all of those subjects. You may not be asked detailed questions at the first interview. Your research will have prepared you to speak intelligently about the company. Be confident; confidence is one of the best characteristics to show during an interview. Arrive on time. Be fully prepared for both the face-to-face interview and, depending on the size of the company, perhaps a stack of forms to fill out. To prepare for

The Interview

the forms as part of your research—research yourself. Arrive with every possible bit of information about your past that would interest the potential employer (see Table 8.6).

Depending on the company and what position you are applying for, you may be asked to submit to an examination or test. If you are applying for a job as an editor, you may be asked to quickly cut a story, commercial, or treatment with basic information provided. The interviewer may ask you to complete another test or application in your handwriting, or she or he may give you access to a computer. Your portfolio should provide samples of your ability to work under pressure, but some companies will want to see if you can work with basic information against a deadline.

If, after the interview, you decide you really want the job, call the company in a day or two to check in if you know the intention is to fill the position right away, if not, call in two or three days. Many first-time job seekers were hired because they were the only ones who took the time and showed the initiative to actually call back.

TABLE 8.6 – Prepare yourself for an interview by making an appearance that indicates you are a mature professional. Prepare all the information for any question you may be asked during the interview. Approach the situation with a clear head and an open mind.

THE INTERVIEW

- ❖ RESEARCH THE FIRM, THE POSITION, AND THE INTERVIEWER
- ❖ PREPARE YOUR INTERVIEW FILES
- ❖ PREPARE YOUR PORTFOLIO
- ❖ ARRANGE FOR THE INTERVIEW
- ❖ ARRIVE ON TIME
- ❖ ARRIVE DRESSED AND APPEARING AS A PROFESSIONAL
- ❖ REVIEW ALL OF YOUR INFORMATION AND RESEARCH
- ❖ PREPARE FOR QUESTIONING
- ❖ KNOW WHO YOU ARE AND WHAT YOU ARE PREPARED TO SELL
- ❖ DELIVER A SALES PITCH THAT IS MEANINGFUL TO THE INTERVIEWER
- ❖ IF OFFERED A POSITION, NEGOTIATE PAY, WORKING CONDITIONS, SCHEDULES AND BENEFITS
- ❖ LEAVE THE INTERVIEW ON A POSITIVE NOTE, WHETHER OFFERED A POSITION OR NOT
- ❖ IF NO POSITION IS OFFERED, ASK ABOUT OTHER POSITIONS
- ❖ FOLLOW UP WITH AN EMAIL OR A PHONE CALL WITHIN 2 WEEKS
- ❖ DON'T GIVE UP, PERSISTENCE IS THE KEY TO SUCCESS

Negotiating pay and benefits is a difficult challenge for all new employees, but even more so for creative applicants. We all know what we think we are worth, but it is difficult to face someone across a desk in a suit and demand that figure. Again, begin this part of the process with research. Find out what that company or similar companies in the same market size pay beginning employees in the position. If the position is one that is union or guild eligible (even if the company is not a signatory to collective bargaining), know what the base scale is for that position. Don't be afraid to ask for that figure even if you are offered less. Knowing your own value again shows confidence, but don't argue. If you are told the figure is the maximum the company is willing to pay, don't walk out the door. Explore any perquisites (perks) such as car or clothing allowances, equipment, overtime pay, moving expenses, a signing bonus or the possibilities of—and time scale for—advancement in the company. Again, don't take rejection personally; try to assume a pleasant negotiating stance, not an argumentative position. If you cannot come to mutually satisfactory terms, don't hesitate to thank the interviewer for her or his time and for considering you for the position.

Sending blind inquiries may yield a result, but be prepared to send hundreds if not more to get one or two responses. Never send unsolicited portfolios. They will be returned unopened or destroyed. Unsolicited résumés and cover letters may receive some limited attention.

Summary

The best job search philosophy requires a three-step plan. First, conduct a detailed search based on research you have gathered on the companies who might be hiring, and develop contacts from friends, family, and your internship. An internship is one of the most beneficial activities you as a soon-to-graduate student can engage in to prepare yourself for building contacts and learning on a practical level what a job in the field of your choice actually is like.

Once you have established a reasonable goal, your next task is to prepare the paperwork you will need to apply for and gain worthwhile employment. You must write a cover letter tailored for each individual company and position, create a résumé that describes you completely but succinctly (who you are and what you are capable of giving to an employer), and put together your portfolio. Each must be carefully and professionally prepared, because they represent who you are and what you are capable of doing.

Ideally, an interview will follow, and again you need to do background research into the company, what the company produces, what the pay scale is, and how your skills may be attractive to the person doing the hiring.

The field of media production is highly competitive and at times frustrating. Many people prepare for careers in the field, and many simply believe they can enter the field without the necessary knowledge, skills, and experience. If you really have the desire and are willing to offer the energy, sacrifice, passion, tenacity, and hard work to succeed, you will enter the ranks of qualified and successful applicants who have found their place.

Further Reading

Addison, Heather, and Charles Berg, eds. *Annual Editions: Film, 07–08*. Dubuque, IA, McGraw-Hill, 2007.

Alten, Stanley R. *Audio in Media*, 10th ed. Belmont, CA: Wadsworth, 2013.

Anderson, Gary H. *Video Editing and Post-Production: A Professional Guide*. Boston: Focal Press, 1999.

Andrew, J. Dudley. *The Major Film Theories*. London: Oxford University Press, 1976.

Armes, Roy. *Film and Reality*. Baltimore, MD: Penguin Books, 1975.

Arneim, Rudolf. *Film as Art*. Berkeley, CA: University of California Press, 1971.

Arntson, Amy E. *Graphic Design Basics*, 6th ed. Belmont, CA: Wadsworth, 2011.

Attkisson, Sharyl, and Don R. Vaughn. *Writing Right for Broadcast and Internet News*. Boston: Pearson Education, 2003.

Bazin, Andre. *What is Cinema?* Ed. Hugh Gray. Berkeley, CA: University of California Press, 1971.

Beardsley, Monroe C. *Aesthetics from Classic Greece to the Present: A Short History*. New York: Macmillan, 1966.

Benedetti, Robert. *From Concept to Screen: An Overview of Film and Television Production*. Boston: Allyn & Bacon, 2002.

Benedetti, Robert, Michael Brown, Bernie Laramie, and Patrick Williams. *Creative Postproduction: Editing, Sound, Visual Effects, and Music for Film and Video*. Boston: Allyn & Bacon, 2004.

Bermingham, Alan. *Location Lighting for Television*. Boston: Focal Press, 2003.

Billups, Scott. *Digital Moviemaking 3.0*. Studio City, CA: Michael Weise Productions, 2007.

Box, Harry C. *Set Lighting Technician's Handbook*, 4th ed. Boston: Focal Press, 2010.

Bregitzer, Lorne. *Secrets of Recording: Professional Tips, Tools, and Techniques*. Boston: Focal Press, 2009.

Browne, Steven E. *High Definition Postproduction Editing and Delivering HD Video*. Boston: Focal Press, 2007.

Burrows, Thomas D., Lynne S. Gross, James C. Foust, and Donald N. Wood. *Video Production: Disciplines and Techniques*, 9th ed. Boston: McGraw-Hill, 2005.

Compesi, Ronald J. *Video Field Production and Editing*, 7th ed. Boston: Allyn & Bacon, 2007.

Crowell, Thomas A. *The Pocket Lawyer for Filmmakers: A Legal Toolkit for Independent Producers*, 2nd ed. Boston: Focal Press, 2011.

Dargis, Manohla, and A.O. Scott. "Film is Dead? Long Live Movies," in *New York Times,* Sunday, 9/9/12, p. 1, 50.

Davis, Douglas, and Allison Simmons, eds. *The New Television: A Public/Private Art*. Cambridge, MA: The MIT Press, 1977.

Debreceni, Todd. *Special Makeup Effects for Stage and Screen*. Boston: Focal Press, 2009.

DiZazzo, Ray. *Corporate Media Production*, 2nd ed. Boston: Focal Press, 2004.

Douglas, John S., and Glenn P. Harnden. *The Art of Technique: an Aesthetic Approach to Film and Video Production*. Needham Heights, MA: Allyn & Bacon, 1996.

Eargle, John. *The Microphone Book*. Boston: Focal Press, 2001.

Edmonds, Robert. *The Sights and Sounds of Cinema and Television: How the Aesthetic Experience Influences our Feelings*. New York: Teachers College Press, 1982.

Eisenstein, Sergei. *Film Form – Film Sense*. Ed. Jay Leyda. New York: Meridian Books, 1957.

Elkins, David E. *The Camera Assistant's Manual*, 6th ed. Boston: Focal Press, 2013.

Elliott, Emory, Louis Freitas Caton, and Jeffrey Rhyne, eds. *Aesthetics in a Multicultural Age*. New York: Oxford University Press, 2002.

Evans, Russell. *Practical DV Filmmaking*. Boston: Focal Press, 2006.

Foust, James C. *On Line Journalism*. Scottsdale, AZ: Holcomb Hathaway Publishers, 2005.

Fowler, Jaime. Editing *Digital Film: Integrating Final Cut, Avid, and Media 100*. Boston: Focal Press, 2001.

Friedmann, Anthony. *Writing for Visual Media*, 4th ed. Boston: Focal Press, 2014.

Gloman, Chuck, and Mark Pescatore. *Working with HDV: Shoot, Edit, and Deliver Your High Definition Video*. Boston: Focal Press, 2007.

Gloman, Chuck, and Tom LeTourneau. *Placing of Shadows: Lighting Techniques for Video Production*, 3rd ed. Boston: Focal Press, 2005.

Goodman, Robert M., and Patrick McGrath. *Editing Digital Video: The Complete Creative and Technical Guide*. New York: McGraw-Hill, 2003.

Grant, August E., and Jennifer N. Meadow. *Communication Technology Update*, 14th ed. Boston: Focal Press, 2014.

Grant, Tony. *Audio for Single Camera Operation*. Boston: Focal Press, 2003.

Gross, Lynne S., and Larry Ward. *Digital Moviemaking*, 7th ed. Belmont, CA: Wadsworth, 2009.

Gutenko, Gregory. *Hidden Ways of Filmmaking: An Introduction to Cultural Environments, Aesthetic Sensation and Media Production Methods.* Amazon.com, Kindle edition, 2012.

Harrington, Richard. *Photoshop for Video.* Boston: Focal Press, 2007.

Hartwig, Robert L. *Basic TV Technology: Digital and Analog,* 4th ed. Boston: Focal Press, 2005.

Hilliard, Robert L. *Writing for TV, Radio, and New Media.* 10th ed. Belmont, CA: Wadsworth, 2011.

Holman, Tomlinson. *Sound for Film and Television,* 2nd ed. Boston: Focal Press, 2001.

Holman, Tomlinson. *Sound for Digital Video.* Boston: Focal Press, 2005.

Holway, Jerry, and Laurie Hayball. *The Steadicam Operator's Handbook.* Boston: Focal Press, 2012.

Honthaner, Eve Light. *Hollywood Drive: What It Takes to Break In, Hang In, and Make It In the Entertainment Industry.* Boston: Focal Press, 2005.

Irving, David, and Peter W. Rea. *Producing and Directing Short Film and Video.* 4th ed. Boston: Focal Press, 2010.

Jackman, John. *Lighting for Digital Video and Television.* San Francisco: CMP Books, 2002.

James, Jack. *Digital Intermediates for Film and Video.* Boston: Focal Press, 2006.

Kauffmann, Sam. *Avid Editing: A Guide for Beginning and Intermediate Users,* 4th ed. Boston: Focal Press, 2009.

Kellison, Catherine. *Producing for TV and New Media: A Real-World Approach for Producers,* 2nd ed. Boston: Focal Press, 2009.

Kindem, Gorham, and Robert Musburger. *Introduction to Media Production: The Path to Digital Media Production,* 4th ed. Boston: Focal Press, 2009.

Kolker, Robert. *Film, Form, & Culture,* 3rd ed. New York: McGraw-Hill: 2006.

Leeds-Hurwitz, Wendy, *Semiotics and Communication: Signs, Codes, Cultures.* Hillsdale, NJ: Erlbaum, 1993.

Maes, Jan, and Mars Vecommen. *Digital Audio Technology, CD, MiniDisc, SACD, DVDA, MP3,* 4th ed. Boston: Focal Press, 2001.

Mamer, Bruce. *Film Production Technique: Creating the Accomplished Image,* 5th ed. Belmont, CA: Wadsworth, 2009.

McClean, Shilo T. *Digital Storytelling: The Narrative Power of Visual Effects in Film.* Cambridge, MA: The MIT Press, 2007.

McKahan, Jason Grant, Caoline Picart, Gregory Thompson, and Kathryn Field, eds. *Multicultural Dimensions of Film: A Reader,* 7th ed. New York: McGraw-Hill, 2001.

McLeish, Robert. *Radio Production,* 5th ed. Boston: Focal Press, 2005.

Millerson Gerald, and Jim Owens. *Video Production Handbook,* 4th ed. Boston: Focal Press, 2009.

Musburger, Robert. *An Introduction to writing for Electronic Media.* Boston: Focal Press, 2007.

O'Steen, Bobbie. *The Invisible Cut: How Editors Make Movie Magic.* Studio City, CA: Michael Wiese Productions, 2009.

Pearlman, Karen. *Cutting Rhythms: Shaping the Film Edit.* Boston: Focal Press, 2009.

Pells, Richard. *Modernist America: Art, Music, Movies, and the Globalization of American Culture.* New Haven, CT: Yale University Press, 2011.

Rabiger, Michael. *Directing the Documentary,* 6th ed. Boston: Focal Press, 2014.

Rayburn, Dan. *Streaming and Digital Media: Understanding the Business and Technology.* Boston: Focal Press, 2007.

Roberts-Breslin, Jan. *Making Media: Foundations of Sound and Image,* 3rd ed. Boston: Focal Press, 2011.

Rose, Jay. *Producing Great Sound for Film and Video,* 3rd ed. Boston: Focal Press, 2008.

Rose, Jay. *Audio Postproduction for Film and Video,* 2nd ed. Boston: Focal Press, 2009.

Rosenthal, Alan. *Writing, Directing, and Producing Documentaries,* 4th ed. Carbondale, IL: Southern Illinois University Press, 2007.

Scharfstein, Ben-Ami. *Art Without Borders: A Philosophical Exploration of Art and Humanity.* Chicago: University of Chicago Press, 2009.

Schneider, Chris. *Starting Your Career in Broadcasting: Working On and Off the Air in Radio and Television.* New York: Allworth Press, 2007.

Simpson, Wes, and Howard Greenfield. *IPTV and Internet Video: Expanding the Reach of Television Broadcasting,* 2nd ed. Boston: Focal Press, 2009.

Skidgel, John. *Producing 24p Video.* San Francisco: CMP Books, 2005.

Sparshott, F. E. *The Structure of Aesthetics.* Toronto: University of Toronto Press, 1965.

Spotted Eagle, Douglas. *Vegas Pro 9 Editing Workshop.* Boston: Focal Press, 2010.

Stein, Leo. *The A-B-C of Aesthetics.* New York: Boni & Liveright, 1927.

Sterling, Christopher, ed. *Focal Encyclopedia of Electronic Media.* CD-ROM. Boston: Focal Press, 1998.

Thompson, Roy, and Christopher Bowen. *Grammar of the Cut,* 3rd ed. Boston: Focal Press, 2013.

Thompson, Roy, and Christopher Bowen. *Grammar of the Edit,* 3rd ed. Boston: Focal Press, 2013.

Tolputt, Bob. *DV Filmmaking,* 2nd ed. Boston: Focal Press, 2006.

Utz, Peter. *Today's Video.* 4th ed. Jefferson, NC: McFarland & Company, 2006.

Uva, Michael. *The Grip Book,* 4th ed. Boston: Focal Press, 2009.
Viers, Ric. *The Sound Effects Bible: How to Create and Record Hollywood Style Sound Effects.* Studio City, CA: Michael Wiese Productions, 2008.
Watkinson, John. *The Art of Digital Audio,* 3rd ed. Boston: Focal Press, 2000.
Watkinson, John. *The Art of Digital Video,* 4th ed. Boston: Focal Press, 2008.
Weynand, Diana. *Final Cut Pro 6: Professional Editing in Final Cut Studio 2.* Berkeley, CA: Peachpit Press, 2007.
Wheeler, Paul. *High Definition Cinematography,* 3rd ed. Boston: Focal Press, 2009.
Wiese, Michael, and Deke Simon. *Film and Video Budgets,* 3rd ed. Boston: Focal Press, 2001.
Wolsky, Tom. *Final Cut Express 3.54: Editing Workshop.* Boston: Focal Press, 2007.
Yoop, Jan Johnson, and Kathy McAdams. *Reaching Audiences: A Guide to Media Writing,* 4th ed. Boston: Allyn & Bacon, 2007.
Zettl, Herbert. *Video Basics 2,* 6th ed. Belmont, CA: Wadsworth, 2010.
Zettl, Herbert. *Television Production Handbook,* 12th ed. Belmont, CA: Wadsworth, 2011.
Zettl, Herbert. *Sight-Sound-Motion,* 7th ed. Belmont, CA: Wadsworth, 2013.

Glossary

4K A production or content medium displaying four thousand horizontal pixels used in digital TV or cinematography.

AAC (Advanced Audio Coding) A lossy audio code serving as the default format for YouTube.

A/B ROLL Editing process using two separate rolls (cassettes or reels) of tape. Each cassette contains alternate shots of the sequence, enabling the editor to use transitions other than straight cuts between shots.

ABERRATION Deviating from the normal, acceptable, or expected response.

ABORIGINAL The first known residents of a region, indigenous people.

ABSTRACT One of three basic media aesthetic choices. Abstract goes beyond realism as seen in the way some music videos and science fiction dramas stretch the audience's imagination and sense of reality.

ADDITIVE The colors used in mixing light and upon which both film and video signals are based: red, blue, and green.

ADVANCED CODING HIGH DEFINITION (AVCHD) A professional file-based production format developed by Sony and Panasonic primarily for camcorders.

ADVANCED TV SYSTEMS (ATSC) An American professional group formed to set standards for television broadcasting beyond analog NTSC, including high-definition and digital television standards.

AESTHETIC ASPECT One of two choices that need to be made during any media session. Aesthetic covers the creative, artistic values; the other considerations are the practical choices.

AMBIENT Prevailing environment; in audio, the background noise present at a location.

AMPLITUDE The instantaneous value of a signal; the electronic equivalent of level or loudness in audio.

ANALOG Electronic signal that is constantly varying in some proportion to sound, light, or a radio frequency.

ANSWER PRINT A copy of edited project used to check the quality and accuracy of the finished project.

APERTURE (IRIS) The size of the lens opening, measured in f-stops.

APPLE BOX A series of various sized boxes used to stand on and carry production items. Manufactured in standard sizes with holes on two sides to ease carrying them about the set or location.

ARABESQUES Artwork based on flowers, fruit, animal outlines producing an intricate interlace pattern of lines.

ARTIFACTS An extraneous or artificial visual created in a video signal.

ASA EXPOSURE INDEX Numerical system that refers to the ability of a film stock to react to light. Set by the American National Standards Institute.

ASCAP, BMI, and SESAC Music publishers who hold copyrights on music.

ASPECT RATIO The measurement of width to height of the visual frame—4:3 in NTSC, 16:9 in HDTV.

ASSEMBLE EDIT Sequential arranging of shots in a linear manner. Can be accomplished on raw tape without previously recording a control track.

ASSETS (Media) A type of media file that includes either an external file or content from an external file. They may be textual (digital), images (media), or multimedia (media).

ATSC-DTV The digital video broadcast standard set by the Federal Communications Commission (FCC) for the United States.

ATTENUATE To lower the level of an electronic signal.

AUDIO The sound portion of the videotape. Frequencies within the normal hearing range of humans.

AUDIO EXCHANGE FILM FORMAT (AIFF) A lossless format used in professional applications. Developed by Apple.

AURAL Having to do with sound or audio.

AUTO TRACE WHITE A system in certain cameras that constantly monitors the light and adjusts the color correction to maintain white balance.

AUTOFOCUS (AF) A system designed to maintain critical focus using sensors to activate motors to reset the focal range.

AUTOMATIC GAIN CONTROL (AGC) Circuit that maintains the audio or video gain within a certain range. Prevents overdriving circuits, which causes distortion but can increase signal-to-noise ratio.

AUTOMATIC LEVEL CONTROL (ALC) Circuit that maintains set levels at the output of an audio compressor to set the proper level for the next stage.

AVAILABLE LIGHT Illumination existing at a location.

AXIOM An obvious truth or starting point of clear reasoning.

BACK FOCUS The distance the lens must be mounted from the focal point for maximum focus.

BACKLIGHT Lamp placed behind the subject, opposite the camera; usually mounted fairly high and controlled with barn doors to prevent light shining directly into the camera lens.

BALANCED LINE An audio cable constructed with two conductors and a shield designed to provide the best protection from outside interference.

BANDWIDTH (1) A measure of the width of a range of frequencies, measured in Hertz, kilohertz (KHz), picahertz (PHz). (2) The rate of data transfer, bit rate or throughput, measured in bits per second (bps).

BARN DOOR Movable metal flap attached to lighting fixtures to allow control over the area covered by the light from that lamp.

BARREL A cable adapter designed to connect two cables ending in similar plugs.

BARS/GAIN SELECTOR A switch that allows the camera operator to record color bars or change the gain setting of the internal video amplifier.

BASE LIGHT The minimum amount of light required to provide an acceptable picture.

BASIC THREE-POINT LIGHTING This lighting is designed to satisfy the need for basic lighting to create an image and provide a realistic setting for a scene. This design derives its name from the three lighting instruments used to achieve satisfactory levels and appearance: key lights, fill lights, and backlights.

BASS The low end of the audio spectrum.

BEL Basic unit of audio measurement. Usually too large for normal usage, so decibels (1 = 10 bel) are used instead.

BENEVOLENT DICTATOR A leader who maintains strong control over an organization, but works to understand and accept the opinions and experiences of the group.

BETACAM One-half-inch professional videotape format developed by Sony specifically for use in a camcorder. Betacam replaced 3/4-inch U-matic as the predominant newsgathering video format. Now upgraded to digital Beta.

BIDIRECTIONAL Microphone that picks up sound from the front and back but rejects most sound from the sides. The pickup pattern appears in the shape of a figure eight.

BIN (BROWSER) A section of the editing screen that shows the files or clips ready to be edited.

BINARY VALUE Number values used in computers and based on the Base 2 system: all numbers may be represented only by either "0" or "1" as opposed to the Base 10 or decimal system used outside of computers.

BIT Smallest digital measurement; 8 bits 1/4 1 byte.

BLACK BURST A composite video signal including sync and color signals, but the video level is at black, or minimum.

BLACK LEVEL The normal level for pedestal or video black in a video signal. See also SETUP.

BLEED Space beyond the critical or essential area that may be seen on some television receivers but not on others.

BLOOM The effect seen when a video signal exceeds the capabilities of the system: white areas bleed into darker areas.

BNC A type of twist-lock video connector, now the most common for professional equipment.

BODY MIC A microphone concealed or hung directly on the body of the performer, sometimes called a lapel or lavalier mic.

BODY MOUNT A method of holding and controlling a camera without the use of a tripod or other fixed mounting. Most common is the Steadicam, which uses a series of gyroscopes, springs, and counter weights.

BOKEH EFFECT Allowing portions of an image to be out of focus intentionally.

BOLLYWOOD Hindi language feature films produced in India, primarily in Mumbia (Bombay) Maharashtra.

BOOM Movable arm from which a microphone or camera may be suspended to allow for movement to follow the action.

BOOST To raise the level of an electronic signal.

BRAINWARE The mental capabilities of people to create, design, and operate complex digital equipment.

BRIGHTNESS The luminance value of a video picture.

BROAD A type of open-faced fill light, usually rectangular in shape.

BUBBLE Leveling device mounted on a tripod pan head consisting of a tube containing liquid with a bubble of air trapped inside. Centering the bubble on a circle or cross-hair indicates that the pan head is level.

BUST SHOT The composition of framing a human from slightly above the waist to the top of the head.

BYTE A measurable number of bits treated as a unit. Also a convenient measurement of digital memory.

CALLIGRAPHER A professional artist who uses specialized pens and brushes to create beautiful lettering or script.

CAMCORDER Camera-recorder combination. Designed originally for news coverage, but now becoming popular for EFP and other productions.

CAPACITOR In a microphone, the element that converts sound waves to an electrical charge consists of two electrically charged metal plates arranged so that when sound waves strike one plate the distance between the two plates creates a changing electrical voltage equivalent to the sound wave.

CARDIOID MIC Specialized unidirectional microphone with a heart-shaped pickup pattern.

CASE Style of letters. Uppercase letters are capital letters; lowercase letters are small letters.

CASSETTE Prepackaged container of either audio or videotape containing a specific length of tape stock, a feed reel, and a take-up reel. BetaSP, S-VHS, miniDV, and Hi-8 systems use incompatible videocassettes.

CATHODE RAY TUBE (CRT) The large picture tube used as video monitors and television receivers replaced by LED, PDP, and plasma monitors.

CD-ROM (COMPACT DISC READ-ONLY-MEMORY) A permanently recorded digital compact disc.

CENTRAL PROCESSING UNIT (CPU) The main control and operating circuits of a computer.

CHARACTER GENERATOR (CG) Computerized electronic typewriter designed to create titles or any other alphanumeric graphics for use in video.

CHARGE COUPLED DEVICE (CCD) A solid-state element designed to convert light to electronics; replaces the pickup tubes in video cameras.

CHIAROSCURO LIGHTING Lighting accomplished with high-contrast areas and heavy shadows.

CHIP A semiconductor integrated circuit. Depending on its design, a chip can replace tubes, resistors, and other electronic components.

CHROMINANCE The portion of the video signal controlling color.

CINEMATOGRAPHER Its narrowest definition is the operator or supervisor of a motion picture camera. Over the years, the job description of a cinematographer has, to some, come to include the field of operating a video camera.

***CINE'MA V'ERITE'* (Film truth)** Documentary motion pictures created to show candid realism combining improvisation recorded to unveil truth or highlight subjects within reality.

CLIP A single shot of a sequence to be edited in an NLE system.

CLIPPED Cut off, chopped short of intended value.

CLOSE-UP (CU) The second tightest shot in a sequence. Camera framing showing intimate detail, often a tight head shot.

CLOSURE Psychological perceptual activity that fills in gaps in the visual field.

CLOUD, THE An overall expression used to describe a variety of different types of computer storage systems connecting to a network such as the internet or stored on a single or multiple set of servers.

CODEC (COmpressionDECompression) The process or type of equipment that modifies digital signals between types of formats or compression ratios.

COLLABORATE To work together especially on an artistic, media production.

COLOR BARS Electronically generated pattern of precisely specified colors for use in standardizing the operation of video equipment.

COLOR CORRECTION (1) A system used to vary color values of a scene by manipulating color gels, filters on light fixtures or lenses. (2) A system of altering or enhancing the color of media images electronically, photographically, or digitally. In the photographic system it is called color timing.

COLOR FILTER ARRAY A system designed to arrange CMSO chip surface to separate red, green, and blue light into a single file for processing.

COLOR TEMPERATURE See KELVIN TEMPERATURE.

COLOR TEMPERATURE CONTROL A series of filters enabling the camera operator to compensate for the variations in Kelvin temperature of the location.

COMPLIMENTARY METAL OXIDE SEMICONDUCTOR (CMOS) A type of solid-state element designed to convert light to electronics.

COMPRESSION In the digitizing process, certain unnecessary or redundant portions of the signal are not digitized, saving precious storage memory.

CONDENSER MIC Transducer that converts sound waves by conductive principle. Requires a built-in amplifier and a power source. Also called electrostatic or capacitor mic.

CONNECTOR PANEL Usually a section on the rear of a piece of equipment where the jacks are located.

CONTINUITY (1) A depiction of continuous action, location, direction, or time. (2) Script written for spots—commercials, public service announcements, or promotional announcements.

CONTINUITY ASSISTANT (CA) The member of the crew who follows the shooting script, keeps track of the logs, and checks to make certain shots will match later in the editing process between shots.

CONTRAST RANGE Ability of a camera to distinguish between shades of reflected black and white light: in TV, 30:1; in film, 100:1; with the human eye, 1,000:1.

CONTRAST RATIO The mathematical comparison of the measured light value reflected from the brightest part of the picture with detail and the darkest part of the picture with detail.

CONTROL TRACK Synchronizing signal recorded onto a videotape to align the heads for proper playback.

CONTROLLER A specialized computer designed to accurately maintain control over a series of videotape decks during the linear editing process.

COOKIE also CUKALORIS.

COPY The words on a script or to duplicate a signal or file.

COUNT DOWN A timed sequence of events leading to the beginning of a production. Numbered frames from 10 to 3, then 3 seconds of black.

COUNTER A meter designed to indicate either a position on a reel of tape or the amount of tape already used. May be calibrated in revolutions, feet, meters, or time.

COVER SHOT Any one of several shots, usually close-ups, designed to give the editor a means of preserving continuity. See also CUTAWAY and CUT-IN.

CRAB DOLLY A small platform large enough for a tripod and camera operator. It usually has four wheels, two designed to provide a means of steering the dolly. Usually pushed by a crew member; sometimes set on tracks for a tracking shot.

CRANES One of the support systems used for single-camera production. Cranes are designed to permit the camera to be raised and lowered over a wide range as well as to swing back and forth for 360 degrees when necessary.

CRITIC One who expresses professional opinions and analysis of art or artistic and media performances.

CRITICAL AREA (ESSENTIAL AREA) Space occupying approximately 80 percent of the center of the video frame. This area is seen with relative surety by the majority of the television receivers viewing that particular program. The 10 percent border outside of the critical area may not be seen by many receivers.

CRITICISM The act of evaluating works of art, artistic, or media performances.

CROP FACTOR A measurement of the differences between format ratios and dimensions.

CROSS-KEY LIGHT A single instrument used to provide key light for one subject and, at the same time, fill light for another subject.

CUE (1) Signal to start talking, moving, or whatever the script calls for. (2) To ready material to be played back or edited by running and stopping a tape, film, record, and so on, at a specified spot.

CUKALORIS A pattern inserted into an ellipsoidal spotlight to throw a mottled design onto the background. Also known as a cookie or gobo.

CUT (TAKE) (1) Cue to stop an action, and the like. (2) An instantaneous change in picture or sound. Cut is considered a film term, and take is considered a video term, but they have become interchangeable.

CUTAWAY Close-up shot of an image related to, but not visible in, the wider shot immediately preceding or following it.

CUT-IN Close-up shot of an image visible in the wider shot immediately preceding or following it.

CYCLE Time or distance between peaks of an alternating voltage. Measured in Hertz (Hz).

DATA FILES Files that store data applied to a specific application for input.

DATA STORAGE SPACE Computer components or recording media designed to permanently retain data.

DECIBEL (dB) Logarithmic unit of loudness. A dB is 1 = 10 of the original unit, the bel.

DECK In media, this term refers to a machine that plays or records audio or video signals.

DEGRADATION Lowering the quality of a signal from transporting, storing, or modifying the signal.

DEMODULATOR Separates audio and video signals in a cable.

DEPTH OF FIELD (DOF) The range of distances from the camera within which subjects remain in acceptable focus.

DIALOGUE Speech between performers, usually seen on camera.

DIAPHRAGM The fine flexible disc that vibrates when either struck by sound waves or if activated by an electronic signal to produce sound waves as used in microphones and speakers.

DICHROIC Filters designed to reflect certain colors of light and pass others.

DIGITAL Binary-based, constant-amplitude signals varying in time.

DIGITAL AUDIO WORK STATION (DAW) A computer designed specifically to manipulate and edit digital audio signals.

DIGITAL CINEMA (DC) Formerly known as electronic cinema. A video format designed to rival the quality of 35-mm film.

DIGITAL SINGLE-LENS RELFEX CAMERA (DSLR) A camera based on a single film reflex body and optics but with a digital sensor and other attachments to facilitate video production.

DIGITAL SUBSCRIBER LINE (DSL) A standard telephone line set up to carry broadband signals.

DIGITAL VERSATILE DISC (DVD) A high-density version of the CD.

DIGITAL VIDEO CAMERA (DVC) A half-inch digital videotape format. Various versions range from DVCam (prosumer level) to DVCPro (professional broadcast level), and PVCProHD (professional high-definition level). Some compatibility between levels and manufacturers.

DIN (DEUTSCHE INDUSTRIE NORMEN) The German standards organization. DIN usually refers to a type of plug or jack.

DIRECTOR Commands the creative aspects of a production. In the field, the director makes creative decisions. In the studio, the director calls the shots on live productions. In the editing room, the director provides opinions.

DIRECTOR'S CUT The finished edited version of a project as approved by the director.

DISK A digital recording medium. May be either magnetic or optical. Ranging from the 3.5-inch floppy to 5-inch CD-ROMs and DVDs, and large hard drives.

DISSOLVE Transition of one image fading into and replacing another. If stopped at the midpoint, it is a superimposition. Also called a lap.

DISTORTION An undesirable change in a signal.

DISTRIBUTION AMPLIFIER (DA) Electronic amplifier designed to feed one signal (audio, video, or pulses) to several different destinations.

DOLLY (1) Three-wheeled or four-wheeled device that serves as a movable camera mount. (2) Movement in toward a subject (dolly in) or back away from a subject (dolly out).

DOWN LINK Transmission path from a satellite to a ground station. Sometimes used to describe the ground station capable of receiving a satellite signal. See also UP LINK.

DRAG The back pressure designed to make panning and tilting a camera head smooth and controlled. The drag can be created by friction, fluid, spring, or geared mechanisms.

DROP FRAME The frames omitted to allow color NTSC to stay in step with actual time.

DUAL-COLUMN FORMAT A scripting format used primarily for live or tape-to-live video and television productions. Developed over the years from radio and audio/video formats. All video and movement instructions are located in the left-hand column, all audio in the right-hand column.

DUB (1) Copying a recorded signal from one medium to another. (2) Replacing or adding voice to a preexisting recording; now called automatic dialogue replacement (ADR).

DVB-T (Digital Video Broadcast-Terrestrial) The high-definition technical standard developed by European on-air broadcasters.

DYNAMIC MIC Transducer designed to convert sound to electronics by using an electromagnetic coil attached to a lightweight diaphragm.

DYNAMIC RANGE Loudness range from the softest to the loudest that can be reproduced by any system without creating distortion.

DYNAMICS Refers to the difference between the loudest and the quietest passage.

EDGE ATTRACTION THEORY When an object appears to move toward the edge, even if it remains stationary in the frame.

EDGE BLEED AREA The 10 percent border around a frame, which may be visible to some viewers.

EDIT DECISION LIST (EDL) List of precise locations of edit points. May be generated manually or by computer.

EDITOR Tape or film specialist charged with assembling stories from footage and recordings to create the final production.

EIAJ (Electronic Industries Association of Japan) Standards setting organization of Japan. At one time, EIAJ referred to a specific 1/2-inch open-reel videotape system.

ELECTRET A small condenser mic often used as a lavalier or mic built-in to equipment.

ELECTRONIC ASPECT The editing criteria to be considered that effects the signal itself, not the visual or aesthetic criteria.

ELECTRONIC FIELD PRODUCTION (EFP) Process of researching, shooting, and editing materials to be utilized in non-news productions.

ELECTRONIC NEWS GATHERING (ENG) Process of researching, shooting, and editing materials to visually report on occurrences of interest, utilizing video cameras and electronic editing specifically for newscasts.

ENCODE Used in compression to eliminate unnecessary frames, color, or spatial descriptions to achieve the level of compression desired.

ENCOMPASS To enclose or surround.

EQUALIZATION Process of compensating for required changes in frequency, level, or phase of an audio or video signal.

ERROR CORRECTION A technique used in computer and video applications to restore data loss due to channel noise and transmission problems.

ETHNIC A member of a group of people classed by common racial, national, tribal, religious, linguistic or cultural origin.

EXPOSURE LATITUDE The difference in exposure in f-stops allowing the difference between the whitest white and darkest black. In film, approximately nine stops; in digital, it is six and a half stops.

EXTERIOR (EXT) A setting or location outdoors.

EXTERNAL ADVANCED TECHNOLOGY ATTACHMENT (eSATA) A high-speed mass storage device installed outside of the unit served.

EXTREME CLOSE-UP (ECU or XCU) Tightest framing of a shot in a sequence, for example, just the eyes or hands of a subject.

EXTREME WIDE SHOT (EWS or XWS) Widest shot of a sequence, for example, an entire city block or football stadium.

F A type of connector for a cable intended to carry a modulated signal or signals. See also RF.

FACILITIES (FAX) Technical equipment, lights, cameras, microphones, and so on.

FACSIMILE (FAX) Transmission of information by optical/electronic system through telephone lines.

FADE, IN OR OUT A gradual change in signal, either from zero to maximum or maximum to zero. Can apply to either audio or video.

FAY A series of fixed-focus lamps mounted in a bank. A FAY has a color temperature of 5,400 degrees Kelvin. See also PAR.

FEDERAL COMMUNICATIONS COMMISSION (FCC) Federal agency charged with the supervision and regulation of all electronic communication media in this country.

FIELD One-half of a complete interlaced television picture; 262.5 lines of the 525 NTSC system occurring once every 60th of a second. Two interlaced fields make a complete frame. One complete progressive video field may consist of from 360 to 1040 lines in a single fame.

FIELD OF VIEW The range of subjects and settings that a camera shows in a single shot.

FILL LIGHT Soft, shadowless light used to reduce contrast and lighten shadow areas. Usually placed on the opposite side of the camera from the key light and low enough to remove harsh shadows.

FILTER A colored element placed in front of or behind a lens.

FIREWIRE (IEEE 1394) Also known as iSync or iLink. A standard for transmission of data between digital equipment. A high-performance standard becoming one of the preferred methods of moving data in the media production world.

FISHPOLE Handheld expandable mic boom.

FIXED FOCUS INSTRUMENTS One of the three basic types of field lighting instruments. Fixed-focus instruments are designed around a lamp similar to an auto headlight. See also PAR and FAY.

FLAG An opaque piece of material hung between a light and subject or set to control light or throw a shadow.

FLASH DRIVE A small, portable digital memory device designed to connect to a USB outlet to operate as portable hard drive. Also known as a thumb drive, pen drive, key drive, or USB drive.

FLASH FRAME An unwanted frame between two edited shots.

FLIPCAM A small video camera with a portion that swings open.

FLOODLIGHT A non-lensed instrument that provides soft, diffused light.

FLUORESCENT LIGHT Gas-filled tube that emits light when an electrical current ionizes the gas. It does not emit light of a specific Kelvin temperature, but is bluish green in color.

FLYING ERASE HEAD Erase head mounted on the rotating head mount of a helical recorder. Designed to allow precise editing of the video signal without losing sync between shots.

FOCAL LENGTH Theoretical distance from the optical center of the lens to the focal plane. Determines, with the size of the image surface, the angle of view, depth of field, and image size.

FOCAL POINT The position behind the lens where the image is concentrated.

FOCUS The ability of a lens to create the sharpest image of a subject.

FOCUSING SPOTLIGHTS One of the three basic types of field lighting instruments. Focusing spotlights are either open faced without a lens or lensed with a Fresnel or plano-convex lens. Focusing spots are essential for critical creative lighting.

FOLEY SESSION Named for Jack Foley, an early sound operator in film. A studio designed to create sounds in postproduction.

FOOT CANDLE Older measurement of illumination. Originally, the amount of light from one candle, falling on an area one foot square, one foot from the candle.

FORMAT, VIDEOTAPE Specifications of a specific type of videotape. There are approximately 23 different formats in use today.

FRAME (1) Complete video picture, made up of two 262.5-line interlaced scanned fields. There are 30 frames per second in the NTSC system. (2) In HDTV 360 to 1040 lines in the progressive system at a rate of from 24 to 60 fps. (3) The outline of the available area in which to compose a video picture. Today's NTSC standard is a frame 3 units high by 4 units wide, HDTV 9 units high, 16 units wide.

FREEZE FRAME Stopping a single frame within a moving sequence.

FREQUENCY Number of complete cycles an electrical signal makes in one second. Measured in hertz (Hz).

FREQUENCY RESPONSE A measurement of a piece of equipment's ability to reproduce a signal of varying frequencies.

FRESNEL A spotlight equipped with a stepped lens that easily controls and concentrates light.

FRONT FOCUS Creating the sharpest picture by adjusting the lens.

F-STOP A measurement of the size of opening that allows light to pass through an iris or aperture.

FUSE BOX (CIRCUIT BREAKER BOX) The location of alternating current power distribution with individual switches or fuses (in older locations), which protect each circuit from having too much current drawn from it.

GAFFER Senior electrician on a crew.

GAIN The amount of amplitude of an electronic signal. Usually measured in dB.

GAIN CONTROL An electronic control in a camera, usually located internally.

GEN-LOCK Abbreviation for synchronous generation locking. Electronically connecting all circuits together so that synchronizing will remain stable.

GENRE A type of programming (e.g., western, comedy, drama).

GIGAHERTZ A measurement of frequency, one billion hertz.

GIRAFFE Small mic boom mounted on a tripod on wheels, usually designed for limited mic movement.

GLOBAL SHUTTER An electronic shutter that exposes all of the pixels in a single frame simultaneously.

GOBO (1) In video, a set piece that allows a camera to shoot through it, such as a window. (2) In audio, a movable sound reflector board. (3) In film, a movable freestanding pattern cutout similar to a cookie. (4) On stage, the equivalent of a cookie.

GPS COORDINATES A geographical alignment system that describes any one position on earth by its latitude, longitude, and elevation.

GRAND ALLIANCE A consortium of companies organized to develop an American HDTV standard.

GRAPHIC WEIGHT (GRAPHIC FORCE) The perceived value of any item within the picture frame.

GRAPHICS GENERATOR A digital unit designed to create and combine pictures with type. Sometimes called a paint box.

GRAPHICS PROCESSING UNIT (GPU) A specialized computer circuit designed to rapidly manipulate high density media files, especially for editing.

GRAY SCALE Multiple-step intensity scale for the evaluation of a picture. Ranges between television white and television black in a series of calibrated steps.

GRIP A stagehand, a crew person who moves sets, props, dollies, and so forth. The head stagehand is the key grip.

GROUND LOOP In electronics a current in a conductor connected at two points designed to be at the same potential, but are not, or should be connected to ground.

HAND PROPS Items small enough to be picked up and handled, but for the most part, they are items that need to be handled by the talent during the production.

HARD DISK DRIVE (HDD) A magnetic disk drive designed to store large amounts of digital information. Most computers have at least one hard drive installed internally, but hard drives can also be connected externally to digital equipment.

HEAD A pan head supports the camera and is designed to allow both horizontal and vertical movement of the camera.

HEAD SHOT A composition of framing the human just above the shoulders to above the top of the head.

HELICAL Videotape with multiple recording heads that record information in long slanting tracks; each track records one field of information.

HELICAL RECORDING See HELICAL.

HERTZ (Hz) Measurement of frequency. Number of complete cycles completed in one second.

HI-8 Semiprofessional digital 8-mm videotape format developed by Sony for the prosumer market.

HIGH CUT An equalization filter designed to reduce the effect of unwanted high frequencies.

HIGH DEFINITION MULTIMEDIA INTERFACE (HDMI) An audio/video connector used to transfer compressed video data and uncompressed digital data.

HIGH DEFINITION TELEVISION (HDTV) One of several subcategories of advanced TV (ATV). Attempt at creating a video system nearly equal to 35-mm film in resolution and aspect ratio.

HIGH HAT A minimal platform designed to mount a pan head, allowing for shots close to the ground or to mount the camera on a car, boat, or airplane.

HIGH IMPEDANCE A measurement of resistance to current flowing through a cable. High-impedance lines generally are designed to carry signals amplified to at least midlevel to prevent noise being added. Some mics are rated as high impedance, but they must be connected to short cables to prevent picking up extraneous noise.

HINDU A native of India and adherent of Hinduism.

HISTOGRAM A measurement device to determine the density of the colors and light processed throughout a digital video system.

HYPER FOCAL DISTANCE The point from the lens that creates depth of field from infinity to foreground. Most prime lenses indicate the hyper focal point for each f-stop. Most video camcorder lenses do not.

IDIOT CARD A prompting device made of large bold key words written on cards held next to the camera lens for the talent's benefit.

IMAGE NOISE The appearance of "graininess" or random pixels of brightness or color not present in the original subject. Most noticeable in dark areas of the image. May result from too much heat, too high an ISO setting, or insufficient light on the subject.

IMAGE ORTHICON (I-O) An early video camera tube. The development of the I-O opened the way for reasonably mobile studio and remote cameras.

IMAGE PROCESSOR A digital file amplifier used in digital cameras to increase the signal strength.

IMPEDANCE Apparent AC resistance to current flowing in a circuit. Measured in ohms.

INCANDESCENT LIGHT Inert, gas-filled electric lamp emitting light and heat from a glowing filament. A typical lamp is the tungsten-halogen lamp used in most production instruments.

INCIDENT LIGHT Illumination from a light source. Measured in foot candles or lux by pointing the light meter at the light source.

INNOVATION Introducing something new, a new device or method.

INPUT Signal entering a system or an electrical unit.

INSERT EDIT Assembling a video production by adding video and audio signals to a master that already has had control track recorded on it. Insert edits also can be made over existing edited files.

INSTITUTE OF ELECTRICAL AND ELECTRONICS ENGINEERS (IEEE) An organization that serves professionals and students in technical, research, and innovation in technical fields beyond electronics.

INSTITUTE OF RADIO ENGINEERS (IRE) An organization formed in 1912 to develop technical standards for the new electronics industry. It merged in 1963 with AIEE to form IEEE.

INTEGRATED SERVICE DIGITAL BROADCAST (ISDB) The digital broadcast standard set for Japan.

INTERIOR (INT) Setting or location inside of a building or structure.

INTERLACED SCANNING The method of combining two fields of scan lines into one frame.

INTERNAL GAIN CONTROL A potentiometer that allows continuous gain settings on a camera.

INTERVALOMETER A control that sets the number of frames per second at which the recorder will operate. This compresses the action in any time elapsed required for the production.

INTRO Abbreviation for introduction.

INVERSE SQUARE LAW A mathematical analysis of changes in alternating energy. The amount of energy is inversely proportionate to the change in distance. The formula is easily applied to calculations of lighting and audio levels.

IRIS See APERTURE.

IRIS FADE-IN/FADE-OUT An iris fade-in or fade-out is created by placing the iris control on manual and setting the iris opening stopped all the way down. With the recorder rolling, the iris may be slowly opened up and brought to the proper setting. This creates a fade-in. A fade-out is created by reversing the procedure: A scene is started with the recorder rolling and the iris set properly. At the right moment, the iris is stopped down until the picture fades to black. Neither of these effects works well unless the light level is low enough so that the iris is nearly wide open at the proper setting.

IRIS INST. CONTROL A camera control designed so that you can zoom in on the surface that is reflecting the average amount of light for that scene, such as the face of the subject. Press the iris inst. control, which locks the iris at that setting, and then zoom back or pan to whatever framing is needed or to the beginning of that scene.

IRIS MODE CONTROL Allows you to choose between setting the iris manually or letting the camera's automatic iris circuits set the iris.

ISDB-T The Japanese digital video standard.

ISLAMIC The religious faith of Muslims including belief in Allah as the sole deity and Muhammad as his prophet.

IT EMPLOYEE A worker specializing in design, repair, and operating information technology equipment.

JACK A cable connector mounted on equipment.

JARGON Terminology and slang of a particular field.

JOINT PHOTOGRAPHICS EXPERTS GROUP (JPEG) A standards group originally intent on setting standards for still photography, but some of the standards and systems evolved into systems used in motion pictures, video, and computers.

JUMP CUT Any one of several types of poor edits that either break continuity or may be disturbing to the audience.

KELVIN TEMPERATURE Measurement of the relative color of light. Indicated as degrees Kelvin. The higher the temperature, the bluer the light, the lower the temperature, the redder the light. Also known as color temperature.

KEY LIGHT Apparent main source of light. Usually from one bright light above and to one side of the camera.

KICKER A light focused from the side on the subject or on a particular section of the set.

KILOHERTZ (kHz) A measurement of alternating energy, 1,000 hertz.

KORAN The book of sacred writings accepted by Muslims as revelations made to Muhammad by Allah.

LAG That characteristic of a sensor in which a picture trails its own images as the camera moves. Lag varies depending on the quality of the sensor.

LAPTOP A portable computer designed small enough to fold and carry. Also a term for laptop editor. A single unit portable nonlinear editor.

LAVALIER (LAV) Microphone worn around the neck. Also sometimes called a lapel mic when clipped to a tie or front of the clothing.

LAYING DOWN CONTROL TRACK The process of recording a sync signal. It requires a video signal, a set of sync signals, but no audio is needed. Usually records color bars or a video black signal.

LEAD ROOM Extra space in front of any moving object in the camera frame.

LENS Glass or plastic designed to focus and concentrate light on a surface to form an image.

LENS CAP Opaque covering to slip over the end of a lens to protect the surface from damage and to protect the image device from excessive light.

LEVEL Relative amplitude or intensity. Used to indicate light audio, video, and other electronic signals.

LIGHT METER (EXPOSURE METER) Instrument used to measure the intensity of light. May be calculated in foot candles, lux, or f-stops.

LIGHT-EMITTING DIODE (LED) A solid-state component that emits light when a small voltage is applied. Useful as a level or operating condition indicator.

LIGHTING RATIO A numerical value comparing the amount of incident light provided by the fill lights alone against the amount of incident light provided by the combination of key plus fill light. The standard ratio is 2:1.

LINE LEVEL Signal amplified enough to feed down a line without fear of degradation. A microphone level is lower than line level; speaker level is higher.

LINEAR In a straight line.

LIQUID CRYSTAL DISPLAY (LCD) (1) A flat-screen video monitor. (2) A source of flat, even light balanced to daylight.

LOCAL AREA NETWORK (LAN) A set of wires designed to carry digital signals between several peripherals or computers.

LOCATION Area or site of a production. Usually refers to sites away from studios.

LOG Listing of shots as they are recorded on tape.

LONGITUDINAL Lengthwise. In media, refers to the method of recording audio and control track signals.

LOOPING The process of rerecording audio during postproduction. Also now called automatic dialogue replacement (ADR).

LOSSLESS A compression method that preserves the original data yet reduces the bandwidth required for processing and storage.

LOSSY A compression method that discards redundant data to reduce the amount of bandwidth needed to process and store a file.

LOUDNESS Perceived intensity of audio. Depends on the intensity and saturation of the sound, as well as the sensitivity of the listener to a range of frequencies.

LOW CUT An equalization filter designed to reduce the effect of unwanted low frequencies.

LOW IMPEDANCE A measurement of resistance to current flow. Low impedance circuits often are at a low level. High-quality mic lines are low impedance with two conductors and a shield to prevent noise entering the circuit.

LUMEN (lm) A measure of the total amount of visible light emitted from a source.

LUMINANCE The brightness component of a video signal.

LUX European measurement of light intensity. There are approximately 10 lux per one foot candle.

MANIPULATE To control or operate in a skillful manner.

MASTER SHOT Extended wide shot establishing the scene and often running the entire length of the sequence. Intended to be broken down in the editing process.

MATTE BOX A mounting mechanism on the front of a lens designed to hold filters, sun shades or other accessories used in electronic cinematography.

MEDIUM CLOSE-UP (MCU) Relative average framing for a shot, often framed from the waist up.

MEDIUM SHOT (MS) Wider than an MCU, often framed head to toe.

MEMORY CARD A thin combination of solid-state circuits designed to store digital signals. Also known as a flash drive or flash card.

MENUS A series of operational options that can be read in the viewfinder of a camera or on the face of a recorder. The options may be modified by watching the menus while adjusting the equipment.

METADATA (Data about data) Date enclosed within a data file that may include a variety of different specific facts about the original file: in video—technical specifications of the shot, editing and distribution information.

METAL OXIDE SEMICONDUCTOR (MOS) A type of solid-state element designed to convert light to electronics; replaces the pickup tube in video cameras.

MICROCAMERA Small video camera, also called lipstick cam, action cam.

MICROWAVE High-frequency carrier for both audio and video signals. Operates only on a line-of-sight path.

MIGRATION To move data from one place to another; to gather different types of related data into a single file or location.

MINIDV A narrow-gauge digital tape recording medium. May be used to record either or both audio or video, SD or HD signals.

MINI-PLUG (1/8th INCH) Audio connector designed for small equipment. Scaled–down version of 1/4-inch phone plug.

***MISE-EN-SCÉNE* (Placing on stage)** Sometimes called The Grand Defining Term of cinema. An expression describing the visual theme of a visual production.

MIXED LIGHTING A set lit with light of various Kelvin temperatures.

MIXER A piece of electronic equipment designed to combine several signals. Usually refers to an audio board or console.

MOBIL DEVICE A small electronic, usually digital communication tool used to transmit and receive signal and data.

MODULATION To vary the amplitude, frequency, or phrase of a signal to carry a different signal.

MODULATOR An electronic component designed to impress one signal on another, usually of a higher frequency.

***MOIRÉ* EFFECT** A wavy, shimmering pattern in the video.

MONITOR (1) To listen to or watch audio or videotapes or off-air programs. (2) Device used to view video signals, much like a TV receiver, but usually of much higher quality and generally does not have an RF section for off-air monitoring.

MONOCHROME A visual creation using only one color, or only black against white.

MORGUE Library, reference files, storage for used scripts, tapes, maps, and other reference material.

MOS A film term indicating a shot was recorded silent, or it is said, as the early German film directors said, "Mit out sound."

MPEG LAYER III (MP3) An audio format designed to reduce the amount of data required yet maintain a faithful reproduction of the original sound, a lossy system.

MPEG (MOTION PICTURE EXPERTS GROUP) A series of compression standards used in digitizing visual media.

NAT SOUND Ambient sound that exists on location, recorded as a story happens. Often used as background for a voiceover. Sometimes called wild sound.

NEUTRAL An aesthetic level without any specific genre or setting, often used for newscasts.

NEUTRAL DENSITY (ND) A type of filter that decreases light passage without changing the color value of the light.

NICKEL-CADMIUM (NiCad) A rechargeable battery consisting of nickel oxide hydroxide and metallic cadmium as electrodes. Small and capable of carrying more voltage than most other rechargeable batteries.

NOISE Any undesirable additions to a signal.

NON-DESTRUCIVE EDIT The process of performing edit cuts without damaging or losing control of the original footage.

NON-DROP-FRAME (NDF) Timing system that follows clock time precisely as opposed to drop frame that must compensate for color signals.

NONLINEAR (NLE) The storage and editing of video and audio digital signals. Comparable to film editing in that edits can be made in any order without disturbing previously edited sequences; also nonevasive, in that the original footage is not handled during the editing process.

NOSE ROOM The extra space allowed for in front of the face when framing the human head if facing in a specific direction.

NOTAN A lighting style similar to Japanese watercolors: high-key, few shadows, evenly lit.

NTSC (NATIONAL TELEVISION STANDARDS COMMITTEE) (1) The organization charged with setting television standard in the United States in the early days of television. (2) The television standard now in use in North America, much of South America, and Japan.

OFFLINE Using the lowest-quality and lowest-cost editing system suitable for a particular project.

OMNIDIRECTIONAL Microphone pickup pattern that covers 360 degrees around the mic.

ONLINE Using the highest-quality and highest-cost editing system suitable for a particular project.

OPEN UP The process of increasing aperture size in a lens. The f-stop number decreases in size.

OPERATOR Person whose main responsibility is to operate equipment, as contrasted with technicians, whose main responsibility is to install, repair, and maintain equipment; and engineers, whose main responsibility it is to research, design, and construct equipment.

OPTICAL IMAGE STABILIZATION (OIS) A system designed to compensate for shooting with hand-held cameras.

OPTICS/OPTICAL Having to do with lenses or other light-carrying components of a video or film system.

OSCILLOSCOPE Test equipment used to visualize a time factor system, such as a video signal. Shows a technician what the picture looks like electronically. May also be used to analyze audio or other signals.

OUTPUT Signal leaving a system or electrical unit.

OVER-THE-SHOULDER (OS) A typical news interview shot in which part of the interviewer's shoulder appears in the foreground and the person being interviewed faces the camera.

P2 A solid-state digital card designed by Panasonic for their cameras. The card records digital media in the same manner as flash drives.

PALMCORDER A small hand-held digital video camera, designed by Panasonic.

PAN Horizontal movement of a camera; short for panorama.

PAN HEAD Mechanism designed to firmly hold a camera on the top of a tripod, pedestal, or boom while allowing for smooth, easily controlled movement of the camera horizontally (pan) and vertically (tilt). May be mechanical, fluid, geared, or counterbalanced.

PAR A series of fixed-focus lamps mounted in a bank. A PAR has a color temperature of 3,200 degrees Kelvin. See also FAY.

PARABOLIC MIC Focused, concave, reflective, bowl-shaped surface with a mic mounted at the point of focus. Used to pick up specific sounds at a distance. Commonly used during sporting events.

PEDESTAL (1) Electronic calibration between blanking and black level. (2) Hydraulic, compressed-air, or counterbalanced studio camera mount; designed to permit the camera to be raised straight up or down effortlessly and smoothly.

PEDESTAL CONTROL Changes the black level or contrast of the picture.

PERAMBULATOR A large, wheeled, platform-mounted boom that a mic boom operator rides. Capable of swinging a mic over a large area.

PERCEPTIBLE That which may be accurately sensed by seeing or hearing.

PERIPHERAL Accessories connected to digital equipment-printers, decks, hard drives.

PERSISTENCE OF VISION A visual and mental phenomenon creating an after-image in the mind approximately 1/25th of a second after exposure to an image. Considered the basis for animation, film, and video motion perception.

PHANTOM POWER The 48 volts required by condenser mic preamplifiers located in the mic. If the mic does not carry its own battery power, phantom power may be supplied through the mic line by the mixer or recorder.

PHASE The relationship of two signals differing in time but on a common path.

PHASE ALTERNATIVE LINE (PAL) A television system developed in England using 625 lines and 50 frames rather than the 525–60 system of NTSC. Used in many countries around the world.

PHENOMENON An extraordinary, significant, high quality production or production process.

PHOTOGRAPHER Originally, a person taking still photographs. In some markets, the term photographer was applied to news cinematographers, and even today, the term sometimes is applied to videographers.

PHOTOSENSITIVE PICKUP ELEMENT A chip, or combination of chips to convert light into an electronic signal.

PICTURE LOCK An editing stage when the visual and audio segments are aligned and synced.

PITCH The perception by humans of frequency.

PITCH SESSION A verbal presentation of a concept to a producer, funding source, or sponsor to gain funds and permission to proceed with the production.

PIXEL A short version of "picture element." A single sample of digital color information.

PIXILATION A process of removing a certain number of frames from a sequence so that the objects appear to be jumping about or suspended and moving in space.

PLASMA DISPLAY PANEL (PDP) Flat screen video monitor.

PLOSIVE SOUNDS Vocalization made by the human voice that tends to pop a microphone. Sounds beginning with the letters "p" and "b," among others.

PLOT A scale drawing of the location of a shoot.

PLUG A connector on the end of a cable.

PLUG-INS Applications added to a computer to expand the capabilities and operations of the original application.

POCKET CAM A small hand-held camera, usually consumer quality.

POD CASTING Streaming media intended for mobile reception.

POINT-OF-VIEW (POV) A camera angle giving the impression of the view of someone in the scene.

PORTFOLIO An edited collection of the best work of a creative person in media or other artistic field.

POSITION MONITOR, INDICATOR An monitor tool used to locate clips in the non-linear editing process.

POWER SELECTOR SWITCH A control on a camera or tape deck used to switch the power source from either a battery or external AC power.

PRACTIAL ASPECT The editing criteria to be considered that must meet the needs of the system used within the available material.

PREAMPLIFIER (PREAMP) Electronic circuit designed to amplify weak signal to usable level without introducing noise or distortion.

PRIME LENS A fixed focal length lens.

PRISM A glass or plastic block shaped to transmit or reflect light into different paths.

PRODUCER Person in charge of a specific program.

PRODUCER'S CUT The final edited version of a project that has been approved and accepted by the producer.

PROGRESSIVE SCANNING A video frame constructed of a series of lines continuously forming a single frame before starting another scan sequence.

PROMPTER Device used to provide the talent with the copy as they perform on camera. Can be handheld copy beside the camera or a signal fed to a monitor mounted with mirrors to project the copy in front of the camera lens so the anchor can look directly into the camera. This signal may come from a signal fed directly from a computer.

PROPOSAL A concise summary of a project intended as a sales tool to accurately describe a production and to sell a sponsor on funding.

PROSUMER A category of producer and equipment that falls below that of professional quality but higher than consumer quality.

PUBLIC ADDRESS (PA) Sound-reinforcing system designed to feed sound to an audience assembled in a large room.

PULLING FOCUS The process of changing focus in the middle of a shot. Also known as rack or rolling focus.

PULSE CODE MODULATION (PCM) A digital recording system based on sampling an analog signal at regular intervals (usually audio).

QUADRAPLEX (QUAD) First practical professional videotape format. Quadraplex used 2-inch tape pulled across four heads to achieve a high-quality signal. No longer manufactured.

QUANTIZATION The measurement of a signal indicating the number of discrete levels of analog measured in the conversion process to a digital signal.

QUARTER-INCH PLUG (PHONE) Audio connector used for many years for high-impedance signals. Still used in some consumer equipment and patch panels.

QUARTZ-HALOGEN A lamp designed to provide a fixed color temperature of 3,200 degrees Kelvin.

R, Mg, B, Cy, G, Y. Red, Magenta, Blue, Cyan, Green, and Yellow are the traditional colors shown on a color bar used to adjust color cameras.

RACK, ROLL FOCUS Changing focus in the middle of a shot. See also PULLING FOCUS.

RASTER ge1620 The complete sequence of lines that make up the field of lines creating a video picture.

REDUNDANT ARRAY INDEPENDENT DRIVE (RAID) An arrangement of a series of magnetic disks for storing large quantities of media files.

RCA The U.S. corporation that promoted the NTSC video system, the developer of many early television inventions, and the original owner of NBC radio and television networks.

RCA PLUG (PHONO) Audio and video connector designed originally for use only with the RCA-45 revolution per minute record player. Now used as a consumer audio and video connector. Some professional equipment uses this plug for line level audio. Not to be confused with the phone (1/4-inch plug).

REALISTIC An aesthetic value of production creating as lifelike a setting as possible.

RECORD, CONVAS MONITOR The screen in NLE that shows what a series of clips look like after editing.

RECORDER DECK In a linear editing system, the deck that records the final edited sequence. See also EDITOR.

REDUNDANT Duplication of files, equipment, personal, and operations.

REFLECTANCE VALUES The amount of light reflected from the brightest and darkest objects in the picture used to determine contrast ratio.

REFLECTED LIGHT Illumination entering a lens reflected from an object. Measured with a reflected light meter pointing at the object from the camera.

REFLECTORS Large foam boards covered on one side with a variety of surfaces: plain white, colored, or textured. These are used to throw a soft fill light into areas not easily reached with instruments or to provide light when an instrument is not available or would cast an additional shadow.

REGISTRATION The alignment of either electronic or physical components of a system. Especially important in tube cameras.

RELEASE (1) Legal document allowing the videographer to use the image and/or voice of a subject. (2) Public relations copy.

RENDER Combining digital signals to follow a preordered virtual signal into the file's final form.

RESOLUTION Ability of a system to reproduce fine detail. In video determined by the number of vertical lines, in film and computers, the number of pixels per line.

RETICULE Markings on a waveform monitor to indicate the level of the video signal.

RETURN VIDEO OR VTR RETURN CONTROL A button on the camera that, when pressed, feeds the picture being played back from the tape deck into the viewfinder, allowing the videographer to observe the images already recorded.

REVERSING POLARITY Electronically changing video light values from dark to bright and colors to their opposites.

RF (1) Those frequencies above the aural frequencies. (2) A type of plug attached to a cable designed to carry a modulated signal. Also called "F" plug.

RF MIKE A wireless microphone operating on a radio frequency carrier.

RIBBON MIC A transducer utilizing a thin gold or silver corrugated ribbon suspended between the poles of a magnet to create an electrical output.

RIDING GAIN The manual process of maintaining specific levels of electronic signals.

RIPPLE CUT A means of inserting new footage within a previous edited project.

ROLL The command given by the director to start tape or the film camera recording.

ROLLING OR PULLING FOCUS Changing focus on a camera while recording.

ROLLING SHUTTER An electronic shutter that exposes each line of a frame in a CMOS chip individually.

RULE OF THIRDS The composition and framing theory that the visual frame may be split into nine sections by the intersection of two vertical lines and two horizontal lines, each one-third of the way into the frame.

SALISH The major group of the native American tribes of the Pacific Northwest and British Columbia.

SAMPLED INTERVAL The determined selection of timing in converting analog to digital signal.

SAMPLING In the process of converting an analog signal to digital, the number of times per second the signal is measured to determine the equivalent digital signal.

SANSKRIT An ancient Indo-Aryan language of Hinduism and India.

SATELLITE Geostationary orbiting space platform with transponders to pick up signals from the Earth and retransmit the signals back down to Earth in a pattern, called a footprint, that covers a large area of the Earth.

SATURATION Intensity of a signal, either audio or video, but especially used as the third of three characteristics of a color video signal.

SCAN AREA The portion of the subject that the camera converts into an electronic signal.

SCENE A series of related shots, usually in the same time and location.

SCENE SCRIPT A full script without individual shots indicated.

SCRIM A metallic or fabric filter placed over a lighting instrument to diffuse and soften the light.

SCRIPT Complete manuscript of all audio copy and video instructions of a program.

SCRIPT FORMAT The physical layout of instruction on a page used to guide the cast, crew, and director on the desires and goals of the writer. May take a variety of forms, depending on the genre of the production.

SELECTIVE PERCEPTION Choosing to see, hear, or sense without regard to all other stimuli present.

SEQUENCE Individual shots edited into scenes, and individual scenes edited together to make a story.

SEQUENTIAL COLOR WITH MEMORY (SECAM) The color television system developed by the French and in use in many countries around the world.

SERIAL DIGITAL INTERFACE (SDI) A digital video connecting system set by SMPTE (Society of Motion Picture and Television Engineers).

SERVER A data software and hardware storage system designed to store and make available data to be retrieved on demand, may be a single computer or a series of networked computers.

SERVO LOCK An electronic synchronization signal that keeps recording devices running at the proper rate and in step with other signals.

SET The physical space within a studio for the production of a visual scene.

SET DESIGN The process of creating on paper the environment for a visual production.

SET LIGHT A lamp focusing on the area behind the talent or objects to provide a pattern on the background or to wipe out unwanted shadows.

SET PIECES A type of dressing for a set: furniture, wall hangings, and objects too large or fixed in place to be handled by performers.

SET UP The assembly of equipment and people in preparation for rehearsing a production.

SETUP Same as pedestal and black level; electronic calibration between blanking and black level.

SHOOTING LIST (SHOT SHEET) A listing of all shots in the order they are to be made, regardless of their order in the script.

SHOOTING SCRIPT A script complete in all details, including specific shot descriptions.

SHOT One continuous roll of the recorder; the smallest unit of a script.

SHOT SHEET Also known as shooting list. A listing of all shots in the order they are to be made, regardless of their order in the script.

SHOTGUN Ultra-unidirectional microphone designed to pick up sound at a distance by excluding unwanted sound from the sides of the mic.

SHUTTLE Movement of videotape back and forth while searching for edit points. Usually done at speeds faster or slower than real time.

SIGNAL-TO-NOISE RATIO (S/N RATIO) The mathematical ratio between the noise level in a signal and the program level. The higher the ratio, the better the signal.

SINGLE-COLUMN FORMAT A script format derived from stage script format now used in both feature film and some types of video productions. All instructions and dialogue are arranged down the middle of the page with various margins and placement of copy indicating instructions, character's names, settings, and dialogue.

SITE SURVEY A detailed listing of all the information needed to shoot on location at a certain site.

SLANT TRACK Another name for helical recording.

SLATE Several frames identifying the shot, tape reel number, or other logging information. Usually recorded at the beginning of the tape.

SMART PHONE Is a mobile (cell) phone with advanced computing and connectivity capabilities beyond those of a traditional cell phone.

SOCIETY OF MOTION PICTURE AND TELEVISION ENGINEERS (SMPTE) A professional engineering organization that sets visual and aural standards in this country.

SOFTLIGHT A large light fixture that emits a well-diffused light over a broad area.

SOLARIZATION An in-camera effect created by varying the pedestal and gain to remove portions of the picture or expand other portions.

SOLID STATE DRIVE (SSD) A data storage device using integrated circuits (flash memory) rather than a disc or other movable mechanism.

SOURCE DECK In an editing station, the deck playing back the original footage.

SOURCE, VIEWER MONITOR A screen that shows the first frame of a clip to be edited in an NLE editing system.

SPEED The response the camera operator and sound operator give to the director to inform her or him that both of their machines are running at the proper rate before starting to record the shot.

SPLITTER BOX Device used to feed an input signal to more than one output. Commonly used at news conferences to avoid a jumble of microphones by splitting the feed from one mic to all those covering the event.

SPOT METER A light meter designed to read a very small area of reflected light.

SPOTLIGHT A lamp designed to provide a hard-edged controllable field of light. Fresnels and ellipsoidals are typical spotlights.

STANDARD DEFINITION (SD) A video signal of lower quality than high definition (HD).

STANDARD OPERATING PROCEDURE (SOP) Predetermined methods of accomplishing tasks. Often set by corporate or upper management policy.

STANDBY The command a director gives to warn the crew, cast, and others in the studio or on location that a camera is about to roll.

STEREOTYPE A standardized and oversimplified creation accepted by a general population.

STICKS Another name for a tripod.

STOCK New, unused tape or film before it is exposed to light.

STOP DOWN Decreasing the amount of light passing through a lens. Stopping down increases the f-stop number.

STORYBOARD A series of drawings indicating each shot and accompanying audio in a production.

STREAMING Distributing a video or audio program continuously on the Web.

STRIKE To tear down and pack up equipment and settings from a shooting location.

SUPERIMPOSITIONS (SUPERS) Two or more simultaneously fed video signals, stopping a dissolve at the halfway point.

S-VHS PLUG A plug that carries video signals split into two separate signals, Y and C, for higher-quality transmission of video than standard VHS.

SWISH PAN A rapid horizontal movement of the camera while recording. May be used as a transition device.

SWISH ZOOM A pan shot accomplished by starting on a scene and at the end of the shot, quickly panning the camera at a high enough rate so that the image is blurred.

SWITCHER (1) In multicamera or postproduction, a device used to change video sources feeding the recording tape deck. (2) The person operating the video switcher.

SxS CARD A solid-state card designed by Sony for their cameras. The card records digital media in the same manner as flash drives.

SYNC PULSES Signals created either in the camera or in a sync generator and added between the fields and between the lines. They are part of the recorded signal, and the receiver locks onto those pulses when the tape is played back or the signal is broadcast. The pulses can be corrected if there are errors in their timing by running the signal through a time base corrector (TBC).

SYNCHRONOUS (SYNC) Signals locked in proper alignment with each other; sound and picture locked together, all the various video signals in their proper relationship to each other.

SYNTAX Connecting files into orderly systems.

TABLET A mobile computer containing display, circuitry and battery systems. Advanced tablets also may contain camera, microphone, touchscreen, keyboard.

TACTILE CONTROL Making control changes using fingers or hands.

TENT An opaque sheet of material suspended over a subject to diffuse and soften the light.

THREE-SHOT A camera composition focused on three people or objects.

THUNDERBOLT An Apple connecting system designed to provide for multiple high performance equipment connected to a single port.

TILT The vertical movement of a camera on a pan head.

TIMBRE The perception of a musical note that differentiates the same note from a piano or clarinet.

TIME BASE CORRECTOR (TBC) Electronic device used to lock together signals with dissimilar sync. May also be used to correct for phase, level, and pedestal errors in original recordings.

TIME CODE Time-based address recorded on videotape to allow for precise editing. SMPTE time code is the time code most universally used at present.

TIMELINE (1) The calendar schedule of a production, with each step of the production from beginning to end set as goal dates to be met to keep the production progressing on schedule. (2) A visual indication of either or both the audio and video signals in timed segments on a NLE system.

TONE A sound created by generating a single frequency for test purposes and for setting standard levels on recordings.

TRACKING Movement of a camera to the left or right, parallel to the subject, usually while mounted on a set of tracks for maximum smoothness and control.

TRANSCODE To convert from one video of graphic format to another, as opposed to encoding which refers to the original file.

TRANSDUCER Any device used to convert any form of energy to another form: a camera transduces light to video; a microphone transduces sound to electronics; a speaker transduces electronics to sound.

TRANSFORMER Magnetic voltage-changing or impedance-changing device.

TREATMENT A narrative description of a production. It should read more like a novel than a script, because it is intended for a nonmedia person.

TREBLE High frequencies of the audio band.

TRIPOD Three-legged portable camera support. See also STICKS.

TRUCK A side-to-side movement of the entire camera mounted on a tripod, dolly, or pedestal mount.

TUNGSTEN LIGHT Relatively efficient gas-filled light source of approximately 3,200 degrees Kelvin temperature.

TWO-SHOT A camera composition focused on two people or objects.

UHF (ULTRA HIGH FREQUENCY) (1) Frequency band for television broadcasting channels 14 to 69. (2) An older, large, threaded type of video connector.

UMBRELLA LIGHT A means of creating a soft, defused light by focusing a spotlight on the inside of an umbrella designed with a reflective interior surface.

UNBALANCED A circuit usually consisting of a single conductor and a shield.

UNIDIRECTIONAL Microphone pickup pattern from a single direction. Comes in a variety of degrees of pickup angle, from cardioid to super unidirectional (shotgun).

UNIVERSAL SERIAL BUS (USB) A bidirectional digital circuit designed to connect a series of digital peripherals with a computer to create an efficient system.

UP LINK Transmission path from an Earth-based station up to a satellite. Sometimes used to describe the ground station capable of sending a satellite signal. See also DOWN LINK.

VALID An object that is relevant and accurate.

VARIABLE FOCAL LENGTH LENS (ZOOM) A lens that can have its focal length changed while in use.

VCR (VIDEOCASSETTE RECORDER) A recording system that uses tape contained in closed cassettes.

VECTORSCOPE Electronic test equipment designed to show the color aspects of the video signal.

VERISIMILITUDE Depicting reality or truthfulness.

VERTICAL INTERVAL TIME CODE (VITC) Time address recorded within the vertical interval blanking instead of on a separate linear track.

VIDEO (1) Picture portion of an electronic visual system. (2) All-inclusive term for electronic visual reproduction systems; includes television, cablevision, corporate media, and video recording.

VIDEO HOME SYSTEM (VHS, S-VHS) JVC-developed consumer VCR system. The "S" in S-VHS stands for "separate," as it is a semicompatible component recording system rather than a composite system.

VIDEOGRAPHER The proper term for the operator of a video camera.

VIDICON A type of video camera tube that replaced the Image Orthicon. It is lighter, smaller, and more durable, and it provides higher resolution.

VIEWFINDER The miniature video monitor mounted on the camera so the operator can see what is framed by the camera.

VIGNETTING A reduction in brightness near the corners or edges of an image.

VIRTUAL A copy of an original signal or file. Used to manipulate the signal before rendering the final signal. A nonvolatile signal.

VISUAL The video portion of the program.

VISUAL EFFECTS (VFX) A digitally created shot or image.

VOICE-OVER (VO) Story that uses continuous visuals, accompanied by the voice of an unseen narrator.

VOLT An electronic measurement of the pressure available at a power source. In North America, the standard is 110–120 V.

VOLUME The measurable loudness of a sound signal.

VOLUME UNIT (VU) Measurement of audio level. Indicates the average of the sound level, not the peak.

VTR (VIDEOTAPE RECORDER) A system that uses tape mounted on open reels.

VTR SELECTOR SWITCH Enables your camera to operate with a variety of different recorders manufactured by someone other than the manufacturer of your camera.

VTR START SWITCH A switch that may be mounted on the camera body, but more than likely it is mounted on the lens handgrip close to the thumb for easy use. This switch allows you to start and stop the recorder without leaving the camera or taking your eye from the viewfinder.

WAIST SHOT A composition framing a human from just below the waist to the top of the head.

WATT Measurement of power used in a piece of electrical or electronic equipment.

WAVEFORM Either an electronic or visualized reproduction of a signal indicating peaks and valleys of the electrical value of the signal.

WAVEFORM AUDIO FILE FORMAT (WAV) A format that may store either compressed or uncompressed files, usually used for CD sound files. Developed by Microsoft.

WAVEFORM MONITOR An electronic measuring tool; both oscilloscopes and vectorscopes are waveform monitors.

WEDGE Plate fastened to the bottom of a camera that allows it to be quickly mounted to a tripod equipped with a matched slot.

WHITE BALANCE Electronic matching of the camera circuits to the color temperature of the light source.

WHITE LEVEL (GAIN) Level of maximum voltage in a video signal.

WIDE SHOT (WS or LS) The second widest shot in a sequence. A WS is often used as an establishing shot to identify the environment and set the scene.

WILD SOUND Ambient background sound. See also NAT SOUND.

WINDOW DUB A low-quality copy of original footage with the time code signal visible in the frame.

WIPE Electronic special effects transition that allows one image to be replaced by another with a moving line separating the two pictures. Stopping a wipe in mid-movement creates a split screen.

WORK FLOW The process of moving audio and video signals from one production stage to another from inception through manipulation to distribution.

WRATTEN A series of filters originally designed for photography but adapted for use in cinematography and videography.

X-AXIS The plane running horizontally to the camera.

XLR PLUG Professional audio connector that allows for three conductors plus a shielded ground. Special types of multi-pin XLR plugs are used for headsets and battery power connectors.

Y-AXIS The plane running vertically to the camera.

YOTTAHERTZ (yHz) One septillion, or 1,000,000,000,000,000,000,000,000 hertz. Useful for indicating digital storage.

Z-AXIS The plane running away or toward the camera.

ZOOM See also VARIABLE FOCAL LENGTH LENS.

ZOOM LENS CONTROL Usually a rocker switch, which allows you to press one end to zoom in and the other end to zoom out. The harder you press, the faster the lens zooms. A gentle touch produces a slow, smooth zoom. On some cameras, an additional control allows you to set the speed range of the zoom control from very slow to very fast.

ZOOM MODE CONTROL Allows the operator to either zoom the lens manually or use its motorized control to zoom the lens.

Index